Code as Creative M

Code as Creative Medium
A Handbook for Computational Art and Design

By Golan Levin and Tega Brain

The MIT Press
Cambridge, Massachusetts
London, England

Library of Congress Cataloging-in-Publication Data

Names: Levin, Golan, author. | Brain, Tega, author.
Title: Code as creative medium : a handbook for computational art and
 design / by Golan Levin and Tega Brain.
Description: Cambridge : The MIT Press, [2021] | Includes
 bibliographical references and index.
Identifiers: LCCN 2020022997 | ISBN 9780262542043 (paperback)
Subjects: LCSH: Computer art—Study and teaching. | Computer
 art—Problems, exercises, etc. | Computer programming—Problems,
 exercises, etc.
Classification: LCC N7433.83 .L48 2021 | DDC 776.07—dc23
LC record available at https://lccn.loc.gov/2020022997

10 9 8 7 6 5 4 3

This project was supported in part by the National Endowment for the
Arts, through Art Works grant #1855045-34-19 in the Media Arts
discipline. To find out more about how National Endowment for the Arts
grants impact individuals and communities, visit www.arts.gov.

This project was also made possible through support from the Frank-
Ratchye Fund for Art @ the Frontier (FRFAF), and the generosity of Edward
H. Frank and Sarah G. Ratchye, administered by the Frank-Ratchye
STUDIO for Creative Inquiry at Carnegie Mellon University; and from the
Integrated Digital Media Program at NYU Tandon School of Engineering.

NATIONAL ENDOWMENT for the ARTS · arts.gov

The Frank-Ratchye STUDIO for Creative Inquiry

Contents

Foreword

Casey Reas
June 2020

When I was first learning to code, this book would have made a world of difference. I had been trying to learn for three years on and off—on my own and then through an evening extension class in 1997—and there were no resources I knew of at that time that were devoted to coding through the visual arts. My class only provided examples and exercises in the domains of math and text. (My final assignment was to make an accounting system for a fictional bank.) It was a challenge and a chore, but I knew I needed programming skills to make what I wanted to make.

Outside of class, when I finally knew enough C to start making visual things, everything changed. My motivation kicked in and I learned more in a few weeks than I had learned in months prior. The resulting collection of cryptic experiments called *Reactive 006* opened the door for me to join John Maeda's Aesthetics + Computation Group (ACG) at the MIT Media Lab in 1999. The ACG was the place I had been looking for. As a small research group, it brought together a wide range of artists, designers, and coders to explore a new kind of synthesis between those domains. Some of those early experiments evolved into the initial set of examples for Processing 1.0, which Ben Fry and I released in 2001. My two years in ACG clarified my future and led to my first experiences teaching code.

As I discovered firsthand, the teaching style for learning to code within computer science rarely worked for visual arts students, so those of us who taught visual artists and designers invented new approaches to immerse students in this way of thinking and making. This meant breaking the existing teaching methods apart and building them again in new ways. Starting with the exercises in John Maeda's *Design By Numbers* book, I made guesses about what might work in my classroom and then slowly improved the curriculum year by year by adding and removing assignments while figuring out the balance between code and ideas. I compared notes with others and, over time, something very different from the original computer science curriculum emerged.

The first Eyeo Festival in 2011 was a pivotal moment in this story, when a loose online network of artists, designers, educators, and technologists converged in Minneapolis to meet in person for the first time. The 2013 festival supported the first "Code+Ed" summit, which brought together a large group of committed educators. Tega and Golan both participated in this full day of sharing and recording new ideas for a creative coding curriculum, and it was where they began to research and collect the

teaching techniques and strategies of hundreds of educators. This book is the first to collect this community's wisdom in one place, to better share it with new generations of instructors.

Great artworks get remembered, but not the humble methods of artist training. Our collective online courses are fragile, with more and more of that material lost month by month as URLs and servers change. This book is important in the same way that Johannes Itten's *Design and Form* opened a window into Bauhaus pedagogy. It preserves assignments and exercises at this moment of transition in arts education when we're all collectively trying to figure it out.

Like many others then and now, I first learned to code through reading books; yet all books about coding grapple with which language to use. Python, Java, C++, Javascript? Any choice excludes groups of educators and learners and narrows the audience. Tega and Golan have addressed this dilemma by making *Code as Creative Medium* language-agnostic—it smartly doesn't include code within the book. This decision has allowed them to focus on higher-level concepts related to code and the arts, without the requirements of explaining coding fundamentals. Subjects like color, drawing, landscapes, and self-portraits become the primary axes and technical topics like variables, functions, and arrays are secondary. This is an important and exciting reversal. *How refreshing to have a creative coding book that won't quickly become obsolete!*

How can we engage "creative people" with the strange way of writing that is code? How can we engage "code people" with a sophisticated visual arts curriculum? *Code as Creative Medium* tackles these difficult questions by curating over 30 years of exploration in visual arts education. It not only offers guidance on new ways to involve students; instructors will find themselves challenged and inspired as well. I've taught visual arts students for two decades and I learned something new on every page of this book. There's enough material here to build curricula for multiple, diverse courses. In addition, it can be used for teaching a weekend workshop, to build a creative coding module for high school students, or to seed a new certificate program. It is an *essential* resource for a rapidly evolving field.

Thank you, Tega and Golan, for such a thoughtful and generous gift to our expanding community. I'm amazed at how far we've come in the last twenty years. With this book as our guide, we can travel so much further. Onward!

Introduction

Late one summer, we found ourselves discussing the highs and lows of teaching computational art and design as we prepared our syllabi for the fast-approaching term. As we swapped ideas for exercises, we discovered that we had each chosen to assign "the clock," a project that asks students to develop a dynamic representation of time. We had been educated in different countries—Golan in the USA and Tega in Australia—and yet it became clear that we shared an extensive tradition of such assignments: traded, like folk tales, by those teaching code in art and design schools around the world. These pedagogic traditions, however, were mostly absent from the programming primers on our bookshelves, which dealt above all with *how* to write code, rather than *what* to make when learning to code and *why*. This book is our attempt to address this gap and capture an evolving vernacular. It is a book for artists, designers, and poets who are already working with code as a creative medium, or who are curious about doing so. It is for computer scientists, software developers, and engineers who are looking for more open-ended, expressive, or poignant ways to apply their skills. And it is a playbook for educators in all of these fields—a companion to help plan a semester's journey, and a guide to bring students into a creative, thoughtful, and ultimately transformative engagement with computation. Our project draws on research, educational materials, and candid firsthand accounts from a vibrant community of practitioners and educators, all of whom are navigating the challenges of blending engineering and poetry in their courses and creative work.

It's difficult to overstate the importance of computational literacy in 21st-century life. Computer programming, once an esoteric skill in engineering and business, has now acquired broad applicability in fine arts, design, architecture, music, humanities, journalism, activism, poetry, and many other creative fields. But in the classroom, the adaptation of programming education to students with different objectives and learning styles has not kept apace. Instead, for more than half a century, computer science departments have defined the design, delivery, and cultural norms of programming curricula—and the resulting mismatch between traditional computer science education and art and design students has become a persistent challenge. As designer-engineer Leah Buechley has observed, traditional computer science courses often fail to connect with students who learn best from concrete experiences, not abstract principles; who prefer to work improvisationally, instead of following formulas; and who aim to create things that are expressive, rather than utilitarian.[1] We are witnessing the shear between the history of *computer science*

as a *discipline*, concerned with the nature and optimality of algorithms, and the new reality of *computer programming as a skill*, a form of basic literacy with practical utility (and idioms) in every field. There is also a growing understanding that programming education needs to reach more diverse and previously underserved populations, and an appreciation that new and more culturally potent teaching methods are required to achieve this.[2] Fortunately, such alternative pedagogies—in the form of arts-oriented programming toolkits, classroom approaches, assignments, and community support structures—have arisen within the growing set of cultural practices known as "creative coding."

"Creative coders" are artists, designers, architects, musicians, and poets who use computer programming and custom software as their chosen media. These practitioners blur the distinction between art and design and science and engineering, and in their slippery interdisciplinarity, may best be described with the German word *Gestaltern*, or "creators of form." Their tools of choice are programming environments like Processing, p5.js, Tracery, Max/MSP/Jitter, Arduino, Cinder, openFrameworks, and Unity, all of which have been developed to honor the particular needs and working styles of both professionals and students with visual-spatial, musical-rhythmic, verbal-linguistic, and bodily-kinesthetic intelligences.[4] Because many of these creative coding toolkits are free and open-source, they have radically democratized software development, positioning programming as a potent mode of cultural inquiry. The exercises and assignments in this book assume that the learner is using one or another of these creative coding tools, or something like them.

Who Is This Book For?

This book is a manual and sourcebook for teaching and learning the use of code as a creative medium, and for exploring programming in a more vibrant cultural context. It contends with software as an artistic material, offering pathways to learn its grain and texture, strengths and limitations. We hope this book will find use among university educators (in fields like media arts, design, informatics, media studies, and human-computer interaction); those who teach computer programming in high schools, or as a general undergraduate education requirement, such as "CS for non-majors" courses; and workshop leaders (at makerspaces, hackerspaces, code schools, educational retreats, and adult education programs). We also believe this book may be directly useful to artists, designers, and creative autodidacts who seek prompts for self-directed software projects.

Processing seeks to ruin the careers of talented designers by tempting them away from their usual tools and into the world of programming and computation. Similarly, the project is designed to turn engineers and computer scientists to less gainful employment as artists and designers.
—Ben Fry and Casey Reas[3]

To me, the title artist *said nothing about one's medium, message or format. It spoke instead to a certain type of wideness, a flexible approach to considering the world.*
—Mimi Onuoha[5]

Why make a book for *teachers*? There are many books that serve to introduce students to the basics of computational art and design, but few have been written with the educator in mind. This is surprising given that so many of us teach. We teach to nurture and mentor the next generation, we teach to support our art and design practices, and we teach for the love of being in dialogue with those who are different than ourselves. We often do this in an increasingly corporatized university system that relies heavily on income from teaching, but provides almost no training to faculty on how to do it well. With little else to go on, approaching the lectern after the completion of graduate studies often involves reverse engineering the pedagogy of our own favorite teachers: how did they manage class time? How did they structure their assignments? To such a reader, this book offers a collection of helpful patterns. They are taken from our own experiences as educators, collected directly from more than a dozen of our colleagues, and distilled from the online syllabi and other resources posted by hundreds of our peers.

What's Worth Making, and Why?

Creative coding courses are now a standard offering in many art and design programs, reflecting not only the incursion of computing into everyday life, but also the ongoing work of software arts tooling, teaching practices, and community-building. We are indebted to decades of work on toolkits that accommodate diverse learning styles, have clear syntax, and are supported by generous and inclusive documentation. The creative coding community's focus on *how* to code has dramatically expanded to *whom* it has become accessible. But it has also led us to equally important questions about *what* to make and *why* to make it.

In computational art and design, many responses to the questions of *what* and *why* continue historic lines of creative inquiry centered on procedure, connection, abstraction, authorship, the nature of time, and the role of chance. The pursuit of these formal and conceptual concerns in the medium of computation has created new practices and aesthetics, and has also heightened a sensibility to the forces and flows of computation itself. Creators have become attuned to the ways in which working computationally encourages certain perspectives and occludes others. Media artists, computational designers, and other creative coders are the bards of a generative and interactive poetics, and, in the words of Julie Perini, "can provide dis-alienating experiences for a society desperately in need of healing."[7]

The main challenge is trying to create work that touches people at an emotional level, as opposed to them thinking about the technology or wondering about how it was made. Making poems, not demos, is how we refer to it, i.e. making work that is like a poem, short yet dense, re-tellable, rhythmic, meaningful as opposed to a demo that feels like technology for technology's sake.
—Zach Lieberman[6]

Increasingly, computational artists and designers have also developed more overtly political practices that both anticipate and respond to technological transformations in society—allowing for "experimentation with new ways of seeing, being, and relating, as well as opportunities to develop innovative strategies and tools for resistance movements."[10] Such practices adopt and recombine methods from speculative and critical design, relational aesthetics, and critical engineering to provoke reconsideration of the origins and consequences of new technologies and their uneven impact on different individuals and communities. The assignments and exercises in this book are designed to provide entry points into the technical skills, aesthetic issues, and social considerations involved in these and many other modes of practice.

Marshall McLuhan observed that art is a "Distant Early Warning system that can always be relied on to tell the old culture what is beginning to happen to it."[12] Artistic engagements with computation and emerging technologies, perhaps even more so than science fiction, offer a tangible glimpse of what may eventually become the everyday.[13] Whom does this clairvoyance serve? For five decades, the most prominent computer science research centers (including Bell Labs, Xerox Parc, MIT Media Lab, and Google ATAP) have included technologically literate artists in the project of "inventing the future," instrumentalizing artistic inquiry in the service of capital. As Stewart Brand explained, following his residency at MIT: "The deal was very clear. The Lab was not there for the artists. The artists were there for the Lab. Their job was to supplement the scientists and engineers in three important ways: they were to be cognitive pioneers; they were to ensure that all demos were done with art—that is, presentational craft; and they were to keep things culturally innovative."[14]

With the fracturing of civic life after social media, the malignant growth of digital authoritarianism, and the looming threat of environmental catastrophe, the sheen has come off Silicon Valley and the folly of technological solutionism has become clear. To the extent that we continue to prototype new futures within the framework of late capitalism, and echoing McLuhan's notion of the arts as a "warning system," there is a new urgency for artists and designers to have a seat at the tables where technological agendas are set. As Michael Naimark has argued, "Artists bring criticality to environments that are otherwise vulnerable to the Achilles' heel of nerd culture: techno-optimism and technophilic enthusiasm."[16] The technologically literate artist or designer has an

Art is the only ethical use of AI.
—Allison Parrish[8]

My apps are as useful as a song.
—Scott Snibbe[9]

We need a multifaceted and transdisciplinary approach blending art, science, theory, and hands-on experimentation. The media will talk about how it all works, but to fully understand, to appropriately educate others, to devise suitable policies, and to form strategies of resistance, we need to know how it breaks.
—Heather Dewey-Hagborg[11]

Digital art and design rework technology into culture, and reread technology as culture. What's more, they do so in a concrete, applied way, manipulating the technology itself, with a latitude that admits misapplication and adaptation, rewiring and hacking, pseudofunctionality and accident. Creative practice also fractures that technocultural material into millions of heterogeneous interests and agendas, specific investigations, aesthetics, approaches, and projects.
—Mitchell Whitelaw[15]

essential role to play in checking society's worst impulses. Not only can they ring the alarms when freedom and imagination are threatened; they can also use their privilege to create systems that, as Elvia Wilk writes, "champion subjective experience," "expand the range of human expression," and make space in our conversations and institutions for as many perspectives as possible.[17]

This book is an argument for creators with hybrid skills and open hearts. We insist upon the value of arts literacies within engineering spaces, and engineering literacies in the arts—and we believe that doing so is critically important at a time when education systems increasingly prioritize corporate agendas over the cultivation of capacities like critique, imagination, empathy, and justice.[20] An arts literacy provides a vocabulary for recognizing the politics of technologies, and for negotiating and renegotiating the values and priorities they reinforce.[21] The world is not a computer, it is not a system to be optimized, and it will always refuse to be neatly resolved into stable categories or fixed value systems.[22] Education in the arts cultivates capacities for navigating this messiness, as well as celebrating qualitative ways of knowing. As software continues to permeate our lives, we need to foster culturally enmeshed ways to contextualize it, question it, modify it, and develop shared understandings for working with it. Just as "everyone should learn to code," everyone should also be equipped with the intellectual tools of the arts. Education in culturally oriented computational practices, such as those gathered together in this book, offers a rich way to do both.

A Field Guide for Teaching

This playbook presents resources and practices for building what we believe are good assignments, good lectures, and good classrooms in our field. As a distillation of our shared values, it lays out teaching tools for project-based learning, materials for composing lectures that highlight a range of approaches from a diverse group of makers, and strategies for the creation of exciting classrooms.

Project-based learning is a key pedagogical approach in the arts. Unlike most programming textbooks, the assignments shared here are open-ended prompts, encouraging curiosity-driven and improvisational approaches to the use of code. We believe a good assignment should present a set of constraints that are tight enough to learn necessary skills, but at the same time, inspire a wide range of possible responses, allowing

Amidst all the attention given to the sciences as to how they can lead to the cure of all diseases and daily problems of mankind, I believe that the biggest breakthrough will be the realization that the arts, which are conventionally considered "useless," will be recognized as the whole reason why we ever try to live longer or live more prosperously. The arts are the science of enjoying life.
—John Maeda[18]

We can participate in fantasies that see technology bringing the world into predictable control, but I prefer to work through an alternative vision that sees technology embracing the messiness and uncertainty of the world to cultivate experiences of wonder, curiosity, enchantment, and surprise that come from seeing oneself as small part of a great number of wonders that surround us in everyday life.
—Laura Devendorf[19]

Humanists must be educated with a deep appreciation of modern science. Scientists and engineers must be steeped in humanistic learning. And all learning must be linked with a broad concern for the complex effects of technology on our evolving culture.
—Jerome B. Wiesner[23]

for productive comparisons in critique. A good assignment should also offer a way to examine a timely social question—as Paolo Pedercini writes, it should constitute "an entry point to a critical issue."[25] And for the computational artist or designer in particular, it should preserve room for the critical, imaginative, or expressive reconsideration of technology and its possibilities. We believe a good creative coding assignment should be an invitation to look at technology with fresh eyes: defamiliarized, recontextualized, and reinterpreted. We are hardly the first educators to advocate for this sort of "socially situated learning-by-making"; rather, we continue the work of pioneers like Idit Harel and Seymour Papert, and others like Sherry Turkle and Mitchel Resnick, whose visions for "situated constructionism" in technology education, though decades old, have yet to be fully realized.[26]

The assignments in this book have been chosen with these criteria in mind, offering opportunities for personalizing, weirding, debating, and queering computation. Each is elaborated in a syllabus module that includes variations for differing skill levels or learning objectives. Each places equal importance on the cultural valence of computer technologies, codecraft, the subjectivity of the practitioner, and awareness of historic lines of inquiry. These prompts make space for diverse and personalized work, and aim to preserve the student's dignity, curiosity, whimsy, and criticality in an educational landscape where students are all too often asked to create (or worse, re-create) bank software. Importantly, the assignments in this book are also language-agnostic, allowing students to develop responses using whichever programming toolkit is preferred.

To demonstrate some of the ways in which these assignments can be approached, we have illustrated these modules with art and design projects selected on the basis of their *pedagogic value*: that is, not only for their excellence as projects, but also for how easily they can be explained in a classroom setting. The exemplars in our illustrations are thus not intended to articulate a canon of computational artworks and design projects, but rather to support a canon of assignments. Where we have omitted classic and influential works of media art or design—and there are so many—it is for this reason. Likewise, the high value we place on explicability also underpins our occasional inclusion of little-known projects by students.

Why focus on projects? We take seriously the analogy between coding and writing. When you learn to write, it's not enough to learn spelling, grammar, and punctuation. It's important to learn to tell stories and communicate your ideas. The same is true for coding.
—Mitchel Resnick[24]

To me an assignment is useful if it does any of the following: (1) constitutes an entry point to a critical issue; (2) builds transferable skills (blinking an LED on an Arduino is dull but introduces some important concepts); (3) allows students to make something personally relevant: a chance to develop their own creative practice, or make a portfolio piece, regardless of their elected sub-discipline.
—Paolo Pedercini[27]

The task, then, is to challenge not only forms of discriminatory design in our inner and outer lives, but to work with others to imagine and create alternatives to the techno quo—business as usual when it comes to technoscience—as part of a larger struggle to materialize collective freedoms and flourishing.
—Ruha Benjamin[28]

We acknowledge that the landscape of software-based creative practices is vastly greater than the scope of this book. So too are the ways in which these themes can be approached. In selecting examples to illustrate each assignment, we have attempted to represent a diverse range of practitioners. But there is much more work to be done. As Heather Dewey-Hagborg has noted, "The intersection of arts and technology brings the worst of both worlds together. The tech industry is so white male, and the art world also prioritizes white men. But then, when you put those two together, it's like it just explodes."[29] This has significant implications for who identifies as being able to work creatively with software, and we emphatically affirm the ongoing need to diversify who is represented in lectures and syllabi as an essential part of dismantling the systemic racism and sexism in our institutions and cultures.[30]

Giving space to a multitude of voices and perspectives is not only critical for counteracting the obliviousness of those in positions of power to understanding the potential risks or harms of what they design,[31] but also for what Kamal Sinclair calls "democratizing the imagination for the future."[32] Both are urgent challenges in hybrid fields where computation and the imagination come together. However, attempts to address these biases in isolation still leave other shortcomings in place. We acknowledge, for example—as we write within elite universities on the East Coast of North America—that this book emerges from our particular context, and that it reifies the myopia of the communities in which we participate. We also recognize, with humility, that vocabularies and values inherited from the arts can guide the way: art gives us tools to reveal partial perspectives, acknowledge subjectivity, transform how we see, and address unjust power relations. Taking inclusion as a starting point, creative coding pedagogies can offer a powerful way to address these histories and futures, broadening how programming skills are taught, why they matter, who is positioned to use them, and how.

In addition to providing resources for assignments and lectures, this book also provides strategies for sustaining classrooms that minimize frustration and maximize the freedom to make mistakes. We recognize that developing fluency in a new medium can demand silencing one's inner critic, at least for a while. Computing technologies, in particular, are often discouragingly brittle and impersonal, making the hurdles of creative work even steeper. In an educational environment, methodologies from traditional computer science classrooms (such as emphasizing solitary

Every single student comes with something. [People] are not empty vessels. They come to the table with something valuable from a community and a culture. The more you can help them make that bridge between what they have and what they want to do, the more engaged they will be, and the longer they can stick with it. We have to make that connection.
—Nettrice Gaskins[33]

work policed by plagiarism detectors) can exacerbate individual frustration and erode group morale.[34] The creative coding educator, in addition to explaining interdisciplinary techniques and showing inspiring projects, must also be sensitive to the mood of their classroom and students. As author and educator bell hooks observes, the necessity of actively orchestrating the emotional dimensions of a classroom is often overlooked. For hooks, *excitement*, "generated by collective effort," reinforces a group's mutual investment in each other's work and is a key ingredient in establishing an environment that is conducive to learning, empowerment, and transformation.[35] The Classroom Techniques and the Interviews sections of this book compile the wisdom of numerous educators regarding how they build classroom communities and help individuals cope with frustration. These sections share techniques for guiding arts practitioners who do not necessarily identify as programmers through their initial fear and inevitable frustrations.

How This Book Is Organized
This book contains three primary sections: Assignments, Exercises, and Interviews.

Part One, Assignments, is a collection of syllabus modules. Each module is built around an open-ended assignment or project prompt. These are recurring and even "classic" project briefs, collected from dozens of our peers and mentors, that we have received, tested, adapted, or observed over the course of more than two decades in higher education. Although loosely ordered by difficulty, the modules may also be grouped by their emphasis on key concerns in computational arts and design, including:

generativity
Iterative Pattern, Face Generator, Generative Landscape, Parametric Alphabet, Parametric Object

interactivity
Virtual Creature, Drawing Machine, One-Button Game, Conversation Machine

transcoding and transmediality
Clock, Custom Pixel, Data Self-Portrait, Measuring Device, Synesthetic Instrument

connectivity
Bot, Collective Memory, Experimental Chat, Browser Extension, Creative Cryptography

corporeality and virtuality
Augmented Projection, Personal Prosthetic, Virtual Public Sculpture, Extrapolated Body

Each module includes a *Brief* that summarizes the artistic prompt; *Learning Objectives*, which define the goals of the module in terms of demonstrable skills or knowledge acquisition; *Variations*, a set of easements and further opportunities for experimentation; and a short essay, *Making it Meaningful*, that serves as a guide to understanding the assignment's significance, challenges, and potential avenues of approach. An illustrated collection of annotated examples of historic and contemporary projects—our touchstones—demonstrate how different artists and students have previously approached the assignment's premise. An appendix on the provenance of these assignments provides more information about their history and (where possible) their original authors.

Part Two, Exercises, consists of short programming prompts that hone the mastery of specific technical skills, while remaining idiomatically relevant to artists and designers. These exercises develop the student's skills in the use of computational techniques to control elementary visual (or in some cases, auditory or textual) patterns and forms, and may be assigned as homework or as in-class activities. Although the exercises grant some latitude as to the specific details of their implementation—they have no single correct solution—they are nevertheless written to make both perceptual and technical evaluations possible. One exercise on the theme of iteration, for example, requires the student to write code that generates the alternating squares of a checkerboard. The exercises are organized into topical sections, including conditional testing, iteration, typography, and visualization, and they range in level of difficulty.

In creating a compendium of assignments and exercises, we have taken inspiration in and comfort from several key precursors: *Draw It with Your Eyes Closed: The Art of the Art Assignment*, by Dushko Petrovich and Roger White (2012); *Taking a Line for a Walk: Assignments in Design*

Education, by Nina Paim, Emilia Bergmark, and Corinne Gisel (2016); *The Photographer's Playbook: 307 Assignments and Ideas*, by Jason Fulford and Gregory Halpern (2014), and *Wicked Arts Assignments: Practising Creativity in Contemporary Arts Education*, by Emiel Heijnen and Melissa Bremmer (2020). Each is a kind of pedagogic potluck for their respective creative spheres and showed us how a book could bring together projects, exercises, and approaches from a field of practice. These books also demonstrate that there is no one-size-fits-all way of designing a curriculum or running a classroom—as confirmed by the educators whose varied and even contradictory advice is shared in our next section.

Part Three, Interviews, presents thematically organized conversations with thirteen diverse and renowned educators. In this section, instructors like Dan Shiffman, Lauren McCarthy, and Taeyoon Choi speak to the practical, philosophical, and spiritual challenges of teaching expressive and critical studio arts through the often unwelcoming toolsets of software development. Underpinning many of our questions is a concern for how education might repair the persistent split between the sciences and humanities:[36] How can we encourage "heart" in the midst of technical education? What pedagogic strategies are necessary to teach technical material to artists? How do you corral students with diverse skillsets? These questions are unique to the hybrid nature of computational art and design, and they reveal themselves in a particularly stark way when the educator must rapidly oscillate between teaching art and math. In their responses, our interview subjects offer nuts-and-bolts advice for software arts instruction, as well as broader strategies for interdisciplinary education.

Take This Book and Run with It

At first glance, it may seem curious that in a book about coding pedagogy, there is no code to be found. For those interested, we have provided an open code repository online that contains solutions to our exercises in several popular programming languages, as well as helpful "starter" code, where possible, for the larger, open-ended assignments. There are two reasons why we have not provided code in the pages of this book itself. The first speaks to the trade-off that occurs when students are provided with starter code: on one hand, it gives them a head start, but in our experience, it also dramatically narrows the students' imaginations and the scope of the resulting projects. The second reason, more importantly to us, concerns the longevity of this

book. In not tying the assignments to specific programming languages and development environments, we hope to preserve their relevance as generations of platforms inevitably come and go. We will be updating our online code repository as technologies change, and we warmly invite contributions from those who wish to port or extend our examples to topics and toolkits outside our own expertise.

Whether you are teaching or learning creative coding in your kitchen, in a school or at a university, in an arts program or in a STEM field, with others or by yourself—we believe there will be something here to enrich your experience. We can't wait to see what you or your students make.

Notes

1. Leah Buechley, "Expressive Electronics: Sketching, Sewing, and Sharing" (lecture, wats:ON? Festival, Carnegie Mellon University, Pittsburgh, PA, April 2012), https://vimeo.com/62890915.

2. See, for example, Mark Guzdial, "Computing Education Lessons Learned from the 2010s: What I Got Wrong," *Computing Education Research Blog*, January 13, 2020, https://computinged.wordpress.com/2020/01/13/computing-education-lessons-learned-from-the-2010s-what-i-got-wrong/.

3. Ben Fry and Casey Reas, "Processing 2.0 (or: The Modern Prometheus)" (lecture, Eyeo Festival, Minneapolis, MN, June 2011), 0:45, https://vimeo.com/28117873.

4. Howard Gardner, *Frames of Mind: The Theory of Multiple Intelligences* (New York: Basic Books, 2011).

5. Mimi Onuoha, "On Art and Technology: The Power of Creating Our Own Worlds," Knight Foundation, last modified March 2, 2018, https://knightfoundation.org/articles/authors/mimi-onuoha/.

6. "YesYesNo," *IdN Magazine* 19, no. 5 October 2012): 30–31.

7. Julie Perini, "Art as Intervention: A Guide to Today's Radical Art Practices," in *Uses of a Whirlwind: Movement, Movements, and Contemporary Radical Currents in the United States*, ed. Team Colors Collective (Chico, CA: AK Press, 2010), 183, http://sites.psu.edu/comm292/wp-content/uploads/sites/5180/2014/10/Perini-Art_as_Intervention.pdf.

8. Claire Evans (@YACHT), "Thanks so much for having us! Full credit due to the brilliant @aparrish for saying 'art is the only ethical use of AI' during a panel we hosted in NYC a few months back. It's become our mantra <3," Twitter, December 2, 2019, 5:01 PM.

9. Scott Snibbe, personal communication to Golan Levin. See Golan Levin (@golan), " @snibbe used to say, it's "as useful as a song". Case closed." Twitter, September 4, 2018, 9:11 PM.

10. Perini, 183.

11. Heather Dewey-Hagborg, "Sci-Fi Crime Drama with a Strong Black Lead," *The New Inquiry*, July 6, 2015, https://thenewinquiry.com/sci-fi-crime-drama-with-a-strong-black-lead/.

12. Marshall McLuhan, *Understanding Media: The Extensions of Man* (New York: McGraw Hill, 1964), 22.

13. Golan Levin, "New Media Artworks: Prequels to Everyday Life," *Flong* (blog), July 19, 2009, http://www.flong.com/blog/2009/new-media-artworks-prequels-to-everyday-life/.

14. Stewart Brand, "Creating Creating," *WIRED*, January 1, 1993, https://www.wired.com/1993/01/creating/.

15. Adapted (with permission) from Mitchell Whitelaw, *Metacreation: Art and Artificial Life* (Cambridge, MA: The MIT Press, 2004), 5. See Mitchell Whitelaw (@mtchl), "Written by my younger and more idealistic self - if I could revise it now I'd expand / disperse 'art' to encompass a wider range of practices (including design). But thanks Sara [Hendren]!," Twitter, April 29, 2020, 11:48 PM.

16. Michael Naimark, personal communication to Golan Levin, 2014.

17. Elvia Wilk, "What Can WE Do? The International Artist in the Age of Resurgent Nationalism," *The Towner*, September 11, 2016, http://www.thetowner.com/international-artists-nationalism/.

18. John Maeda, in "VOICES; John Maeda," *The New York Times*, November 11, 2003, https://www.nytimes.com/2003/11/11/science/voices-john-maeda.html.

19. Laura Kay Devendorf, "Strange and Unstable Fabrication" (PhD diss., University of California, Berkeley, 2016), 81, https://digitalassets.lib.berkeley.edu/etd/ucb/text/Devendorf_berkeley_0028E_16717.pdf.

20. Orit Halpern, "A History of the MIT Media Lab Shows Why the Recent Epstein Scandal Is No Surprise," *Art and America*, November 21, 2019, https://www.artnews.com/art-in-america/features/mit-media-lab-jeffrey-epstein-joi-ito-nicholas-negroponte-1202668520/.

21. Danielle Allen, "The Future of Democracy," *HUMANITIES* 37, no. 2 (Spring 2016), https://www.neh.gov/humanities/2016/spring/feature/the-future-the-humanities-democracy.

22. Tega Brain, "The Environment Is Not a System," *A Peer-Reviewed Journal About* 7, no. 1 (2018): 152–165.

23. In *Momentum*, MIT Media Laboratory, 2003, http://momentum.media.mit.edu/dedication.html.

24. From Mitchel Resnick, "Computational Fluency," Medium, September 16, 2018, https://medium.com/@mres/computational-fluency-776143c8d725. (Adapted from his book *Lifelong Kindergarten*.) See also Yasmin Kafai and Mitchel Resnick, *Constructionism in Practice: Designing, Thinking, and Learning in A Digital World* (New York: Routledge, 1996).

25. Paolo Pedercini, personal communication to Golan Levin, June 16, 2020.

26. Idit Harel and Seymour Papert, "Situating Constructionism," in *Constructionism* (Norwood, NJ: Ablex Publishing, 1991), http://web.media.mit.edu/~calla/web_comunidad/Reading-En/situating_constructionism.pdf.

27. Pedercini, June 16, 2020.

28. Ruha Benjamin, ed., *Captivating Technology: Race, Carceral Technoscience, and Liberatory Imagination in Everyday Life* (Durham, NC: Duke University Press, 2019), 12.

29. Heather Dewey-Hagborg, "Hacking Biopolitics" (lecture, The Influencers 2016: Unconventional Art, Guerrilla Communication, Radical Entertainment, CCCB, Barcelona, October 2016), 48:20, https://vimeo.com/192627655.

30. See the Refresh campaign and project that has addressed gender bias in the Prix Ars Electronica awards: https://refreshart.tech/.

31. Catherine D'Ignazio and Lauren F. Klein call this the "privilege hazard" in their book *Data Feminism* (Cambridge, MA: MIT Press, 2020), 57.

32. Kamal Sinclair, "Democratize Design," Making a New Reality, May 18, 2018, https://makinganewreality.org/democratize-design-86d2385865bd.

33. "The Technologists in the Studio: Nettrice Gaskins Highlights the Connections between Communities, Cultures, Arts, and STEM," Wogrammer, April 24, 2019, https://wogrammer.org/stories/nettrice.

34. James W. Malazita and Korryn Resetar, "Infrastructures of Abstraction: How Computer Science Education Produces Anti-Political Subjects," *Digital Creativity* 30, no. 4 (December 2019): 300–312, https://doi.org/10.1080/14626268.2019.1682616. Malazita and Resetar discuss how the ubiquitous use of plagiarism tools in computer science infrastructurally discourages collaboration, discussion, and knowledge sharing. This can be observed firsthand in David Kosbie's Automated Plagiarism Detection Tool tutorial, developed for CMU introductory programming course 15-110, https://www.youtube.com/watch?v=LdU0dTPaueU.

35. bell hooks, *Teaching to Transgress* (New York: Routledge, 2014), 7–8.

36. As identified by C. P. Snow in *The Two Cultures* (Rede Lecture, University of Cambridge, 1959).

Part One: Assignments

Iterative Pattern
Generating a texture or textile design

Brief

Write code to generate a tiling pattern or textural composition, as for wallpaper or fabric. Give consideration to aesthetic issues like symmetry, rhythm, color; detail at multiple scales; precise control of shape; and the balance between organic and geometric forms.

Your pattern should be designed so that it could be infinitely tiled or extended. Design something you would like to put on the walls or floor of your home, or that you could imagine yourself wearing. Export your pattern in a high-resolution format, and print it as large as possible for your peers' review. Remember to sketch first.

Learning Objectives
- Create visual designs using the Cartesian coordinate system and combining drawing functions
- Use functional abstraction to encapsulate the code for modular design elements
- Generate and critique designs with symmetries and/or seamless repetition

Variations
- Experiment with 2D graphics transformations, such as rotation, scaling, and mirror reflections.
- Use nested iteration to develop 2D rhythms or other gridlike visual structures.
- Create a helper function to abstract the way in which a complex visual element (such as a flower, animal, fruit, or fleur-de-lis) is rendered throughout your design.

- Reproduce a preexisting textile or wallpaper design using code only.
- Make a kaleidoscope by incorporating a photographic image or video feed into a pattern with symmetric reflections.
- Have your pattern printed on real fabric or wrapping paper. Consider other output devices or on-demand services for realizing your pattern, such as computer-controlled laser cutters, knitting machines, or lace-making machines.
- Make an animated "dynamic wallpaper" loop to use in the background of your videoconferences. Your design should scale gracefully by rendering correctly at different canvas resolutions.[i]

Making It Meaningful

Pattern is the starting point from which we perceive and impose order in the world. Examples of functional, decorative, and expressive pattern-making date from ancient times and take the form of mosaics, calendars, tapestry, quilting, jewelry, calligraphy, furniture, and architecture. There is an intimate connection between pattern design, visual rhythm, geometry, mathematics, and iterative algorithms. This prompt invites the creator to hone their understanding of these relationships in formal terms. An important variation of this prompt is to realize designs physically, through either digital printing, fabrication in an unusual material, or at an unexpected scale. This can be a watershed moment of synthesis for software artists who crave making something physical.

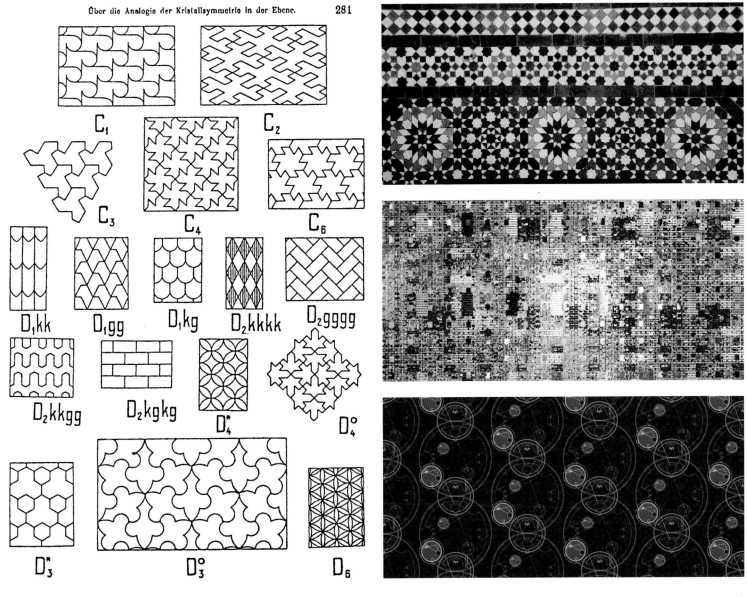

C_1

C_2

C_3

C_4

C_6

$D_1 kk$

$D_1 gg$

$D_1 kg$

$D_2 kkkk$

$D_2 gggg$

$D_2 kkgg$

$D_2 kgkg$

D_4^*

D_4°

D_3^*

D_3°

D_6

Captions

1. In *Spamgetto* (2009), the Italian design agency Todo presents computationally generated wallpaper whose elements include text from thousands of spam emails.

2. Georg Pólya's illustrations (1924) of the seventeen periodic plane symmetry groups had a profound influence on the algorithmic patternmaking of M. C. Escher.

3. Zellige terracotta tiles in Marrakech (17th century) form edge-to-edge, regular, and other tessellations.

4. Casey Reas's *One Non-Narcotic Pill A Day* (2013) presents a dynamic collage pattern generated from a video recording.

5. Alison Gondek, a scenic design student at Carnegie Mellon studying introductory programming, used p5.js to create this pattern inspired by the "Circular Gallifreyan" language from *Doctor Who*.

6. Vera Molnár was among the first artists to use a computer. Her 1974 untitled plotter drawing demonstrates patterns arising from the interaction between procedural iteration and randomized omission.

7. Leah Buechley explores the intersection of computation and craft. The design of her lasercut curtain (2017), generated in Processing, features multiple forms of iteration and controlled randomness.

Additional Projects

Dave Bollinger, *Density Series*, 2007, generative image series.

Liu Chang, *Nature and Algorithm*, 2016, algorithmic images, satellite imagery, ink on paper.

Joshua Davis, *Chocolate, Honey and Mint*, 2013, generative image series.

Saskia Freeke, *Daily Art*, 2010–2020, generative image series.

Manolo Gamboa Naon, *Mantel Blue*, 2018, ink on paper.

Tyler Hobbs, *Isohedral III*, 2017, inkjet print on paper, 19 x 31".

Lia, *4jonathan*, 2001, generative image series.

Holger Lippmann, *The Abracadabra Series*, 2018, generative image series.

Jonathan McCabe, *Multi-Scale Belousov-Zhabotinsky Reaction Number Seven*, 2018, generative image series.

Vera Molnár, *Structure de Quadrilateres (Square Structures)*, 1987, ink on paper.

Nontsikelelo Mutiti, *Thread*, 2012–2014, screen print on linoleum tiles.

Nervous System, *Patchwork Amoeba Puzzle*, 2012, lasercut plywood.

Helena Sarin, *GANcommedia Erudita*, 2020, inkjet printed book.

Mary Ellen Solt, *Lilac*, 1963, concrete poetry.

Jennifer Steinkamp, *Daisy Bell*, 2008, video projection.

Victor Vasarely, *Alom (Rêve)*, 1966, collage on plywood, 99 1/5 x 99 1/5".

Marius Watz, *Wall Exploder B*, 2011, wall drawing, 9 x 3.6 m.

Readings

David Bailey, *David Bailey's World of Escher-Like Tessellations*, 2009, tess-elation.co.uk.

P. R. Cromwell, "The Search for Quasi-Periodicity in Islamic 5-fold Ornament," *The Mathematical Intelligencer* 31 (2009): 36–56.

Anne Dixon, *The Handweaver's Pattern Directory: Over 600 Weaves for 4-shaft Looms* (Loveland, CO: Interweave Press, 2007).

Ron Eglash, *African Fractals: Modern Computing and Indigenous Design* (New Brunswick, NJ: Rutgers University Press, 1999).

Samuel Goff, "Fabric Cybernetics," *Tribune* (blog), August 23, 2020.

Branko Grünbaum and G. C. Shephard, *Tilings and Patterns* (New York: W. H. Freeman & Company, 1987).

"Wallpaper Collection," Collections, Historic New England, historicnewengland.org.

Owen Jones, *The Grammar of Ornament* (London: Bernard Quaritch Ltd., 1868).

Albert-Charles-Auguste Racinet, *L'Ornement Polychrome* (Paris: Firmin Didot et Cie, 1873).

Casey Reas et al., *{Software} Structures*, 2004–2016, artport.whitney.org.

Petra Schmidt, *Patterns in Design, Art and Architecture* (Vienna: Birkhäuser, 2006).

Notes
i. This variation was contributed by Tom White (@dribnet).

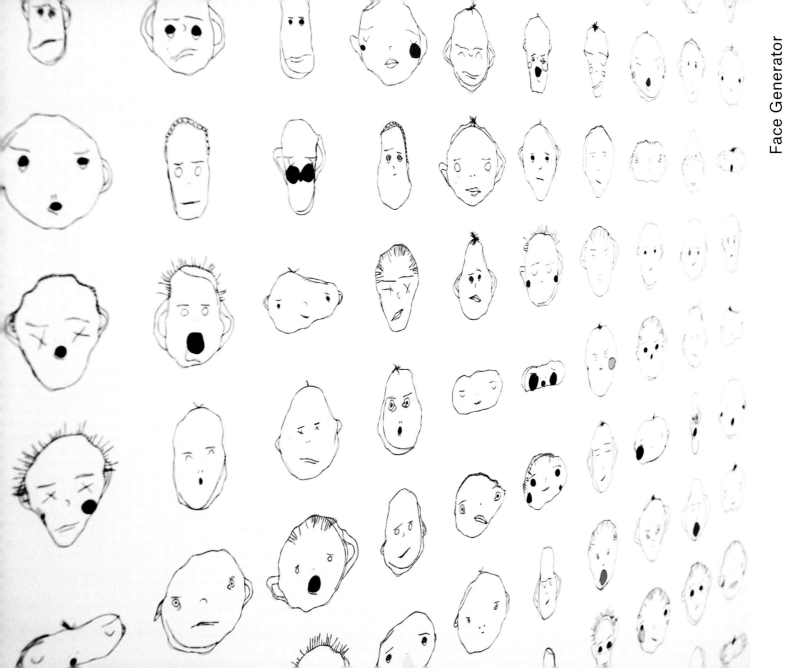

Face Generator
Drawing parametric faces

Brief

Write code to design an image of a face that is parameterized by at least three dimensions of variability, but preferably more. For example, you might have variables that specify the size, position, color, or other visual characteristics of the eyes, nose, and mouth. The variations in these features may be used to alter the face's expression (happy, sad, angry); the face's identity (John, Maria); and/or the face's species (cat, monkey, zombie, alien). Give special consideration to controlling the precise shape of face parts, such as the curves of the nose, chin, ears, and jowls, as well as characteristics like skin color, stubble, hairstyle, blemishes, interpupillary distance, facial asymmetry, cephalic index, and prognathism. Differentiate continuous parameters (such as size and position of features) and discrete parameters (such as the presence of piercings, or the number of eyeballs). Will your faces be 2D or 3D? Will they be shown in a frontal, profile, or three-quarters view? Your system should generate a new face whenever the user presses a button.

Learning Objectives

- Design parametric forms using drawing functions and the Cartesian coordinate system
- Apply generative design principles to expressive character design
- Conduct meta-design (design a system to design things)

Variations

- Use your software to generate a deck of collectible trading cards (like Pokémon or baseball cards) featuring a group of imaginary heroes or monsters. Print out the cards.
- Try using real-world multivariate data as the basis for generating new faces, instead of randomness.
- Create an interactive tool that allows people to make self-portraits in a cartoon style. Document your software with an example.
- Consider the comparative merits of a design in which faces are assembled from a diverse collection of ready-made assets (mustaches, noses, etc.), versus a design in which faces are generated from continuously variable curves and shapes.
- Add functionality to your face so that it responds to audio, microphone, or speech input.

Making It Meaningful

Humans are equipped with an exquisite sensitivity to faces. From infancy, we easily recognize faces and can detect very subtle shifts in expressions, often being able to discern the slightest change in mood and sincerity in ways that remain impossible for computers. Faces also allow us to readily identify family resemblances or recognize friends in crowds. Faces are so central to visual perception that "the impairment of our face-processing ability is seen as a disorder, called *prosopagnosia*, while unconsciously seeing faces where there are none is an almost universal kind of *pareidolia*."[i]

This assignment draws inspiration from the "Chernoff face" data visualization technique, which leverages this sensitivity by using facial features to represent multivariate data. In Chernoff faces, features such as the eyes, ears, mouth, and nose represent data according to their shape, size, placement, and orientation. Whereas Herman Chernoff used 18 variables to synthesize a face, Paul Ekman and Wallace Friesen's *Facial Action Coding System* analyzes faces with 46, each variable corresponding to the action of a different facial muscle.

Works that generate faces present the conceptual opportunity to devise a possibility space or an imaginative context for portraits—like a family album, high school yearbook, or tradeable card deck.

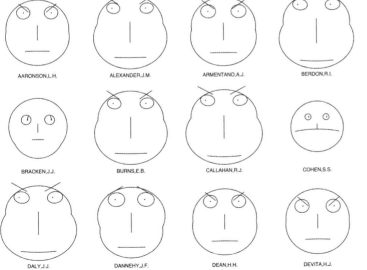

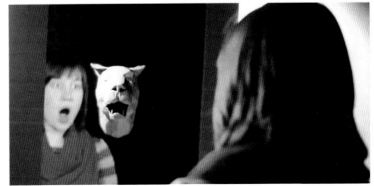

A B C D

E F G H

AARONSON,L.H. ALEXANDER,J.M. ARMENTANO,A.J. BERDON,R.I.

BRACKEN,J.J. BURNS,E.B. CALLAHAN,R.J. COHEN,S.S.

DALY,J.J. DANNEHY,J.F. DEAN,H.H. DEVITA,H.J.

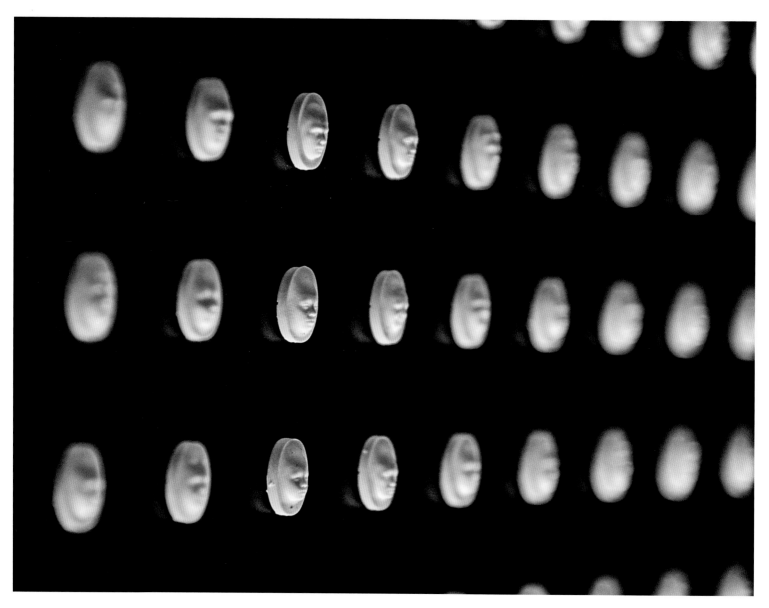

Code as Creative Medium

The layout diagram at top shows numbered boxes: 8, 9, 10, 11, 12, 13, 14.

Captions

8. Although Matthias Dörfelt's *Weird Faces* (2012) look hand-drawn, they are entirely generated by custom software.

9. In Heather Dewey-Hagborg's astounding *Stranger Visions* (2012), forensic 3D portraits are computed from found DNA fragments.

10. "Chernoff faces" (1973) represent multivariate data by parameterizing the shape, size, position, and orientation of the parts of the face.

11. In Kate Compton's software *Evolving Faces with User Input* (2009), a genetic algorithm governs a population of faces, each described with an array of floating point numbers. By selecting a favorite face, the user can interactively guide the evolution of the population.

12. In Mike Pelletier's *Parametric Expression* (2013), values that govern the articulation of facial models are pushed beyond their normal limits.

13. In Karolina Sobecka's *All the Universe Is Full of the Lives of Perfect Creatures* (2012), the visitor puppeteers an avatar according to the movements of their own face.

14. *Prescribed to Death* is a wall memorial comprised of 22,000 pills carved with human faces, representing Americans who died from opioid addiction in 2017. Every 24 minutes—the frequency of U.S. opioid deaths—a Rhino Grasshopper script directs an onsite CNC machine to carve a new face into an additional pill. The project was developed for the National Safety Council's "Stop Everyday Killers" campaign by artist collective Hyphen-Labs, Energy BBDO, MssngPeces, and Tucker Walsh.

Additional Projects

Zach Blas, *Facial Weaponization Suite*, 2011–2014, masks computationally modeled from aggregate face data.

Lorenzo Bravi, *Bla Bla Bla*, 2010, sound-reactive phone application.

Joy Buolamwini, *Aspire Mirror*, 2015, mirror and generative face system.

Heather Dewey-Hagborg, *How Do You See Me*, 2019, self portraits generated via adversarial processes.

Adam Harvey and Jules LaPlace, *Megapixels*, 2017, art and research project.

Hyphen-Labs and Adam Harvey, *HyperFace*, 2017, computer vision camouflage textile.

Mario Klingemann, *Memories of Passersby I*, 2018, system for synthesizing portraits using neural nets.

Golan Levin and Zachary Lieberman, *Reface [Portrait Sequencer]*, 2007, system for generating face composites.

Jillian Mayer, *IMPRESSIONS*, 2017, facial analysis and billboard campaign.

Macawnivore, *Nose Chart*, 2014, digital drawing.

Kyle McDonald and Arturo Castro, *Face Substitution*, 2012, face-swapping application and installation.

Orlan, *The Reincarnation of Saint ORLAN*, 1990–1993, facial surgery as performance.

Ken Perlin, *FaceDemo*, 1997, interactive face simulation.

Readings

Greg Borenstein, "Machine Pareidolia: Hello Little Fella Meets Facetracker, *Idea for Dozens* (blog), UrbanHonking.com, January 14, 2012.

Charles Darwin, *The Expression of Emotions in Man and Animals* (London: John Murray, 1872).

Heather Dewey-Hagborg, "Sci-Fi Crime Drama with a Strong Black Lead," *The New Inquiry*, July 16, 2015.

Paul Ekman and Wallace Friesen, *Facial Action Coding System (FACS)*, 1976.

Zachary Lieberman, "Más Que la Cara Overview," Medium.com, April 3, 2017.

Bruno Munari, *Design as Art* (London: Penguin Books Ltd., 1971).

Jean Robert and Francois Robert, *Face to Face* (Zurich: Lars Muller Publishers, 1996).

George Tscherny, *Changing Faces* (New York: Princeton Architectural Press, 2004).

Notes

i. Kyle McDonald, "Face as Interface," GitHub repository for Appropriating New Technologies (NYU ITP), last modified May 11, 2017.

Clock
Representing time

Brief

Design a "visual clock" that displays a novel or unconventional representation of the time. Your clock should appear different at all times of the day, and it should repeat its appearance every 24 hours (or other relevant cycle, if desired). Challenge yourself to convey the time without numerals.

You are encouraged to question basic assumptions about how time is mediated and represented. Ponder concepts like biological time (chronobiology), ultradian and infradian rhythms, solar and lunar cycles, celestial time and sidereal time, decimal time, metric time, geological time, historical time, psychological time, and subjective time. Inform your design by reading about the history of timekeeping systems and devices and their transformative effects on society.

Learning Objectives
- Review and research historical methods, devices, and systems for timekeeping
- Devise graphic concepts and technologies for representing time that go beyond conventional methods of visualization and mediation
- Use programming to design, through the control of shape, color, form, and motion
- Apply motion graphics techniques to the representation of temporal information

Variations
- Feel free to experiment with any of the tools at your disposal, including transparency, color, sound, dynamism, and physical actuation. Reactivity to the cursor is optional.
- Avoid using Roman, Arabic, or Chinese numerals, but make the time readable through other means, such as by visualizing numeric bit patterns or using iteration to present countable graphic elements.
- Make a clock that operates at a much slower time scale, changing over months, seasons, or human lifespans.
- Develop your clock for a portable or wearable device, such as a mobile phone, smart watch, fitness tracker, or other standalone computer with a miniature display. Consider incorporating data from your device's other sensors into your design, such as the user's image, movements, body temperature, or heartbeat.
- Free yourself from the desktop or laptop screen, and design your clock for a context of your own choosing. If you could place your clock anywhere, where would it be? On the side of a building? In a piece of furniture? In a pocket? On someone's skin, as a digital tattoo? Include a drawing, rendering, or other mockup showing your clock as you imagine it in situ.

Making It Meaningful
Attempts to mark time stretch back many thousands of years, with some of the earliest timekeeping technologies being gnomons, sundials, water clocks, and lunar calendars.

Even today's standard representation of time, with hours and minutes divided into 60 parts, is a legacy inherited from the ancient Sumerians, who used a sexagesimal counting system.

The history of timekeeping is a history driven by economic and militaristic desires for greater precision, accuracy, and synchronization. Every increase in our ability to precisely measure time has had a profound impact on science, agriculture, navigation, communications, and, as always, warcraft.

Despite the widespread adoption of machinic standards, there are many other ways to understand time. Psychological time contracts and expands with attention; biological cycles affect our moods and behavior; ecological time is observed in species and resource dynamics; geological or planetary rhythms can span millennia. In the twentieth century, Einstein's theory of relativity further upended our understanding of time, showing that it does not flow in a constant way, but rather in relation to the position from which it is measured—a possibly surprising return to the significance of the observer.

Captions

15. Lee Byron's *Center Clock* (2007) displays the time as countable, bouncy circles. After each minute passes, 60 white "second" circles coalesce to form a new violet "minute" circle, and so on.

16. Using a slit-scan technique, Jussi Ängeslevä and Ross Cooper's *Last Clock* (2002) presents activity traces from a live video feed at three different time scales: one minute, one hour, and one day.

17. In Golan Levin's *Banded Clock* (1999), the seconds, minutes, and hours of the current time are represented as a series of countable stripes.

18. Drawing from a gargantuan database of tweets, *All the Minutes* by Jonathan Puckey and Studio Moniker (2014) is a Twitter bot that reposts mentions of the current time.

19. Mark Formanek's *Standard Time* (2003) is a 24-hour performance in which 70 workers constantly construct and deconstruct a large wooden "digital" display of the current time.

20. *Ink Calendar* by Oscar Diaz (2009) uses the capillary action of ink spreading across paper to display the date.

Additional Projects

Maarten Baas, *Real Time: Schiphol Clock*, 2016, performance and video, Amsterdam Airport Schiphol.

Maarten Baas, *Sweeper's Clock*, 2009, performance and video, Museum of Modern Art, New York.

Marco Biegert and Andreas Funk, *Qlocktwo Matrix Clock*, US Patent D744,862 S, filed May 8, 2009, and issued December 8, 2015.

Jim Campbell, *Untitled (For The Sun)*, 1999, light sensor, software and LED number display, White Light Inc., San Francisco.

Bruce Cannon, *Ten Things I Can Count On*, 1997–1999, counting machines with digital displays.

Mitchell N. Charity, *Dot Clock*, 2001, online application.

Taeyoon Choi and E Roon Kang, *Personal Timekeeper*, 2015, interactive hardware and software system, Los Angeles Museum of Art, Los Angeles.

Revital Cohen and Tuur Van Balen, *Artificial Biological Clock*, 2008, data-driven mechanical sculpture.

Skot Croshere, *Four Letter Clock*, 2011, modified electronic alarm clock.

Daniel Duarte, *Time Machine*, 2013, custom analog electronics.

Ruth Ewan, *Back to the Fields*, 2016, botanic installation.

Daniel Craig Giffen, *Human Clock*, 2001–2014, website.

Danny Hillis et al., *The Clock of the Long Now*, 1986, mechanical system, Texas.

Masaaki Hiromura, *Book Clock*, 2013, video, MUJI SHIBUYA, Tokyo.

Tehching Hsieh, *One Year Performance (Time Clock Piece)*, 1980–1981, performance.

Humans since 1982, *The Clock Clock*, 2010, aluminum and analog electronics.

Humans since 1982, *A Million Times*, 2013, aluminum and analog electronics.

Natalie Jeremijenko, Tega Brain, Jake Richardson, and Blacki Migliozzi, *Phenology Clock*, 2014, phenology data, software, and hardware system.

Zelf Koelman, *Ferrolic*, 2015, software, hardware, and ferrolic fluid.

Rafael Lozano-Hemmer, *Zero Noon*, 2013, software system with digital display.

George Maciunas, *10-Hour Flux Clock*, 1969, plastic clock with inserted offset face, Museum of Modern Art, New York.

John Maeda, *12 O'Clocks*, 1996, software.

Christian Marclay, *The Clock*, 2010, film, 24:00, White Cube, London.

Ali Miharbi, *Last Time*, 2009, analog wall clock and interactive hardware.

Mojoptix, *Digital Sundial*, 2015, 3D-printed form.

Eric Morzier, *Horloge Tactile*, 2005, interactive software and screen.

Sander Mulder, *Pong Clock*, 2005, inverted LCD screen and software.

Sander Mulder, *Continue Time Clock*, 2007, mechanical system.

Bruno Munari, *L'Ora X Clock*, 1945, plastic, aluminum, and spring mechanism, Museum of Modern Art, New York.

Yugo Nakamura, *Industrious Clock*, 2001, Flash program and installation.

Katie Paterson, *Time Pieces*, 2014, modified analog clocks, Ingleby Gallery, Edinburgh.

Random International, *A Study Of Time*, 2011, aluminum, copper, LEDs, and software, Carpenters Workshop Gallery, London.

Saqoosha, *Sonicode Clock*, 2008, 2008, audio waveform generator.

Yen-Wen Tseng, *Hand in Hand*, 2010, modified analog electronic clock.

Laurence Willmott, *It's About Time*, 2007, language data, software, and hardware.

Agustina Woodgate, *National Times*, 2016, modified electric clock system.

Readings

Donna Carroll, "It's About Time: A Brief History of the Calendar and Time Keeping" (lecture, University Maastricht University, Maastricht, Netherlands, February 23, 2016).

Johanna Drucker, "Timekeeping," in *Graphesis: Visual Forms of Knowledge Production* (Cambridge, MA: Harvard University Press, 2014).

John Durham Peters, "The Times and the Seasons: Sky Media II (Kairos)," in *The Marvelous Clouds: Toward a Philosophy of Elemental Media* (Chicago: University of Chicago Press, 2015).

Joshua Foer, "A Minor History of Time without Clocks," *Cabinet Magazine*, Spring 2008.

Amelia Groom, *Time (Documents of Contemporary Art)* (Cambridge, MA: MIT Press, 2013).

Golan Levin, "Clocks in New Media," GitHub, 2016.

Richard Lewis, "How Different Cultures Understand Time," *Business Insider*, June 1, 2014.

Leo Padron, "A History of Timekeeping in Six Minutes," August 29, 2011, video, 6:37.

Generative Landscape
World-making and terraforming

Brief

Write a program that presents an ever-changing, imaginative "landscape." Populate your landscape with features that are suitable for your concept: trees, buildings, vehicles, animals, people, food items, body parts, hairs, seaweed, space junk, zombies, etc.

Give consideration to the depth of variation in your landscape: after how much time does your landscape become predictable? How might you forestall this as long as possible? How can you generate a landscape that is both coherent and engaging?

Consider: foreground, middle-ground, and background "layers"; variation at the macro-scale, meso-scale, and micro-scale; natural and human-made features; utopia, dystopia, and heterotopia; the immersive use of motion parallax; and the potential for surprise through the placement of infrequent features.

Learning Objectives
- Apply principles of generative design to terrain, scenery, and worlds of the imagination
- Bias randomness to carefully regulate probabilities
- Carry out a metadesign process

Variations
- Populate your landscape with one or more of the "three verticals" (people, trees, and buildings):

according to Jungian psychology, these are the defining psychological features of landscapes.
- Pay attention to the manner in which the landscape moves past the "camera." For example, it might appear to scroll by (as if you were looking out the window of a train); or approach from a first-person point of view (as if you were driving, or riding a roller coaster), or slide underneath (as if you were looking out of a glass-bottomed airplane). Consider a moving or even roving camera, capable of rotation as well as translation.
- Depict an outside scene, an interior one (such as objects on a conveyor belt), or an altogether dreamlike one.
- Experiment with 3D (as in noise terrains); 2D (as in side-scrolling video games); "2.5D" layered spaces; orthographic views; or even nonlinear, non-Cartesian geometries.
- Give consideration to sound and the possibility for audiovisual synchronicities (as in *Guitar Hero*).
- Make an autonomous creature, vehicle, or other character traverse your landscape.
- Implement features in your landscape that grow, evolve, or erode over time.

Making It Meaningful

We are a migrant species, instilled with a wanderlust that continually clamors for new horizons. Before the modern era of mobility, landscape paintings were often the primary means by which people could visualize faraway lands and mentally escape to them.

Today, eight-year-olds trade "seeds" for favored Minecraft worlds, and procedurally generated environments have become commonplace in video games, where the algorithmic production of novel landscapes is an economic necessity for inexhaustible play. For the meta-designer and artist-programmer, there is assuredly something godlike about calling forth world upon world. It is probably not a coincidence that the first all-CGI sequence in a feature film depicted the synthesis of an entire planet, in the triumphant "Genesis Sequence" of *Star Trek II* (1982).

Generative design systems, whether used to create faces, landscapes, creatures, or chairs, define seemingly infinite possibility spaces. Pay heed, however, to what Kate Compton calls the "10,000 Bowls of Oatmeal Problem": "I can easily generate 10,000 bowls of plain oatmeal, with each oat being in a different position and different orientation, and mathematically speaking they will all be completely unique. But the user will likely just see a lot of oatmeal."[i] As Compton indicates, the challenge and opportunity of meta-design is in architecting systems whose results offer *perceptual uniqueness*, and are thus meaningfully distinct.

This assignment asks you to bring forth a world from your imagination. Alternatively, you may create an accurate computational representation of a very real place—and generate "more" of it.

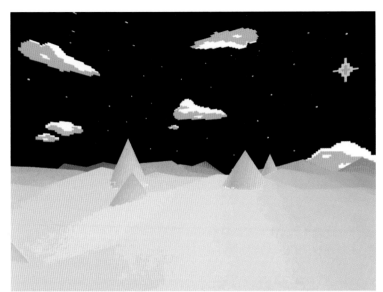
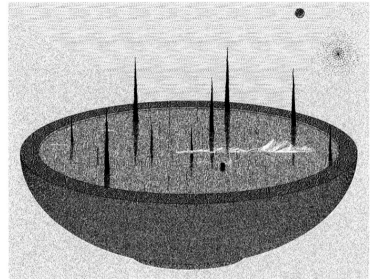

Assignments

Captions

21. Daniel Brown generates dystopian housing projects in his beautifully lit fractal series, *Travelling by Numbers* (2016).

22. Kristyn Janae Solie's *Lonely Planets* (2013) is a stylized 3D terrain that shifts between minimalism and psychedelia. The work was created for Casey Reas's undergraduate course, Live Cinema through Creative Coding.

23. "Fractional noise" mountains (c. 1982), developed by Benoît Mandelbrot and Richard F. Voss at IBM, were a landmark in mathematical terrain synthesis.

24. Everest Pipkin generates barren flowerpot landscapes in *Mirror Lake* (2015), a poetic and mysterious browser experience.

25. In Jared Tarbell's classic *Substrate* (2003), simulated urban tectonics arise from elementary principles of accretion, branching, and feedback.

Additional Projects

Memo Akten and Daniel Berio, *Bozork Quest*, 2013, scene generated with a fragment shader.

Tom Beddard, *Surface Detail*, 2011, evolving fractal landscape.

Tom Betts, *British Countryside Generator*, 2014, procedural world engine.

Ian Cheng, *Emissaries*, 2015–2017, trilogy of evolving animated worlds.

Char Davies, *Osmose*, 1995, interactive VR.

Field.io, *Interim Camp*, 2009, generative software and film.

Simon Geilfus, *Muon glNext*, 2014, landscape generation software.

Chaim Gingold, *Earth: A Primer*, 2015, interactive book app.

Beatrice Glow, *Mannahatta VR: Envisioning Lenapeway*, 2016, immersive visualization.

Michel Gondry, *Chemical Brothers "Star Guitar,"* 2003, video clip.

Vi Hart et al., *Float*, 2015, virtual reality game.

Hello Games, *No Man's Sky*, 2016, multiplayer video game.

Robert Hodgin, *Audio-Generated Landscape*, 2008, audio-generated landscape system.

Robert Hodgin, *Meander*, 2020, procedural map generator.

Anders Hoff, *Isopleth*, 2015, virtual landscape generator.

Joanie Lemercier, *La Montagne*, 2016–2018, digital print on paper and projection.

Jon McCormack, *Morphogenesis Series*, 2001–2004, computer model and prints on photo media.

Joe McKay, *Sunset Solitaire*, 2007, software projection and performance.

Vera Molnár, *Variations St. Victoire*, 1989–1996, silkscreen prints on canvas.

Anastasia Opara, *Procedural Lake Village*, 2017, generative 3D landscape.

Paolo Pedercini and Everest Pipkin, *Lichenia*, 2019, city building game.

Planetside Software, *Terragen*, 2008, scenery generator software.

Davide Quayola, *Pleasant Places*, 2015, digital paintings.

Jonathan Zawada, *Over Time*, 2011, 3D models and oil on canvas.

Readings

Kate Compton, Joseph C. Osborn, and Michael Mateas, "Generative Methods" (paper presented at 4th Workshop on Procedural Content Generation in Games, Chania, Greece, May 2013).

Ian Cheng, "Worlding Raga: 2—What Is a World?" *Ribbonfarm, Constructions in Magical Thinking* (blog), March 5, 2019.

Philip Galanter, "Generative Art Theory," in *A Companion to Digital Art*, ed. Christiane Paul (Hoboken, NJ: John Wiley & Sons, Inc., 2016), 146–175.

Robert Hodgin, "Default Title, Double Click to Edit" (lecture, Eyeo Festival, Minneapolis, MN, June 2014).

Jon McCormack et al., "Ten Questions Concerning Generative Computer Art," *Leonardo* 47, no. 2 (April 2014): 135–141.

Paolo Pedercini, "SimCities and SimCrises" (lecture, 1st International City Gaming Conference, Rotterdam, Netherlands, 2017).

Virtual Creature
Creating artificial life

Brief

Your job, Dr. Frankenstein, is to create new life. Program a species of virtual organism: it could be a sensate creature, a dynamic flock or swarm, an artificial cell-culture, a novel plant, or an ecosystem. Your software should algorithmically generate the form and behavior of your new lifeform(s). Will they be able to sleep, reproduce, die, or eat one another? Consider the relationships between the individuals in your species and develop a corresponding interplay of simulated forces such as attraction or avoidance. Your creature may benefit from inhabiting an ecosystem or environment with abiotic elements that present additional constraints or opportunities.

Give consideration to the potential for your creature to operate as a cultural artifact. Can it attain special relevance through metaphor or commentary or by addressing a real human need or interest?

Learning Objectives

- Review, discuss, and write functions to animate different types of organic motion
- Design and implement programs using an object-oriented programming approach
- Program an interaction between objects

Variations

- Create an ecosystem containing a pair or "dyad" of creatures that respond to each other in some way: predator/prey, symbionts, etc.
- Program your creature so that its appearance arises from its behaviors, or vice versa. For example, consider how an amoeba's pseudopod is both the visual boundary of its body and also the expression of a tropism. Perhaps the form of your creature's body emerges from an underlying particle simulation, ragdoll physics, or reinforcement learning system.
- Write object-oriented code to encapsulate your species of creature. Exchange your code with other students whose creatures implement the same protocols (eat, sleep, forage, etc.). Collect at least two other species and combine them in an ecosystem. *This variation can be executed using a versioning tool such as GitHub, spurring insights into collaborative software development and the importance of code comments.*
- Present your digital ecosystem as an augmented projection, siting it on a specific surface. Can your (virtual) lifeforms respond to the physical characteristics of your (real) chosen location?

Making It Meaningful

As the myths of Pygmalion, Golem, and Frankenstein show, the god-like desire to create artificial life (AL) persists throughout our folklore. This impulse also underlies the history of robotics, where gestures are mechanically automated in the *Karikuri* of Japan and in the early automata of Europe, like Turriano's "Praying Monk" (c. 1560) or de Vaucanson's "Defecating Duck" (1738). With computers, software simulations of life systems allow behaviors and interactions to be programmed and scaled across massive multiagent systems. Many of these systems exhibit *emergence*, where self-regulation, apparent intelligence, and coordinated behaviors arise from simple rules followed by many actors.

Whether the medium is hardware or software, the goal of AL is to create the impression that an engineered system is *alive*. Unlike the creative work of "character design," where the focus is on visual appearance, this assignment is concerned with the construction of a creature with responsive, dynamic behaviors that are contingent on environmental interactions. To emphasize this, an instructor may challenge students to instill lifelike behavior in creatures whose bodies are restricted to ultra-minimal forms, such as a pair of rectangles.

A creature without a context is boring—with nothing to do, and no one to do it to. Stories happen, character is perceived, meanings are made when an agent operates on or within an environment that likewise acts on it. By placing a creature into feedback with external forces or subjects, and especially with the actions of an interacting user, we can create companions that stave off loneliness or appear to have feelings, virtual pets like the Tamagotchi that evoke empathy through their fragility, or sublime simulated ecosystems that evolve in surprising ways.

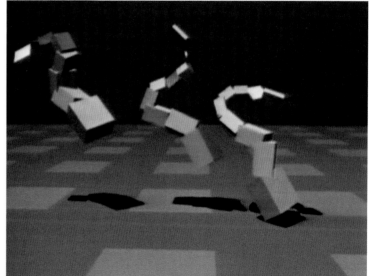

Captions

26. Brent Watanabe's *San Andreas Streaming Deer Cam* (2015–2016) is a live video stream from a computer running a modified version of *Grand Theft Auto V*. The artist's mod creates an autonomous deer and follows it as it wanders through a fictional city, interacting with its surroundings and the game's AI characters. During one of its streaming episodes, the deer wandered along a moonlit beach, caused a traffic jam on a major freeway, got caught in a gangland gun battle, and was chased by the police.

27. *Connected Worlds* (2015) by Design IO (Theo Watson and Emily Gobeille) is a large-scale interactive installation developed for New York's Great Hall of Science. The work presents six immersive habitats, projected across both walls and floors, that allow visitors to interact with simulated water flows and learn about the role of the water cycle in different ecosystems. Watson and Gobeille devised dozens of responsive creature species to populate the space.

28. Neurophysiologist William Grey Walter's "tortoises" of 1948–1949 were early electronic robots capable of phototaxis and object avoidance.

29. Karl Sims's *Evolved Virtual Creatures* (1994) presents simulated creatures that evolve charming and idiosyncratic methods of locomotion using genetic algorithms.

Additional Projects

Ian Cheng, *Bob (Bag of Beliefs)*, 2018–2019, animations of evolving artificial lifeforms.

James Conway, *Game of Life*, 1970, cellular automaton.

Sofia Crespo, *Neural Zoo*, 2018, creatures generated with neural nets.

Wim Delvoye, *Cloaca*, 2000–2007, large-scale digestion machine.

Ulrike Gabriel, *Terrain 01*, 1993, photoresponsive robotic installation.

Alexandra Daisy Ginsberg. *The Substitute*, 2019, video installation and animation.

Edward Ihnatowicz, *Senster*, 1970, interactive robotic sculpture.

William Latham, *Mutator C*, 1993, generated 3D renderings.

Golan Levin et al., *Single Cell* and *Double Cell*, 2001–2002, online bestiary.

Jon McCormack, *Morphogenesis Series*, 2002, computer model and prints on photo media.

Brandon Morse, *A Confidence of Vertices*, 2008, generated animation.

Adrià Navarro, *Generative Play*, 2013, generated characters and card game.

Jane Prophet and Gordon Selley, *TechnoSphere*, 1995–2002, online environment and generative design tool.

Matt Pyke (Universal Everything), *Nokia Friends*, 2008, generative squishy characters.

Susana Soares, *Upflanze*, 2014, hypothetical plant archetypes.

Christa Sommerer and Laurent Mignonneau, *A-Volve*, 1994–1995, interactive installation.

Christa Sommerer and Laurent Mignonneau, *Lifewriter*, 2006, interactive installation.

Francis Tseng and Fei Liu, *Humans of Simulated New York*, 2016, participatory economic simulation.

Juanelo Turriano, *Automaton of a Friar*, c. 1560, Smithsonian Institution, National Museum of American History.

Jacques de Vaucanson, *Canard Digérateur*, 1739, automaton in the form of a duck.

Lukas Vojir, *Processing Monsters*, 2008–2010, online bestiary.

Will Wright and Chaim Gingold et al., *Spore Creature Creator*, 2002–2008, creature construction software.

Readings

Jean Baudrillard, *Simulacra and Simulation* (Ann Arbor: University of Michigan Press, 1994).

Valentino Braitenberg, *Vehicles: Experiments in Synthetic Psychology* (Cambridge, MA: MIT Press, 1984).

Bert Wang-Chak Chan, "Lenia: Biology of Artificial Life," *Complex Systems* 28, no. 3 (2019), 251–286.

Ian Cheng et al., *Emissaries Guide to Worlding* (London: Koenig Books, 2018).

Craig W. Reynolds, "Steering Behaviors For Autonomous Characters," *Proceedings of the Game Developers Conference* (1999), 763–782.

Daniel Shiffman, *The Nature of Code: Simulating Natural Systems with Processing* (self-pub., 2012).

Mitchell Whitelaw, *Metacreation: Art and Artificial Life* (Cambridge, MA: MIT Press, 2006).

Custom Pixel
Reimagining the display

Brief

Pixels are the fundamental building blocks of bitmap images and digital displays. Conventionally, pixels are square, uniform, and parked in a static Cartesian grid. Challenge these assumptions by writing code to reconstruct a specific photographic image using "custom picture elements" of your own devising. What if pixels were hexagonal? Could they be arranged on an irregular lattice? What if they overlapped, moved, or had a variety of sizes? What if an image was itself constructed from fragments of other images, or from a database of tiny icons, symbols, flags, or emojis? Think carefully about the relationships between your "pixel concept" and the image you choose to transform. At no time should your original image be directly visible.

Learning Objectives

• Reflect on the constitution and perception of images in art, design, and digital imaging
• Explore the relationship between an image and its component parts
• Appropriately access low-level pixel data

Variations

• Implement your own style of "Divisionism" by constructing picture elements from pairs or triplets of contrasting patches.
• Instead of square pixels, use polar coordinates to construct an image from annular sectors.
• Design picture elements that resemble brushstrokes, with control parameters like

"thickness" and "irregularity." How can these elements reproduce higher-level visual features in your original image, such as its edges, gradients, and spots? Can your brushstrokes capture the orientations of these features?
• Modify your code so that it interprets a video or live webcam stream, giving consideration to how you can reduce frame-to-frame differences and flickering. What sort of subject matter is best suited to your algorithm?
• Invent a display that produces images by moving or rearranging a collection of real, physical objects (such as pebbles or candy).
• Some image compression algorithms operate by means of specially designed picture elements. Read about quadtrees, run-length encoding, dictionaries of 8x8-pixel JPEG blocks, and Gabor wavelets. Devise a compression algorithm inspired by one of these techniques. What are the aesthetics and artifacts of your algorithm?

Making It Meaningful

Artworks comprised of novel pixels are literally "new media"; they illustrate McLuhan's well-worn adage that the medium (itself) is the message. The impact of this message can be weakened, however, when a novel imaging technique is applied without consideration to its subject. Is the project "just a display"? A key path to the production of meaning in this genre of work, therefore, is the purposeful creation of a relationship between form and content: between the nature of a display's constituent picture elements and the subjects they portray. Projects

by Chris Jordan, El Anatsui, and Jenny Odell, for example, present the conceptual contradiction that arises when something valuable appears to be wholly constructed out of trash or detritus.

Custom picture elements can create intrigue at multiple scales, allowing for new ways of seeing that urge the viewer to reconsider the experience of image consumption. What was formerly an instantaneous phenomenon ("I saw it") becomes an interactive process of close observation ("I examined it"). A common strategy is to alternately create and resolve visual ambiguity. Images constructed using a photomosaic technique, for example, provide an engrossing means by which fans can "zoom in" to reminisce about a favorite subject. The Pointillist and Divisionist painters of the late 1800s, by contrast, created paintings that required the viewer to "zoom out," actively fusing spots of colors in their mind's eye in order to recognize the painting's subject. Multi-scale works also defy easy reproduction, increasing their aura.

The use of custom picture elements can prompt reflection about the conditions of image production. When we pore over a Byzantine micromosaic, we marvel at the evident labor that went into creating and placing each individual tile. Contemporary artworks like *10,000 Cents* by Koblin and Kawashima address these conditions directly, making use of networked labor markets like Mechanical Turk to question the nature of digital economies and authorship.

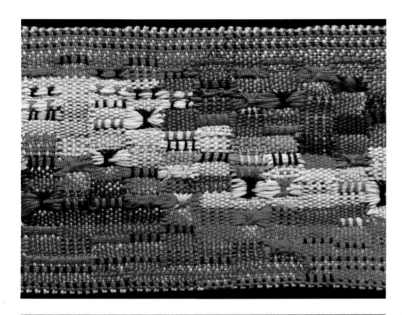

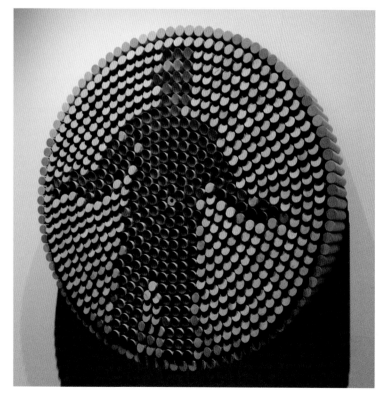

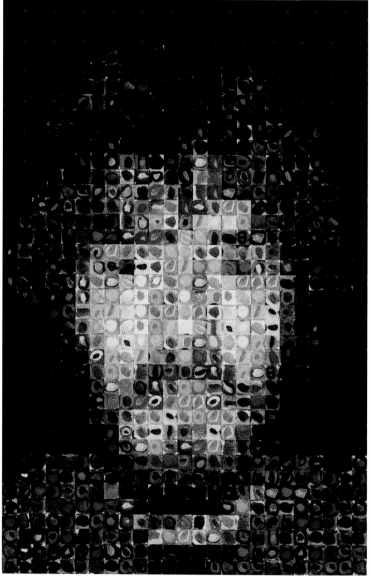

Captions

30. Aram Bartholl's *0,16* (2009) is a wholly analog light installation that uses translucent paper to transform the visitors' shadows into large-scale pixels.

31. Textile arts such as weaving, knitting, and needlepoint are ancient cultural practices of pixel logic. In works like *South of The Border* (1958, shown here in detail), textile designer and Bauhaus educator Anni Albers used ingenious combinations of threads to produce custom pixels.

32. Leon Harmon and Ken Knowlton's *Studies in Perception #1* (1966) is a mosaic of small scientific symbols, arranged into the form of a nude using Knowlton's BEFLIX programming language. It appeared on the front page of the *New York Times* on October 11, 1967, and was shown in the Museum of Modern Art's 1968 exhibition *The Machine as Seen at the End of the Mechanical Age*, introducing computer art to a broad American public for the first time.

33. Jenny Odell describes her *Garbage Selfie* as "a self portrait composed of everything I threw away, recycled or composted between February 10 and March 1, 2014."

34. Charles Gaines dissects photographs into grids of hand-painted elements, using indeterminacy and other mathematical principles, in order to explore the constructed nature of representation. Shown here and in detail is his *Numbers and Trees: Central Park Series II: Tree #8, Amelia* (2016), a photograph with acrylic on plexiglas.

35. Aaron Koblin and Takashi Kawashima's *10,000 Cents* (2008, shown here in detail) is a crowdsourcing system that produced a representation of a US $100 bill. The artists write: "Using a custom drawing tool, thousands of individuals working in isolation from one another painted a tiny part of the bill without knowledge of the overall task. Workers were paid one cent each via Amazon's Mechanical Turk." The project's conditions of production and distribution perhaps inadvertently highlight the inequity of distributed labor markets.

36. Daniel Rozin has spent decades producing hand-crafted pixels from every material imaginable including wood, fur, and even toy penguins. His *Peg Mirror* (2007) consists of 650 wooden dowels that are cut on an angle and individually motorized. As they rotate, the pegs catch light or cast shadows, recreating the scene captured by a central camera.

37. Scott Blake's *Chuck Close Filter* software (2001–2012) transforms any image into the pixelated style of a Chuck Close painting. Following its release, Blake was threatened with legal action by Close, who asserted that the software trivialized his art and threatened his livelihood. Blake's *Self Portrait Made with Lucas Tiles* (2012) is wholly constructed of squares taken from Close's painting *Lucas* (1991).

Additional Projects

El Anatsui, *Earth Shedding Its Skin*, 2019, aluminum and copper wire.

Angela Bulloch, *Horizontal Technicolor*, 2002, modular light sculpture.

Jim Campbell, *Reconstruction Series*, 2002–2009, custom electronics, LEDs, and cast resin screens.

Evil Mad Scientist Laboratories, *StippleGen*, 2012, image processing software.

Frédéric Eyl and Gunnar Green, *Aperture*, 2004–05, interactive facade.

Kelly Heaton, *Reflection Loop*, 2001, kinetic sculpture with Furby pixels.

Chris Jordan, *Running the Numbers II: Portraits of Global Mass Culture*, 2009–, variable material.

Rafael Lozano-Hemmer, *Pareidolium*, 2018, software, camera, and ultrasonic atomizers.

Vik Muniz, *Pictures of Garbage*, 2008, photographed arrangements of detritus.

Everest Pipkin, *Unicode Birds*, 2013–2019, unicode and twitter bot.

Gonzalo Reyes-Araos, *RGB Paintings*, 2018, oil on paper, mounted on aluminum, KINDL Berlin.

Elliat Rich, *What colour is the sky*, 2011, printed aluminum swatches and steel frame.

Peiqi Su, *The Penis Wall*, 2014, kinetic sculpture.

Tali Weinberg, *0.01% of vacant potential homes*, 2012, archival pigment print on paper.

Readings

Scott Blake, "My Chuck Close Problem," *Hyperallergic*, July 9, 2012.

Meredith Hoy, *From Point to Pixel: A Genealogy of Digital Aesthetics* (Hanover, NH: Dartmouth College Press, 2017).

Christopher Jobson, "People as Pixels," *This Is Colossal*, February 24, 2012.

Julius Nelson, *Artyping* (Johnstown, PA: Artyping Bureau, 1939).

Omar Shehata, "Unraveling the JPEG," *Parametric Press* 1 (Spring 2019): n.p.

Rob Silvers, "Photomosaics: Putting Pictures in Their Place" (master's thesis, MIT, 1996).

Barrie Tullett, *Typewriter Art: A Modern Anthology* (London: Laurence King Publishing, 2014).

Drawing Machine
Tools for doodling and depicting

Brief

Create a program that expands, augments, muddles, complicates, questions, analyzes, spoils, undermines, improves, accelerates, or otherwise alters the concept or act of drawing. Clarify the intent of your system, such as whether your project is a tool, toy, game, or performance instrument. Demonstrate its unique properties by using it to produce a series of at least three drawings.

Learning Objectives

• Deeply examine the process of drawing
• Evaluate the affordances and artifacts of creative tools
• Use appropriate data structures for recording, storing, and manipulating gesture data

Variations

• Create a system that brings drawings to life.
• Question intent. Derive marks from the actions of an entity that is (probably) unaware that it is drawing: a pedestrian, a turtle, a kite.
• Deprivilege the dominant hand. Make a drawing tool that is operated by the user's face, voice, or some other part of their body.
• Drawing is usually conceived as a solo activity. Create a drawing machine that requires two people to operate it.
• Make a "single purpose" drawing machine, such as a tool that can only draw ducks.
• Identify and challenge some other basic assumption about drawing, such as the notion that drawings are made on a flat surface; that drawings are recordings that are meant to endure; that drawings can be "finished"; or that drawings are distinct from text.
• Make a tool that functions critically—for instance, that rejects the technological imperatives of accuracy, realism, and utility and instead prioritizes expressivity, irreproducibility, and whimsy.
• Develop a system that analyzes and derives insights from a database of drawings.

Making It Meaningful

"Make your own paintbrush" is a classic art school prompt, encouraging students to create tools from parts of the body or found materials. The exercise personalizes and defamiliarizes the act of mark-making, and invites a deeper consideration of how tools and technologies shape artistic expression. The Drawing Machine assignment captures this spirit in the domain of software, opening up questions of constraints, autonomy, and augmentation in human-machine collaboration.

The act of drawing translates gesture from the body to the page through an apparatus. The primogenitor of today's computational drawing tools was Sketchpad, developed by Ivan Sutherland as part of his MIT PhD thesis in 1963, which made it possible for a person and a computer "to converse rapidly through the medium of line drawings."[i] Widely credited as the first graphical user interface, Sketchpad substituted page for screen and leveraged the infinite malleability of virtual form for the first time. Its descendants, like AutoCAD, Photoshop, and Illustrator, are now mature products, and their interaction vocabularies have become standardized and ubiquitous and thus taken for granted. Innovating in this space now requires either breaking a core assumption about drawing, or experimenting with mark-making in unfamiliar contexts.

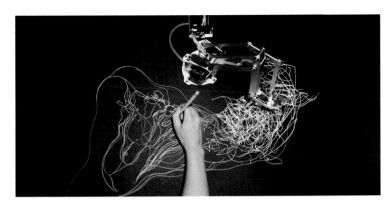

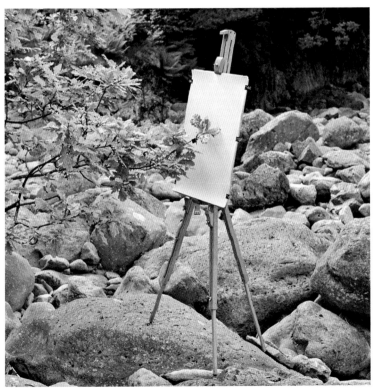

Captions

38. The paintings in Addie Wagenknecht's *Alone Together* series (2017) are produced by a Roomba domestic robot as it traces around the artist's reclining body, smearing International Klein Blue paint as it goes. The work responds to both the technologized automation of labor and the history of action painting, where women's bodies were sometimes used as paint brushes.

39. Sougwen Chung collaborates with semi-autonomous robot arms to produce drawings like those in her *Drawing Operations* series (2015–2018).

40. To create *Tree Drawings* (2007), Tim Knowles attaches pencils to the limbs of trees and captures the resulting marks on paper.

41. The *Sketch Furniture* (2007) system by Swedish agency Front Design combines motion capture and digital fabrication. Using this system, a designer can record three-dimensional, freehand drawings of virtual furniture at a 1:1 scale, and then fabricate these forms using a large-scale 3D printer.

42. Graffiti Research Lab was a collective dedicated to outfitting artists and protesters with open-source technologies for urban communication. In *L.A.S.E.R. Tag* (2007), a computer vision system tracks the spot of a user's handheld laser pointer. A high-power video projection, calibrated to the camera system, enables the user to display their tags at an architectural scale.

43. *Sloppy Forgeries* (2018) by Jonah Warren is a game in which players, using computer mice and simplified color palettes, race to draw the most accurate replicas of famous paintings.

44. In Julien Maire's *Digit* performance (2006), poetic texts magically appear beneath the artist's fingertip as he runs it across a sheet of white paper. Mechanisms from a thermal printer have been discreetly concealed under his hand.

45. Paul Haeberli's *DynaDraw* (1989) is an early computational drawing environment in which the brush is modeled as a springy physical object with simulated mass, velocity, and friction. The augmentation of the drawing process with exaggerated virtual physics, and a range of adjustable parameters, leads to new forms of gestural and calligraphic play.

Additional Projects

Akay, *Tool No. 10: Robo-Rainbow*, 2010, device for spray-painting rainbows.

Peter Edmunds, *SwarmSketch*, 2005, collaborative digital canvas.

Free Art and Technology (F.A.T.) Lab, *Eyewriter*, 2009, eye-tracking drawing tool.

William Forsythe, *Lectures from Improvisation Technologies*, 1994, video series.

Ben Fry, *FugPaint*, 1998, antagonistic paint program.

Johannes Gees, *Communimage*, 1999, digital collaborative collage.

David Ha, Jonas Jongejan, and Ian Johnson, *Sketch-RNN Demos*, 2017, neural network drawing experiment.

Desmond Paul Henry, *Serpent*, 1962, pen and ink mechanical drawing, Victoria and Albert Museum, London.

Jarryd Huntley, *Art Club Challenge*, 2018, drawing game iOS app.

Jonas Jongejan et al., *Quick, Draw!*, 2017, drawing game with neural net.

So Kanno and Takahiro Yamaguchi, *Senseless Drawing Bot*, 2011, chaotic drawing robot.

Soonho Kwon, Harsh Kedia, and Akshat Prakash, *Anti-Drawing Machine*, 2019, antagonistic drawing machine.

Louise Latter and Holly Gramazio, *Doodle*, 2020, exhibition of software art at Birmingham Open Media (BOM).

Jürg Lehni, *Viktor*, 2011, scalable robotic drawing machine.

Golan Levin, *Yellowtail*, 1998, audiovisual animation software.

Zachary Lieberman, *Drawn*, 2005, interactive installation.

Zachary Lieberman, *Inkspace*, 2015, accelerometer-dependent drawing app.

John Maeda, *Timepaint*, 1993, drawing software demonstration.

Kyle McDonald and Matt Mets, *Blind Self-Portrait*, 2011, machine-aided drawing system.

JT Nimoy, *Scribble Variations*, 2001, drawing software.

Daphne Oram, *Oramics Machine*, 1962, photo-input synthesizer for "drawing sound."

James Paterson and Amit Pitaru, *Rhonda Forever*, 2003–2010, 3D drawing tool.

Pablo Picasso, *Light Paintings*, 1950, long-exposure photographs by Gjon Mili, Museum of Modern Art, New York.

Amit Pitaru, *Sonic Wire Sculptor*, 2003, app for 3D drawing and composition.

Eric Rosenbaum and Jay Silver, *SingingFingers (Finger Paint with Your Voice)*, 2010, software for fingerpainting with sound.

Toby Schachman, *Recursive Drawing*, 2012, drawing software.

Karina Smigla-Bobinski, *ADA*, 2011, analog interactive installation.

Alvy Ray Smith and Dick Shoup, *SuperPaint*, 1973–75, 8-bit paint system.

Scott Snibbe, *Bubble Harp*, 1997, drawing software implementing Voronoi diagrams.

Scott Snibbe, *Motion Phone*, 1995–2012, networked animation system.

Scott Snibbe et al., *Haptic Sculpting*, 1998, prototype software for physically mediated haptic sculpting.

Laurie Spiegel, *VAMPIRE*, 1974–1979, color-music mixing software.

Christine Sugrue and Damian Stewart, *A Cable Plays*, 2008, audiovisual performance.

Ivan E. Sutherland, *Sketchpad: A Man-Machine Graphical Communication System*, 1964, drawing program.

Clement Valla, *A Sequence of Lines Consecutively Traced by Five Hundred Individuals*, 2011, video.

Jeremy Wood, *GPS Drawings*, 2014, drawings from GPS data.

Iannis Xenakis, *UPIC*, 1977, graphical music scoring system.

Readings

Pablo Garcia, "Drawing Machines," DrawingMachines.org, accessed April 14, 2020.

Jennifer Jacobs, Joel Brandt, Radomír Mech, and Mitchel Resnick, "Extending Manual Drawing Practices with Artist-Centric Programming Tools," in *Proceedings of the 2018 CHI Conference on Human Factors in Computing Systems* (New York: Association for Computing Machinery, 2018), 1–13.

Golan Levin, "2-02 (Drawing)," Interactive Art and Computational Design, Carnegie Mellon University, Spring 2016, accessed April 14, 2020.

Zach Lieberman, "From Point A to Point B" (lecture, Eyeo Festival, Minneapolis, MN, June 2015), video, 7:20–19:00.

Scott Snibbe and Golan Levin, "Instruments for Dynamic Abstraction," in *Proceedings of the Symposium on Nonphotorealistic Animation and Rendering* (New York: Association for Computing Machinery, 2000).

Notes

i. Ivan E. Sutherland, "Sketchpad: A Man-Machine Graphical Communication System," *Simulation* 2, no. 5 (1964): R-3.

Modular Alphabet
Structuring letterforms with a common model

Brief

Design a typeface (using any graphic primitives you prefer) so that all of the letters of the alphabet are structured by the same software parameters and graphic logic. For example, you might design an alphabet in which every letter is exclusively constructed from three arcs, or from four rectangles, or from a small grid of squares. After you have designed all of your letters, typeset the entire alphabet in a single image so that it can be seen at a glance.

An essential technical goal is for you to store descriptive parameters for your letters in some kind of array or object-oriented data structure, and then create a single function that renders any requested letter from this data. If you're writing individual functions to draw each letter, you're doing something wrong.

Learning Objectives

- Conceive and appraise graphical concepts for dynamic typography
- Use parameters to manipulate and/or animate letterforms
- Apply principles of metadesign to font design
- Use arrays to store geometric data

Variations

- Typeset a carefully chosen word that has a special relationship to your letterforms' design.
- Give your letters inherently unstable properties. Animate them by deflecting their control points with a sinusoidal wiggle, Perlin noise, or real-time interactivity.
- Create a system to animate the transitions between letterforms, allowing any letter to smoothly morph into any other. Pressing a key should initiate an animated transition (of approximately a second's duration) from the previous letter to the next desired letter. *Instructors: for introductory students, it may be helpful to provide a template for transitioning between letterforms.*
- Consider a design in which letters are traces deposited by moving particles—whose paths are affected by forces from different spatial configurations of attractors and repulsors.
- A "forced aligner" is a computer program that takes audio files and their transcripts and returns extremely precise timing information. Using your typeface and a "forced aligner" (such as *Gentle* by Ochshorn & Hawkins), create time-synced dynamic typography that not only synchronizes perfectly with a speech file, but also responds parametrically to the sound of the speaker's voice.

Making It Meaningful

Extending from Adrian Frutiger's Univers (1954), Donald Knuth's computational METAFONT (1977), and Adobe's "Multiple Master" fonts (1994), it has become increasingly common practice to design highly adaptable type *systems* that go far beyond the rigid limits of static type*faces*. Peter Biľak writes: "Prior to Univers, type designers concerned themselves with the relationships between letters of the same set, how an 'A' is different from a 'B'. Univers goes beyond the quest to design individual letters, attempting instead to create a system of relationships between different sets of shapes which share distinctive parameters."[i]

This prompt prioritizes the creative value of constraints. Restricted to designing letterforms with shared parameters, it requires modularity, economy, and an ingenuity about shapes whose variety and complexity students often take for granted. The expressive potential for contingent, interactive, and subtly time-varying form systems should not be overlooked. Take a moment to reflect on your resultant type system. For which letters does the structuring pattern succeed best or fail hardest?

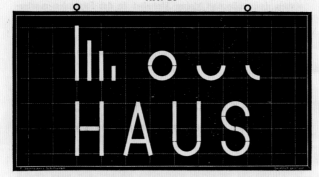

Wandtafel zur Veranschaulichung der Schriftbildung
Abb. 28

Behälter mit den aufsteckbaren Grundzügen der Schrift
zur Veranschaulichung der Buchstabenbildung
Abb. 29

FREGIO MECANO

(Carattere scomponibile)

Minimo Kg. 2,50 Si vendono anche figure separate : minimo Kg. 1 per figura

Captions

46. Nikita Pashenkov's *Alphabot* (2000) is a Transformer-like virtual robot "that communicates with humans by changing its shape to form characters of the English alphabet." The 3D robot is constructed from eight hinged segments, and can smoothly re-fold its shape into any letterform.

47. Mary Huang's *Typeface: A Typographic Photobooth* (2010) is a font whose parameters (such as slant, x-height, etc.) are governed by signals from a real-time face tracker.

48. David Lu's *Letter 3* (2002) presents an interactive alphabet whose letters are formed by manipulating the control points of a single, compound Bézier curve. Each letter can fluidly transform into any other.

49. In Peter Cho's classic *Type Me, Type Me Not* (1997), each letter is constructed from two "Pac-Man" filled arcs and is represented by just ten numbers.

50. In Yuichiro Katsumoto's *Mojigen & Sujigen* (2016), six interconnected electromechanical elements form the letters of the alphabet by moving into different positions.

51. Bruno Munari's *ABC with Imagination* (1960), a children's alphabet book, included a set of modular pieces for typographic play.

52. In 1878, amidst widespread use of the calligraphic Fraktur blackletter, inventor Friedrich Soennecken sought to modernize and rationalize German typography and penmanship. Soennecken developed Schriftsystem, a method for constructing glyphs exclusively from arcs and straight lines. Decades later, his system influenced the design of the German Institute for Standardization's DIN 1451 Engschrift typeface, now used throughout Germany for many purposes.

53. *Fregio Mecano* ("mechanic ornament") is a set of 20 modular, geometric shapes for constructing letters and images in highly flexible ways. Devised in Italy by Giulio da Milano in the early 1930s, it was released by the Nebiolo typefoundry.

54. Julius Popp's *bit.fall* (2001–2016) produces ephemeral texts by releasing droplets of water through a series of precisely timed, computer-controlled solenoid valves.

Additional Projects

Agyei Archer, *Crispy*, 2017, variable font.

Erik Bernhardsson, *Analyzing 50K Fonts Using Deep Neural Networks*, 2016, machine-learning font.

Michael Flückiger and Nicolas Kunz, *LAIKA: A Dynamic Typeface*, 2009, interactive font.

Christoph Knoth, *Computed Type*, 2011, interactive typographic system.

Donald Knuth, *METAFONT*, 1977–1984, font design system.

Urs Lehni, Jürg Lehni, and Rafael Koch, *Lego Font Creator*, 2001, font.

John Maeda, *Tangram Font*, 1993, font.

JT Nimoy, *Robotic Type*, 2004, robotic typographic system.

Michael Schmitz, *genoTyp*, 2004, genetic typography tool.

Kyuha (Q) Shim, *Code & Type*, 2013, book and website.

Joan Trochut, *Supertipo Veloz*, 1942, modular type system digitized by Andreu Balius and Àlex Trochut in 2004.

Julieta Ulanovsky, *Montserrat*, 2019, variable font.

Flavia Zimbardi, *Lygia*, 2020, variable font.

Readings

Johanna Drucker, *The Alphabetic Labyrinth: The Letters in History and Imagination* (London: Thames and Hudson, 1995).

C. S. Jones, "What Is Algorithmic Typography?," *Creative Market* (blog), May 2, 2016.

Christoph Knoth, "Computed Type Design" (master's thesis, École Cantonal d'Art de Lausanne, 2011).

Donald Knuth, "The Concept of a Meta-Font," *Visible Language* 16, no. 1 (1982): 3–27.

Jürg Lehni, "Typeface as Programme," Typotheque.

Ellen Lupton, *Thinking with Type: A Critical Guide for Designers, Writers, Editors, and Students* (New York: Princeton Architectural Press, 2010).

Rune Madsen, "Typography," lecture for Programming Design Systems (NYU).

"Modular Typography," Tumblr.

François Rappo and Jürg Lehni, *Typeface as Programme* (Lausanne, France: École Cantonal d'Art de Lausanne, 2009).

Dexter Sinister, "Letter & Spirit," *Bulletins of the Serving Library* 3 (2012).

Alexander Tochilovsky, "Super-Veloz: Modular Modern" (lecture, San Francisco Public Library, March 13, 2018).

Notes

i. Peter Biľak, "Designing Type Systems," 2012, ilovetypography.com.

Data Self-Portrait

Data Self-Portrait
Quantified selfie

Brief

Create a visualization that presents insights from a dataset about yourself. You may use pre-existing data (such as your email archive, fitness tracker data, etc.) or create a new system specifically for collecting data about an aspect of your life. The data you collect need not be temporal; for example, you might reimagine your wardrobe as a database of interrelated items. Can you collect data about phenomena that nobody has seen or thought of before?

Your visualization is a tool you're building to help you answer a question about yourself. You can use existing measurement technologies, or devise new manual or automatic data collection techniques. You're encouraged (but not required) to combine multiple sources of data, to make interesting comparisons.

Learning Objectives

- Implement the complete pipeline of information visualization: from data acquisition, parsing, and cleaning to representation, distillation, and interaction
- Identify and use fundamental data structures
- Carry out an in-depth consideration of information aesthetics

Variations

- Give yourself permission to be specific. Sometimes focusing your investigation on a subset of your data is not only simpler, but can be much more interesting. For example, instead of visualizing all of your text messages (a study of your texting behavior), what if you only examine the ones you exchanged with a certain person (a study of your relationship)?
- Take time-stamped data and present it in a way that does not use a timeline. Consider your email: While you can certainly visualize it as a timeline (e.g., the number of emails you process per day), you could also view it as a graph (e.g., the social network of your contacts), or as a histogram (e.g., the words you use most often).
- Build a custom device to capture data about yourself, using a novel sensor, or by mounting a sensor in an unexpected place.
- Give your data-capture system to your friends. Ask them to collect data for two weeks. Produce a set of what Edward Tufte calls "small multiples": uniform visualizations that allow your friends' data to be easily compared.
- Create an interactive visualization. Consider how your project can allow operations like zooming, sorting, filtering, and/or querying.

Making It Meaningful

Databases are amassed from our digital communications, search histories, transactions, step counts, sleep patterns, and journeys. How do we make sense of this "data exhaust" and how does this change our understanding of ourselves? What data is collected and what is not? What sorts of activities resist quantification and measurement and why? This task invites a deep exploration of portraiture and self-representation in the age of quantification.

Corporate and governmental surveillance is changing our lives on both personal and societal scales. How does the knowledge that our lives are being recorded change them? Consider how fitness tracking, initially celebrated by the quantified self community for its promise of new insight, was later aggressively promoted by the insurance industry and, in some cases, became required by employers. Likewise, consider the data collected by major social media platforms, and how this data feeds targeted advertising, structures the algorithmic presentation of online content, and produces contemporary phenomena like filter bubbles.

Code as Creative Medium

```
┌──────────┐  ┌────┬────┐  ┌──────────┐
│ 55       │  │ 56 │ 58 │  │ 60       │
│          │  ├────┼────┤  │          │
│          │  │ 57 │ 59 │  │          │
└──────────┘  └────┴────┘  └──────────┘
```

Captions

55. Shan Huang's *Favicon Diary* (2014), developed while she was a student at Carnegie Mellon, is a chronologically ordered compilation of the favicons from every website that she visited over the course of several months. In addition to producing her own data self-portrait, Huang also released a Google Chrome browser extension so that others could do the same.

56. In *Dear Data* (2016), a year-long project, Giorgia Lupi and Stephanie Posavec mailed weekly hand-drawn postcards to each other that visualized some (quantified) aspect of their lives, such as the number of doors they entered, or how many times they laughed.

57. Tracey Emin's *Everyone I Have Ever Slept With 1963–1995* (1995) is a tent with the names of Emin's lovers embroidered on the inside.

58. Fernanda Viégas's *Themail* (2006) analyzes the contents of email correspondence, showing the significant words that characterize each relationship.

59. Responding to a late-1970s surge in interest in the body's natural circadian rhythms, Sonya Rapoport's *Biorhythm Audience Participation Performance* (1981) used a commercial kit to predict her daily biorhythms, then compared her own experience with the computerized predictions.

60. *Stay* (2011) is an example of Hasan Elahi's ongoing "self-surveillance" work, in which he collects photographs of his daily life and preemptively sends them to the FBI.

Additional Projects

Rachel Binx, *Wi-Fi Diary*, 2014, image capture software.

Beatriz da Costa, Jamie Schulte, and Brooke Singer, *Swipe*, 2004, performance and installation.

Hang Do Thi Duc and Regina Flores Mir, *Data Selfie*, 2017, browser extension.

W. E. B. Du Bois, charts prepared for the Negro Exhibit of the American Section at the Paris Exposition Universelle, 1900, ink on posterboard.

Luke DuBois, *Hindsight Is Always 20/20*, 2008, light boxes, software, and presidential speech transcripts.

Takehito Etani, *Masticator*, 2005, electronic wearable with audiovisual feedback.

Nick Felton, *Annual Reports*, 2005–2014, letterpress and lithograph.

Laurie Frick, *Time Blocks Series*, 2014–2015, wood-based data visualization.

Brian House, *Quotidian Record*, 2012, vinyl record.

Jen Lowe, *One Human HeartBeat*, 2014, online biometrics visualization.

Katie McCurdy, *Pictal Health: Health History Visualization*, 2014, health data software.

Lam Thuy Vo, *Quantified Breakup* (blog), Tumblr, October 23, 2013–September 25, 2015.

Stephen Wolfram, "The Personal Analytics of My Life," *Stephen Wolfram: Writings* (blog), March 8, 2012.

Readings

Witney Battle-Baptiste and Britt Rusert, eds., *W. E. B. Du Bois's Data Portraits: Visualizing Black America* (San Francisco: Chronicle Books, 2018).

Robert Crease, "Measurement and Its Discontents," *New York Times*, October 22, 2011.

Judith Donath et al., "Data Portraits," in *Proceedings of SIGGRAPH 2010* (New York: Association for Computing Machinery, 2010), 375–83.

Ben Fry, *Visualizing Data: Exploring and Explaining Data with the Processing Environment* (Sebastopol, CA: O'Reilly Media, Inc., 2008).

Giorgia Lupi, "Data Humanism: The Revolutionary Future of Data Visualization," *Printmag*, January 30, 2017.

Chris McDowall and Tim Denee, *We Are Here: An Atlas of Aotearoa* (Auckland, NZ: Massey University Press, 2019).

Scott Murray, *Creative Coding and Data Visualization with p5.js: Drawing on the Web with JavaScript* (Sebastopol, CA: O'Reilly Media, Inc., 2017).

Gina Neff and Dawn Nafus, *Self-Tracking* (Cambridge, MA: MIT Press, 2016).

Maureen O'Connor, "Heartbreak and the Quantified Selfie," *NY Magazine*, December 2, 2013.

Brooke Singer, "A Chronology of Tactics: Art Tackles Big Data and the Environment," *Big Data and Society* 3, no. 2 (December 2016).

Edward R. Tufte, *The Visual Display of Quantitative Information* (Cheshire, CT: Graphics Press, 2001).

Jacoba Urist, "From Paint to Pixels," *The Atlantic*, May 14, 2015.

Augmented Projection
Illuminated interventions

Brief

Design a projected decal for a physical place or object. Your response could be a time-based display of graphics or video specifically composed to illuminate something *other* than a blank projection screen. Your imagery might relate to (and elicit new meanings from) otherwise banal architectural features in a wall, such as a power outlet, doorknob, water spigot, elevator buttons, or window frame. You might design a projection for a specific object, or, if you are able, for a dynamic site such as a vehicle or a performer's body.

Sketch some poetic or playful concepts for imagery that relates to the geometric, structural, historical, or political features of your site. Create your concept in code, and project your imagery onto your site or object, taking special care to document it. If your design requires precise alignment between virtual and physical spaces, you'll need a tool for projector calibration and keystone correction. Consider libraries like Keystone (for Processing), ofxWarp (for openFrameworks), Cinder-Warping (for Cinder), or software like Millumin or TouchDesigner.

Learning Objectives

- Review techniques for working with projectors
- Employ code and light to create relationships between real and virtual, physical and digital
- Design and realize a site-specific artistic concept or experiment

Variations

- Reinterpret a classic arcade game such as Pong, Snake, Qix, or Pac-Man so that it uses a specific wall as a playing field. Incorporate the wall's windows and other features into the game as obstacles.
- Create an audiovisual presentation in which features of a real environment are activated by colored projections, synchronized to music.
- Create an "in-situ data visualization" that projects information about a site onto that site. This could take the form of a superimposed "x-ray," datagraph, political commentary, etc.
- Use a physics library, such as Box2D, to orchestrate realistic-looking "collisions" between your projected graphics and the actual physical features of your site.
- Give consideration to scale. Small is OK.
- Use computer vision to assist with feature detection, projector calibration, and alignment.
- Create an ecosystem of virtual creatures using simulation principles such as flocking. Have the creatures respond to the features of your chosen wall.

Making It Meaningful

A wide range of new meanings awaits when an illuminated virtual layer is superimposed onto the physical world. Projection can operate as a commentary or a critique, an intervention to probe the historical or political dimensions of a building or monument. In other uses, the projection is a site-specific information visualization, revealing the internal structures of places or objects, the activities that occur in relation to them, or the resources required in their operation. In performance contexts, projections have created new opportunities for responsive set designs, shadow-play, and choreographies of "digital costumes": responsive, projected displays that are tightly coupled to a performer's body and movements. Augmented projections range from spectacular public illusions that make buildings appear to shimmer, to intimate poetic gestures at the scale of the human face.

The key challenge is to create a strongly motivated relationship between real and virtual: between the projected light and the specific person, place, or thing onto which it is projected. Exemplary works accomplish this through a combination of both formal and conceptual engagement with the site. Choices about what to project on, and what to project on it, are made simultaneously.

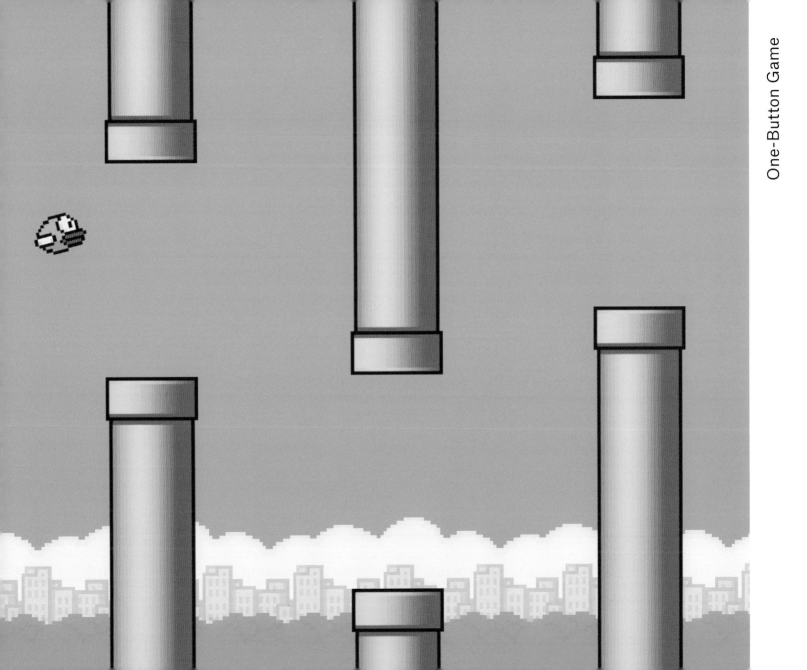

One-Button Game
Designing within tight constraints

Brief
Your challenge is to make a game whose interface is limited to a single button.

A button has two states: pressed and released. How can you design a core game mechanic solely using the changes between these states? These actions could control movement (running, jumping, flying), an action (attacking, transforming), or a change in the environment (gravity, weather, friction). For multiplayer games, your system may use one button per player. You are encouraged to think beyond making a "runner" game—the most common one-button game mechanic, in which the player's avatar jumps over pits and obstacles.

Learning Objectives
• Design and realize a game within tight design constraints
• Discuss, differentiate, and appraise the range of game mechanics possible with a single binary input
• Develop an aesthetic or narrative treatment that supports the play experience

Variations
• Keyboard emulators like the Makey-Makey allow the rapid construction of whimsical button controllers from household materials like bananas and Play-Doh. Using a keyboard emulator, construct a custom game controller that is part of a piece of clothing, furniture, or architecture.

• Convert a classic arcade game into a one-button game by "automating" (eliminating) interactions that are customarily under control of the player. For example, *Space Invaders* uses two sets of controls: one to move the player's laser cannon back and forth, and another to fire at descending aliens. It can be changed into a one-button game by making the cannon move back and forth on an automatic schedule.
• Modify the problem scope so that your game uses continuously valued data from a single sensor, such as a slider, knob, photoresistor, or microphone.

Making It Meaningful
The one-button game belongs to a classic category of games wherein user interaction is limited to a single binary input. As the popularity of *Tiny Wings* and *Flappy Bird* make evident, this category remains more relevant than ever, particularly in the context of small mobile devices. Yet today's bountiful computational resources tend to encourage a focus on sumptuous audiovisuals, making it easy to overlook how strict design constraints can counterintuitively produce engrossing experiences. As Andy Nealen, Adam Saltsman, and Eddy Boxerman have observed, much can be done with simple inputs, narrow decision spaces, and minimal graphics, as they help focus a designer on "the most relevant rules, mechanics and representations of a system, while still providing for an intractably large possibility space."[i]

Despite its minimal affordances, a single button can allow a surprisingly wide range of expressive interactions—and therefore, game design strategies—through the manipulation of timing. The duration of a button press, for example, can be used to regulate the amount of "energy" applied to a virtual game object (such as charging a battery or stretching a slingshot). A game mechanic may operate by counting how often a player presses the button within a unit of time (i.e., taps per second); measuring the precision of the player's rhythmic sensibility (i.e., how accurately they can achieve a pulse of periodic taps); or quantifying the player's feel for timing (whether their button taps are early or late, relative to another game event). Sequences of long and short button presses can even be used to communicate text through Morse code.

The provocative potential of the one-button game is unleashed when the controller is placed deliberately in the world and interpreted in new physical forms. As designers like Kaho Abe, Kurt Bieg, and Ramsey Nasser show, when attached to different parts of the body, novel multiplayer interactions can be choreographed and agilities tested. Taken together, these strategies outline ways in which a designer can savor tight constraints to make compelling and novel game play.

Captions

71. The popular mobile game *Flappy Bird* was released by Dong Nguyen in 2013. Tapping the screen boosts the flight of a small bird, keeping it aloft and helping it avoid obstacles as they scroll by.

72. Artist Rafaël Rozendaal, co-creator of *Finger Battle* (2011), writes: "The game is very simple: two players, tap as fast as you can, the fastest tapper wins." Each player is restricted to tapping in their own zone (blue or red). If a player taps faster than their opponent, their zone grows in size—making it easier to tap the screen, and accelerating the game to its conclusion.

73. In Major Bueno's *Moon Waltz* (2016), a single-button side-scroller, the player does not directly control the main character. Instead, the game's button performs a narrative function in a chain of cause and effect: pressing the button parts the clouds, which reveals the moon, which causes the main character to transform into a werewolf, enabling new modes of attack.

74. Jonathan Rubock's *One Button Nipple Golf* (2016) employs a tap-and-hold interaction and partial automation to control both the orientation and strength of the player's putt. Before the putt, a rotating indicator continually orbits around the tee; the player determines the orientation of their putt from this indicator by deciding when to press the button. The strength of the player's putt is then regulated by how long they hold the button down. The golf course is a landscape of human torsos, in which nipples are the golf holes.

75. Kaho Abe's *Hit Me!* (2011) is a physical, screenless game in which each player wears a button on their head. The objective is to tap your opponent's button before they tap yours.

76. Moving the button to a different location on the body, Kurt Bieg and Ramsey Nasser extend Abe's core game mechanic with richly suggestive play. In *Sword Fight* (2012), each player sports an Atari-style joystick strapped to their groin, with which they attempt to strike their opponent's action button. Awkward hilarity ensues.

Additional Projects

Kaho Abe and Ramsey Nasser, *Shake it Up!*, 2013, two-player physical game.

Atari, *Steeplechase*, 1975, arcade game.

Stéphane Bura, *War and Peace,* 2010, online game.

Peter Calver (Supersoft), *Blitz,* 1979, video game for Commodore.

Bill Gates and Neil Konzen, *DONKEY.BAS*, 1981, video game distributed with the original IBM PC.

Andreas Illiger, *Tiny Wings*, 2011, mobile game.

Kokoromi Collective, *Gamma IV Showcase: One Button Games*, 2009, one-button game competition website.

Konami, *Badlands,* 1984, laserdisc cowboy-themed shooter game.

Paolo Pedercini (Molleindustria), *Flabby Physics,* 2010, online game.

Adam Saltsman (Atomic), *Canabalt,* 2009, video game.

SMG Studio, *One More Line,* 2015, online and mobile game.

Phillipp Stollenmayer, *Zip-Zap*, 2016, mobile game.

Readings

Barrie Ellis, "Physical Barriers in Video Games," OneSwitch.org.uk., accessed April 14, 2020.

Berbank Green, "One Button Games," Gamasutra.com, June 2, 2005.

Paolo Pedercini, syllabi for Experimental Game Design (CMU School of Art, Fall 2010–2020).

Paolo Pedercini, "Two Hundred Fifty Things a Game Designer Should Know," Molleindustria.org, accessed July 20, 2020.

George S. Greene, "Boys Can Have a Carnival of Fun with This Simply Built High Striker," *Popular Science* (September 1933): 59–60.

Katie Salen and Eric Zimmerman, *Rules of Play: Game Design Fundamentals* (Cambridge, MA: MIT Press, 2005).

Notes

i. Andy Nealen, Adam Saltsman, and Eddy Boxerman, "Towards Minimalist Game Design," in *Proceedings of the 6th International Conference on Foundations of Digital Games* (ACM Digital Library, 2011), 38–45.

Art Assignment Bot @artassignbot · 3h
Make an event about trips, due tomorrow.

🔁 1 ♥ 1 •••

Art Assignment Bot @artassignbot · 18m
Produce an assemblage using ranges, due on Tue, Jan 02, 2018.

🔁 1 ♥ 1

Art Assignment Bot @artassignbot · 1h
Make a 3D print using privates, due in 53 minutes.

🔁 1 ♥ 1 •••

Art Assignment Bot @artassignbot · 2h
Produce a website with selfs, due in 58 seconds.

🔁 1 ♥ 1 •••

Art Assignment Bot @artassignbot · 3h
Make a linocut with satellites, due on Mon, Jan 1.

🔁 1 ♥ 3 •••

Art Assignment Bot @artassignbot · 7h
Construct a poster using perforations, due on Mon, Jan 1.

🔁 ♥ 1 •••

Art Assignment Bot @artassignbot · 8h
Construct a durational performance challenging muscles, due on Tue, Jan 02, 2018.

🔁 1 ♥ 1

Art Assignment Bot @artassignbot · 12h
Produce a print analyzing oceans, due tomorrow.

🔁 1 ♥ 2 •••

Art Assignment Bot @artassignbot · 13h
Produce an installation about storms, due in 4 seconds.

🔁 1 ♥ •••

Art Assignment Bot @artassignbot · 14h
Produce an etching using chairpersons, due in 46 seconds.

🔁 1 ♥ •••

Art Assignment Bot @artassignbot · 15h
Produce an oil painting with deletions, due in 24 seconds.

Produce an etching with meats, due in 18 minutes.

🔁 ♥ 2 •••

Art Assignment Bot @artassignbot · 30 Dec 2016
Produce a piece of software with blasts, due in 53 seconds.

🔁 1 ♥ 4 •••

Art Assignment Bot @artassignbot · Jan 1
Produce a piece with lumps, due in 8 seconds.

🔁 ♥ 2 •••

Art Assignment Bot @artassignbot 1 Sep 15
Produce an animated GIF about numbers, due in 19 minutes.

Sophie Houlden
@S0phieH [Follow]

.@artassignbot pic.twitter.com/VzLdTCYlIN
4:23 PM - 1 Sep 2015

🔁 3 ♥ 17

Art Assignment Bot @artassignbot 5 Feb
Make a drawing with apples, due in 30 seconds.

Chad Etzel
@jazzychad [Follow]

.@artassignbot pic.twitter.com/mW56NPY2UN
7:05 PM - 5 Feb 2016

Art Assignment Bot @artassignbot 13 Jul 14
Construct an event of vulnerability, due in 3 minutes.

Liam
@inky [Follow]

@artassignbot AAAAAAAA
10:01 AM - 13 Jul 2014

🔁 1 ♥ 2

Art Assignment Bot @artassignbot 9 Jul
Create a digital collage critiquing runways, due tomorrow.

Maxwell Neely-Cohen
@nhyphenc [Follow]

@artassignbot done pic.twitter.com/0abacdkK6W
4:02 PM - 9 Jul 2016

🔁 ♥ 1

Art Assignment Bot @artassignbot 19 Sep 14
Create a functional object about food, due in 58 seconds.

Ranjit Bhatnagar
@ranjit [Follow]

Eggplant tablet stand DONE! Only 20mn late RT @artassignbot Create a functional object about food, due in 58 seconds. pic.twitter.com/NmEB5tMlgT
1:22 PM - 19 Sep 2014

🔁 2 ♥ 14

Art Assignment Bot @artassignbot 2 Sep 14
Construct a series about gender, due in 6 seconds.

newupdate
@newupdate [Follow]

@artassignbot 😱😱😱😱
11:02 PM - 2 Sep 2014

🔁 ♥ 2

Bot
Autonomous artistic agent

Brief

Create an autonomous software agent, or "bot," that generates posts to an online social media platform at regular intervals. Your bot might generate dialogue, stories, recipes, lies, witty quips, or poems, or it might publish wholly non-textual media such as images, sounds, melodies, comic strips, or animated GIFs. Your project may be a publishing platform, intermittently sharing content to an audience of subscribers, or it may operate as a social actor, interacting directly with other users. It might explore a particular theme, perform a role, communicate an emotional disposition, or promote a specific agenda. Your bot could also work as a filter, by aggregating, republishing, or reinterpreting content from other sources. Explore the different interactions afforded by the API of your chosen platform. The key is that your machine must publicly share its media online, and it must be orchestrated through code.

Some important ground rules apply. Your program may not perform illegal actions. Your program should not spread hate speech (whether purposefully or accidentally), harass people, or make threats. It is wise for your bot to identify itself as an automated process. If you wish your program to interact with real individuals, those persons must first "opt-in" by following your bot. If you disobey this restriction, your project is likely to be short-lived; you risk having your account blocked or terminated *very* quickly.

Learning Objectives

- Design a creative work that uses an API
- Integrate computational techniques for content generation (or filtering) in a social media context
- Differentiate and appraise the aesthetics of systems for generating public performances

Variations

- *For introductory students:* Start by using an online notification service such as If This Then That (IFTTT) to automate online interactions with minimal coding.
- Have your bot reveal something interesting about the API of its online platform.
- Create a bot that responds to an online data stream (such as a newspaper) or that presents items pulled from a cultural archive (such as a museum collection). This will likely require you to negotiate another API in addition to that of your bot's social media platform.

Making It Meaningful

Online bots interact with humans, serve political agendas, broadcast real-time data, and share artistic, literary, and scientific content. Poetic bot-maker Allison Parrish describes her agents as "cute robot explorers" sent to probe (and transmit reports about) unknown territories of "semantic space."[i] For computational artists, social media platforms offer the key mechanism by which a bot's procedurally generated content can be published to willing subscribers. No matter how obscure the bot, there is probably an audience for it.

The use of non-human software agents, once primarily the domain of computer science researchers and artists, is now so prevalent that bots generate a majority of Internet traffic. Search engines use "spider" bots to index the web, while malicious "botnets" conduct coordinated attacks, spread misinformation, sow distrust, and amplify extreme points of view on digital platforms. The ability of chatbots to convincingly simulate conversation, or pass the "Turing test," remains fraught, as demonstrated by the great "bot purges" of 2014-2018. These purges saw social media platforms suspend automated accounts and increase regulation in response to public concern about automated media manipulation impacting real electoral processes and political discourse.

From ELIZA to Alexa, chatbots continue to learn to mimic human communication through interactions with their users, reviving questions like: What areas of our lives should be automated by software? What does it mean to be human? Bots with AI inspire hope and anxiety, dual sentiments that are palpable in fictional depictions like *2001*'s HAL 9000 and Samantha in the movie *Her*.

Reverse OCR

I am a bot that grabs a random word and draws semi-random lines until the OCRad.js library recognizes it as the word.

By Darius Kazemi, creator of Alternate Universe Prompts, Museum Bot, and Scenes from The Wire.

soldier

— 2 days ago

salad

— 3 days ago with 2 notes

Captions

77. Jeff Thompson's *Art Assignment Bot* (2013) generates creative prompts for thousands of followers.

78. The *Ephemerides* (2015) Twitter bot by Allison Parrish publishes pairings of generated poetry and randomly selected NASA images.

79. Everest Pipkin and Loren Schmidt's *Moth Generator* (2015) is a Twitter bot that synthesizes images of imaginary moths, accompanied by generated nomenclatures for each specimen. More than 11,000 people have signed up to receive these "lepidoptera automata."

80. *Reverse OCR* (2014) by Darius Kazemi is a Tumblr bot that selects a random word and draws semi-random lines until an OCR library recognizes the resulting image as that word.

81. The *Random Darknet Shopper* (2014) by !Mediengruppe Bitnik is an automated online shopping bot that spends an allowance of $100 in bitcoins per week on purchases from the Darknet.

82. *CSPAN 5* (2015) by Sam Lavigne is a YouTube bot that automatically edits videos from the C-SPAN channel, reducing them to their most frequent words and phrases.

Additional Projects

Anonymous, *Congress Edits*, 2014, Twitter bot.

American Artist, *Sandy Speaks*, 2017, AI chat platform.

Ranjit Bhatnagar, *Pentametron*, 2012, Twitter bot.

Tega Brain, *Post the Met*, 2014, Craigslist bot.

James Bridle, *Dronestagram*, 2012, social media bots.

George Buckenham, *Cheap Bots, Done Quick!*, 2016, bot-making tool.

Kate Compton, *Tracery*, 2015, generative text-authoring tool.

Voldemars Dudums, *Hungry Birds*, 2011, Twitter bot.

Constant Dullaart, *attention.rip*, 2017, Instagram bot.

shawné michaelain holloway, *~ FAUNE ~* : EDIT FLESH.PNG*, 2013, Tumblr bot.

Surya Mattu, *NY Post Poetics*, 2015, Twitter bot.

Kyle McDonald, *KeyTweeter*, 2010, Twitter bot.

Ramsey Nasser, *Top Gun Bot*, 2014, Twitter bot.

Pall Thayer, *I Am Still Alive*, 2009, Twitter bot.

Thricedotted, *How 2 Sext*, 2014, Twitter bot.

Jia Zhang, *CensusAmericans*, 2015, Twitter bot.

Readings

danah boyd, "What Is the Value of a Bot?," *Points* (blog), datasociety.net, February 25, 2016.

Michael Cook, "A Brief History of the Future of Twitter Bots," GamesbyAngelina.org, updated January 13, 2015.

Madeleine Elish, "On Paying Attention: How to Think about Bots as Social Actors," *Points* (blog), datasociety.net, February 25, 2016.

Lainna Fader, "A Brief Survey of Journalistic Twitter Bot Projects," *Points* (blog), datasociety.net, February 26, 2016.

Jad Krulwich and Robert Krulwich, "Talking to Machines," *Radiolab* (podcast), May 30, 2011.

Rhett Jones, "The 10 Best Twitter Bots That Are Also Net Art," *Animal*, January 9, 2015.

Darius Kazemi, "The Bot Scare," *Notes* (blog), tinysubversions.com, December 31, 2019.

Rachael Graham Lussos, "Twitter Bots as Digital Writing Assignments," *Kairos: A Journal of Rhetoric, Technology, and Pedagogy* 22, no. 2 (Spring 2018), n.p.

Allison Parrish, "Bots: A Definition and Some Historical Threads," *Points* (blog), datasociety.net, February 24, 2016.

James Pennebaker, "The Secret Life of Pronouns," filmed February 2013 in Austin, TX, TED video, 17:58.

Elizaveta Pritychenko, *Twitter Bot Encyclopedia* (self-pub., Post-Digital Publishing Archive, 2014).

Mark Sample, "A Protest Bot Is a Bot So Specific You Can't Mistake It for Bullshit: A Call for Bots of Conviction," Medium.com, updated May 30, 2014.

Saiph Savage, "Activist Bots: Helpful but Missing Human Love?," *Points* (blog), datasociety.net, November 29, 2015.

Jer Thorp, "Art and the API," *blprnt.blg* (blog), blprnt.com, August 6, 2013.

Samuel Woolley et al., "How to Think about Bots," *Points* (blog), datasociety.net, February 24, 2016.

Notes

i. Allison Parrish, "Exploring (Semantic) Space with (Literal) Robots" (lecture, Eyeo Festival, Minneapolis, MN, June 2015).

Collective Memory
Creative crowdsourcing

Brief

Create an online, open system that invites visitors to collaborate on or contribute to a collectively produced media object. Your project should enable its participants to make changes that persist over time for others to experience (and potentially, modify). The result should be a dynamically evolving visual, textual, sonic, or physical artifact that develops from a novel interaction between friends, siblings, collaborators, neighbors, or strangers. Carefully consider the kinds of actions or authorship you hope to elicit, and how the interaction design of your system influences individual (and hence collective) behavior. Paradoxically, the tightest constraints often produce the most interesting results. Can you create the conditions for unexpected emergent behaviors to arise?

The problem of "bootstrapping" sometimes arises in crowdsourced endeavors where it can be challenging to attract the first wave of participants, particularly if the system does not become interesting until there is significant participation. Does your project need an enlistment strategy?

Learning Objectives
- Differentiate and appraise the aesthetics, design, and concept of systems that support collaboration and emergent creative behavior
- Design an interface, balancing constraints and incentives for participation
- Implement fundamental data structures

Variations
- Consider how (or whether) your system scales. Would your project survive "going viral"?
- Implement a form of automated "weathering," in which your system gradually organizes, alters, or prunes its participants' contributions over time.
- Your project may attract trolls, bigots, spammers, bots, vandals, and other visitors acting in bad faith. Be prepared to consider the problem of content moderation (automated or otherwise). Are your users anonymous, or are they somehow accountable?

Making It Meaningful

From wasp nests to Wikipedia, principles of emergence explain how the cumulative contributions of thousands of independent agents can produce sophisticated forms. On the Internet, the art of orchestrating large groups of people is called "crowdsourcing," and the technologies for such information husbandry offer rich opportunities to explore cybernetic concepts like feedback, autopoiesis, and the nuances of collective behavior. The simplest crowdsourcing rulesets can yield a startling glimpse of the consciousness of the global hive-mind, as in Kevan Davis's *Typophile: The Smaller Picture* (2002), or the epic Place experiment on Reddit (2017). It should surprise no one that crowdsourcing may also channel our darkest impulses, as happened with Microsoft's Tay, an AI chatbot that developed offensive speech patterns through conversations with the crowd.

Collectively created artifacts vary considerably. At one extreme are phenomena, like desire paths or the Great Pacific Garbage Patch, that arise as the inadvertent by-products of myriad human actions. "Memory quilts" and traditional folk songs thread together deliberate contributions from many individuals, but are typically structured according to fixed, widely understood cultural idioms (grids, rhyme schemes, etc.). Other collectively authored artifacts aggregate independent contributions through an undirected process of accumulation; examples of such works include cairns, gum walls, "love padlock" bridges, Yayoi Kusama's *Obliteration Room* installation, and, on the Internet, graffiti walls like Drawball and SwarmSketch.

Internet artists have enlisted online participants to collaboratively tend gardens, write poetry, produce drawings, interpret imagery, annotate video, and contribute to historical archives. In the genre of the crowdsourced meta-artwork, the creator defines browser-based interactions that scope a user's creative influence—and then distributes artistic agency to a large, open, and often rapidly evolving group. Success depends on carefully balancing constraints (such as limiting available "ink," or whether or not users are permitted to alter another's contribution) and incentives (such as the opportunity to engage creatively with a favorite song, or participate in a novel creative activity or political action).

typophile: the smaller picture

The collective consciousness of Typophile is attempting to create the letter "**A**".

Should the orange pixel be ...

Black or White ?

There have been 12025 flips to this letter.

> Browse the history of this picture
> View it as an animation.
> Discuss the project.

A B C D E F G H I J K L M N O P Q R S T U V W X Y Z a b c d e f g h i j k l m n o p q r s t u v w x y z 1 2 3 4 5 6 7 8 9 0

v1.1 - Created by Kevan Davis, based on this account of a hive-mind audience.
Feedback and comments to smaller.picture@kevan.org

◁ ⌐ABCDEFGHIJKLMNOPQRSTUVWXYZ ▷
⊞ Uppercase Alphabet: Snapshot updated 1/12/04 10:23PM CST.

Captions

83. In *Exhausting a Crowd* (2015), Kyle McDonald invites online audiences to annotate a 12-hour video recording of a public place with their own observations of the scene. Inspired by Georges Perec's 1974 experimental literary work *An Attempt at Exhausting a Place in Paris*, McDonald opens up a process of close observation to a broad public, crowdsourcing the discovery and preservation of moments that might otherwise go unnoticed.

84. A *cairn* is a human-made pile of stones, often accreted over the course of centuries. Since prehistoric times, these collaboratively produced structures have served as landmarks, trail markers, and memorials.

85. *Telegarden* (1995) by Ken Goldberg and Joseph Santarromana is an interactive networked installation consisting of a garden and a robotic arm. Online visitors view the garden via a webcam, and can plant, water, and tend seedlings by controlling the arm.

86. Roopa Vasudevan's *Sluts across America* (2012) is a compilation of user-submitted messages advocating for reproductive freedoms, geolocated and displayed on a U.S. map.

87. In *Dead Drops* (2010), Aram Bartholl creates an offline file-sharing service by covertly mounting USB storage devices throughout a city. If a passerby connects their computer to one of the USB drives, they can download whatever information prior visitors have contributed, or upload new files of their own.

88. Studio Moniker's *Do Not Touch* (2013) is a crowdsourced music video. Visitors to an interactive web application listen to a song, during which they receive simple instructions on how to move their mouse cursor ("Catch the green dot"). Thus orchestrated, these cursor movements are recorded and then played back in sync with the song.

89. *Typophile: The Smaller Picture* (2002) is a website by Kevan Davis wherein visitors are prompted to contribute to the design of a letterform, such as the letter 'A'. Each visitor's creative options are tightly restricted: their only choice is to decide whether a given pixel, in a 20x20 grid, should be black or white. The letterform's grid is initialized with random noise. Gradually, as members of the crowd contribute decisions about individual pixels, a collectively designed typeface is produced.

90. *Place* (shown here in detail) was a 1000x1000 pixel collaborative canvas hosted on Reddit. During a 72-hour period in April 2017, registered users could edit the canvas by selecting the color of a single pixel from a 16-color palette. Because each user could only alter one pixel every five minutes, crowds developed elaborate methods to collectively draw images, write messages, create flags, and overwrite the contributions of others.

91. For the *Iyapo Repository* (2015), Salome Asega and Ayodamola Okunseinde crowdsource speculations on the future from people of African descent. The artists take the resultant blueprints for cultural technological artifacts, realize them as objects, and acquisition them into the collection.

Additional Projects

Olivier Auber, *Poietic Generator*, 1986, contemplative social network game.

Andrew Badr, *Your World of Text*, 2009, collaborative online text space.

Douglas Davis, *The World's First Collaborative Sentence*, 1994, collaborative online text.

Peter Edmunds, *SwarmSketch*, 2005, collaborative online digital canvas.

Lee Felsenstein, Mark Szpakowski, and Efrem Lipkin, *Community Memory*, 1973, public computerized bulletin board system.

Miranda July and Harrell Fletcher, *Learning to Love You More*, 2002–2009, assignments and crowdsourced responses.

Agnieszka Kurant, *Post-Fordite 2*, 2019, fossilized enamel paint sourced from shuttered car manufacturing plants.

Yayoi Kusama, *The Obliteration Room*, 2002, interactive installation.

Mark Napier, *net.flag*, 2002, online app for flag design.

Yoko Ono, *Wish Tree*, 1996, interactive installation.

Evan Roth, *White Glove Tracking*, 2007, crowdsourced data collection.

Jirō Yoshihara, *Please Draw Freely*, 1956, paint and marker on wood, outdoor Gutai Art Exhibition, Ashiya, Japan.

Readings

Paul Ryan Hiebert, "Crowdsourced Art: When the Masses Play Nice," *Flavorwire*, April 23, 2010.

Kevin Kelly, "Hive Mind," in *Out of Control: The New Biology of Machines, Social Systems, & the Economic World* (New York: Basic Books, 1995).

Ioana Literat, "The Work of Art in the Age of Mediated Participation: Crowdsourced Art and Collective Creativity," *International Journal of Communication* 6 (2012): 2962–2984.

Dan Lockton, Delanie Ricketts, Shruti Chowdhury, and Chang Hee Lee, "Exploring Qualitative Displays and Interfaces" (paper presented at CHI '17: CHI Conference on Human Factors in Computing Systems, Denver, CO, May 2017).

Trent Morse, "All Together Now: Artists and Crowdsourcing," *ARTnews*, September 2, 2014.

Manuela Naveau, *Crowd and Art: Kunst und Partizipation im Internet*, Image 107 (Bielefeld, Germany: Transcript Verlag, 2017).

Howard Rheingold, *Smart Mobs: The Next Social Revolution* (New York: Basic Books, 2002).

Clay Shirky, "Wikipedia – An Unplanned Miracle," *The Guardian*, January 14, 2011.

Carol Strickland, "Crowdsourcing: The Art of a Crowd," *Christian Science Monitor*, January 14, 2011.

"When Pixels Collide," sudoscript.com, 4 April 2017.

Assignments

Experimental Chat
Interrogating "togetherness"

Brief
Design a multi-user environment that allows people in different locations to communicate with each other in a new way. Your system could facilitate language-based interactions like typing, speaking, or reading. Alternatively, it could convey non-verbal aspects of presence, such as gestures or breathing, to explore what Heidegger calls *Dasein*, or "being there together." Carefully consider the agency of participants in your system, and the timing and directionality of their messages. Are the users passive observers, listening to the murmurings of a crowd, or are they contributors to a grand conversation? Is communication asynchronous, wherein a user's traces are encountered by others later? Or is it synchronous, allowing for simultaneous participation in a live event? Is your system intended for one-to-one, one-to-many, many-to-one, or many-to-many?

Learning Objectives
- Differentiate, discuss, and appraise modalities of verbal and non-verbal communication
- Use a server-client model and a library for real-time networked communication
- Develop, design, and realize a concept for a social space

Variations
- Think beyond your laptop: consider the location(s) where your chat system can be situated, the typical activities people do there, and the relationships they may have. Is your

system in a bus station? An orchestra pit? A bedroom? A helmet? Are your participants mutual strangers? Collaborators? Lovers? Parents and their infants?
- Create an environment in which networked users "feel" each other's presence in a novel way.[i]
- Explore the senses. How might your users communicate with colors? Vibrations? Odors?
- Consider asymmetries of time, scale, agency, or ability. Perhaps one user is limited to communicating with a single fingertip, while the other must use their entire body.
- Create a multiuser environment in which one of the "users" is a crowd (such as a Mechanical Turk workgroup), or an artificial intelligence, such as an ELIZA chatbot, a translation service, Apple Siri, or an automated online assistant.
- Develop a MUD (Multi-User Dungeon), a text-based, multiplayer virtual world. Design a fixed lexicon and syntax of commands for your players, and a task or problem that your players must solve using this vocabulary.
- Use your chat system in a live public performance that incorporates scripted or improvised contributions from both local and remote participants.

Making It Meaningful
Electronic networks provide powerful ways of connecting people who are physically separate. The creation of communication tools (and virtual social spaces) has characterized networked computation since its inception, beginning with the CTSS instant messaging feature

(1961), AUTODIN email service (1962), Douglas Engelbart's collaborative real-time text editor (1968), the Talkomatic conferencing system (1973), and multiplayer games like *Colossal Cave Adventure* (1975).

Computational artists and designers have aimed to expand telecommunication beyond the exchange of character symbols into an experience that employs the full sensory and expressive capabilities of our bodies. Myron Krueger's *Videoplace* (1974–1990) and Kit Galloway and Sherrie Rabinowitz's *Hole in Space* (1980) were early systems that took different approaches to full-body telepresence. Today's VR and teledildonics are obvious (and increasingly commercial) extensions of this.

Counterintuitively, some of the most compelling communication systems use strictly limited symbol-sets or rigid constraints on bandwidth. (Consider the telephone, or micro-blogging tools like Twitter.) In the absence of high-resolution sensory information, our imaginations fill in the rest.

ur name: [Tega]

shout in the void [go]

Golan (you)

Tega

POOPCHAT PRO

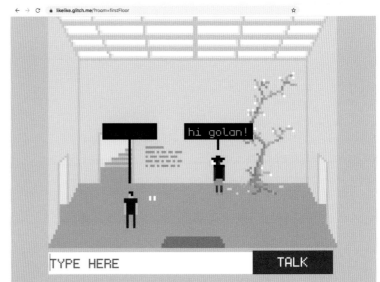

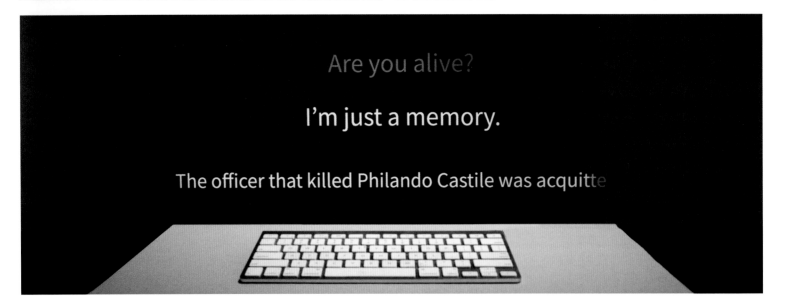

Captions

92. *Hole in Space* (1980), a "communication sculpture" by Kit Galloway and Sherrie Rabinowitz, used live two-way video to connect street-level pedestrians in Los Angeles and New York City.

93. In *The Trace* (1995) by Rafael Lozano-Hemmer, a participant encounters the moving, ghostlike, real-time "presence" of another person, represented by the glowing intersection of a pair of light-beams. The other person is located in an identical but separate room—and perceives the first participant in the same way.

94. *the space between us* (2015) by David Horvitz is a mobile app that connects two people's phones. Once connected, the app displays the distance to and direction of the other person.

95. Scott Snibbe's *Motion Phone* (1995) is a collaborative, multiplayer drawing environment in which participants draw animated forms onto a shared canvas.

96. *Poop Chat Pro* (2016) by Maddy Varner is both a real-time chat space and an asynchronous graffiti wall, in which messages are deposited as quivering animations for others to find later.

97. *Meatspace* (2013) by Jen Fong-Adwent and Soledad Penadés is an ephemeral conversation space in which participants' written messages are accompanied by animated GIF loops, instantaneously captured from their webcams.

98. The *Online Museum of Multiplayer Art* (2020), a virtual wing of Paolo Pedercini's LIKELIKE neo-arcade, features "playful environments that interrogate our notions of mediated sociality and digital embodiment."

Among the museum's many conceptually oriented chat installations is the "Censorship Room" in which "each word can only be uttered once and never again."

99. American Artist's installation *Sandy Speaks* (2017) explores the possibilities of chat from beyond the grave. Using a custom-trained AI chatbot, this project places a visitor in conversation with the real words of Sandra Bland, who discussed racism and police brutality in an extensive series of YouTube videos just weeks before her own death in police custody.

Additional Projects

Olivier Auber, *Poietic Generator*, 1986, contemplative social network game.

Wafaa Bilal, *Domestic Tension*, 2007, interactive video installation.

Black Socialists of America, *BSA's Clapback Chest*, 2019, custom search engine.

Tega Brain and Sam Lavigne, *Smell Dating*, 2016, smell-based dating service.

Jonah Brucker-Cohen, *BumpList*, 2003, email list.

Dries Depoorter and David Surprenant, *Die With Me*, 2018, mobile chat app.

Dinahmoe, *_plink*, 2011, multiplayer online instrument.

Exonemo, *The Internet Bedroom*, 2015, online event.

Zach Gage, *Can We Talk?*, 2011, chat program.

Ken Goldberg and Joseph Santarromana, *Telegarden*, 1995, collaborative garden with industrial robot arm, Ars Electronica Museum, Linz, Austria.

Max Hawkins, *Call in the Night*, 2013, phone call service.

Miranda July, *Somebody*, 2014, messaging service.

Darius Kazemi, *Dolphin Town*, 2017, dolphin-inspired social network.

Myron Krueger, *Videoplace*, 1974–1990, multiuser interactive installation.

Sam Lavigne, Joshua Cohen, Adrian Chen, and Alix Rule, *PCKWCK*, 2015, digital novel written in real time.

John Lewis, *Intralocutor*, 2006, voice-activated installation.

Jillian Mayer, *The Sleep Site, A Place for Online Dreaming*, 2013, website.

Lauren McCarthy, *Social Turkers*, 2013, system for crowdsourced relationship feedback.

Kyle McDonald, *Exhausting a Crowd*, 2015, video with crowdsourced annotations.

László Moholy-Nagy, *Telephone Picture*, 1923, porcelain enamel on steel.

Nontsikelelo Mutiti and Julia Novitch, *Braiding Braiding*, 2015, experimental publishing project.

Jason Rohrer, *Sleep Is Death (Geisterfahrer)*, 2010, two-player storytelling game.

Paul Sermon, *Telematic Dreaming*, 1992, live telematic video installation.

Sokpop Collective, *sok-worlds*, 2020, multiplayer collage.

Tale of Tales, *The Endless Forest*, 2005, multiplayer online role-playing game.

TenthBit Inc., *ThumbKiss* (renamed as the *Couple* app), 2013, mobile messaging app.

Jingwen Zhu, *Real Me*, 2015, chat app with biometric sensors.

Assignments

Readings

Roy Ascott, *Telematic Embrace: Visionary Theories of Art, Technology, and Consciousness*, ed. Edward A. Shanken (Berkeley: University of California Press, 2007).

Lauren McCarthy, syllabus for Conversation and Computation (NYU, Spring 2015).

Joanne McNeil, "Anonymity," in *Lurking: How a Person Became a User* (New York: Macmillan, 2020).

Joana Moll and Andrea Noni, *Critical Interfaces Toolbox* (2016), crit.hangar.org, accessed July 20, 2020.

Kris Paulsen, *Here/There: Telepresence, Touch, and Art at the Interface*. (Cambridge, MA: MIT Press, 2017).

Casey Reas, "Exercises," syllabus for Interactive Environments (UCLA D|MA, Winter 2004).

Notes

i. This variation is adapted from Paolo Pedercini, "Remote Play / Remote Work," syllabus for Experimental Game Design (CMU School of Art, Fall 2020).

Browser Extension
Lens for the Internet

Brief

A *browser extension* is a software add-on that alters the behavior of a web browser application. It can serve as a jumping-off point for creative intervention in the online realm. Extensions can change the appearance of specific online content, add additional information layers, redirect a viewer to different URLs, or change browser behaviors. Popular extensions serve to block ads, obscure the user's identity, circumvent censorship, fact-check politicians, and provide dictionary definitions.

In this assignment, you are asked to design and build a browser extension that alters the appearance of (a part of) the Internet, or that augments, defamiliarizes, or estranges a viewer's browsing experience in a poetic or critical way. Publish your extension to a public platform, such as the Chrome Web Store or the Firefox Add-ons site.

Learning Objectives
- Review protocols for website structure and display
- Identify and creatively experiment with Internet browser functionality and APIs
- Develop a creative browser-based intervention

Variations
- *For introductory students:* Begin by modifying website code in the console of the browser. The styling and content of a page can be temporarily edited by changing the CSS or HTML of a page directly or algorithmically using JavaScript. This exercise introduces students to the console, and to the underlying structure of a website; it can later scaffold the creation of their extension.
- Focus on one specific intervention, such as a text modification, a word or image find-and-replace, a style-based CSS change, or a content augmentation in which an extra layer of information is added to websites.
- Incorporate a regular expression.
- Make an extension that augments the Web through the use of data from an external online API or database.
- Build a plugin that incorporates multiuser functionality, allowing its users to become aware of (or interact with) others using the same extension. This may require the use of WebSockets.

Making It Meaningful

As a window mediates a view of the physical world, the browser mediates the online world of the Internet. Altering this quotidian equipment with a custom extension is a key opportunity for creative play and disruption at both the system level and the content level. Doing so requires direct engagement with the infrastructure and protocols of the browser, a favorite topic of "software studies" scholars like Alexander Galloway, Matthew Fuller, and Wendy Hui Kyong Chun, who aim to lay bare the means by which the Web is constructed and how it shapes our experience of the world.

Some experimental extensions that manipulate the display of everyday content build on ideas from the history of conceptual art, such as the Situationist strategies of defamiliarization and *détournement,* which estrange the mundane and enhance perception of the familiar. Browser extensions can also be vehicles for culture jamming, activism, critical design, and parody, by explicating and revealing otherwise obscure relationships, or by calling attention to or strategically editing political doubletalk, newspeak, dog-whistles, and spin.

Releasing tools can be a form of critical and contextual creative practice. Outlets for the publication of browser extensions, like the Chrome Web Store or the Firefox Add-ons site, powerfully amplify the author's ability to enlist the participation of the public in shaping new power dynamics. That said, these spaces are tightly controlled sandboxes whose terms of service are ultimately aligned with their owners' business model. Projects that challenge the terms of their gatekeepers, such as *AdNauseam* (which falsifies advertising engagement), may be removed or disabled.

Captions

100. Melanie Hoff's *Decodelia* (2016) uses principles of color theory to transform the way a web browser renders pages, making their content legible only to those wearing red-tinted glasses.

101. Jonas Lund's *We See in Every Direction* (2013) connects all of its concurrent users in a collaborative browsing experience.

102. Steve Lambert's *Add Art* (2008) plugin for the Firefox browser automatically replaces online advertisements with art.

103. *Newstweek* (2011) by Julian Oliver and Danja Vasiliev is a custom Internet router that enables the artists to alter how news websites appear to other people on their WiFi network.

104. *Us+* (2013) by Lauren McCarthy and Kyle Mcdonald is a dystopian add-on for Google's video chat software. Using facial analysis, speech-to-text, and natural language processing, the *Us+* software analyzes the users' conversation and attempts to offer suggestions for improving their interaction.

Additional Projects

Todd Anderson, *Hitchhiker*, 2020, browser extension for live performance.

American Artist, *Looted,* 2020, website intervention.

BookIndy, *BookIndy: Browse Amazon, Buy Local*, 2015, browser extension.

Allison Burtch, *Internet Illuminator*, 2014, browser extension.

Brian House, *Tanglr*, 2013, browser extension.

Daniel C. Howe, Helen Nissenbaum, and Vincent Toubiana, *TrackMeNot*, 2006, browser extension.

Daniel C. Howe, Helen Nissenbaum, and Mushon Zer-Aviv, *AdNauseam*, 2014, browser extension.

Darius Kazemi, *Ethical Ad Blocker*, 2015, browser extension.

Surya Mattu and Kashmir Hill, *People You May Know Inspector*, 2018, app.

Joanne McNeil, *Emotional Labor*, 2015, browser extension.

Dan Phiffer and Mushon Zer-Aviv, *ShiftSpace*, 2007, browser extension.

Radical Software Group, *Carnivore*, 2001, Processing library.

Sara Rothberg, *Scroll-o-meter*, 2015, browser extension.

Rafaël Rozendaal, *Abstract Browsing*, 2014, browser extension.

Joel Simon, *FB Graffiti*, 2014, browser extension.

Sunlight Foundation, *Influence Explorer*, 2013, browser extension.

The Yes Men et al., *The New York Times Special Edition*, November 2008, website.

Readings

Guy Debord and Gil J. Wolman, "A User's Guide to Détournement," trans. Ken Knabb, *Les Lèvres Nues* no. 8 (May 1956).

Alexander Galloway, "Protocol: How Control Exists after Decentralization," *Rethinking Marxism* 13, nos. 3–4 (Fall–Winter 2001): 81–88.

Joana Moll and Andrea Noni, *Critical Interfaces Toolbox* (2016), crit.hangar.org, accessed July 20, 2020.

Rhizome.org, "Net Art Anthology," accessed April 11, 2019.

Aja Romano, "How Your Web Browser Affects Your Online Reality, Explained in One Image," *Vox*, May 3, 2018.

Creative Cryptography
Poetic encodings

Brief

Create a digital system that encodes a message into a media object, and also provides a means of decoding it. Your system should be designed to hide information in plain sight—within images, text, video, sound, or physical forms. Think carefully about the specific information your system is designed to encode, and the significance of the relationship between this information and the medium that contains it. You may choose to encode text, data, code, images, music, or other information of your choosing. Present one or more examples of your system in use. This assignment can be tailored to focus on *steganography* (the act of hiding a message in another medium) or *cryptography* (the act of encoding a message).

Learning Objectives

· Review common steganographic and cryptographic techniques
· Apply methods for working with data like compression, encoding, and decoding
· Explore conceptual and poetic possibilities of encoding and translation

Variations

· Add layers of encryption into your system for added security or poetry.
· Consider different constraints that might determine the encoding technique you develop. For example, if your means of transmission is extremely low bandwidth (as was the case when Morse code was developed), your system will be shaped by this parameter. The encoding method could also constrain your message to be perceived in one sensory domain (e.g., hearing, sight, or touch) as is the case with Braille or sign languages.

Making It Meaningful

The advent of the written word created a need for secure communications, both for those in power and those who would oppose them. This need for secure messaging has long inspired techniques of cryptography, defined as the encoding of messages. Some historic cryptographic approaches rely on the use of pre-computational devices like the decoding wheel, the Polybius square, and the Enigma machine, while others use simple ciphers like the pigpen cipher, Morse code, Braille, or ROT13. For children, there can be a wholesome joy in exchanging secret messages with one's friends, and a thrill in the effort of unlocking and revealing them.

Steganography is the special cryptographic technique of concealing information within another media format. Early cryptographers like Sir Francis Bacon and William Friedman were fond of steganography, building systems to hide messages in music scores, photographs, and even flower arrangements. Digital technologies offer many possibilities for creative steganography. Unused pixels or bytes in files can be filled with invisible information, data can be transcoded into different media, and (as with acrostics) messages can be distributed across huge volumes of online communications.

The 2013 Snowden revelations confirmed that the US government was recording the online communications of the American public, and produced a collective realization that unencrypted communications across digital networks are inherently insecure. On the Internet, it is impossible to know if communications are intercepted, making the development of practical and reliable cryptographic technologies an ongoing urgent challenge.

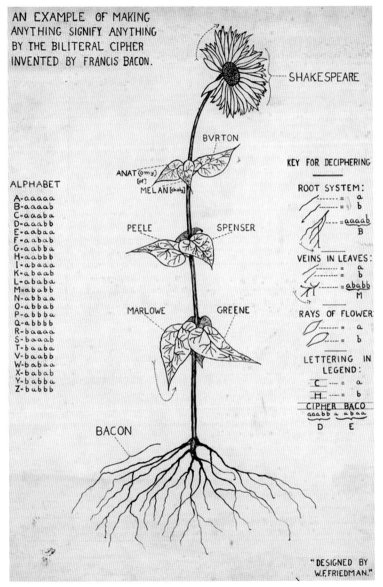

AN EXAMPLE OF MAKING ANYTHING SIGNIFY ANYTHING BY THE BILITERAL CIPHER INVENTED BY FRANCIS BACON.

SHAKESPEARE

BVRTON

ANAT(omy) [of] MELAN(choly)

PEELE SPENSER

MARLOWE GREENE

BACON

ALPHABET

A-aaaaa
B-aaaab
C-aaaba
D-aaabb
E-aabaa
F-aabab
G-aabba
H-aabbb
I-abaaa
K-abaab
L-ababa
M-ababb
N-abbaa
O-abbab
P-abbba
Q-abbbb
R-baaaa
S-baaab
T-baaba
V-baabb
W-babaa
X-babab
Y-babba
Z-babbb

KEY FOR DECIPHERING

ROOT SYSTEM:
= a
= b
= aaaab
B

VEINS IN LEAVES:
= a
= b
= ababb
M

RAYS OF FLOWER
= a
= b

LETTERING IN LEGEND:
C = a
H = b

CIPHER BACO
aaabb a abaa
D E

"DESIGNED BY W.F.FRIEDMAN."

Captions

105. Amy Suo Wu's *Thunderclap* (2017) employs steganography to distribute the suppressed work of Chinese anarcho-feminist He-Yin Zhen (1886–1920) through the medium of clothing accessories. The work co-opts shanzhai fashion (a style featuring nonsense English), together with QR codes, as a covert system to publish subversive writings for a Chinese context.

106. A botanical drawing of a flower by William and Elizebeth Friedman (1916) uses a bilateral cipher invented by Francis Bacon to encode "BACON" in the roots and the names of Elizabethan authors and books in the leaves.

107. Maddy Varner's *KARDASHIAN KRYPT* (2014) is a steganographic Chrome extension that covertly encodes messages into (and decodes messages from) photographs of Kim Kardashian. The low-order bits of the image shown here contain text from "A Room of One's Own" by Virginia Woolf.

108. *Block Bills* (2017) by Matthias Dörfelt (Moka) is a collection of 64 banknote designs generated from the Bitcoin blockchain.

109. In *Disarming Corruptor*, Matthew Plummer-Fernández presents a reversible algorithm for corrupting 3D CAD files. The artist's software twists 3D meshes into illegible configurations, helping users circumvent surveillance and other limitations on file-sharing.

110. *Biopresence* (2005) by Shiho Fukuhara and Georg Tremmel, a collaboration with scientist Joe Davis, uses Davis's DNA Manifold algorithm to transcode human DNA into the DNA of a tree.

111. The *Talking Popcorn* installation by Nina Katchadourian (2001) uses a Morse code decoder to interpret messages "spoken" by a popcorn machine.

112. Each copy of *Notepad* (2007) by Matt Kenyon and Douglas Easterly resembles a standard yellow legal pad. The ruled lines on its pages, however, actually consist of microprinted text with the full names, dates, and locations of each Iraqi civilian death on record from the first three years of the Iraq War. One hundred copies of *Notepad* were covertly distributed to US senators and representatives, to help ensure that the names of Iraqi civilians would be memorialized in official US archives.

Additional Projects

Anonymous, *Genecoin*, 2014, system for encoding human DNA in Bitcoin.

Aram Bartholl, *Keepalive,* 2015, fire-powered network.

Liat Berdugo, Sam Kronick, Ben Lotan, and Tara Shi, *Encoded Forest*, 2016, passwords stored in tree-planting patterns.

Ingrid Burrington, *Secret Device for Remote Locations*, 2011, solar-powered Morse code message.

"Ciphers, Codes, & Steganography," 2014, Folger Shakespeare Library exhibition.

Cryptoart Publishers, *Cryptoart*, 2020, system for storing Bitcoin in physical art.

Heather Dewey-Hagborg, *How Do You See Me?*, 2019, self-portraits generated via adversarial processes.

Henry Fountain, "Hiding Secret Messages Within Human Code," *The New York Times*, June 22, 1999.

Eduardo Kac, *Genesis*, 1999, biblical passage encoded in DNA.

Sam Lavigne, Aaron Cantu, and Brian Clifton, *You Can Encrypt Your Face,* 2017, face masks.

Lindsay Maizland, "Britney Spears's Instagram Is Secretly Being Used by Russian Hackers," *Vox*, June 8, 2017.

Julian Oliver, *The Orchid Project*, 2015, photographs with encoded firmware.

Everest Pipkin, *Ladder*, 2019, encoded poem.

Readings

Florian Cramer, *Hiding in Plain Sight: Amy Suo Wu's* The Kandinsky Collective (Ljubljana, Slovenia: Aksioma Institute for Contemporary Art, 2017), e-brochure.

Manmohan Kaur, "Cryptography as a Pedagogical Tool," *Primus* 18, no. 2 (2008): 198–206.

Neal Koblitz, "Cryptography as a Teaching Tool," *Cryptologia* 21, no. 4 (1997): 317–326.

Susan Kuchera, "The Weavers and Their Information Webs: Steganography in the Textile Arts," *Ada: A Journal of Gender, New Media, and Technology* 13 (May 2018).

Shannon Mattern, "Encrypted Repositories: Techniques of Secret Storage, From Desks to Databases," *Amodern* 9 (April 2020).

Jussi Parikka, "Hidden in Plain Sight: The Steganographic Image," unthinking. photography, February 2017.

Charles Petzold, *Code: The Hidden Language of Computer Hardware and Software* (Hoboken, NJ: Microsoft Press, 2000).

Phillip Rogaway, "The Moral Character of Cryptographic Work" (paper presented at Asiacrypt 2015, Auckland, NZ, December 2015).

Simon Singh, "Chamber Guide," The Black Chamber (website), accessed April 12, 2020.

Hito Steyerl, "A Sea of Data: Apophenia and Pattern (Mis-) Recognition," *e-flux Journal* 72 (2016).

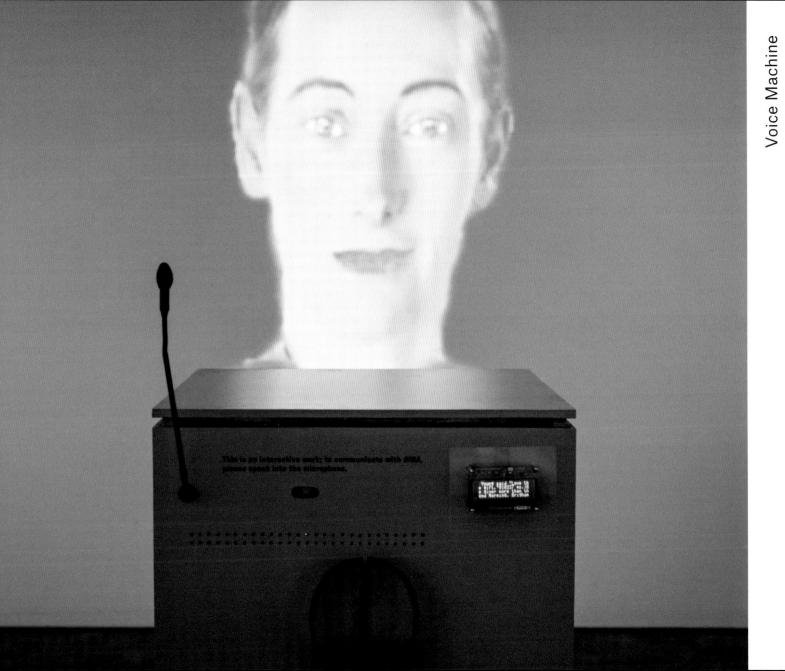

Voice Machine
Spoken word and voice play

Brief

Create an interactive chatbot, eccentric virtual character, or spoken word game centered around computing with speech input and/or speech output. For example, you might make a rhyming game or memory challenge; a voice-controlled book; a voice-controlled painting tool; a text adventure; or an oracular interlocutor (think: Monty Python's Keeper of the Bridge of Death). Consider the creative affordances of using a tightly restricted vocabulary as well as the dramatic potential of rhythm, intonation, and volume of speech. Keep in mind that speech recognition is error-prone, so find ways to embrace the lag and the glitches—at least, for another couple of years. Graphics are optional.

Learning Objectives
- Discuss and explore the expressive possibilities of working with voice and language as a creative medium
- Apply a toolkit for speech recognition and/or speech synthesis
- Design, advance, and execute a concept for a creative work with a voice interface

Variations
- Add speech interactions to an appliance or everyday object. What if your toaster could talk?
- Recall your favorite road-trip word games. Create a competitive, multiplayer speech game in which the computer is the referee.
- Appropriate or subvert a commercial voice assistant as a readymade for a performance.

- Take inspiration from the ways in which pets and babies use speech—often inferring meaning from the tone or prosody of a voice, rather than the words that are spoken. For example, you might make an interactive babbling machine, or a virtual pet that responds to your intonation.

Making It Meaningful

The capacity to speak has long been perceived as a sign of intelligence. For this reason, machines that speak can seem uncanny or even supernatural, as they decouple ancient bindings between voice, living matter, and intelligence. In the field of interaction design, voice interfaces are thought to make technologies more intuitive and accessible than their visual or typographic counterparts—but such anthropomorphized machines do this at the expense of our ability to accurately estimate how much they actually "understand."

In a conversation, information is transmitted and received on multiple registers—in not only what is said, but also how it is delivered, and by whom. We have exquisitely tuned capacities for inferring contextual information like emotion, gender, age, health, and socioeconomic status from a speaking voice. Intonation, rhythm, pace, and rhyme are also used to create drama, suspense, sarcasm, and humor. When creating new experiences through speech, simple operations may be the most generative. For example, a vast range of meanings can arise just from altering the emphasis of words in a sentence.

Speech has a key paralinguistic social role. Through chit-chat and banter we establish trust, build relations, and create intimacy. Wordplay, punnery, and other playful verbal exchanges create a protected space for this social activity by exploiting ambiguities in the rules of language itself. Culture is embedded and propagated in the protocols of knock-knock jokes, call-and-response songs, and once-upon-a-time fairy tales. These rule-based media lend themselves well to creative manipulation with code. Some potentially helpful tools to algorithmically generate speech include context-free grammars, Markov chains, recurrent neural nets (RNN), and long short-term memory (LSTM) systems. *Note that some commercial speech analysis tools transmit the users' voice data to the cloud, raising issues of data ownership and privacy.*

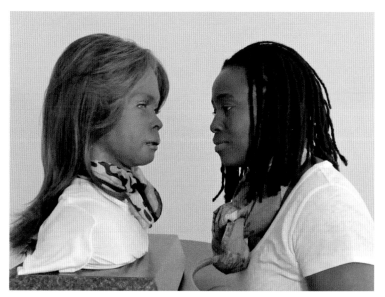

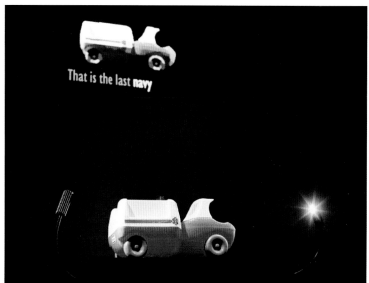

☎ TELEPHONEGRAM *"The Game of Phones"* <u>Over 300 games played!</u>

TELEPHONEGRAM is a service that sends your voice messages by passing them through a round of the classic children's game of telephone.

Read about the latest updates <u>on the blog.</u>

▶ Game #439: **<u>Old Acquaintances Edition</u>** < ? >

47 participants played from December 31 2014 11:45 AM to March 6 2020 6:27 PM

The Operator	Emelie Hegarty	Kate Sweater	Blair Neal	
Fernando The Cat	JM Imbrescia	Dan Winckler	Dennis Collective	
Mike Bullock	Jedahan	Elizabeth Press	Josh Goldberg	Lisa Rogers
Mike Bullock	Cash 4 Gold	Caitlin Foley	Ngoc Cong	Lisa Rogers
Tamer	Owen Bush	Jesse Stiles	Cash 4 Gold	Mark Graveline
Dan Winckler	Chucks Larms	Elizabeth Press	Blair Neal	Guy Schaffer
MOUNTAIN OF WAFFLES!	Nick Teeple	Imanol Gomez	Danielle Furfaro	
Lisa Rogers	Andrew Lynn	Josh Goldberg	Aaron	Thom Stylinski
Kevin Luddy	Cash 4 Gold	Jesse Stiles	Emelie Hegarty	
A damn Gross man	Misha Rabinovich	Imanol Gomez	Nick Teeple	
Tamer	il young son			

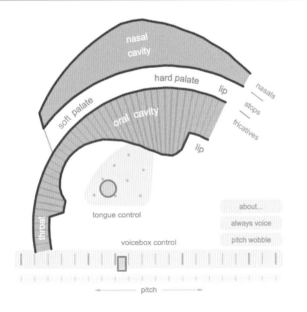

| 113 | | 114 | 116 | | 118 | 120 |
| | | 115 | 117 | | 119 | 121 |

Captions

113. Lynn Hershman Leeson's *DiNA, Artificial Intelligent Agent Installation* (2002–2004) is an animated, artificially intelligent female character with speech recognition and expressive facial gestures. DiNA converses with gallery guests, generating answers to questions and becoming "increasingly intelligent through interaction."

114. In *Conversations with Bina48* (2014), Stephanie Dinkins performs improvised conversations about algorithmic bias with BINA48, a chatbot-enabled face robot. BINA48 was commissioned by entrepreneur Martine Rothblatt, and constructed by roboticist David Hanson, to resemble Rothblatt's wife Bina.

115. *Hey Robot* (2019) by Everybody House Games is a game in which teams compete to make a smart home assistant (such as Amazon Alexa or Google Home) say specific words.

116. In David Rokeby's *The Giver of Names* (1991–1997), a camera detects objects placed on a pedestal by members of the audience. A computerized voice then describes what it sees—with strange, uncanny, and often poetic results.

117. *When Things Talk Back* (2018), by Roi Lev and Anastasis Germanidis, is a mobile AR app that gives voice to everyday objects. The software automatically identifies objects observed by the system's camera, and anthropomorphizes them with AR overlays of simple faces. It then uses ConceptNet, a freely available semantic network, to retrieve information about the objects and their possible interrelationships. The app uses this information to generate humorous and sometimes poignant conversations between the objects in the scene.

118. David Lublin's *Game of Phones* (2012) is "the children's game of telephone, played by telephone." Players receive a phone call and hear a prerecorded message left by the previous player; they are then prompted to re-record what they recall hearing for the next person in the queue. After a week, the entire chain of messages is published online.

119. Neil Thapen's playful *Pink Trombone* (2017) is an interactive articulatory speech synthesizer for "bare-handed speech synthesis." Using a richly instrumented simulation of the human vocal tract, the project enables a wide range of vocal noisemaking in the browser.

120. Kelly Dobson's *Blendie* (2003–2004) is a 1950s Osterizer blender, adapted to respond empathetically to a user's voice. A person induces the blender to spin by vocalizing. *Blendie* then mechanically mimics the person's pitch and power level, from a low growl to a screaming howl.

121. In Nicole He's speech-driven forensics game, *ENHANCE.COMPUTER* (2018), players yell out commands like "Enhance!"—living out a science-fiction fantasy of infinitely zoomable images.

Additional Projects

Tim Anderson, Marc Blank, Bruce Daniels, and Dave Lebling, *Zork*, 1977–1979, interactive text-based computer game.

Isaac Blankensmith with Smooth Technology, *Paper Signals*, 2017, system for making voice-controlled paper objects.

Mike Bodge, *Meme Buddy*, 2017, voice-driven app for generating memes.

Stephanie Dinkins, *Not The Only One*, 2017–2019, voice-driven sculpture trained on oral histories.

Homer Dudley, *The Voder*, 1939, device to electronically synthesize human speech.

Ken Feingold, *If/Then*, 2001, sculptural installation with generated dialogue.

Sidney Fels and Geoff Hinton, *Glove Talk II*, 1998, neural network-driven interface translating gesture to speech.

Wesley Goatly, *Chthonic Rites*, 2020, narrative installation with Alexa and Siri.

Suzanne Kite, *Íŋyaŋ Iyé (Telling Rock)*, 2019, voice-activated installation.

Jürg Lehni, *Apple Talk*, 2002–2007, computer interaction via text to speech and voice recognition software.

Golan Levin and Zach Lieberman, *Hidden Worlds of Noise and Voice*, 2002, sound-activated augmented reality installation, Ars Electronica Futurelab, Linz.

Golan Levin and Zach Lieberman with Jaap Blonk and Joan La Barbara, *Messa di Voce*, 2003, voice-driven performance with projection.

Rafael Lozano-Hemmer, *Voice Tunnel*, 2013, large-scale interactive installation in the Park Avenue Tunnel, New York City.

Lauren McCarthy, *Conversacube*, 2010, interactive conversation-steering devices.

Lauren McCarthy, *LAUREN*, 2017, smart home performance.

Ben Rubin and Mark Hansen, *Listening Post*, 2002, installation displaying and voicing real-time chatroom utterances.

Harpreet Sareen, *Project Oasis*, 2018, interactive weather visualization and self-sustaining plant ecosystem.

Superflux, *Our Friends Electric*, 2017, film.

Joseph Weizenbaum, *ELIZA*, 1964, natural language processing program.

Readings

Zed Adams and Shannon Mattern, "April 2: Contemporary Vocal Interfaces," readings from Thinking through Interfaces (The New School, Spring 2019).

Takayuki Arai et al., "Hands-On Speech Science Exhibition for Children at a Science Museum" (paper presented at WOCCI 2012, Portland, OR, September 2012).

Melissa Brinks, "The Weird and Wonderful World of Nicole He's Technological Art," *Forbes*, October 29, 2018.

Geoff Cox and Christopher Alex McLean, "Vocable Code," in *Speaking Code: Coding as Aesthetic and Political Expression* (Cambridge, MA: MIT Press, 2013), 18–38.

Stephanie Dinkins, "Five Artificial Intelligence Insiders in Their Own Words," *New York Times*, October 19, 2018.

Andrea L. Guzman, "Voices in and of the Machine: Source Orientation toward Mobile Virtual Assistants," *Computers in Human Behavior* 90 (2019): 343–350.

Nicole He, "Fifteen Unconventional Uses of Voice Technology," Medium.com, November 26, 2018.

Nicole He, "Talking to Computers" (lecture, awwwards conference, New York, NY, November 28, 2018).

Halcyon M. Lawrence, "Inauthentically Speaking: Speech Technology, Accent Bias and Digital Imperialism" (lecture, SIGCIS Command Lines: Software, Power & Performance, Mountain View, CA, March 2017), video, 1:26–17:16.

Halcyon M. Lawrence and Lauren Neefe, "When I Talk to Siri," *TechStyle: Flash Readings* 4 (podcast), September 6, 2017, 10:14.

Shannon Mattern, "Urban Auscultation; or, Perceiving the Action of the Heart," *Places Journal*, April 2020.

Mara Mills, "Media and Prosthesis: The Vocoder, the Artificial Larynx, and the History of Signal Processing," *Qui Parle: Critical Humanities and Social Sciences* 21, no. 1 (2012): 107–149.

Danielle Van Jaarsveld and Winifred Poster, "Call Centers: Emotional Labor over the Phone," in *Emotional Labor in the 21st Century: Diverse Perspectives on Emotion Regulation at Work*, ed. Alicia A. Grandey, James M. Diefendorff, and Deborah E. Rupp (New York: Routledge, 2012): 153–73.

"Vocal Vowels," Exploratorium Online Exhibits, accessed April 14, 2020.

Adelheid Voshkul, "Humans, Machines, and Conversations: An Ethnographic Study of the Making of Automatic Speech Recognition Technologies," *Social Studies of Science* 34, no. 3 (2004).

Measuring Device
Sensing as a critical and creative act

Brief

Create a machine that asks a question of the world. Your machine should either measure something interesting, measure something in an interesting way, or create an interesting provocation by bringing an uncommon measurement to our attention. The focus here is on the selection and collection of intriguing data (using a microcontroller and a sensor), rather than on the production of an attractive interpretation or visualization. What overlooked dynamics or invisible rhythms can you discover?

Your project's location is critically important: the situation of your device will affect who encounters it, how it is perceived, and the meanings it evokes. It's up to you whether your device measures human activity or the activity of something else in the environment (cars, animals, lights, doors, etc.) Consider if you are measuring ambient, incidental, or deliberate activity, and whether or not your device is passive or actively used. Be sure to make a video documenting your measurement device at the data collection point. Although you may use any sensor you like, remember that even a humble switch is a sensor—and that some switches, like tilt-switches, can measure inadvertent movements in the world. Likewise, having a proximity sensor doesn't mean you have to measure proximity. Instead, you might measure the amount of time that something is proximal to the sensor (recording seconds, not centimeters). Or perhaps you might count the number of times that something has come close to the sensor.

Sometimes, student electronics projects can look suspicious. If you install your device in a public place, be sure to secure necessary permissions (such as from your campus safety officer), and attach a small sign to your device with appropriate information.

Learning Objectives

- Review and critique methods for collecting data
- Experiment with social, performative, and sculptural modes of data presentation
- Assemble and install sensor hardware

Variations

- Restrict data collection to a specific site, such as the classroom or a nearby park.
- Provide students with a screen or other display, such as a multi-digit 7-segment LED, so they can represent their sensor readings at the site of data collection—creating the potential for public interaction and additional poignance.

Making It Meaningful

Census historian James C. Scott points out that measurement is a political act. Artists like Natalie Jeremijenko collect measurements in order to prompt evidence-driven discussion; others, like Mimi Onuoha, point out that what is *not* measured is equally revealing of a culture's biases and indifferences (the study of which is called *agnotology*). In the weird world of quantum physics, the term "observer effect" refers to the idea that the very act of measurement changes the subject being measured. Measurement, or the collection of data, alters the world and the way we see it.

Data collection has become a key practice across many fields. "Citizen science" is an educational and political movement that enlists everyday people in scientific activities and often focuses on monitoring local environmental conditions through distributed DIY sensing. For example, in the aftermath of the Fukushima disaster, radiation sensors were distributed to a concerned public, who transmitted readings to a central server.

Scholars Catherine D'Ignazio and Lauren Klein outline ways to responsibly work with data, taking philosophical ideas from feminist thought and applying them to data collection and visualization practices. The principles of feminist data visualization include acknowledging that data represents an incomplete perspective; emphasizing the context and the situation in which data was collected; and providing a way for those represented in the data to respond to it.

There is often something absurd, poignant, or whimsically futile about the act of measurement —an attempt to reduce an infinitely complex experience to a handful of numbers. In the arts, measurement can explicitly remind us that our understanding of reality is only ever an approximation.

The diagram at the top of the page shows boxes labeled: 122, 123, 124, 125, 126, 127, 128

Captions

122. Presented as a device for measuring the hypothetical "Despondency Index" of a given locale, Natalie Jeremijenko and Kate Rich's *Suicide Box* (1996) nevertheless records very real data regarding suicide jumpers from the Golden Gate Bridge.

123. *The Deep Sweep* (2015) by the Critical Engineering Working Group is an aerospace probe that scans the otherwise out-of-reach signal space between land and stratosphere.

124. Maddy Varner's *This or That* (2013), a "DIY voting poster," is a student project made from paper-mounted electronics. A passerby taps sticky notes to vote between two options (e.g., "cats" versus "dogs") proposed by other strangers.

125. Michelle Ma's *Revolving Games* (2013), another student project, measures the speed of a revolving door with an accelerometer, then displays the high score on an LED. Ma's game encourages risk-taking in an otherwise quotidian setting.

126. Catherine D'Ignazio's *Babbling Brook* (2014) is a red networked flower sculpture containing water quality sensors. The flower is installed outdoors in a creek or stream and audibly reports its data in the form of bad jokes to anyone listening.

127. In *Picture Sky* (2015), Karolina Sobecka and Christopher Baker coordinate groups of people to take photographs of the sky at the same moment that a satellite captures an image from above.

128. *Library of Missing Datasets* (2016) by Mimi Onuoha is a systematized archive of hypothetical datasets. These data voids stand as potent reminders of what a society chooses to ignore or overlook.

Additional Projects

Timo Arnall, *Immaterials: Ghost in the Field*, 2009, RFID probe, long-exposure photography, and animation.

Timo Arnall, Jørn Knutsen, and Einar Sneve Martinussen, *Immaterials: Light Painting WiFi*, 2011, WiFi network sensor, LED lights, and long-exposure photography.

Tega Brain, *What the Frog's Nose Tells the Frog's Brain*, 2012, custom fragrance, electronics, and home energy monitor.

Centre for Genomic Gastronomy, *Smog Tasting*, 2015, air samples, experimental food cart, and smog recipe.

Hans Haacke, *Condensation Cube*, 1963–1965, kinetic sculpture.

Terike Hapooje, *Dialogue*, 2008, real-time video of thermal camera imagery.

Usman Haque, *Natural Fuse,* 2009, network of electronically assisted plants.

Joyce Hinterding, *Simple Forces*, 2012, conductive graphite drawing and analog electronics.

Osman Khan, *Net Worth*, 2006, magnetic card reader, custom software, and interactive installation.

Stacey Kuznetsov, Jian Cheung, George Davis, and Eric Paulos, *Air Quality Balloons*, 2011, air quality sensors, microelectronics, and weather balloons.

Rafael Lozano-Hemmer, *Pulse Room*, 2006, interactive installation with heart-rate sensors activating an array of incandescent light bulbs.

Rafael Lozano-Hemmer, *Tape Recorders*, 2011, interactive installation with sensors and robotically activated measuring tapes.

Agnes Meyer-Brandis, *Teacup Tools*, 2014, tea cups and atmospheric sensors.

Joana Moll, *CO2GLE*, 2015, online carbon calculator.

Joana Moll, *DEFOOOOOOOOOOOOOOOO-OOOOOOREST*, 2016, online visualization.

Moon Ribas, *Seismic Sensor*, 2007–2019, seismic-sensing body implants.

Anri Sala, *Why the Lion Roars*, 2020, temperature-based editor of feature films.

Julijonas Urbonas, *Counting Door*, 2009, modified video camera and door that tracks its visitor count.

Readings

Benjamin H. Bratton and Natalie Jeremijenko, *Suspicious Images, Latent Interfaces* (New York: Architectural League of New York, 2008).

Catherine D'Ignazio and Lauren F. Klein, "On Rational, Scientific, Objective Viewpoints from Mythical, Imaginary, Impossible Standpoints," in *Data Feminism* (Cambridge, MA: MIT Press, 2020).

Jennifer Gabrys, "How to Connect Sensors" and "How to Devise Instruments," in *How to Do Things with Sensors* (Minneapolis: University of Minnesota Press, 2019), 29–71.

Natalie Jeremijenko, "A Futureproofed Power Meter," *Whole Earth*, Summer 2001.

Mimi Onuoha, "When Proof Is Not Enough," *FiveThirtyEight* (blog), ABC News Internet Ventures, July 1, 2020.

James C. Scott, *Seeing like a State: How Certain Schemes to Improve the Human Condition Have Failed* (New Haven: Yale University Press, 1998).

Assignments

Personal Prosthetic
A new verb for the body

Brief

Design a prosthetic device that responds to its wearer's behavior or environment, enabling "a new verb for the body." Your device should sense something (movement, sound, temperature, online data), possibly with the aid of machine learning, and produce an electromechanical action or result in response. Make a video of your prosthetic in use. Your video could be candid, documenting your work in a public location, or it could be staged to tell the narrative of your work.

Marshall McLuhan considered all technologies to be an extension of the human body, arguing that in one way or another they serve to amplify or accelerate existing physical faculties or cognitive functions. Use McLuhan's terminology to discuss your project: is your wearable a physical, cognitive, or communicative extension of the body? What does your prosthetic augment, replace, constrain, assist, reinforce, signal, reveal, communicate, strengthen, amplify, or diminish?

Learning Objectives

- Review, discuss, and appraise the design of wearable technologies
- Generate and critique design concepts spanning interaction design, performance art, fashion, and biomimetics
- Design a physical computing system that combines sensors, actuators, and microcontrollers (such as an Arduino) into interactive electronic circuits

Variations

- Constrain your response to a single type of action, such as a physical gesture.
- Design a biomimetic prosthetic, inspired by an animal. What new power does it lend to the wearer?
- Design for one has often resulted in design for many. Pick a specific person. Interview them about their habits, and observe their daily routine. Create a prosthetic device just for them.
- Subvert individualism: design a prosthetic device that two or more people wear together.
- Suppose, through the wearable, that your body is connected to the Internet. What signal should your body communicate? With whom?
- Omit the sensor. Instead, make a preexisting dataset experienceable (or performable).
- *Instructors: Ask your students to present their prosthetics in a fashion show.*

Making It Meaningful

Prosthetics are any artificial additions to the body. They are used in a wide range of contexts, including medicine, combat, fitness, theater, and fashion. Many people's daily attire includes prosthetics that enhance bodily functions, including perception (such as eyeglasses and hearing aids) and mobility (such as walking canes and inline skates), or that protect the body from the environment (e.g., shoes, helmets, respirators, knee pads). Jewelry can be understood as "social prostheses," operating as markers of social status, signifiers of gender or community affiliations, tools of beautification, carriers of personal meaning, or (as with amulets and phylactery) talismanic protection.

Increasingly, prosthetics are conduits for digital data. Body-worn computers like smartphones allow the wearer to exchange signals and media from any location, and across heretofore impossible distances. More specialized telemetry appendages like fitness trackers, personal locator beacons, and parolee ankle monitors collect and broadcast the wearer's position, activity, and even metabolic data—sometimes to unintended recipients. Digital data now penetrates the body itself, in a burgeoning market of "intimate hardware" with Bluetooth capabilities. In a quest to prototype a "better human," proponents of the transhumanist "body hacking" movement invade the body's boundaries even further, implanting RFID chips and other circuits under their own skin. The propinquity of these devices brings new urgency to familiar problems in privacy and security.

Prosthetics as a genre raises important questions about typical and atypical bodies, abilities, and identities. Rather than approaching these technologies as a means to restore the body to some sort of assumed norm, this prompt invites a reframing of the discourse of disability—as scholar Sara Hendren urges, "rethinking the default bodily experience."

What could it mean for a person to have a prehensile tail, or chemosensitive antennae?

What if one's appearance could disrupt the normal operation of camera systems? The design of a novel prosthesis opens the door to imaginative play with one's identity and abilities. Explored through the lens of costumes and performance, prosthetics also become a probe for remapping social rituals or, through fantasy and biomimicry, defamiliarizing biological norms. The new prosthetist can invent anatomies, performative appendages, and novel organs for extrasensory perception. She might help a client assume a new social identity, or forge a new relationship to infrastructures of surveillance, in ways that offer a fresh perspective on technocultural systems we often take for granted.

ENTERED BACK
RIGHT OF NECK

ENTERED RIGHT
OF MID BACK

ENTERED BACK
OF RIGHT SHOULDER

STEPHON
CLARK

Captions

129. Brazilian artist Lygia Clark pioneered the exploration of prosthetics within a conceptual art context. Her *Dialogue Goggles* device (1964), designed to be worn by two simultaneous participants, restricts their field of vision exclusively to mutual eye contact.

130. Sputniko!'s *Menstruation Machine* (2010), fitted with a blood-dispensing mechanism and electrodes that shock the abdomen, is a device that simulates the pain and bleeding of a five-day menstruation process.

131. *ScreamBody* (1997-1998), a "wearable body organ" by Kelly Dobson, is a portable space for screaming. The scream is recorded and stored in the device, and can later be released in a place where, when, and how the wearer chooses.

132. Sarah Ross's *Archisuits* (2005-2006) are an edition of leisure suits that enable the wearer to recline comfortably on public furniture otherwise designed to deter sleeping in public. The clothes contain large foam pads that fit into, onto, or around specific structures in the built environment of Los Angeles.

133. Inspired by the perceptual powers of other species, Chris Woebken and Kenichi Okada's *Animal Superpowers* (2008-2015) is a series that augments or amplifies the wearer's sensing abilities. Their *Ant Apparatus*, for example, allows you to "see" with microscopes on your hands, while *Bat Vision Goggles* makes ultrasonic sound audible to humans.

134. Caitrin Lynch and Sara Hendren's *Engineering at Home* (2016) presents an online archive of vernacular prosthetics and daily living tools devised by Cindy, a quadruple amputee.

135. *Entry Holes and Exit Wounds* (2019), a performance by CMU sophomore Steven Montinar, uses a kinesthetically enhanced garment to make data palpable. In this project, cellphone vibrators, embedded in clothing and sequenced by an Arduino, index the gunshots that killed 12 black victims of police brutality.

136. *The Social Escape Dress* (2016) is a part of the *Urban Armor* project by Kathleen McDermott, a series of electronic wearables that investigate personal and public space.

137. *The Rift: An Afronaut's Journey* (2015), a performance by Ayodamola Okunseinde, presents Afrofuturist wearable technologies for a time-traveling protagonist from the future, Dr. Tanimowo, who seeks to understand the reasons for the collapse of his culture. The performer's "Afronaut suit" includes a communication device, a feeding system, and a breathing apparatus.

Additional Projects

Lea Albaugh, *Clothing for Moderns*, 2014, electromechanical garments, Carnegie Mellon University, Pittsburgh.

Siew Ming Cheng, *Spike Away – How to Protect Your Personal Space on the Subway*, 2013, plastic vest with spikes, Singapore.

Jennifer Crupi, *Unguarded Gestures 1–3*, 2019, aluminum and silver implements.

Amisha Gadani, *Animal Inspired Defensive Dresses*, 2008–2011, interactive garments.

Mattias Gommel, *Delayed*, 2003, interactive sound installation, «Son Image», Laboratorio Arte Alameda, Mexico City.

Neil Harbisson and Moon Ribas, *Cyborg Arts*, 2010–2020, cyborg art organization.

Kate Hartman, *Porcupine Experiments*, 2016, lasercut cardboard with straps and fittings.

Rebecca Horn, *Finger Gloves*, 1972, finger extension sculptures.

Di Mainstone et al., *Human Harp*, 2012–2015, suspension bridge interactive sound art.

Daito Manabe, *electric stimulus to face – test*, 2009, bio-responsive wearable device.

Lauren McCarthy, *Tools for Improving Social Interactivity*, 2010, bio-responsive garments.

MIT AgeLab, *AGNES (Age Gain Now Empathy System)*, 2005, age-simulating garments and prostheses, MIT, Cambridge.

Alexander Müller, Jochen Fuchs, and Konrad Röpke, *Skintimacy*, 2011, haptic device and sound-processing software.

Sascha Nordmeyer, *Communication Prosthesis (HyperLip)*, 2009, facial prosthesis.

Stelarc, *Third Hand*, 1980, robotic prosthetic arm, Yokohama.

Jesse Wolpert, *True Emotion Indicator*, 2014, electronic headware.

Readings

Philip A. E. Brey, "Theories of Technology as Extension of Human Faculties," *Metaphysics, Epistemology, and Technology*, Research in Philosophy and Technology 19, ed. C. Mitcham (London: Elsevier/JAI Press, 2000), 59–78.

Erving Goffman, *The Presentation of Self in Everyday Life* (Garden City, NY: Doubleday, 1959).

Donna J. Haraway, "A Cyborg Manifesto: Science, Technology, and Socialist-Feminism in the Late Twentieth Century," in *Simians, Cyborgs, and Women: The Reinvention of Nature* (New York: Routledge, 1991), 149–181.

N. Katherine Hayles, *How We Became Posthuman: Virtual Bodies in Cybernetics, Literature, and Informatics* (Chicago: University of Chicago Press, 1999).

Sara Hendren, *What Can a Body Do?* (New York: Riverhead Books, 2020).

Madeline Schwartzman, *See Yourself Sensing: Redefining Human Perception* (London: Black Dog Press, 2011).

Parametric Object
Post-industrial design

Brief

Create a program that generates 3D objects. More specifically, your program should generate a family of 3D objects that are all parameterized in the same way, but that differ when their parameters are set to different values. The output from your program should be suitable, at least in principle, for prototyping in the real world.

Give consideration to the way in which your parametric object operates as a cultural artifact. How might your software attain special relevance by generating things that address a real human need or interest? Can it make a dataset tangible or wearable? Is it possible for a generated object to be critical or tactical? Is it a tool? Garment? Decoration? Can it be funny, surprising, or unexpected? If you are hunting for a concept, it may be helpful to think of things in the world around us that are mass-produced but that *could* be (or ought to be) personalized. Document your object so that it can be shared with relevant audiences.

Learning Objectives

• Apply generative design principles to the design of 3D form
• Control solid geometry operations with algorithmic techniques
• Discuss form in relation to the contexts of the body, society, or the environment

Variations

• *For introductory students:* Write software to define a surface of revolution that produces a series of vases, cups, candlesticks, spinning tops, etc.
• Working "unplugged" (without a computer), devise a set of rules for creating a class of objects from everyday materials. Your rules should incorporate an element of chance (such as a coin flip) or a dependency on real-world data (by collecting a measurement). Make at least two objects according to your rules.
• Write software that generates a tactile, 3D-printable map from cartographic data.

Making It Meaningful

Generative design is the activity of authoring a system of rules for automating design decisions. In the case of the parametric object, a form is produced with properties articulated by certain variables. Changing the values of these variables changes the form in response, and incorporating elements of contingency or randomness can produce unique objects in every iteration. Among other approaches, parametric forms can be assembled from different arrangements of modular components, lofted from mathematical curves and surfaces, or produced through the actions of simulated physics.

3D parametric objects can be rendered in physical materials with the help of a wide range of fabrication technologies. These include additive technologies like 3D printers, which accrete or accumulate material, and subtractive technologies such as mills, which remove material from a piece of stock. The earliest of these, the CNC (computer-numeric controlled) milling machine, was developed in the 1950s through a military-funded, Cold War initiative to create mathematically precise propellers for aircraft. The early 1960s saw the parallel development of CAD (computer-aided design) tools to simplify the process of specifying geometries for CNC manufacture, and it wasn't long before artists finagled access to these technologies. In 1965, around the same time as the first exhibition of computer-generated plotter art, pioneer Charles "Chuck" Csuri became the first artist to employ CNC tooling for expressive ends, in his abstract *Numeric Milling* sculptures.

The creation of generative forms does not necessarily require computer programming. Traditions of process-based, open-ended and rule-based conceptual art create meaning in the tension between algorithmic logics and the material or social contingencies of the real world. Highly systematic thinking underpins works like *SCUMAK* by Roxy Paine (a metasculptural machine that extrudes randomly-shaped plastic blobs); Nathalie Miebach's handmade sculptures, structured according to weather data; and Laura Devendorf's *Being the Machine* project, an "alternative 3D printer" in which instructions typically provided to fabrication machines are instead given to human makers.

Manufactured objects gain a role in our lives through their utility as furniture, housewares, tools, toys, and ornaments. At times, however, the "one size fits all" approach in industrial design means "no size fits any." Parametric design counters this by enabling "mass customization"—offering personalization akin to handcrafted and homemade forms, but at a heretofore impossible scale. Eyeglasses, prosthetics, and other wearables, for example, can be customized using measurements or scans taken from an individual's body. Maps, histograms, and time series can be generated from data and rendered into tactile media; this "physical visualization" approach can be useful in widening the accessibility of data for the visually impaired, or in producing mementos or souvenirs that encode information from highly personal experiences. In situations where uniqueness is prized, algorithmic design techniques can guarantee that no two items are alike. Parametric design also holds the alluring promise of creating "optimal" forms for a given situation (e.g., solving for the greatest strength per unit of material). While this is important for reducing the material impact of design processes, we must also recognize that over-optimization risks producing unduly specific outcomes in a dynamic world.

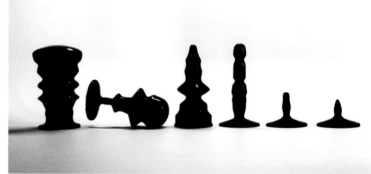

Captions

138. *Fahz* (2015), by Brooklyn design studio Des Des Res, is a fabrication system for producing unique custom vases. The negative space around each vase is generated from silhouettes of the customer's face.

139. Jessica Rosenkrantz and Jesse Louis-Rosenberg, also known as the design studio Nervous System, are pioneers of simulating natural phenomena to produce 3D forms. Their *Kinematic Dress* (2014) is made up of over 2000 unique, interlocking triangular facets that are capable of accommodating the curves of the body. The entire dress is 3D printed as a single folded piece of material.

140. Jonathan Eisenman's *Vase Parametric Model* (2014) illustrates how a simple vase form may be parameterized.

141. *Grand Old Party* (2013) by Matthew Epler is a set of computationally generated butt plugs. Each form is a "physical visualization" whose diameter represents the voter approval rating, over time, of select presidential candidates.

142. *Filament Sculptures* (2014), by the mononymous Austrian artist Lia, are computationally generated forms in which a 3D printer's hot filament has been allowed to droop in unpredictable ways. Each sculpture arises through a negotiation between virtual and physical parameters, articulated by the CAD model, 3D printer settings, and natural forces in the physical world.

143. Charles Csuri's *Numeric Milling* (1968) sculpture is one of the earliest artworks produced with a computer-controlled milling machine. Csuri wrote: "While the device was capable of making a smooth surface, I decided it was best to leave the tool's marks for the paths."

144. For his interactive installation *Wage Islands* (2015), Ekene Ijeoma generated a new topography for New York City, in which elevation represents the inverse of median wages. As the lasercut sculpture is submerged into ink-dyed water, it visualizes the "wage islands" where low-wage workers can afford to rent.

145. Adrien Segal's *Cedar Fire Progression* (2017) is a data-driven sculpture that depicts (from bottom to top) the evolving geographic contour of a wildfire front over time.

146. Amanda Ghassaei's *3D Printed Record* (2012) is a playable, 12-inch, 33rpm phonograph disc whose spiral groove geometry is computationally derived from audio data. The fidelity of its sound reveals the limits and artifacts of digital fabrication.

147. *Meshu* (2012) by Rachel Binx and Sha Huang exemplifies the use of 3D fabrication pipelines to produce personalized jewelry pieces, on demand, that are derived from a customer's geospatial information.

148. *Open Fit Lab* (2013) by Lisa Kori Chung and Kyle McDonald is a performance in which 3D scans of the audience's bodies are used to generate garment patterns for on-the-spot assembly of custom-tailored pants.

149. The objects in Morehshin Allahyari's *Material Speculation: ISIS* series (2015–2016) are procedural reconstructions of ancient artifacts destroyed by ISIS militants—systematically recreated from dozens of publicly available photographs. Shown here is Allahyari's reconstruction of a Roman-period figure of King Uthal of Hatra, smashed at the Mosul Museum in 2015.

Additional Projects

Alisa Andrasek et al., *Li-Quid*, 2016, generated chair design.

Ingrid Burrington, *Alchemy Studies*, 2018, iPhone 5 cast in resin sphere.

Mat Collishaw, *The Centrifugal Soul*, 2017, mixed media three-dimensional zoetrope.

David Dameron, in Paul Freiberger, "Sculptor Waxes Creative with Computer," *InfoWorld*, July 6, 1981.

Laura Devendorf, *Being the Machine*, 2014–2017, videos, instructable, and app for generating human-executable g-code fabrication instructions.

Erwin Driessens & Maria Verstappen, *Tuboid*, 2000, computationally generated wooden sculptures and virtual environments.

John Edmark, *Blooms*, 2015, 3D-printed stroboscopic sculptures.

Madeline Gannon, *Reverberating across the Divide*, 2014, context-aware modeling tool.

Gelitin, *Tantamounter 24/7*, 2005, copy machine performance.

Nadeem Haidary, *In-Formed*, 2009, fork as data visualization.

Mike Kneupfel, *Keyboard Frequency Sculpture*, 2011, 3D-printed information visualization.

Golan Levin and Shawn Sims, *Free Universal Construction Kit*, 2012, software and SLS nylon 3D prints.

Nathalie Miebach, *To Hear an Ocean in a Whisper*, 2013, data sculpture.

Neri Oxman et al., *Silk Pavilion*, 2013, structure made by silkworms.

Roxy Paine, *SCUMAK (Auto Sculpture Maker)*, 1998–2001, sculpture-making machine.

Matthew Plummer-Fernández and Julien Deswaef, *Shiv Integer*, 2016, Thingiverse mashup bot and SLS nylon 3D prints.

Stephanie Rothenberg, *Reversal of Fortune: The Garden of Virtual Kinship*, 2013, telematic garden visualizing philanthropic data.

Jenny Sabin, *PolyMorph*, 2014, modular ceramic sculpture.

Jason Salavon, *Form Study #1*, 2004, video of generated objects.

Keith Tyson, *Geno Pheno Sculpture "Fractal Dice No. 1"*, 2005, algorithmically generated sculpture.

Wen Wang and Lining Yao et al., *Transformative Appetite*, 2017, computationally shaped pasta.

Mitchell Whitelaw, *Measuring Cup*, 2010, generated cup visualizing 150 years of Sydney temperature data.

Maria Yablonina, *Mobile Robotic Fabrication System for Filament Structures*, 2015, fabrication system.

Readings

Christopher Alexander, "Introduction" and "Goodness of Fit," *Notes on the Synthesis of Form* (Cambridge, MA: Harvard University Press, 1964), 1–27.

Morehshin Allahyari and Daniel Rourke, *The 3D Additivist Cookbook* (Amsterdam: The Institute of Network Cultures, 2017).

Nathalie Bredella and Carolin Höfler, eds., "Computational Tools in Architecture, Cybernetic Theory, Rationalization, and Objectivity," special issue, *arq: Architectural Research Quarterly* 21, no. 1 (March 2017).

Joseph Choma, *Morphing: A Guide to Mathematical Transformations for Architects and Designers* (London: Laurence King Publishing, 2013).

Pierre Dragicevic and Yvonne Jansen, *List of Physical Visualizations and Related Artifacts,* dataphys.org, accessed April 13, 2020.

Marc Fornes, *Scripted by Purpose: Explicit and Encoded Processes within Design*, 2007, exhibition.

Wassim Jabi, *Parametric Design for Architecture* (London: Laurence King Publishing, 2013).

Vassilis Kourkoutas, *Parametric Form Finding in Contemporary Architecture: The Simplicity within the Complexity of Modern Architectural Form* (Riga, Latvia: Lambert Academic Publishing, 2012).

Golan Levin, "Parametric 3D Form" (lecture, Interactive Art & Computational Design, Carnegie Mellon University, Pittsburgh, Spring 2015).

D'Arcy Wentworth Thompson, *On Growth and Form*, 2nd ed. (Cambridge, UK: Cambridge University Press, 1942).

Claire Warnier et al., eds., *Printing Things: Visions and Essentials for 3D Printing* (New York: Gestalten, 2014).

Liss Werner, ed., *(En)Coding Architecture: The Book* (Pittsburgh: Carnegie Mellon University School of Architecture, 2013).

Virtual Public Sculpture
Augmenting a site

Brief

Robert Smithson has remarked that "the site is a place where a piece should be but isn't." In this assignment, you are asked to create the missing piece for a site using augmented reality (AR). More specifically: place and view a virtual object of your choice, at a scale of your choice, in a physical location of your choice, with a programmatic behavior of your choice.

When choosing your site, consider the conceptual and aesthetic opportunities offered by its location and history, as well as the ways in which it is occupied. Write down some observations about who uses the site, and how. Your location may be public, generic, or private. For example, it could be a prominent landmark, an unspecified supermarket aisle, your bedroom, or even the palm of your hand.

Your virtual object may be appropriated, downloaded, recycled, modeled, or scanned. You might conceive of your object as a "sculpture," "monument," "installation," or "decoration," or as something else entirely ("anomaly," "natural formation"). Write some code that makes it behave in a certain way. For example, it could rotate slowly in place, emit a shower of particles, or change size whenever the viewer gets close.

Assume that your intervention will be viewed on a mobile device or tablet. Document your project in video, capturing both "over-the-shoulder" and "through-the-device" perspectives. Your documentation should convey how an audience would experience your artwork. How does your project change and reflect relationships between physical and virtual, public and private, screen and site? Publish your intervention, and its documentation, so that it can be shared with others.

Learning Objectives

- Develop, design, and execute a creative intervention at a specific site
- Review the technical requirements and workflow of augmented reality
- Plan and create documentation of augmented reality projects

Variations

- Develop and enact a performance that makes use of your virtual object.
- Create an intervention that appears to remove an object, rather than adding one.
- Design an experience that connects both a virtual intervention (in AR) and a real, physical intervention (such as a prop) of your own design.
- "Gamify" your site with augmented reality objects that turn it into an obstacle course, treasure hunt, escape room, playing field, or game board.
- Research the history or current use of the site, and develop an augmentation that uses data derived from this place. Examples of data might include statistics about power consumption or pollution, architectural or geologic features, historic photographs, audio clips of interviews, or real-time weather information.

Making It Meaningful

Augmented reality (AR) adds a layer of virtual information to the world. Media like 3D animations, text, or images can be anchored to locations, landscape features subtracted, and the world distorted. Whereas public artworks are sometimes criticized for their lack of engagement with the concerns of local communities (and scathingly derided as "plop art"), public artworks in AR offer opportunities to counter this criticism with their potential to be dynamic, interactive, and mutable by audiences. Situated in public space, AR artworks bring together the expressive languages and critical traditions of public art, street performance, graffiti, and video games.

Advertising, branding, and other corporate media are ready targets for unsanctioned activist interventions using AR. As Banksy urges, "Any advert in a public space that gives you no choice whether you see it or not is yours....You can do whatever you like with it. Asking for permission is like asking to keep a rock someone just threw at your head."[i] AR in public space offers the possibility of articulating or even prototyping new power relationships in ways that would be impossible within the controlled channels of institutions and mass media. As Mark Skwarek and Joseph Hocking demonstrate in *The Leak in Your Hometown* (2010), one strategy to give

interventions wide traction is to use well-known logos or other ubiquitous symbols as visual "anchors" (targets) for critical augmentation, enabling a project to become "site-specific" in any place featuring that sign. For the purposes of culture jamming and design activism, which aim to reframe issues and shift opinion through the viral manipulation of media, this combination of Internet-distributed apps with a savvy selection of AR anchors can be particularly effective.

This prompt is similar to the Augmented Projection assignment, in that both invite the artist to create a dynamic virtual addition to a specific site. In both, the challenge is to design interventions that are tightly coupled to their contexts. There are, however, some key differences. Where projections operate like painting, obeying logics of representation, abstraction, and illusion, augmented reality is more akin to sculpture, deploying objects that do not *represent*, but simply *exist* in space. Formally speaking, augmented reality does not require a projection surface, making it possible to suspend AR objects in mid-air or have them move around the viewer. Likewise, 3D forms in AR can exist at any apparent scale, from palm-sized to sky-filling, and can even appear behind or inside real-world objects (as with an X-ray). Taken together, these properties of AR allow for new ways of choreographing the actions and movements of audiences. Finally, the distributed nature of AR displays also means that people in the same place can see different things, or (as

Skwarek and Hocking show) people in different places can see the same thing.

For better or worse, augmented worlds observed through phones, tablets, and goggles are not universally viewable, and must be actively experienced by participants who are in on the joke—in what are ultimately private views in a public space. This hyper-individual nature of AR may eventually have unforeseen political consequences, such as digital redlining, the creation of filter bubbles, and the amplification of radical views.

#TheWholeStory

Edith Wharton

1862 - 1937

A Pulitzer Prize-winning American
novelist, short story writer, and
designer. She was thrice nominated
for the Nobel Prize in Literature.

Captions

150. Keiichi Matsuda's *HYPER-REALITY* (2016) is a richly detailed short film that anticipates a dystopic near-future of ubiquitous AR advertising, gamified consumerism, and corporate surveillance.

151. Jeffrey Shaw's *Golden Calf* (1994) was a pioneering work of augmented reality. Using a handheld LCD screen fitted with a Polhemus position tracking system, viewers could observe a virtual 3D sculpture of a golden calf hovering above an otherwise empty pedestal.

152. *Nail Art Museum* (2014) by Jeremy Bailey is a tiny virtual museum in which canonical works of art appear positioned on finger-mounted plinths.

153. *The Whole Story* (2017) by Y&R New York aims to address gender parity in public monuments by allowing users to view, share, and add virtual statues of notable women alongside existing public statuary.

154. Mark Skwarek and Joseph Hocking created *The Leak in Your Hometown* (2010) in response to the BP Deepwater Horizon oil spill. The augmented reality smartphone app anchors an animation of a leaking oil pipe to any BP logo.

155. Nathan Shafer's *Exit Glacier* project (2012) is a site-specific smartphone app that depicts the historic extent of the Exit Glacier in the Kenai Mountains of Alaska, visualizing glacial recession due to climate change.

156. *Augmented Nature* (2019) by Anna Madeleine Raupach uses natural objects like trees, stumps, and lichen-covered rocks as anchors for poetic site-specific animations.

Additional Projects

Awkward Silence Ltd, *Pigeon Panic AR*, 2018, augmented reality pigeon game app.

Aram Bartholl, *Keep Alive*, 2015, outdoor boulder installation with fire-powered WiFi and digital survival guide repository.

Janet Cardiff and George Bures Miller, *Alter Bahnhof Video Walk*, 2012, augmented reality walking tour of the Alter Bahnhof, Kassel, Germany.

Carla Gannis, *Selfie Drawings*, 2016, artist book with AR experiences.

Sara Hendren and Brian Glenney, *Accessible Icon Project*, 2016, icon and participatory public intervention.

Jeff Koons, *Snapchat: Augmented Reality World Lenses*, 2017, augmented reality public sculpture installations.

Zach Lieberman and Molmol Kuo, *Weird Type*, 2018, augmented reality text app.

Lily & Honglei (Lily Xiying Yang and Honglei Li), *Crystal Coffin*, 2011, AR app, virtual China Pavilion at the 54th Venice Biennale.

Jenny Odell, *The Bureau of Suspended Objects*, 2015, archive of discarded belongings.

Julian Oliver, *The Artvertiser*, 2008, AR app for advertisement replacement.

Damjan Pita and David Lobser, *MoMAR*, 2018, AR art exhibition.

Mark Skwarek, *US Iraq War Memorial*, 2012, participatory AR memorial.

Readings

AtlasObscura.com, "Unusual Monuments," accessed April 14, 2020.

Henry Chalfant and Martha Cooper, *Subway Art*, 2nd ed. (New York: Thames and Hudson, 2016).

Vladimir Geroimenko, ed., *Augmented Reality Art: From an Emerging Technology to a Novel Creative Medium*, 2nd ed. (New York: Springer, 2018).

Sara Hendren, "Notes on Design Activism," accessibleicon.org, last modified 2015, accessed April 14, 2020.

Josh MacPhee, "Street Art and Social Movements," Justseeds.org, last modified February 17, 2019, accessed April 14, 2020.

Ivan Sutherland, "The Ultimate Display," *Proceedings of the IFIP Congress* 65, vol. 1 (London: Macmillan and Co., 1965): 506–508.

Notes

i. Banksy, *Cut It Out* (United Kingdom: Weapons of Mass Disruption, 2004).

I'm a dancer

I dance because it feels like my responsibility my calling

the world

ay I move

Extrapolated Body
Interpreting the dynamic human form

Brief

Create a virtual mask or costume, and use it in a performance.

In this assignment, you are asked to write software that creatively interprets or responds to the movements of your face or body, as observed by a motion capture or computer vision system. More precisely: develop a computational treatment of spatiotemporal data captured from a person, such as the coordinates of features on their face, the 3D locations of their joints, or points along the 2D contour of their silhouette.

Consider whether your treatment serves a ritual purpose, a practical purpose, or works to some other end. It may visualize or obfuscate your personal information. It may allow you to assume a new identity, including something nonhuman or even inanimate. It may have articulated parts and dynamic behaviors. It may be part of a game. It may blur the line between self and others, or between self and not-self.

Depending on the materials at hand, your system may use a standard webcam or a specialized peripheral (like a Kinect depth sensor). Furthermore, your solution may require you to learn how to use APIs for real-time face tracking or pose estimation, receive and interpret data transmitted by precompiled body-tracking apps (e.g., via OSC), or record and interpret data from a professional mocap system.

Design your software for a specific performance, and plan your performance with your software in mind; be prepared to explain your creative decisions. Rehearse and record your performance.

Learning Objectives

- Survey the tools and workflows for motion capture
- Use algorithmic techniques to develop a visual interpretation of motion data
- Explore aesthetic and conceptual possibilities in animating human form and movement

Variations

- *Instructors: It is helpful to provide students with a code template for a tracking library, such as PoseNet (via ml5.js) or FaceOSC. In so doing, this assignment may be restricted to just the face or body.*
- You may perform your project yourself, or you may collaborate with any performer available to you. Is your software intended for a person with highly specialized movement skills (dancer, musician, athlete, actor), or can anyone operate it?
- The assignment brief poses the problem of creating interactive software that responds to real-time data. Instead, generate an animation using pre-recorded (offline) motion capture data. Create or select this data carefully. You might record data yourself, if you have access to a motion capture studio; use mocap data from an online source (such as a research archive or commercial vendor); or creatively augment a favorite YouTube video with the help of a pose estimation library.
- Remember that you may position your virtual "camera" anywhere; your motion capture data need not be displayed from the same point of view as your sensor. Consider rendering your performer's body from above, from a moving location, or even from their own point of view.
- In contrast to an *expressive* concept (such as a character animation or playful interactive mirror), develop an *analytic* treatment, such as an information visualization, that diagrams and compares the movements of body joints or facial landmarks over time. For example, your software could present comparisons between different people making similar expressions, or it could provide insight into the articulations of movements by a violinist.
- Consider using sound synchronized to your motion capture data. This sound might be the performer's speech, music to which they are dancing, or sounds synthetically generated by their movements.
- Rather than depicting the body itself, write software to visualize how an environment is disturbed by a body, as with footprints in sand.
- Use your face or body to puppeteer something nonhuman: a computer-generated animal, monster, plant, or customarily inanimate object.
- Visualize a relationship between two or more performers' bodies.
- Focus on the actions of a single part of the body or face.

Making It Meaningful

Costumes, masks, cosmetics, and digital face filters allow the wearer to fit in or act out. We dress up, hide or alter our identity, play with social signifiers, or express our inner fursona. We use them to ritualistically mark life events or spiritual occasions, or simply to obtain "temporary respite from more explicit and determinate forms of sociality, freeing us to interact more imaginatively and playfully with others and ourselves."[i]

Many innovations in understanding, visualizing, and augmenting the dynamic human body originate as analytic tools (most often, for military purposes) that are then creatively repurposed as expressive ones (for the arts and entertainment). The effect of this evolution is that scientific techniques for capturing body movement, such as Étienne-Jules Marey's chronophotography, contribute to the development of new artistic languages, such as Marcel Duchamp's Cubist abstraction. Additional examples include the motion capture suit, first developed by Marey in 1883 in physiological research on soldier movement, and the technique of what is now called "light painting" (long-exposure photographs of lights attached to moving bodies), explored in depth in 1914 by Frank and Lillian Gilbreth to analyze and optimize the activities of soldiers and workers.

Body movement is an important dimension of storytelling, central to the vocabularies of performance and dance, and also to those of animation and puppeteering, where it is essential to creating the illusion of life. As Alan Warburton explains, animators develop character by "creating an equivalence between who someone is, and how they move.... Any audience should know instantly who a character is just from their motion."[ii] This conflation of *how we look and move* and *who we are* is also a foundational premise of video surveillance technologies—which, extending from problematic disciplines like physiognomy, phrenology, and somatotypology, aim to deduce a subject's moral character from their outward appearance.

The face, with its significant role in identity and communication,[iii] is of particular focus in carceral technologies. Facial recognition systems are perilous for many reasons: they enable automated nonconsensual identification and are therefore ripe for misuse in the context of policing and authoritarian regimes; they operate with the allure of objectivity despite being prone to catastrophic inaccuracies; they are difficult to audit and contest by those they impact most; and their use is often invisible. On the flip side, face trackers have also been used for expressive, entertaining, and educational purposes. They serve as digital masks and face filters; as controllers for games (as in Elliott Spelman's "eyebrow pinball" game, *Face Ball*); as musical interfaces (Jack Kalish's *Sound Affects* performance); as controllers for richly parameterized graphic designs (Mary Huang's typographic *TypeFace*); as a means for furthering public understanding of surveillance technologies (Adam Harvey's *CV Dazzle*); and as tools for interrogating contemporary culture (Christian Moeller's *Cheese* or Hayden Anyasi's *StandardEyes*). In working with computational face and body tracking libraries, media artists and interface designers are encouraged to reflect on the origins of their tools, and the extent to which their use in a creative work reinforces the teleology of carceral surveillance systems. How might creative engagements activate what Ruha Benjamin calls "a liberatory imagination," where the goal is to illuminate or circumvent these mechanisms and envisage a more just, egalitarian, and vibrant world?[iv]

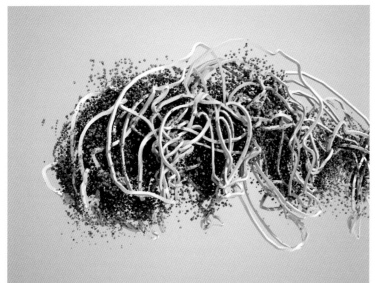

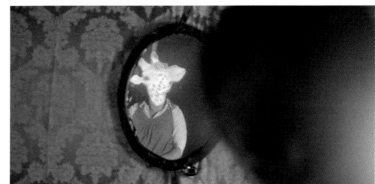

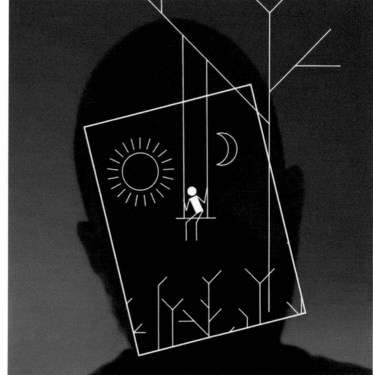

Captions

157. Using pose estimation and speech recognition technologies, choreographer Bill T. Jones collaborated with Google Creative Lab to produce *Body, Movement, Language* (2019), a series of interaction studies in which participants can use their bodies to position their own spoken words in the space around them.

158. In partnership with the London 2012 Olympic and Paralympic Games, Memo Akten and Davide Quayola developed *Forms*, a series of abstract 3D visualizations of athletes' trajectories and mechanics.

159. Referencing the utopian formalism of 1960s architecture, *Walking City* (2014) by Universal Everything is a "slowly evolving video sculpture" structured around a cycle of human locomotion.

160. While students at the University of Paris 8, Sophie Daste, Karleen Groupierre, and Adrien Mazaud developed *Miroir* (2011), an interactive installation in which a spectator sees a ghostly animal head superimposed onto the reflection of their own face. The anthropomorphized double closely follows their movements and expressions.

161. *Más Que la Cara* (2016), a street-level interactive installation by YesYesNo, presents imaginative, poster-like interpretations of spectators' faces.

Additional Projects

Jack Adam, *Tiny Face*, 2011, face measurement app.

Rebecca Allen, *Catherine Wheel*, 1982, computer-generated character.

Hayden Anyasi, *StandardEyes*, 2016, interactive art installation.

Nobumichi Asai, Hiroto Kuwahara, and Paul Lacroix, *OMOTE*, 2014, real-time tracking and facial projection mapping.

Jeremy Bailey, *The Future of Marriage*, 2013, software.

Jeremy Bailey, *The Future of Television*, 2012, software demo.

Jeremy Bailey, *Suck & Blow Facial Gesture Interface Test #1*, 2014, software test.

Jeremy Bailey and Kristen D. Schaffer, *Preterna*, 2016, virtual reality experience.

Zach Blas, *Facial Weaponization Suite*, 2011–2014, masks digitally modeled from aggregate data.

Nick Cave, *Sound Suits*, 1992–, wearable sculptures.

A. M. Darke, *Open Source Afro Hair Library*, 2020, 3D model database.

Marnix de Nijs, *Physiognomic Scrutinizer*, 2008, interactive installation.

Arthur Elsenaar, *Face Shift*, 2005, live performance and video.

William Fetter, *Boeing Man*, 1960, 3D computer graphic.

William Forsythe, *Improvisation Technologies*, 1999, rotoscoped video series.

Daniel Franke and Cedric Kiefer, *unnamed soundsculpture*, 2012, virtual sculpture using volumetric video data.

Tobias Gremmler, *Kung Fu Motion Visualization*, 2016, motion data visualization.

Paddy Hartley, *Face Corset*, 2002–2013, speculative fashion design.

Adam Harvey, *CV Dazzle*, 2010–, counter-surveillance fashion design.

Max Hawkins, *FaceFlip*, 2011, video chat add-on.

Lingdong Huang, *Face-Powered Shooter*, 2017, facially controlled game.

Jack Kalish, *Sound Affects*, 2012, face-controlled instruments and performance.

Keith Lafuente, *Mark and Emily*, 2011, video.

Béatrice Lartigue and Cyril Diagne, *Les Métamorphoses de Mr. Kalia*, 2014, interactive installation.

David Lewandowski, *Going to the Store*, 2011, digital animation and video footage.

Zach Lieberman, *Walk Cycle / Circle Study*, 2016, computer graphic animation.

Rafael Lozano-Hemmer, *The Year's Midnight*, 2010, interactive installation.

Lauren McCarthy and Kyle McDonald, *How We Act Together*, 2016, participatory online performance.

Kyle McDonald, *Sharing Faces*, 2013, interactive installation.

Christian Moeller, *Cheese*, 2003, smile analysis software and video installation.

Nexus Studio, *Face Pinball*, 2018, game with facial input.

Klaus Obermaier with Stefano D'Alessio and Martina Menegon, *EGO*, 2015, interactive installation.

Orlan, *Surgery-Performances*, 1990–1993, surgical operations as performance.

Joachim Sauter and Dirk Lüsebrink, *Iconoclast / Zerseher*, 1992, eye-responsive installation.

Oskar Schlemmer, *Slat Dance*, 1928, ballet.

Karolina Sobecka, *All the Universe Is Full of the Lives of Perfect Creatures*, 2012, interactive mirror.

Elliott Spelman, *Expressions*, 2018, face-controlled computer input system.

Keijiro Takahashi, *GVoxelizer*, 2017, animation software tool.

Universal Everything, *Furry's Posse*, 2009, digital animation.

Camille Utterback, *Entangled*, 2015, interactive generative projection.

Theo Watson, *Autosmiley*, 2010, whimsical vision-based keyboard automator.

Ari Weinkle, *Moodles*, 2017, animation.

Assignments

Readings

Greg Borenstein, "Machine Pareidolia: Hello Little Fella Meets Facetracker," *Ideas for Dozens* (blog), UrbanHonking.com, January 14, 2012.

Joy Buolamwini and Timnit Gebru, *Gender Shades*, 2018, research project, dataset, and thesis.

Kate Crawford and Trevor Paglen, "Excavating AI: The Politics of Images in Machine Learning Training Sets, excavating. ai, September 19, 2019.

Regine Debatty, "The Chronocyclegraph," *We Make Money Not Art* (blog), May 6, 2012.

Söke Dinkla, "The History of the Interface in Interactive Art," kenfeingold.com, accessed April 17, 2020.

Paul Gallagher, "It's Murder on the Dancefloor: Incredible Expressionist Dance Costumes from the 1920s," DangerousMinds. net, May 30, 2019.

Ali Gray, "A Brief History of Motion-Capture in the Movies," *IGN*, July 11, 2014.

Katja Kwastek, *Aesthetics of Interaction in Digital Art* (Cambridge, MA: MIT Press, 2013).

Daito Manabe, "Human Form and Motion," GitHub, updated July 5, 2018.

Kyle McDonald, "Faces in Media Art," GitHub repository for Appropriating New Technologies (NYU ITP), updated July 12, 2015.

Kyle McDonald, "Face as Interface," 2017, workshop.

Jason D. Page, "History," LightPaintingPhotography.com, accessed April 17, 2020.

Shreeya Sinha, Zach Lieberman, and Leslye Davis, "A Visual Journey Through Addiction," *New York Times*, December 18, 2018.

Scott Snibbe and Hayes Raffle, "Social Immersive Media: Pursuing Best Practices for Multi-User Interactive Camera/Projector Exhibits," in *Proceedings of the SIGCHI Conference on Human Factors in Computing Systems* (New York: Association for Computing Machinery, 2009).

Nathaniel Stern, *Interactive Art and Embodiment: The Implicit Body as Performance* (Canterbury, UK: Gylphi Limited, 2013).

Alexandria Symonds, "How We Created a New Way to Depict Addiction Visually," *New York Times*, December 20, 2018.

Alan Warburton, *Goodbye Uncanny Valley*, 2017, animation.

Notes

i. Nathan Ferguson, "2019: A Face Odyssey," *Cyborgology*, July 17, 2019, accessed July 27, 2019.

ii. Alan Warburton, "Fairytales of Motion," Tate Exchange video essay, April 24, 2019, accessed July 27, 2019.

iii. See the Face Generator assignment.

iv. Ruha Benjamin, ed., *Captivating Technology: Race, Carceral Technoscience, and Liberatory Imagination in Everyday Life* (Durham, NC: Duke University Press, 2019), 12.

Synesthetic Instrument
A machine for performing sound and image

Brief

Create an "audiovisual instrument" that allows a performer to produce tightly coupled sound and visuals. Your software should make possible the creation of both dynamic imagery and noise/sound/music, simultaneously, in real time.

You are challenged to create an open-ended system in which sonic and visual modalities are equally expressive. Its results should be inexhaustible, deeply variable, and contingent on the performer's choices, and the basic principles of its operation should be easy to deduce, yet also allow for sophisticated expression. Interactions with your instrument should generate predictable results.

Assume your instrument receives input from the actions and gestures of a performer. Will they use a keyboard, mouse, multi-touch trackpad, pose tracker, or a less common sensor? Select (or construct) your instrument's physical interface with care, giving consideration to its expressive affordances. Categorize the data streams it provides: are these continuous values, or changes in logical states? Do they have a perceptible duration, and are they persistent or instantaneous? Are they one-, two-, three-, or four-dimensional?

Assume your instrument generates output for a graphic display and audio system. Think through the possibilities offered by different visual variables like hue, saturation, texture, shape, and motion, and different auditory elements including pitch, dynamics, timbre, scales, and rhythm. Link these sonic and visual elements together by establishing *mappings* between your system's input and output. For example: the faster the performer moves her cursor, the brighter her cursor appears, and the higher the pitch of a synthesized tone. Such mappings help set up expectations that can be manipulated by a performer to create contrast, tension, surprise, and even humor.

Attune us to your instrument's unique expressive qualities by using it in a brief performance. One suggestion for structuring this performance is to begin with an expository demonstration of your instrument's interface, guiding the audience into understanding how it operates before presenting more complex material. The repetition and subsequent elaboration of themes is also a helpful compositional strategy.

Learning Objectives
- Review historical precedents in audiovisual instrument design
- Explore ways to control and connect sound and visuals
- Review and implement event-driven programming
- Apply interaction design principles to the development of performance instruments, with special attention to a system's responsiveness, predictability, ease of use, and interface

Variations
- *Instructors: require all students to use the same type of physical interface (such as a game controller, pressure-sensitive stylus, or barcode reader). This will allow them to better contrast their solutions.*
- Develop a "QWERTY instrument" that is wholly played through typed actions on a standard computer keyboard. This simplified format can helpfully limit your design to the use of discrete inputs (button presses, rather than continuous gestures), and discrete outputs (triggering pre-recorded and pre-rendered media, rather than synthesizing sounds and graphics through the real-time modulation of continuous parameters). Embed your project in a web page and publish it online. Consider how the provenance of your sounds and images can enrich your concept.
- *For advanced students:* Develop your project with a pair of programming environments that handle sound and image separately. Some arts-engineering toolkits (like Max/MSP/Jitter, Pure Data, SuperCollider, and ChucK) excel at sound synthesis, while other development environments (like Processing, openFrameworks, Cinder, and Unity) have richer feature sets for graphics. Signals can be shared between the applications by means of a communications protocol like OSC or Syphon.
- Mapping performance gestures to your instrument's control parameters is perhaps the foremost design challenge of this assignment. Body movements that feel logically simple may produce hard-to-interpret sensor data; likewise,

small changes to your instrument's control parameters may have nonlinear perceptual effects. Improve the intuitiveness of your instrument's mappings by incorporating a tool for real-time regression, such as Rebecca Fiebrink's Wekinator or Nick Gillian's Gesture Recognition Toolkit.

- Create an instrument that will only be used by one person. (This is at odds with commercial agendas and corporatized HCI education, in which the expectation is that design is something done for the widest range of users.)

Making It Meaningful

Good instruments offer inexhaustible possibilities for expression, composition, and collaboration. To a performer, the value of an instrument hinges on how well it supports the creative feedback loop known as "flow."[i] An instrument that is responsive but crunchy can be more gratifying than a device that easily begets dazzling results. Hence, in this assignment, the emphasis is on the suppleness of an instrument's interaction design and the range of expression it makes possible (the performer's experience), rather than on the aesthetics of the audiovisuals it produces.

A "North Star" for instrument design is to create something "instantly knowable, yet infinitely masterable."[ii] Consider the pencil, or the piano: its basic principles of operation are simple enough for a child to deduce, yet one can spend a lifetime using it and still find more

to say; sophisticated expressions are possible, and mastery is elusive. From the standpoint of systems design, our challenge is that ease of learning and expressive range are antithetical design requirements: optimize for one, and the other suffers. In making an instrument for simultaneous sound and image, this challenge is compounded by another: expressive malleability in one modality often comes at the expense of rigidity in the other.

It is helpful to consider the typology of audiovisual systems and the design strategies they use. Sound visualization, for example, is a common feature in desktop music players, VJ software, and phonology tools. Principles of image sonification underpin film scores, game music, and some tools for the visually impaired. The term "visual music," used by creators of some color organs and abstract films, can even refer to a strictly silent medium, one comprised solely of animated imagery with temporal structures that are analogous to musical ones. In the realm of computer-based performance systems, designers have used a variety of visual interface metaphors to control and represent sound. "Control panel" interfaces, for example, use knobs, sliders, buttons, and dials to govern synthesis parameters, evoking the look of vintage synthesizers. "Diagrammatic" interfaces, such as scores and timelines, use the graphical conventions of information visualization to organize representations of sound along axes like time and frequency. Others use "audiovisual

objects," wherein a performer stretches, manipulates, or knocks virtual objects together in order to trigger or modulate corresponding sounds. In "painterly interfaces," gestural marks performed on a 2D surface conjure and influence a fine-grained aural material.

Captions

162. In the Web-based performance *In C* (2015) by Luisa Pereira, Yotam Mann, and Kevin Siwoff, a group of performers use mice and keyboards to control the pace at which their individual instruments advance through a graphical score, producing highly variable musical results.

163. Amit Pitaru's *Sonic Wire Sculptor* (2003) is a tablet-based system for authoring looping scores. Melodies are represented by drawings that curl around a cylindrical 3D space.

164. *Psychic Synth* (2014) by Pia Van Gelder is a responsive audiovisual environment in which a participant's brainwaves are captured by an EEG headset, in order to establish an immersive biofeedback loop that governs video projection, colored light, and immersive sound.

165. *Patatap* (2012) by Jono Brandel and Lullatone is a browser-based app for the simultaneous performance of sound and animated imagery. Each key on a standard computer keyboard triggers a unique noise and snappy animation.

166. Jace Clayton's *Sufi Plug Ins* (2012) are a suite of seven free tools that extend the functionality of Ableton Live, a commercial music software sequencer. These software-as-art visual interfaces are designed to support non-Western conceptions of sound, such as North African maqam scales and quartertone tuning. The interface is written in the Berber language of Tamazight, using its neo-Tifinagh script.

167. *Orca* (2018) by Hundred Rabbits is an esoteric programming language and live-coding interface for creating and performing procedural sound sequencers.

Additional Projects

Louis-Bertrand Castel, *Clavecin Oculaire (Ocular Harpsichord)*, 1725–1740, proposed mechanical audiovisual instrument.

Alex Chen and Yotam Mann, *Dot Piano*, 2017, online musical instrument.

Rebecca Fiebrink, *Wekinator*, 2009, machine learning software for building interactive systems.

Google Creative Lab, *Semi-Conductor*, 2018, gesture-driven online virtual orchestra.

Mary Elizabeth Hallock-Greenewalt, *Sarabet*, 1919–1926, mechanical audiovisual synthesizer.

Imogen Heap et al., *Mi.Mu Gloves*, 2013–2014, gloves as gestural control interface.

Toshio Iwai, *Piano – As Image Media*, 1995, interactive installation with grand piano and projection.

Toshio Iwai and Maxis Software Inc., *SimTunes*, 1996, interactive audiovisual performance and composition game.

Sergi Jordà et al., *ReacTable*, 2003–2009, software-based audiovisual instrument.

Frederic Kastner, *Pyrophone*, 1873, flame-driven pipe organ.

Erkki Kurenniemi, *DIMI-O*, 1971, electronic audio-visual synthesizer.

Golan Levin and Zach Lieberman, *The Manual Input Workstation*, 2004, audiovisual performance with interactive software.

Yotam Mann, *Echo*, 2014, musical puzzle game, website, and app.

JT Nimoy, *BallDroppings*, 2003–2009, animated musical game for Chrome.

Daphne Oram, *Oramics Machine*, 1962, photo-input synthesizer for "drawing sound."

Allison Parrish, *New Interfaces for Textual Expression*, 2008, series of textual interfaces.

Gordon Pask and McKinnon Wood, *Musicolour Machine*, 1953–1957, performance system connecting audio input with colored lighting output.

James Patten, *Audiopad*, 2002, software instrument for electronic music composition and performance.

David Rokeby, *Very Nervous System*, 1982–1991, gesturally controlled software instrument using computer vision.

Laurie Spiegel, *VAMPIRE (Video and Music Program for Interactive Realtime Exploration/ Experimentation)*, 1974–1979, software instrument for audiovisual composition.

Iannis Xenakis, *UPIC*, 1977, graphics tablet input device for controlling sound.

Readings

Adriano Abbado, "Perceptual Correspondences of Abstract Animation and Synthetic Sound," *Leonardo* 21, no. 5 (1988): 3–5.

Dieter Daniels et al., eds., *See This Sound: Audiovisuology: A Reader* (Cologne, Germany: Walther Koenig Books, 2015).

Sylvie Duplaix et al., *Sons et Lumieres: Une Histoire du Son dans L'art du XXe Siecle* (Paris: Editions du Centre Pompidou, Catalogues Du M.N.A.M., 2004).

Michael Faulkner (D-FUSE), *vj audio-visual art + vj culture* (London: Laurence King Publishing Ltd., 2006).

Mick Grierson, "Audiovisual Composition" (DPhil thesis, University of Kent, 2005).

Thomas L. Hankins and Robert J. Silverman, *Instruments and the Imagination* (Princeton, NJ: Princeton University Press, 1995).

Roger Johnson, *Scores: An Anthology of New Music* (New York: Schirmer/Macmillan, 1981).

Golan Levin, "Audiovisual Software Art: A Partial History," in *See This Sound: Audiovisuology: A Reader*, ed. Dieter Daniels et al. (Cologne, Germany: Walther Koenig Books, 2015).

Luisa Pereira, "Making Your Own Musical Instruments with P5.js, Arduino, and WebMIDI," Medium.com, October 23, 2018.

Martin Pichlmair and Fares Kayali, "Levels of Sound: On the Principles of Interactivity in Music Video Games," in *Proceedings of the 2007 DiGRA International Conference: Situated Play*, vol. 4 (2007): 424–430.

Assignments

Don Ritter, "Interactive Video as a Way of Life," *Musicworks* 56 (Fall 1993): 48–54.

Maurice Tuchman and Judi Freeman, *The Spiritual in Art: Abstract Painting, 1890–1985* (Los Angeles: Los Angeles County Museum of Art, 1986).

John Whitney, *Digital Harmony: On the Complementarity of Music and Visual Art* (New York: Byte Books/McGraw-Hill, 1980).

John Whitney, "Fifty Years of Composing Computer Music and Graphics: How Time's New Solid-State Tactability Has Challenged Audio Visual Perspectives," *Leonardo* 24, no. 5 (1991): 597–599.

Notes

i. Mihaly Czikszentmihalyi, *Flow: The Psychology of Optimal Experience* (New York: Harper Perennial Modern Classics, 2008).

ii. Golan Levin, "Painterly Interfaces for Audiovisual Performance" (master's thesis, MIT, 2000).

Computing without a Computer

Ono's *Grapefruit*

Browse the prompts in Yoko Ono's *Grapefruit* series, and, if possible, execute one.[1] Contemplate giving instructions as a mode of creative practice. Devise an instructional painting in Ono's style.

Drawing Games

In pairs, play a game of *Dots and Boxes* (by Édouard Lucas) and *Sprouts* (by John H. Conway and Michael S. Paterson) to deepen your understanding of rule-based drawing games.[4]

Wall Drawing #118

Execute Sol LeWitt's *Wall Drawing #118* (1971): "On a wall surface, any continuous stretch of wall, using a hard pencil, place fifty points at random. The points should be evenly distributed over the area of the wall. All of the points should be connected by straight lines."[2]

Zoom Schwartz Profigliano

In groups of five, play the rule-based conversation game "Zoom Schwartz Profigliano," in which an ever-expanding vocabulary of whimsical nonsense words establishes precise rules for what can be spoken, to whom, when, and how.[5] (Photo: College of DuPage.)

Conditional Design: The Beach

Organize into groups of four, and give each person their own color marker. Execute "The Beach" from the "Conditional Design Manifesto" by Luna Maurer et al.: "Each turn, find the most empty space on the paper and place a dot in the middle of it."[3]

Be the Computer I

Arrange the class in a grid configuration and give each person a sheet of paper so that each student is responsible for a pixel. One person takes charge and programs the pixels by showing the group a script or by giving them direct commands.[6]

Procedural Drawing

Develop your own procedural drawing rule set in the spirit of Sol LeWitt or the prompts from conditionaldesign.org. Have one or more of your peers produce a drawing with your system. Consider devising systems using other materials such as tape or string.

Be the Computer II

Write a simple program to create a static drawing. Give your code to a peer, and (without showing them your screen) ask them to predict and hand-draw the result. When they are finished, compare the computer's drawing with their hand-drawn work.

Human Fax Machine

In groups of two or four, devise a sound language for describing how marks are made. You may use a sound-making device (two spoons, a set of keys) or your own mouth noises, so long as you use no spoken words. Write down the code, then split your group into "transmitters" and "receivers," with a visual barrier in between. Test the system. A "transmitter" should take a simple hand-drawn image and transmit it across the barrier to the "receiver." When finished, compare the original with the transmitted image and fix any problems in your system. Do this with several images, and discuss.[7]

Additional References

Casey Reas, {Software} Structures, 2004, http://artport.whitney.org/commissions/softwarestructures/text.html.

Basil Safwat, Processing.A4, 2013, http://www.basilsafwat.com/projects/processing.a4/.

FoAM, notes for Mathematickal Arts workshop, 2011, https://libarynth.org/mathematickal_arts_2011.

J. Meejin Yoon, "Serial Notations / Drift Drawings," 2003, https://ocw.mit.edu/courses/architecture/4-123-architectural-design-level-i-perceptions-and-processes-fall-2003/assignments/problem1.pdf.

Notes

1. Yoko Ono, Grapefruit (London: Simon & Schuster, 2000).

2. Andrew Russeth, "Here Are the Instructions for Sol LeWitt's 1971 Wall Drawing for the School of the MFA Boston," Observer, October 1, 2012, https://observer.com/2012/10/here-are-the-instructions-for-sol-lewitts-1971-wall-drawing-for-the-school-of-the-mfa-boston/.

3. Luna Maurer, Edo Paulus, Jonathan Puckey, and Roel Wouters, "Conditional Design: A Manifesto for Artists and Designers," accessed April 14, 2020, https://conditionaldesign.org/workshops/the-beach/.

4. Wikipedia, "Dots-and-Boxes," http://en.wikipedia.org/wiki/Dots_and_Boxes; Wikipedia, "Sprouts," http://en.wikipedia.org/wiki/Sprouts_(game).

5. David King, "Zoom Schwartz Profigliano," 1998, https://www.scottpages.net/ZSP-Rules-2012.pdf.

6. John Maeda, Creative Code (New York: Thames and Hudson, 2004), 216.

7. Brogan Bunt and Lucas Ihlein, "The Human Fax Machine Experiment," Scan (Sydney): Journal of Media Arts Culture 10, no. 2 (2013): 1–26.

Graphic Elements

One with Everything

Explore your graphics toolset by drawing one of each type of primitive it provides. For example, you might draw a rectangle, ellipse, arc, line segment, Bézier curve, polyline, and polygon. Experiment with their options and parameters, such as fill color, stroke weight, etc.

Coding Mondrian

Using code, reproduce a Mondrian painting, such as *Composition No. III, with Red, Blue, Yellow and Black* (1929). Pay attention to detail.

Quadrilateral Zoo

Write commands to plot the vertices of a family of quadrilaterals: square, rectangle, parallelogram, rhombus, trapezoid, dart, and kite.

Coding *Stadia II*

Select and crop a small rectangular region from Julie Mehretu's painting *Stadia II*. Using a program such as Photoshop, read out the colors and coordinate data from this fragment. Use this data to faithfully recreate the fragment with shapes, lines, curves, and custom shape functions.

Draw Your Initials

Draw your initials with primitive shapes and lines.

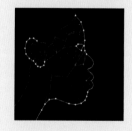

Draw, Then Code

Spend 20 minutes drawing on paper: a self-portrait, landscape, still life, or geometric design. Create your drawing with adequate care and detail. Now recreate your drawing using code. (Image: *p5.js Self-Portrait*, a student project by Zainab Aliyu, 2015.)

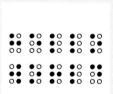

Braille Tool

Reproduce the Braille alphabet using filled and unfilled circles. If you can, store a representation of these patterns in an array, and create a tool that allows a user to compose, print, and (with a stylus) emboss Braille messages.

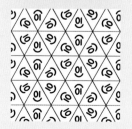

Kaleidoscope

Devise a small graphical motif. Write a program that uses your toolset's graphics transforms to translate, reflect, and rotate copies of this motif, in the manner of a kaleidoscope.

Iteration

Simple Iteration: Seven Circles

Use iteration to copy the figure on the left, in which seven circles are positioned across the canvas. The position of each circle should be computed using your loop's counting variable. Make sure the first circle is inset by a margin; it should not lie on the edge of the canvas.

Receding Landscape

Use iteration to create a series of vertical lines across the screen. Create the illusion of a receding landscape by placing the lines' endpoints more closely together at the top of the canvas.

Transitioning Rectangles

Recall that *any* visual property can be linked to a loop variable, not just position. Use iteration to generate a series of rectangles. Your code should simultaneously control several of the rectangles' visual properties, including their position, height, and fill color.

Lines to the Cursor

Use iteration to create an interactive display featuring a series of ten lines. Each line should connect the cursor to one of a series of points distributed evenly across the canvas.

String Art Challenge

Use iteration to recreate the figure on the left. Your code should draw exactly eight lines.

Color-Bar Gradient

Using iteration, generate a gradient that "lerps" (linearly interpolates) from one fill color to another across exactly 17 rectangles. Implement some code that randomizes the two terminal colors whenever the user clicks a button.

Mini-Calendar

Use iteration to render a row of visual elements: one element for each of the days of the current month. All of the elements should be drawn identically, *except* for the one whose index corresponds to the current day. Differentiate this element in some way.

Dashed Line

Write a program that generates a dashed line between two points. (You may not use a "ready-made" dashed line.) Your dashes should always have a fixed length, such as 10 pixels, so that longer lines require more dashes. Connect one of your line's endpoints to the cursor.

Nested Iteration: Checkers

Create a checkerboard using a nested loop. Recall that a checkerboard is an 8x8 grid of alternating black and white squares, starting with white in the top left corner.

Geometric Progression

Generate a series of visual elements whose dimensions exhibit a geometric progression. The size of each element should be computed by multiplying the size of the one before it by a constant ratio. In the design at left, each circle is 1.3 times larger than the previous one inside it.

Iteration with Functions

Write a function that encapsulates the code to render a simple visual element (a leaf, face, etc.). Give your function arguments that determine where the element will be positioned. Using iteration, call your function to display a grid of these elements.

Moiré Patterns

Generate a set of parallel lines or curves, spaced at narrow intervals. Overlap two copies of your line set, differing by a small rotation, to create a moiré pattern. Place some dimension of variability, such as the line separation or rotation angle, under interactive control.

Stochastic Elements

Create an evocative composition in which an iterative loop deposits small elements in random locations around the canvas. These elements might look like craters, potholes, pimples, ants, chocolate chips, holes in Swiss cheese...

Recoding *Schotter*

Schotter by Georg Nees (1968) is a classic algorithmic artwork that depicts a gradient from order to chaos across a 12x22 grid of squares. In it, the squares' orientations become increasingly randomized towards the bottom of the page. Re-code this work, paying attention to detail.

Interrupted Grid

Use nested iteration to generate a grid of visual elements. Write code such that on each iteration, with a small random probability, an alternative element is occasionally drawn instead.

Hexagonal Grid

Write a custom function that draws a hexagon. Using iteration, call this function to fill your sketch with a grid of hexagons. For regular hexagons, you may need to consult some trigonometry.

Color

Color Observation
Carefully observe the color of your shirt, your table, the wall of your room, and the palm of your hand. Proceeding exclusively by modifying numbers in code, and without using a camera or scanning device, reproduce these colors to the best of your ability.

Threshold of Perception
Create a composition showing the smallest interval between colors that you can distinguish. One possible composition is a filled circle in front of a flat background, such that the colors of the background and circle are almost imperceptibly different.

Overlapping Color
Overlap three semi-transparent circles, each with a different color, to create regions of overlapping colors. Explore the effects of different colors and transparency values. Experiment with different pixel transfer modes (also called "blend modes"). Draw the circles without outlines.

Interactive Complement
Complementary colors are 180° degrees apart on the color wheel. Split the canvas into two equal-sized rectangles, side by side. Using the HSB color model, create an interaction in which one rectangle's color is controlled by the cursor position and the other rectangle contains the complement of this color.

Constructing a Gradient
Create a smooth gradient between two colors. *Hint*: use iteration to render many thin, adjacent parallel lines, each with subtly different colors. How does your choice of color model (RGB or HSB) affect the result?

Accented Palette
Create a color scheme or palette with a dominant "base color" and an "accent color" formed from its complement. Devise a method of randomly sampling this palette such that the base color is selected roughly 75% of the time. Fill a grid of squares with colors selected using this method.

Color Wheel
Using the HSB color model, create a program that displays every hue on the screen in the form of a color wheel.

Split Complements
A color's "split complements" are a pair of colors just adjacent (±15–30°) on the color wheel. Create an interactive sketch that displays swatches of the split complements for a color selected by the user.

Josef Albers Color Relativity I

Study Josef Albers's color relativity exercises and write a program, like the one shown at left, that makes three colors look like four.[1] Control the components of the third color (in the spots) using your cursor. Under what conditions do the spots look the same or different?

Palette from Photo

Select a photo. Write a program that derives an optimal five-color palette from your chosen image. (There are many ways to do this, but one of the most effective is k-means clustering.) If you can, use your palette to generate "separations" of your original image, like for silkscreening or risograph printing.

Josef Albers Color Relativity II

Using similar techniques as above, create a sketch in which four colors look like three. Demonstrate the relativity of color by duplicating the spots' colors in a location where they can be more easily compared. Can you write a program to generate novel color sets that always fulfill the four-look-like-three condition?

Color Inspector

Load and display a colorful image. Draw three ellipses to the screen and fill them with the red value, the green value, and the blue value, respectively, of an image pixel under the cursor.

Color Survey

Create an interface for specifying a color, using sliders to control its red, green, and blue components. Ask some friends to use your tool to create the colors mauve, teal, and plum. Save the data they create. In another sketch, load and display this data to compare their opinions.

Additional References

Tauba Auerbach, *RGB Colorspace Atlas* (2011), http://taubaauerbach.com/view.php?id=286.

Carolyn L. Kane, *Chromatic Algorithms: Synthetic Color, Computer Art, and Aesthetics after Code* (Chicago: University of Chicago Press, 2014).

Rune Madsen, http://printingcode.runemadsen.com/lecture-color/.

Rune Madsen, https://programmingdesignsystems.com/color/color-models-and-color-spaces/index.html.

Rune Madsen, https://programmingdesignsystems.com/color/perceptually-uniform-color-spaces/index.html.

Robert Simmon, "Subtleties of Color," NASA Earth Observatory: Elegant Figures, last modified August 5, 2013, https://earthobservatory.nasa.gov/blogs/elegantfigures/2013/08/05/subtleties-of-color-part-1-of-6/.

Note

1. See Ticha Sethapakdi, *The Colorist Cookbook* (self-pub., 2015), https://strangerbedfellows.files.wordpress.com/2015/12/the-colorist-cookbook.pdf.

Conditional Testing

Cursor is on the
LEFT

Left or Right
Create a sketch in which a text display indicates whether the cursor is on the left side or the right side of the canvas.

State Machine I
Place a white square on a gray background. Create an interaction wherein a click inside the square turns it black, after which it stays that way. (In this exercise and those that follow, make sure that clicks *outside* the square have no effect.)

Billiard Ball
Create a sketch with a moving ball that bounces off the edges of the canvas. Take care that the ball never appears to overlap the edge of the canvas.

State Machine II
Place a white square on a gray background. Create an interaction wherein each click in the square flips its color. It should flip from white to black (if it is white) or from black to white (if it is black).

One-Person Pong
Create a sketch that recreates the game of Pong for a single user. Can you add a scoring system?

State Machine III
Place a white square on a gray background. Create an interaction wherein two clicks in the square are required to turn it from black to white, but three clicks are required to turn it from white to black.

You see three doors.

Choose Your Own Adventure
Create a branching narrative experience in which clicking in different regions of the screen leads to different rooms, situations, and outcomes. Enhance the experience with sound effects (e.g., door latches) and ambient audio recordings.

State Machine IV
Place a white square on a gray background. Turn the square into a button with a "hover" state: make it white when inactive, yellow when the user is hovering over it (without having clicked), and black when the user is actively holding the mouse button down inside of it.

Unpredictability

Coin Toss
Create a sketch for a coin that is "tossed" every time the mouse button is clicked. Your coin should be evenly weighted so that heads and tails have the same likelihood of appearing. Test your program over ten tosses. What were the observed frequencies of heads and tails?

Order to Chaos
Make an interactive composition that depicts "order" when the cursor is on the left side of the canvas, and "chaos" when it is on the right. The amount of order or chaos (entropy) should vary smoothly according to the cursor position. The `map()` and `constrain()` functions may be helpful.

Roll the Dice
Create an app in which a virtual die is "rolled" every time the mouse is clicked. Your die should be evenly weighted, and each result should have an even 1-in-6 chance of appearing. Test your program over 18 clicks. How well does it perform? Modify your code so that it rolls six dice.

Drunk Walk I: Brownian Motion
Create a sketch in which a small 2D element travels erratically from one moment to the next, leaving a trail across the canvas as it moves. At every timestep, it should update its current position with a small random displacement in both X and Y.

Exquisite Corpse Machine
Ask some friends to prepare drawings of heads, torsos, and legs. Make sure these parts are able to line up interchangeably at the neck and waist. Create an "Exquisite Corpse" generator in which these parts are randomly recombined whenever a button is clicked. (Image: Tatyana Mustakos)

Drunk Walk II: Random Lattice Walk
Create a sketch in which a small element travels erratically from one moment to the next, leaving a trail as it moves. At every timestep, it should have a 1-in-4 chance of moving up, down, left, or right from its previous position.

Intermittent Events
Create a time-based sketch in which a brief event (such as a sound or animation) is triggered sporadically and unpredictably, with a very low probability. You may also display a scrolling timeline showing a history of when the event occurred.

Drunk Walk III: Smoothed Noise
The smoothed quality of Perlin noise allows you to make an animation that is unpredictable, but also has temporal coherence. Use Perlin noise to dynamically regulate the size and position of a circle. Observe the effects of changing the parameters to the noise function.

10 PRINT

In each cell of a square grid, choose with random probability to place a diagonal line pointing up or down. The fascinating maze-like patterns that arise are discussed at length in the book `10 PRINT CHR$(205.5+RND(1)); : GOTO 10` by Nick Montfort et al.[1]

Duotone Truchet Tiling

Create a set of four duotone "Truchet tiles," each with two quarter-circles connecting the midpoints of adjacent sides. Be sure to create all possible orientations and all possible colorings (corners light or corners dark). Randomly place these tiles in a square grid, enforcing continuity of color.

Hitomezashi Sashiko Stitching

Randomly label the columns and rows of a grid with 0s and 1s. For each column, draw a vertical sequence of alternating dashes and gaps, beginning with a dash (for columns labeled 1) or a gap (for columns labeled 0). Similarly, draw horizontal sequences of dashes and gaps for the rows. Observe the resulting patterns.[2]

Noise Mountains

Generate some mountains by creating a series of parallel lines with no spacing between them, spanning from the bottom of the screen to an unpredicable height. Use a Perlin noise function to determine the height of each line.

Imaginary Islands

Use a two-dimensional Perlin noise function to generate a map of imaginary islands. For every pixel: if the value of the noise function is below some threshold value, color the pixel blue (for water); if it is higher than the threshold, color it brown (for land).

Recoding Molnár's *Interruptions*

Carefully study some reproductions of the computational plotter work *Interruptions* (1968–1969) by Vera Molnár.[3] Note how it consists of a grid of lines whose orientations have been randomized. Some lines are also missing, in patches. Write down ten additional observations about the work. To the best of your abilities, write a program to "re-code" *Interruptions*. Write a few sentences describing how your version succeeds or falls short.

Notes

1. *10 PRINT CHR$(205.5+RND(1)); : GOTO 10*, ed. Nick Montfort et al. (Cambridge, MA: The MIT Press, 2012).

2. See Annie Perkins, tweet of March 29, 2020, https://twitter.com/anniek_p/status/1244220881347502080.

3. Vera Molnár, *Interruptions*, plotter artwork, 1968–1969, http://dam.org/artists/phase-one/vera-molnar/artworks-bodies-of-work/works-from-the-1960s-70s.

Arrays

Living Line I
Create an interaction that stores the past 100 mouse positions and displays them as a polyline. Store the mouse data in three different ways: in two 1D arrays (one for X, one for Y); in one 2D array; and in an array of Point2D objects.

Animated Walk Cycle
Load each frame of an animated walk cycle into an array of images, and loop through these to display the character in motion. When a button is pressed, reverse the playback of the animation. (Image from Eadweard Muybridge, *Animals in Motion*, 1902.)

Living Line II
Create an interaction that stores the past 100 mouse positions and displays this path as a polyline. Move an animated ellipse along this path. When it reaches the end, return it to the start and repeat, or have it travel in the other direction.

Plant the Flag
A bumpy "landscape" or terrain, consisting of an array of height values, has been provided for you. Write code that searches through this array and draws "flags" on the peaks (i.e., local maxima).

Living Line III
Create a line using the past 100 mouse positions, as above. Bring your line to life by progressively adding some randomness to each point.

Longest Line Search
Write a program that draws straight lines when the user clicks and drags. Color the longest line red.

Calligraphic Polyline
Create a sketch that stores the past 100 mouse positions. Draw a line between each point and the one previous to it. Make the thickness of this line inversely proportional to the distance between each pair of points, so that faster marks make thinner lines.

Reordering Rectangles
Create a program that stores the coordinates for some rectangles in an array. Reading from this array, your program should paint the rectangles over each other as they are rendered. Write code to reverse the array. Sort the rectangles from right to left. Sort the rectangles by their area.

Time and Interactivity

Eyes Following Cursor
Draw one or more eyes with pupils that follow the cursor. If you can, constrain each pupil to stay within its eyeball.

Abstract Typewriter
Create an expressive keyboard-based performance instrument. Each key should trigger a different animation, image, or sound. Carefully consider the aesthetics of the experience of playing your system. For inspiration, try *Patatap*, an audiovisual keyboard app by Jono Brandel.

Fuse (or Progress Bar)
Program a virtual fuse that takes precisely five seconds to burn. Trigger an interesting event when it finishes, such as fireworks or a volcanic eruption. Consider alternate "skins" to tell a different story with the code for your fuse: a progress bar, a balloon inflating (and bursting).

Easing: Filtering a Variable
Objects rarely move at a constant speed in the real world. Create a sketch in which an ellipse follows the position of the cursor but decelerates on approach. This requires an easing function or a filter for the mouse position values.

Ripples in a Pond
Create a program in which animated circular "ripples" emanate outward from the cursor each time the mouse button is clicked. Consider the speed at which your ripples expand. Implement your ripples in an object-oriented coding style.

Smoothing Data
Create a polyline by storing and displaying a sequence of cursor positions. Now smooth it by progressively averaging each point along the line with its neighbors. Give consideration to how you handle the line's terminal points.

Rain Catcher
Using code, animate a rainy day. Raindrops should appear from beyond the top of your screen and fall at random intervals. (It may be helpful to create a raindrop class.) Create a simple game in which the user can "catch" raindrops that fall close to the cursor.

Audio-Sensitive Animation
Create graphics that respond to the amplitude of microphone sounds. For example, you might illustrate the sound with a sleeping animal that is awakened by loud noises, or a face that appears to be voicing the microphone sound. Audio waveforms should be a starting point, not an end.

Typography

Ransom Letter
Create a sketch to display a brief text in which each letter is individually set with a random typeface and font size.

Scrolling Headlines (Chyron)
Choose a series of recent news headlines and write a program that displays them scrolling along the bottom of the screen. For an additional challenge, fetch the latest headlines automatically using a news API.

One-Line Typewriter
Create a sketch that accumulates and displays a string of letters as they are typed. For an additional challenge, delete characters when the backspace key is pressed.

Split-Flap Display (Word Ladder)
Curate a list of words that all have the same number of letters. Create a display that interpolates from one word to the next, in the manner of a split-flap airport sign, by iterating through the intermediate letters in alphabetical order.

Dynamic Text
Choose a word describing a bodily action, such as "grow," "shiver," or "jump." Animate this word on your screen in a way that represents its meaning. For example, the word "grow" could become larger over time.

Word Finder
Typeset a brief text, such as a poem or email. Create a program that locates instances of a "word of interest" in that text. Your program should perform a visual treatment of that word, such as highlighting, underlining, or redaction.[2]

Responsive Text
Assign an interactive behavior to a word, such as "avoid" or "tickle," that expressively defines its personality relative to the cursor.[1]

Letterform Collage Tool
Create a tool that allows a user to make abstract collages or concrete poetry with letterforms. The user should be able to select a letter with the keyboard and then place it using the mouse. Save three compositions made with your tool.

Procrustean Typography

In Greek mythology, Procrustes stretched or cut different people to make them all fit in a certain iron bed. You will do the same with type. Create a program that captures words typed by the user and adjusts their font size so that they always fit the precise width of the canvas.

Tiny Word Processor

Using a fixed-width font, create a word processor that allows a user to type characters into a field of cells. Provide a text cursor whose position can be moved with the arrow keys and mouse. Implement word-wrapping, deleting (with the backspace key), and text file exporting.

Text along a Curve

Set text along a curve, writing code to position each letter. If you can, orient each letter so that it is locally perpendicular to the curve.[3]

ASCII Vision

Write a program to generate an ASCII art representation of an image. To do this, you'll need a sequence of characters that represents different brightness values in an image. A common character ramp for representing 10 levels of grey is "@%#*+=-:. "[6]

Glyph Hacking: Playing with Outlines

In this exercise you will load a typeface, modify its characters, and save out a new font of your own. Identify a method for loading font outlines into your preferred programming environment, such as by converting a TTF typeface to SVG using FontForge, or by accessing glyph contours directly with `textToPoints()` (in p5.js), opentype.js, the Rune.Font plugin[4] (in Rune.js), or the Geomerative library[5] (in Java Processing). Using code, create a treatment for all of the letters in the alphabet, such as making them puffy or spiky. Name your new font, and use your font to typeset its name. If you can, export your new glyphs to .ttf or another font format when you have finished.

Notes

1. Adapted from Casey Reas and Ben Fry, "Typography," https://processing.org/tutorials/typography/.

2. The text in the poem is from Sonia Sanchez, "This Is Not a Small Voice" (1995), https://poets.org/poem/not-small-voice.

3. Daniel Shiffman, "Strings and Drawing Text," https://processing.org/tutorials/text/.

4. Rune Madsen, "Typography,"http://printingcode.runemadsen.com/lecture-typography/.

5. Ricard Marxer, "Geomerative Library," http://www.ricardmarxer.com/geomerative/.

6. Paul Bourke, "Character Representation of Greyscale Images," http://paulbourke.net/dataformats/asciiart/.

Curves

Butt Generator
Write a program that uses arcs or Bézier curves to generate images of one or more butts.[1]

Parabola
A *parabola* is a curve whose formula is $y=ax^2$, where the variable a is some constant of your choice. Write a program that plots a parabola.

One Circle, Three Ways
Plot a circle (from scratch) three different ways: use the trigonometric functions `sin()` and `cos()` to plot a series of points; approximate a circle with four Bézier curves; and construct a circle with "turtle graphics," using a series of alternating forward steps and small rotations.[2]

Continuity of Bézier Curves
Create a curve by joining two Bézier curves. Now ensure that the combined curve is "C2 continuous," with no visual discontinuities at the point where its components are joined. In other words, there should be continuity of position, tangent slope, and curvature.

Phyllotaxis
Use turtle graphics to generate a phyllotactic spiral.[3] Start your turtle at the center of the canvas. At each step, your turtle should draw a small element; move outwards by a slowly increasing amount; and rotate its orientation by the "Golden Angle," ~137.507764°.

Lissajous
Lissajous curves are useful parametric functions of the form `x=cos(a*t); y=sin(b*t);`, where `a` and `b` are typically small whole numbers. Use the mathematics of Lissajous curves to plot the movements of an animated element.

Spiral
Write a program that draws a spiral. Before you begin, research different types of spirals, such as Archimedes's spiral (the radius of which grows arithmetically) and the logarithmic or equiangular spiral (whose radius grows geometrically). Consider different implementations, such as explicitly plotting your spiral using polar equations, implicitly rendering it by summing small differences (e.g., go forward, turn slightly, repeat), or approximating it piecewise with circular arcs.

Epitrochoid

Polar Curve
Write a program to display a cardioid, epicycloid, hippopede, or other polar curve[4] whose equation takes the form `r = f(theta)`. The identities `x=rcos(theta)` and `y=rsin(theta)` may be helpful. Use the cursor to control parameters of the curve in real time.

Fourier Synthesis
In Fourier synthesis, complex waveforms are made by summing up sine waves of different amplitudes and frequencies. For example, a square wave can be approximated by the sum: `sin(x)+sin(3x)/3+sin(5x)/5+sin(7x)/7....` Generate a square wave with this technique.

Osculating Circle
Every point on a curve has a local *radius of curvature*: the radius of the osculating circle that best approximates the curve at that point. Write a program that displays the osculating circle for points along a mark drawn by the user. You can approximate this by computing a circle from three consecutive points along the mark.

Circle Morphing
Create a program that interpolates between a circle and a triangle.[5]

Shaping Functions
"Shaping functions" are indispensable in generating and altering signals for aesthetic purposes. Also known as tweens, interpolation curves, bias functions, easing curves, or unit generators, these functions are typically designed to receive and produce values between 0 and 1. Use a collection of shaping functions (such as p5.func by Luke DuBois, or Robert Penner's Easing Functions) to create nonlinear relationships between time and position (to make animations) or between position and color (to make interesting gradients).[6]

Notes

1. Inspired by Le Wei, "Butt Generator," accessed April 11, 2020, http://www.buttgenerator.com/.

2. Yuki Yoshida, "Drawing a Circle Code Repository," accessed April 11, 2020, https://github.com/yukiy/drawCircle.

3. Golan Levin, "Turtle's Phyllotactic Spiral," accessed April 11, 2020, http://cmuems.com/2015c/deliverables/deliverables-09/#spiral.

4. Mathworld, "Curves," accessed April 11, 2020, http://mathworld.wolfram.com/topics/Curves.html.

5. See Dan Shiffman, "Guest Tutorial #7: Circle Morphing with Golan Levin," *The Coding Train*, October 25, 2017, video, https://www.youtube.com/watch?v=mvgcNOX8JGQ.

6. Luke DuBois, "p5.func," accessed July 27, 2020, https://idmnyu.github.io/p5.js-func/; Robert Penner, "Easing Functions," accessed July 27, 2020, http://robertpenner.com/easing/.

Shapes

Make a Star
Plot the vertices of a regular 10-sided polygon, using the trigonometric functions `sin()` and `cos()` in the same way that you might generate a circle. Modify your code to generate a star by alternating long and short radii.[1]

Axis-Aligned Minimum Bounding Box
Given a 2D shape represented by a set of points, compute and plot its "bounding box": a useful rectangle defined by the leftmost, rightmost, highest, and lowest points on the shape's contour. Create an interaction in which the shape is displayed differently if the cursor enters its bounding box.

Random Splat
Plot the vertices of a many-sided polygon, using the functions `sin()` and `cos()` in the same way that you might generate a circle, but compute the position of each point with a radius that is slightly randomized. How closely can you make the result resemble a drop of ink?[2]

Computing the Centroid
Given a 2D shape represented by a set of points, compute and plot the "centroid" of its outline— the location whose x-coordinate is the average of the x-coordinates of the points, and whose y-coordinate is the average of the y-coordinates of the points.

Connect the Dots
The numbers below define the vertices of a polygon. Write code that connects the dots to plot the shape. x={81, 83, 83, 83, 83, 82, 79, 77, 80, 83, 84, 85, 84, 90, 94, 94, 89, 85, 83, 75, 71, 63, 59, 60, 44, 37, 33, 21, 15, 12, 14, 19, 22, 27, 32, 35, 40, 41, 38, 37, 36, 36, 37, 43, 50, 59, 67, 71}; y={10, 17, 22, 27, 33, 41, 49, 53, 67, 76, 93, 103, 110, 112, 114, 118, 119, 118, 121, 121, 118, 119, 119, 122, 122, 118, 113, 108, 100, 92, 88, 90, 95, 99, 101, 80, 62, 56, 43, 32, 24, 19, 13, 16, 23, 22, 24, 20};

Perimeter = 391 pixels

Computing the Perimeter
Given a 2D shape represented as a set of points, calculate the length (or *perimeter*) of its outline. To do this, add up the distances between every pair of consecutive points along its boundary. Don't forget to include the distance from the last point back to the first one.

Area = 4982 pixels

Computing the Area
Given a simple (non-self-intersecting) 2D shape whose points are stored in arrays `x[]` and `y[]`, calculate its area. This can be done using Gauss's area formula, or "shoelace algorithm," which sums, for all points `i`, the products `((x[i+1] + x[i]) * (y[i+1] - y[i]))/2.0`.

Shape Metrics: Compactness

Area = 4982
Perimeter = 391
Compactness =

0.41

Area = 4982
Perimeter = 252
Compactness =

0.98

One of the simplest shape metrics is "compactness" (or isoperimetric quotient), which describes the extent to which a shape does or doesn't sprawl. Often used in redistricting to avoid gerrymandering, compactness is a dimensionless, scale-invariant, and rotation-invariant quantity.[3] It is computed by taking the ratio of a shape's area to its squared perimeter. Compute the compactness of the provided shape. Compare this value with the compactness of some other shapes.

Detecting Points of High Curvature

Given a 2D shape represented as a set of points, we can estimate the "local curvature" along the shape's boundary by computing the angle between consecutive trios of points. Using the provided shape, write code to determine which points have especially high curvature (i.e. the fingertips) and mark them with a colored dot. *Hint*: Use the dot product to compute the angles, and the cross product to distinguish positive curvature (convexities) from negative curvature (concavities).

Hand-Drawn Graphics Library

Create a set of functions for rendering basic shapes with a hand-drawn feel. At a minimum, your library should provide functions for drawing line segments, ellipses, and rectangles.

Blob

Using any means you prefer, design and animate an expressive 2D blob. For example: you could create a closed loop of Bézier curves; trace the contours of metaballs (implicit curves) using Marching Squares; calculate a Cassini ellipse, cranioid, or other parametric curve; or simulate a smooth ropelike contour using Verlet integration.

Notes
1. Adapted from Rune Madsen, "Shape: Procedural Shapes," Programming Design Systems, accessed July 6, 2020, https://programmingdesignsystems.com/shape/procedural-shapes/index.html.

2. Adapted from Madsen, "Shape: Procedural Shapes."

3. Wikipedia, s.v. "Compactness measure of a shape," last modified June 22, 2020, https://en.wikipedia.org/wiki/Compactness_measure_of_a_shape.

Geometry

Midpoint of a Line Segment

Write a program that draws two random points (A and B) whenever a button is pressed. Connect these points with a line segment. Calculate the midpoint of this line segment, and place a dot there. Place an additional circle one-third of the way from A to B.

Orientation: 29.4°
Compass Bearing: NE

Compass Orientation

Store the locations of the two most recent mouse clicks and draw a line between them. Using the `atan2()` function, compute the angular orientation of this line. Display this angle in degrees, and label it with the nearest compass direction (N, NE, E, SE, S, SW, W, NW).

Intersection of Two Rectangles

Write a program that draws two randomly sized, randomly placed rectangles whenever a button is pressed. If these rectangles overlap, locate the new rectangle that represents their overlapping region and draw its diagonals.

Angle: 43.5°

Angle between Three Points

Write a program that computes the angle between three points: two randomly placed points, A and B, and the mouse cursor, C. *Hint*: Use the dot product to compute the angles, and use the cross product to distinguish positive from negative curvature.

Construction of a Perpendicular

Write a program that draws a line from the center of the canvas to the cursor. Construct a second line that starts at the cursor, is 50 pixels long, and is perpendicular to the first line.

Distance from
P3 to Line: 423.6

Distance from a Point to a Line

Write a program that creates a random line segment whenever a key is pressed. Compute and display the shortest distance between this line and the cursor. Place a dot at the point on this line that is closest to the cursor.[1]

Parallel Polyline (Offset Curve)

Write a program that stores cursor points as a user draws. Connect these points with a polyline. Use geometry to calculate another polyline, which is offset everywhere from the user's drawing by a distance of 50 pixels.

Intersection of Two Line Segments

Write a program that creates two random line segments whenever a button is pressed. Calculate the intersection point of these two line segments, and if it exists, draw a dot there.[2]

Centroid of a Triangle

Construct a triangle from three random points whenever a button is pressed. Draw lines (called "medians") to connect the midpoints of each side to its opposite vertex. At the intersection of these medians is the triangle's *centroid*. Place a dot there.

Circle from Three Points (Circumcenter)

Construct a random triangle whenever a button is pressed. Generate a circle that passes precisely through all three of its vertices. The center of this circle is called the *circumcenter* of the triangle. Place a dot there. Note: the circumcenter is not always inside the triangle.[3]

Orthocenter of a Triangle

The "altitude" of a triangle is a line that is perpendicular to a given side and passes through the opposite vertex. Write a program that constructs a triangle from three random points whenever a button is pressed. Calculate and display the triangle's three altitudes. The *orthocenter* of this triangle is located at the intersection of its altitudes. Place a dot there. Note: for most triangles, the altitudes will not pass through the midpoints of the sides.

Incenter of a Triangle

The *incenter* of a triangle is located at the intersection of the angle bisectors of a triangle's three corners. Write a program that generates a random triangle whenever a button is pressed and places a dot at its incenter. (The incenter also happens to be the center of a circle inscribed inside the triangle, called the incircle; its radius is obtained by dropping a perpendicular line from the incenter to any of the triangle's sides. If you can, draw the triangle's incircle.)

Notes

1. Paul Bourke, "Points, Lines, and Planes," 1988–2013, http://paulbourke.net/geometry/pointlineplane/.

2. Bourke, "Points, Lines, and Planes."

3. Paul Bourke, "Equation of a Circle from 3 Points (2 Dimensions)," January 1990, http://paulbourke.net/geometry/circlesphere/.

Image

Collage Machine

Collect a directory of images. Write a program that uses these to generate collages of images. Include some unpredicability within it so that it generates a different collage each time it runs.

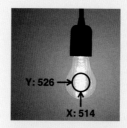

Searching for the Brightest Point

Display the live video feed from your webcam to the screen and process the pixels to find the brightest point in the image. Place an indicator at the location of this pixel.

Color of a Pixel

Display an image. Create an interactive system that continually fetches the color of the pixel under the mouse as it passes over this image. Use this color to fill a shape drawn to the screen as the mouse is moved around.

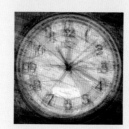

Image Averaging

Collect ten or more images labeled with the same word or concept, such as "apple," "sunset," or "clock." Ensure that all of the images have the same pixel dimensions. Compute a new image that is the pixelwise average of the collection, as a way to visualize regularities in the representation of that concept.

Subsample and Downsample

Write a program that pixelates an image to produce a low-resolution version. Begin by *subsampling* the image (destination pixels are selected from the original). Then, *downsample* the image (destination pixels are local averages).

Edge Detector (Sobel Filter)

Write a program that uses a Sobel filter to detect and display the edges in an image. If you can, compute the strength and orientation of these edges.

Random Dot Dithering

Load an image into memory and fetch the brightness of a pixel in a random location. Generate a random number between 0 and 255; if it is greater than the brightness of the pixel, draw a black dot at a corresponding location on the canvas. Repeat as the picture emerges.

Pixel Sort

Sort the pixels of an image by brightness. Then repeat the exercise, but sort by hue. For tips, see Dan Shiffman's "Coding Challenge #47: Pixel Sorting in Processing" in his *Coding Train* video of December 21, 2016.

Visualization

Text Message Isotype
Collect the text messages that you sent and received over the past week. Count and categorize these messages according to person, topic, or mood. Create an isotype visualization to represent this data pictorially.[1]

Path Plotting I
Using a smartphone app such as OpenPaths or SensorLog, record your GPS location data for a duration of at least one week. Export the latitude and longitude data to a CSV file. Write code to load and visualize the paths of your daily journeys. What observations can you make?

Global Temp.,1880–2016

Temperature Timeline
Download a dataset of the average monthly temperatures where you live. Visualize this data in a chart showing time on the x-axis and temperature on the y-axis. Make three versions of the graph, showing the data as points, as vertical bars, and as data points connected with a curved line.[2]

Path Plotting II
Reuse the location dataset from the previous exercise and visualize it in a way that is *not* a map. Consider displaying information such as path lengths or speed, frequency of visits to a particular location, distance traveled per day, etc.

Pie Chart
Write code to generate a pie chart that displays what you spent on breakfast, lunch, dinner, and coffee yesterday. You will need to use a function that renders a filled arc. Load the data from an external file in a well-structured format like JSON or CSV. Make sure your chart has a key.

NYC Rats

Dot Map
The "Rat Sightings" dataset from NYC OpenData lists all of the complaints about rats made to New York City's 311 response center since 2010. Write a program to map this geolocated data by representing each complaint as a single dot.[4]

NYC Rats

Small Multiple of Radar Charts
Take a "Big Five" personality quiz to (ostensibly) quantify your conscientiousness, agreeableness, neuroticism, openness, and extraversion.[3] Generate a radar chart to visualize this multivariate data. Ask some friends to take the quiz, and create a trellis plot (or "small multiple") that presents their personality charts side by side.

Heat Map
Write a program to display the Rat Sightings data as a spatial heat map. This presents two challenges, as you will need to: design a density function that represents the density of dots in a map as a continuous field, and select a color palette that represents the intensity of this field.

Social Network Graph

Develop a "force directed graph" to visualize a social network, in which individuals are represented as nodes and their relations as links, and the layout is governed by a simulated particle system. Use this to visualize the community of 62 bottlenose dolphins living off Doubtful Sound, New Zealand, as compiled by Lusseau et al.

Social Network Matrix

A *symmetric adjacency matrix* visualizes social interactions in a group. Individuals are listed along a table's rows and columns, and interactions between each pair are quantified in the cells. Create such a visualization for the family of wild monkeys observed by Linda Wolfe as they sported by a river in Ocala, Florida.

Real-Time Data Display

Locate a real-time Internet data stream such as that published by a sensor or an API (weather, stock prices, satellite locations). Create a program that displays this data in an evocative way. The example here shows the location of the International Space Station, available from open-notify.org.[5]

Web Scraping

Write a program to exhaustively "scrape" a collection of online images. For example, you might automate a process to download images of every product offered by a certain vendor. Write a second program to display your images in a grid. How else could you organize the collection?[6]

One Dataset, Four Ways

Visualize the Slate USA Gun Deaths dataset (2013) in four different ways: a map, a timeline, a bar chart based on age, and a fourth method of your choice. If you can, provide an interaction that allows a user to zoom, sort, filter, or query the data. Write about how the different displays provide different insights.[7]

Notes

1. Otto Neurath, *International Picture Language: The First Rules of Isotype* (London: K. Paul, Trench, Trubner & Company, Limited, 1936).

2. Ben Fry, "Time Series," *Visualizing Data: Exploring and Explaining Data with the Processing Environment,* chap. 4 (Cambridge, MA: O'Reilly Media, Inc., 2008).

3. For example: Open-Source Psychometrics Project, "Big Five Personality Test," https://openpsychometrics.org/tests/IPIP-BFFM/.

4. The Rat Sightings dataset is available online at https://data.cityofnewyork.us/Social-Services/Rat-Sightings/3q43-55fe. See also Fry, *Visualizing Data*, chap. 6.

5. OpenNotify.org, International Space Station Current Location, http://open-notify.org/Open-Notify-API/ISS-Location-Now/. Also see Dan Shiffman's sequence of video tutorials, *Working with Data and APIs in JavaScript,* last updated on July 8, 2019, https://www.youtube.com/playlist?list=PLRqwX-V7Uu6YxDKpFzf_2D84p0cyk4T7X.

6. See Sam Lavigne's sequence of tutorials, *Scrapism,* last updated on May 27, 2020, https://scrapism.lav.io/.

7. Dataset available at http://www.slate.com/articles/news_and_politics/crime/2012/12/gun_death_tally_every_american_gun_death_since_newtown_sandy_hook_shooting.html.

Text and Language

I typed BLUE!

String Search

Find a table of color names and their corresponding RGB values. Create an interaction in which a square becomes colored when a user types a known color name. (Is your program case-insensitive?)

Given their physiological requirements, limited dispersal abilities, and hydrologically sensitive habitats, amphibians are likely to be highly sensitive to future climactic changes.

7.09

Frog and Toad ate many cookies, one after another. "You know, Toad," said Frog, with his mouth full, "I think we should stop eating. We will soon be sick." "You are right," said Toad.

3.94

Average Word Length

Write a program that calculates the average word length of a provided text. This is a useful approximation of a text's "reading level." Run your program on several different source materials.

de·**klept**·ism
un·bibl·**ing**
dys·**clar**·tion
re·bio·**meter**
rhino·**rupt**·ed

Nonsense Words

Find some lists of common English prefixes, word roots, and suffixes. Select a random item from each list and combine them in a simple syntax (prefix+root+suffix) to generate plausible nonsense words. What might these words mean?

a act all and and and and another are are beings born brotherhood conscience dignity endowed equal free human in in of one reason rights should spirit they towards with

Sorting Words

Load a document and display its words (a) sorted alphabetically, (b) sorted by their length, and (c) sorted according to their frequency in the text.

ABCDEFGHIJKLMNOPQRSTUVWXYZ

Letter Frequency

Write a program to calculate the frequencies of the letters in a provided text. (Be careful to make your program "case-insensitive.") Write code to generate a visualization (such as a bar chart or pie chart) of the letters' frequencies.

WNYC Employees Demanded Diversity. They Got Another Pandemic to Cut Service That Macron Replaces France's Prime Minister Marijuana Scholar, Dies at 92 After Fighting Plastic Waste Minister in Bid For Fresh Start Won't Return

Cut-Up Machine

In the *Dada Manifesto*, Tristan Tzara describes using a newspaper, scissors, and some gentle shaking to generate irrational poetry. Do the same with code. Write a program that randomizes the lines or sentences of a newspaper article to make a Dada-style poem.

	A	B	C	D	E	F	G	H	I
A	0.00	0.12	0.44	0.20	0.83	0.23	0.34	1.00	0.17
B	0.19	0.01	0.01	0.00	0.03	0.00	0.00	0.01	0.05
C	0.52	0.00	0.04	0.00	0.26	0.00	0.00	0.00	0.50
D	0.29	0.00	0.00	0.00	1.28	0.00	0.00	0.00	0.00
E	0.00	0.49	0.52	0.73	0.58	0.34	0.38	0.00	0.30
F	0.00	0.00	0.00	0.00	0.15	0.09	0.00	0.01	0.24
G	0.18	0.00	0.03	0.26	0.04	0.00	0.04	0.00	0.00
H	0.01	0.00	0.61	0.00	0.22	0.00	0.00	0.00	0.00
I	0.37	0.09	0.29	0.33	0.27	0.25	0.16	0.00	0.01

Letter-Pair Frequency

Write a program to calculate the frequencies of letter pairs (character 2-grams, such as "aa," "ab," "ac") in a large text source. Plot the frequencies in a 26x26 matrix.

35 not like
34 i do
34 do not
33 like them
29 in a
21 eat them
18 with a
18 not in
15 i will
14 i would
14 them in
13 would not
12 would you
11 eggs and

Bigram Calculator

Write a program to calculate the frequency of all bigrams (word-pairs) in a document. *Advanced students:* develop a program that judges the similarity of two text files based on how many bigrams they have in common.

Dammit, Jim!
I'm a **marriage therapist**, not a **meat packer**!

Dammit Jim

Find a list of occupations. Use these in a generative grammar that produces sentences in this format: "Dammit, Jim, I'm an X, not a Y!" (popularized by the sci-fi TV show *Star Trek*). Be sure to write "an X" if X begins with a vowel and "a X" if it begins with a consonant.[1]

I do not like green **junctions** and **switch**.
I do not like them, **Monorail**.

Noun Swizzler

Load a text, and replace each noun with a randomly selected noun taken from a second text. You may need to use a "part-of-speech tagger" to identify the nouns. In your substitutions, try to match the use of plural and proper nouns in the first text.

Knock, knock!
Who's there?
Child.
Child who?
A young person.

Knock-Knock Joke Generator

Create a program that generates knock-knock jokes. At a miminum, your program should select a random word as a response to "Who's there?" and add to this word to create the final line of the joke. Generate ten jokes.

It is hard to erase blue or red **ink**.
Dunk stale biscuits into strong **drink**.

Rhyming Couplets

Select and load a large expository text. Create a program that finds rhyming couplets within it, in order to make new poems. You may need to use an additional library (such as RiTa) to tell you what the words sound like.[2]

onceway uponway a
idnightmay earydray,
ilewhay i onderedpay,
eakway andyay
earyway, overway
anymay a aintquay
andyay uriouscay
olumevay ofyay
orgottenfay orelay

Pig Latin Translator

Create a program that translates provided text into Pig Latin. In this playful scheme, the initial consonant (or consonant cluster) of each word is transferred to the end of that word, after which the syllable "ay" is added.

Meg and Jo closed their weary eyes, and lay at rest, like storm beaten boats

Mrs. Brooke, with her apron over her head, sat sobbing dismally.

"Do you remember our castles in the air?" asked Amy, smiling

Haiku Finder

Write a program that automatically discovers "inadvertent haikus": sentences in a chosen text whose words happen to fall in groups of five, seven, and five syllables. A basic solution will discover haikus with awkward breaks; add heuristics to improve the quality of your results.

Fubour scubore uband
subevuben yubears
ubagubo ubour
fubathubers
brubought fuborth,
ubupubon thubis
cubontubinubent,
uba nubew nubatiubon,
cuboncubeived ubin
lubibubertuby

Argots and Language Games

Investigate argots, secret languages, and word games like Ubbi Dubbi, Tutnese, Pirate English, and Dizzouble Dizzutch. Select one and write a program that translates a provided text into it.

I do not eat like them in like green eat them in they like them. could you eat like them and you?

Markov Text Generator

In a Markov chain, a dataset of letter-pair, bigram, or n-gram frequencies is used as a "probability transition matrix" to synthesize new text that statistically resembles the dataset's source. Build a Markov generator using the data you collected earlier.[3]

There once was
a bug who liked
art.

He thought it
was awfully
tart.

Keyword Extraction with TF-IDF

Obtain a collection of related documents, such as poems, recipes, or obituaries. Write a program that uses the TF-IDF ("Term Frequency - Inverse Document Frequency") algorithm to determine the keywords that best characterize each document.[4]

Limerick Generator

Limerick poems have five lines in an AABBA rhyming pattern. The building block of these lines is the *anapest*: a foot of verse consisting of three syllables, the third of which is accented: *da-da-DA*. Lines 1, 2, and 5 consist of three anapests; they end with a similar phoneme in order to create the rhyme. Lines 3 and 4 also rhyme with each other, but are shorter, consisting of two anapests each. Write a program to generate limericks. Use a code library such as RiTa to help evaluate your words' rhymes, syllables, and stress patterns.[5]

Notes

Exercises in this section were contributed by Allison Parrish.

1. See Darius Kazemi's repository of structured corpora: https://github.com/dariusk/corpora. Also consider code libraries for producing grammar structures, like Tracery by Kate Compton, http://www.crystalcodepalace.com/tracery.html.

2. For Java and JavaScript, see RiTa by Daniel Howe, "RiTa, a Software Toolkit for Computational Literature," https://rednoise.org/rita/. For Python, see NLTK, "Natural Language Toolkit," https://www.nltk.org/.

3. For Python see: "Markovify," https://github.com/jsvine/markovify.

4. See Dan Shiffman, "Coding Challenge #40.3: TF-IDF," *The Coding Train*, October 12, 2016, video, https://www.youtube.com/watch?v=RPMYV-eb6II.

5. Howe, "RiTa"; see "The CMU Pronouncing Dictionary," http://www.speech.cs.cmu.edu/cgi-bin/cmudict.

Simulation

Recursive Tree

Use recursion to create a tree. Begin with a symmetrical design that repeatedly bifurcates. Introduce a variable that proportionally reduces the length of each iteration's branches, and another to alter their orientation. Explore your tree's possibilities by controlling these variables with the cursor.[1]

Fireworks (Particle Shower)

Create a particle class that stores a speck's 2D position and velocity. Add methods to give the particle an initial, randomly generated velocity and constant acceleration. Create an array of particles to simulate a firework. Each element of the array will need to start from the same position.

Flocking

Create a two-dimensional flock of creatures, modeling your animals as particles that exert (and are affected by) forces of mutual *separation* (to prevent collision), *cohesion* (to stick together as a group), and *alignment* (to orient toward similar directions as their neighbors). Connect your governing parameters to sliders or other UI controls, and observe how changing the relative strengths of these forces alters the behavior of the flock or swarm. Include other forces, such as the desire to flee from a predator, the hunger to hunt for food, etc. Be sure to represent your creatures with a graphic that makes their orientation visible.[2]

Braitenberg Vehicles

A Braitenberg vehicle is an autonomous agent that moves and steers based on sensor inputs. It measures a stimulus at its location; depending how this signal is mapped to each wheel's power, the vehicle can appear to exhibit different goals and behaviors. Implement vehicles that steer toward or away from the cursor.

Cursor-Sensitive Particles

Create a particle class that stores a speck's 2D position and velocity. Add a method that enables a particle's motion to be affected by simulated forces. (See Euler integration and Newton's 2nd Law.) Create an array of particles that are attracted to or repelled by the cursor.

Flow Field

Use 2D Perlin noise to compute a flow field, such that every location on the canvas has an associated x-force and y-force. Place particles into this field, impelling them with the forces at their locations. Make recordings of their traces. Confine the particles with periodic boundaries.

Spring

Model a bouncy spring as a particle with a current position P, velocity V, and rest position R. When moved from R, a restorative force F proportional to this displacement pushes it back. Update the particle using Euler integration: add F into V, reduce V by a percentage due to damping, and add V into P.

Circle Packing

Generate a "circle packing": an arrangement of circles such that none overlap, and some (or all) are mutually tangent. In one approach, randomly placed circles are added to unclaimed regions of the canvas and grow until they collide with any previous circles.[3]

Space Colonization

Implement *space colonization*: an iterative algorithm, first described by Adam Runions, for growing networks of branching line structures based on the locations of "growth hormone" sources to which the lines are attracted.[6]

Conway's Game of Life

Create an implementation of "Conway's Game of Life." This classic cellular automaton is one of the simplest and best illustrations of the way in which complex patterns of self-organization can emerge from simple rules.[4]

Differential Growth

Implement *differential growth*, in which a chain of connected nodes (represented by a curve or polyline) uses simple rules like attraction, repulsion, and alignment to produce meandering shapes. The algorithm uses *adaptive subdivision* to interpose new nodes when two adjacent nodes get too far apart.[6]

Diffusion-Limited Aggregation

Implement and explore the coral forms that arise from diffusion-limited aggregation (DLA): a simulation in which meandering particles become fixed in place when they collide with previously fixed particles (or an initial "seed").[5]

Snowflake Generator

Snowflakes are thought to form through a DLA-like process. To make a snowflake generator, modify your DLA simulation from the previous exercise so that it has dihexagonal symmetry.

Notes

1. Dan Shiffman, "Coding Challenge #14: Fractal Trees - Recursive," *The Coding Train*, May 30, 2016, video, 15.52, https://www.youtube.com/watch?v=0jjeOYMjmDU.

2. "6.1: Autonomous Agents and Steering - The Nature of Code," *The Coding Train*, August 8, 2015, video, 14.28, https://www.youtube.com/watch?v=JIz2L4tn5kM. Also see Craig Reynolds's research into steering behaviors and "boids."

3. "Coding Challenge #50.1: Animated Circle Packing - Part 1," *The Coding Train*, January 9, 2017, video, 28.31, https://www.youtube.com/watch?v=QHEQuoIKgNE.

4. "7.3: The Game of Life - The Nature of Code," *The Coding Train*, August 10, 2015, video, 16.03, https://www.youtube.com/watch?v=tENSCEO-LEc.

5. "Coding Challenge #34: Diffusion-Limited Aggregation," *The Coding Train*, August 18, 2016, video, 47.06, https://www.youtube.com/watch?v=Cl_Gjj80gPE.

6. Jason Webb, "Morphogenesis Resources," 2020, https://github.com/jasonwebb/morphogenesis-resources.

Machine Learning

Dataset History Audit

Identify a widely used dataset, such as ImageNet, MNIST, or LFW. Research its content and genesis. Who made it, when, and how? Who uses it, and for what? (What biases might this dataset have?) Describe your findings in one or two paragraphs.

Don't Touch Your Face

Touching your face can spread disease. Train a webcam classifier to detect when you touch your face. Write a program that sounds an alarm if you do. (Image: Isaac Blankensmith's *ANTI-FACE-TOUCHING MACHINE™*, an influential implementation of this concept.)[2]

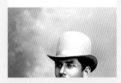

Comparing Models

Use two different image analysis or classification tools to interpret the same image. Write a paragraph that describes and compares their results.

Emoji Translator

Using an image classifier and your computer's camera, train a system that detects your facial expressions and displays corresponding emojis.[3]

Shopping List

Use an object recognition library or a classifier to store a list of all the objects it sees. Use it to make a shopping list of everything in your fridge.[1]

Body as Game Controller

Train an image classifier to determine whether you have raised your left or right hand. Using a "webdriver" (also called a mouse/keyboard automator), write a program in which your classifier controls a classic arcade game, such as Space Invaders, by spoofing presses of the WASD or arrow keys. Examples of webdrivers include the Java Robot class, JavascriptExecutor, and Selenium Browser Automation Project.

What Do You See?

Combine an object recognition classifier with a text-to-speech library. Write a computer program that narrates what it sees through the webcam.

Draw with Your Nose

Use a pose classifier or face tracker to create a program that lets you draw with your nose.[4]

More Like This, Please

Create or download a collection of about a thousand images representing a narrow category of subject matter (cats, flowers, yearbook photos). Using a Generative Adversarial Network (GAN), synthesize new images that appear to belong to this dataset.[7] (Image: "This Foot Does Not Exist" by the MSCHF collective.)

Hand Puppet

Train a webcam regressor to produce a number between zero and one, according to the closing and opening of your hand. (Your regressor could use hand pose data from a tracking library, or it could process the camera's pixels directly.)[5] Use this number to puppeteer the mouth of a simple cartoon face.

Clustering a Collection of Images

Generate a 2D map that reveals similarities between images in a set. Begin with an image dataset that interests you. Using some sort of image analysis library, such as a convolutional neural network, calculate high-dimensional numeric descriptions for each image. Simplify these description vectors to just two dimensions using a dimensionality reduction algorithm, such as UMAP or t-SNE. Plot your images in the (x,y) locations produced by this algorithm. Discuss the clusters you observe. (Image: a UMAP plot by Christopher Pietsch showing the OpenMoji emoji collection.)

Environmental Sound Clock

Collect some audio recordings of the ambient sound in your room in the morning, at midday, in the evening, and at night. Train a classifier or regressor with these sounds. Use this system to display an approximate estimate of the time.

Sentiment Analysis

Collect the last ten text messages that you sent. Use a sentiment analysis tool to assess the mood of each message.[6]

Additional References

Yining Shi, syllabus for Machine Learning for the Web (NYU ITP, Fall 2018 and Spring 2019), https://github.com/yining1023/machine-learning-for-the-web.

Gene Kogan, "Machine Learning for Artists," GitHub, accessed April 11, 2020, https://ml4a.github.io/.

See RunwayML and their learning section that includes libraries for common creative coding environments like Processing. "Learn," RunwayML, accessed April 11, 2020, https://learn.runwayml.com/#/networking/examples?id=processing.

Notes

1. See the image classification example in the ml5.js library: "imageClassifer()," accessed April 11, 2020, https://ml5js.org/reference/api-ImageClassifier/.

2. See the ml5.js and Teachable Machine projects for in-browser tools to train a model. "Image Classifier," accessed July 11, 2020, https://learn.ml5js.org/docs/#/reference/image-classifier; "Teachable Machine," accessed April 11, 2020, https://teachablemachine.withgoogle.com/; and Isaac Blankensmith's "ANTI-FACE-TOUCHING MACHINE," https://twitter.com/Blankensmith/status/1234603129443962880.

3. Hayk Mikayelyan, "Webcam2Emoji," last modified September 16, 2020, https://github.com/mikahayk/ml4w-homework2.

4. Dan Shiffman, "ml5.js Pose Estimation with PoseNet," *The Coding Train*, January 9, 2020, video, 14.24, https://www.youtube.com/watch?v=Olo-DIOkNVg.

5. See the featureExtractor regressor in the ml5.js library, and hand trackers such as Ultraleap and Google's MediaPipe HandPose library.

6. See the sentiment model in the ml5.js library: "Sentiment," accessed July 11, 2020, https://learn.ml5js.org/docs/#/reference/sentiment.

7. See, for example, RunwayML, or the DCGAN tools in ml5.js.

Sound

Theremin

A *theremin* is a monophonic instrument whose volume and pitch are controlled by the positions of a player's hands, relative to two antennae. Using the x and y positions of the cursor, create a simple theremin in code. You may not use mouse clicks or the keyboard.

Modulation

Create a project that uses oscillators and envelopes to continuously modify some parameter of a sound. For example, you might implement *tremolo* (periodic amplitude modulation), *vibrato* (periodic frequency modulation), or *wah-wah* (periodic modulation of a resonant filter).

Sequencer I

Create a sequencer that plays a fixed, looping phrase or a collection of sounds. You will need to use arrays to store values that are interpreted as musical notes, chords, rhythms, or other musical parameters. Advanced students: consider how your sequencer's "score" is displayed.

Filter

Create a simple interactive program that permits the user to filter a sound or noise source, using the x and y positions of a cursor to control the filter. Experiment with different types of filters and their parameters.

Sequencer II

Create a sequencer that allows a performer to record and play back a looping musical phrase. Devise a visual interface so the performer can alter its playback: for example, changing its speed, transposing it, playing it backwards, reordering its notes, or altering its timbre.

Polyphony

Create a sonic experience that explores polyphony. Scaffold this on a visual system (such as a simulation or game) where the pitch of each voice responds to the speed, position, or orientation of a corresponding particle or mob. For simplicity, restrict your polyphony to multiples of the same instrument or sound.

Sampler

A *sampler* is an electronic instrument that triggers sound recordings. Create a sampler that triggers sounds with key presses. Develop a method for altering the nature of the playback in a way that is coupled to the x and y position of the cursor.

Visualizer

Create a music visualizer for a specific musical recording. Your display should respond to the dynamics (volume changes) and, if possible, the frequency content of your chosen music. For simplicity, be sure to select a recording without speech or lyrics.

Data Sonification

Locate a real-time Internet data stream, such as one published by a sensor or an API (monitoring weather, stock prices, satellite locations, tweets, seismic events). Create a program that sonifies this data or uses it to control a musical parameter for a generative composition.

Whistle Cursor

Find a tool to estimate the pitch of a real-time monophonic audio signal, such as the `fzero~` object (Max/MSP/Jitter), `sigmund~` (Pure Data), or `ofxAubio` (openFrameworks). Create an interactive game in which the pitch of the user's whistling is used to steer a spaceship up or down.

Delay Line Effect

Using a *delay line* (a collection of time-delayed copies of a sound), create a program that transforms a specific sound in a customized way. Popular delay line effects include echo and reverb but also flangers, chorus, and harmonization, when governed by an oscillator.

Synthetic Voice

Build a DIY speech synthesizer. Use any audio techniques you wish, except for preexisting speech samples or a text-to-speech system. You could synthesize different vowels with formant synthesis and consonants with gated noise. What word does your machine pronounce best?

Physics-Based Modulation

Create or repurpose some code for a real-time physical simulation, such as a particle system or spring mesh. Use time-varying quantities from the physical simulation to govern continuous parameters of an audio synthesizer. Consider using statistical properties of the simulation as the basis for audio mappings. For example, the average horizontal position of a collection of particles could be mapped to the stereo position of a sound, while the particles' mean velocity could be mapped to pitch. Which mappings produce the most compelling results? Do you note a tight connection between the visualization and sonification of the simulation?

Sound to Physical Action

Use a microphone to control an actuator in a sculpture, environment, or product prototype. Consider how mic placement affects the sounds you'll collect. An example: collect door-knocking sounds with a contact mic; use these to govern a solenoid that makes tapping sounds far away.

Note
Exercises in this section were contributed by R. Luke DuBois.

Games

Immaterial Game
Design a game that requires no materials, such as one you might play on a car ride or on a long walk. Your game should require at least two players.[1]

Recoding a Classic
Recreate a classic arcade game such as Pong, Snake, Tetris, or Space Invaders. Alternatively, *modify* a classic arcade game (code for which is readily found); your mod should introduce a twist or subvert the game in some way.[3]

Collision Detection
Write code that moves two circles around the screen in an unpredictable way. (Consider using something like Perlin noise.) When they overlap, have them indicate this by changing color.

Physics Fun
Create or borrow the code for an organic-looking simulation, such as a bouncing ball or a springy particle system. Now turn it into a game.[4]

Whack-a-Mole
Create a game in which animals or objects appear and disappear abruptly on the screen, and a player has to click on them to score points.[2]

Level Designer
Design a data format to represent maps in a dungeon game. Use a system of tiles so that each map combines tiles of different kinds (e.g., walls, paths, water, treasure). Create a "level design tool" that allows a user to choose, place, and save map data.[5]

WASD Navigation
Implement a control system for the movement of an avatar using the WASD keyboard keys.

Notes
1. Dushko Petrovich and Roger White, eds., *Draw It with Your Eyes Closed: The Art of the Art Assignment* (Paper Monument, 2012), 28.

2, 3, 4, 5. Contributed by Paolo Pedercini.

Part Three: Interviews

Teaching Programming to Artists and Designers

What's different about teaching artists and designers to code, in contrast with teaching programming in a computer science context?

Educator Leah Buechley has observed that artists and designers are accustomed to (1) learning by making concrete examples, rather than by studying abstract principles; (2) working in ways that are improvisational, rather than planned; and (3) creating things that are expressive, rather than utilitarian. Taken together, Buechley's observations delineate some of the key ways in which the assumptions, cultures, and presumed objectives of traditional computer science education often fail for artists and designers. In this section, educators elaborate on the special conditions and considerations for teaching a "studio art course in computer science."

Heather Dewey-Hagborg

I think it's important to teach everyone to code. I think it's a fundamental literacy that we need to be advocating for across the board. But for artists in particular, it has to be *project-based.* I think that the only way you really get artists motivated is by having them work on their own thing, something that they are actually excited about doing. In my experience, giving a bunch of assignments that they don't care about is kind of useless. Instead, if they are trying to synthesize things that they have read or seen a video about into something that they actually want to make, then they will learn it. I think that's maybe more important than what the project looks like, or what language it is written in, or whether it is something visual or not. At the end of the day, people will want to work on all different kinds of things and I really do think that once they learn one language well, they can just pick up any other one. Really, the aim is to make programming a tool for artists to use of their own volition and with their own agency, to make what they really want to make.

Daniel Shiffman

Ultimately people are people, so you can teach classes any number of ways to different groups. However, I think that the idea of *sketching with code* is really important as it implies a lightness in trying things out. I've had this discussion with Lauren McCarthy, who has a really formal computer science background. She was telling me about how hard it was for her to get used to teaching in a creative context like NYU ITP [the Interactive Telecommunications Program at NYU Tisch] because in computer science, there is this feeling of having to know everything, how everything works and of being able to reproduce everything from scratch in a memorized and

almost blue-book test kind of way. In contrast, teaching in a creative environment or in an arts environment is about being able to embrace uncertainty—where students don't necessarily know everything but they should try it anyway, where mistakes might actually lead to exciting ideas, and where there doesn't have to have to be a thing that is solved with an exact answer. In a way, it's almost like stream-of-consciousness coding. I don't want to portray the computer science class in a negative way, but by contrast it's based on learning something exactly and precisely.

To be honest, it's hard for the students. Every semester I have a student say, "Okay, I really feel like I'm not getting this because the thing you showed in class, I can't sit down by myself from a blank sketch and like, write it again." But nobody can do that, really! Everybody who's programming something is programming it because they did something similar before. Or it's built on top of a library and they started with the example, and that's a totally valid way to learn.

Lauren McCarthy

Amongst CS people, I think there is this feeling that the code itself is the art, and that there are all of these ideas and techniques you have to understand first, like managing complexity and modularity, before you can get to really make things. That was really hard for me when I started teaching. I'd think, "Oh, we're just showing the students how to make shapes on the screen; they don't understand what programming is about." But actually that is totally wrong because programming can be about a lot of different things. Usually when teaching artists, some of them will immediately fall in love with the logic of it, but for a lot of

them, that's not why they're excited. Typically they have other goals. If they progress far enough into it, some might start to feel curious about the higher-order stuff of programming, or they may not. As for me, I wasn't interested at all until I realized I could make art with [code], so I think teaching programming to artists is a lot about expanding purist ideas of what programming might be.

Phœnix Perry
I think you need to assume no skill. I think it is really important to make sure that students have the basics right. I think that you also need to review fundamental mathematics in a way that is connected to a visual output. A lot of my students were taught math without it having any meaning; they get taught sine and cosine but they never learned these ideas in terms of animation and oscillation.

Golan Levin: I can relate. Sometimes I have studio art sophomores who don't know the Pythagorean theorem. I'm like, "Here's a right triangle; let's talk about it." And when they struggle with it I have to remind them, "Folks, c'mon. This is ancient Greek technology. It's the 21st century; you need to know this stuff."

But it's mathematics, and it's been strangely segmented from the arts. If you identify as a creative person, it's often really hard to see yourself as a mathematician or as a scientist, or that you would even have the confidence to be good at those things, right? So I think you have to really reintroduce subjects in a language the artists understand, which is visual and auditory. And if you can do that, they'll often get it all of a sudden.

Zach Lieberman
I think one of the biggest challenges to respect when teaching artists to code is that this mode of working tends to be pretty solitary. You're in front of a computer screen. It tends to be a time-consuming and solitary experience and that can be frustrating, especially if you're used to practices that are more physical, or group-based, or based on discussion. Instead of talking to people you are talking with a compiler. You're in a conversation mediated through a computer screen, and I notice students who get frustrated with that.

De Angela Duff
I've actually taught both computer science and art students, because in our digital media department we have both. Computer science students have a totally different mentality from the art/design mindset and one of the reasons why they take our class is because they do want to be "creative." Of course you can't just typecast them...[but] the ones who might be perceived as more traditional computer science students, they don't consider themselves as being creative or having visual art skills.

I have the class post their projects to OpenProcessing.org, so everybody can see everybody else's work, and a lot of times those students [will] be amazed at what other students came up with, and they realize that their drawings weren't as ambitious. It's really important that they can expand upon it and remix it or whatever you want to call it, as we work with this drawing for a long time. So I give them one week to revise. One of my former coworkers used to say that students rise to the water level that you give them and usually that water level is set by somebody in the class. If one of the students does this amazing thing, then

the students look at what they've done and they think, "I can put a little bit more time or effort into this." I hear a lot of, "I can't draw," and it's not about that; it's about creative expression and using these basic building blocks like circles, squares, triangles, lines, and points. Yet this actually is sometimes one of the hardest assignments for a lot of the students.

Rune Madsen

One major difference with teaching designers is that we don't really care about whether the work is done in a "bad" way or if it's implemented in the way engineers would do it. We really just care about making the thing blink, making the thing functional. And then after a long time, the students will learn how to do things properly... but at least when I teach, I'm not that concerned with that in the beginning. In my classes, there is a lot of deconstruction happening that is about technique, but the instruction goes from the artwork *backwards* to the algorithms and the systems, and finding systems in things that the students normally don't think about as having systems. So we look at graphic designers from the '50s and '60s, and things like printed posters that were done before the computer. And then try to deconstruct them into, "So this designer sat down and had to do this thing by hand. But how? What was their system"? And then we take that system and then we go backwards, and think, "Okay, how can we do that in code?" So there is a lot of luring the students—like we start with the end goal and then show them the way and the reason why code is important.

Winnie Soon

From my experience, art and design students have been exposed to artworks in which programming is used in different ways, and so they are not just focused on what works functionally, but are more interested in the thinking behind it. However, programming is still historically and culturally rooted in cultures with high standards of professionalism and instrumentalization; it's seen as a utilitarian skill. When teaching art and design students, I observe that they are very uncomfortable with calling themselves coders or developers. It's like even though you might know how to write, it doesn't mean you would call yourself a "writer."

Allison Parrish

What's great about teaching art students or teaching creative writing students is it's rarely vocationally regulated. Nobody is trying to take my class to see if they can get a better job, or very few students are....But it's kind of a relief and a blessing as an instructor to have students who are very eager to learn what I have to say so that they can apply it in their own arts practice. Whenever I say something or whenever I teach them something, you can just see a light go on in their head and they're like, "This is going to let me do this other thing that's a part of my own practice." It never feels like I have to make the class goal-oriented; it never feels like I have to make the class about working towards something other than our interests as artists. For me, the main difference is that there's a little bit of wiggle room. I can say, "Let's appreciate this process for its aesthetic effect on us," instead of having to ask, "Does this meet these particular criteria in the curriculum?" or "Is this going to prepare students to succeed in the tech industry?"

The Bimodal Classroom

How do you manage novice and experienced students simultaneously?

As programming skills gain wider public adoption, it has become increasingly common to have classes in which experienced and inexperienced programmers are mixed together. This can be particularly vexing in technically oriented contexts, in which the absolute beginners feel lost, while students who are already familiar with the material are bored.

Taeyoon Choi

For me, the best way [to manage differing skill levels in a classroom] is to give two different versions of the same assignment, especially for my electronics classes, where there's often different ways of doing the same thing. I like to give challenges to the experienced people who have done it once, and for the beginners, give them enough time to learn. I want to avoid having one person done in ten minutes while there is another person taking an hour to do it. A more hands-on approach we use at SFPC [the School for Poetic Computation] has been to encourage the advanced students to mentor the beginner students—not in a hierarchical way, but to have them solve the problem together. That has mixed success; it works for some assignments and not for others. Something that I learned from other teachers at SFPC is to encourage the more advanced students to build teaching materials. They may be able to solve a problem quickly, but for them to come up with new assignments from that code or new assignments for another toolset is a more conceptual challenge. It's also important to understand that even the most advanced technical students are probably not experienced teachers or artists, and are probably not confident explaining or helping other people, so there's a lot for them to learn from that practice.

Daniel Shiffman

For a beginner, I try to have an approach of looking at a particular example in incredible detail—so, line by line, making sure every little piece is sort of talked about and understood, and building up this example. In theory I might do that for half the time and then the other half of the time I look at an example from a higher level, talking about the concepts and demoing

it in a way that we can have a more free-form conversation, where it's okay if the students don't suddenly know every part of how the code is working. In some ways I oscillate between shooting for the low end and shooting for the high end, as for me, the place in the middle is sometimes problematic. Like, "I'm kind of showing you the code, but not really" or "I'm just giving you some things but not all of them." This can get confusing. I feel like it's helpful to either go through the process step by step or to just run an example and talk about what it is and why it's meaningful and important. Then students can look at the code later.

In some ways a lot of what I do is creating a feeling of ease in the classroom. I often joke that I don't know if I'm teaching anybody or if I'm just giving people the feeling that they're learning. Ultimately students have to learn it on their own when they go and try the stuff, and so it's important to have people feel empowered and feel that they can do it.

Rune Madsen

I teach a class on graphic design and code. What I say in the beginning is, "Some of you are very experienced programmers, but you may not have the experience in the visual arts that some other people have, and that is a skill you will have to acquire. So, it's as hard and as important for you to work on those things. And equally, if you have never programmed before, you might have skills in other places." So it's not a situation in which students who can already program are considered amazing, but students who are maybe design-driven but have never programmed are regarded as not knowing anything. The other consideration that I have is the pace in the class. I try to never shoot for the lowest common denominator in my class

because it does a disservice to all the other students. So I set the bar pretty high. But then in the classroom, I talk a lot about fundamentals that everyone can do. And then if I want, I can be very clear about saying, "Now we're going to talk about something that might be a little hard for some of you. That's completely okay. If you want to, you can play around with this in the meantime, but if you're interested, feel free to follow along." And then I talk about something that might be a little bit more advanced. Or I'll say, "So everybody practice this now, and I'll go around and help you. If you're really up for a challenge, do this other thing." So I try to have multiple tiers always going at the same time.

Winnie Soon

99% of my students are beginners with no programming experience, but after the first few weeks you do start to see who is really into programming, as these students spend hours and hours on it. Then you see different skill levels, so this issue emerges. I alway emphasize that my course is "low floor, high ceiling," which is discussed by Seymour Papert and Paul Wang in their work on computational thinking. When you introduce programming it has to be with a low barrier; it has to feel accessible so that you can get started. But at the same time it has to feel like there is no limit, no ending, and it's possible to go deeper and deeper. So every assignment I set, even if you are a beginner in terms of coding, you are still able to submit something—with references, with sample code, with tinkering. My assignments aren't computer science assignments where there is a correct answer. Instead, they are conceptual, so that the more advanced students can go really deep and apply more complex programming skills.

Phœnix Perry

Usually what I do is I pull the experienced people aside after class and be like, "Whoa, you're awesome, why don't you go and check out this book. You can ignore me when I talk, if you show me what you can do with this." I give them stuff that's outside their skillset, that's actually really hard material, and it's like a puzzle and then they sort of ignore you in class, and at the end they come back with something. The other thing you can do is turn them into TAs, but the danger with those students is that their knowledge is usually patchy in that they think they know more than they actually know. I've seen those students become the worst in the class because they get lapped by the others who are paying attention and are systematic in a pedagogical way.

Jer Thorp

I've learned to not be very rigid in the way that I define projects, and to allow people to operate within those projects at a comfort level that works for them. The first time I taught my class, I defined the projects so rigidly that the difference between the good coders and the bad coders would really stand out, but by defining the projects less rigidly, it allows people to play to their strengths more. That's something that took me a long time to really embrace. My projects are now about a theme and not about how I insist that you work on that theme.

Lauren McCarthy

I really try to push that it's not just about wanting to program. A lot of times, if you're a very good programmer, that probably means that you haven't spent a lot of time thinking about art or design or user interaction or any of these things. So I just try to emphasize that, but also when we are giving feedback, I try to call on people

who have these other skills to make everyone realize that these are just as important and relevant. Setting expectations in the beginning is helpful. I let the advanced students know that technically [the class] might feel a little bit slow, but that gives them time to explore some of their other ideas. And also vice versa—I try to help the students who are beginners understand that some [of their classmates] have done this before, but [their inexperience] doesn't mean that they are bad at it. I encourage them to not feel intimidated, to survey their skills to see what they are missing, and to ask themselves how they might work on those skills.

Zach Lieberman

I deal with this a lot as most of the classes I teach tend to be mixed...I think having classrooms where there are people with different skill sets is really valuable, specifically in terms of the community. What you want to do is create conversation, create modes in which beginners are asking questions of experts and [there is] a chain of learning. When everyone is in the same place it's much harder to do. What I try to do for the experts is give them prompts where they feel like their input and time in the classroom is both useful and valuable. I often ask them, "Can you take the things that we're talking about and create tools and techniques to teach this better?" I try to turn them into teachers in some way and I try to give them prompts that push them to have that sort of mindset. There are also ways of making everybody a beginner, because everybody is a beginner in something. So in a classroom where there are both beginners and experts, can you figure out ways to push the people who think they know the material and flip what they are doing so that they realize that there is a lot that they don't know? I like to show

them the problem set in a different way, like in a different language or with different constraints.

At some point in a bimodal classroom, I also think there is value in pulling out the beginners or the people who feel like they are lost, and creating a safe place where this small subgroup can meet. So in a classroom of 15 you might have 4 or 5 students who meet privately and you try to raise their comfort level and confidence. They often need a safer space to ask questions they might not ask in class because they are shy about asking.

Luke DuBois

I have to do the "one-room schoolhouse" thing a lot. Sixty percent of my students are products of the New York City public school system because we're NYU's last commuter school and unfortunately, most of my students didn't have the chance to go to Bronx Science or Brooklyn Tech. They went to places where their computing class was maybe how to use Dreamweaver. Some have done CS and they have some math, but nobody ever thought to take them to MoMA or the Guggenheim. One of the things that's really nice about my little proxy for an art program inside an engineering school is that in an engineering school you're encouraged to assign lots of group design work. And so I can figure out these orthogonalities between the students pretty quickly and pair them in ways so that they match each other and so that they have to teach each other stuff. I try to do that as much as possible. It's hard— like this year it's gotten really hard because we started admitting new graduate students coming from other parts of NYU that cover recorded music and undergrad photo. And those kids have a very high cultural fluency, but they don't have any of the computer chops. Or

if they do it's like they know how to use a crack of Ableton really well but they don't know how to code. In response, I made every assignment on how to use photography in some way, but everybody had to have a soundtrack. I "de-oculocentrized" the curriculum and everything had to have music, no matter what.

De Angela Duff

I'm a huge believer in pair-programming, or peer programming. I usually pair a more seasoned programmer with one who is less seasoned or a novice, and I have the novice do the programming and have the more experienced person be the observer. I also encourage the students to form external study groups, as sometimes I find that the students who already have experience programming actually really want to help the other students, and that one of the ways they can do this is by spearheading a study group outside of class. I might also have a student explain a programming concept using different language than what I'm using.

I always tell students to use multiple resources when they learn how to program. I always assign two different textbooks and then tell them to try to get a third resource if they can. They all have different examples and explain certain concepts differently, and I think the more the merrier when they're trying to understand something for the first time.

Tega Brain: You mentioned that you sometimes teach multiple languages in parallel.

I always do. I don't want students thinking "I can only program in X," because I teach programming as a tool and I want my students to be able to program in any programming environment. If they know what a loop is, or what

an array is, or what an object is as a concept, then they just need to figure out the syntax. I teach three programming languages at the same time only because they usually drop one. I don't tell them two is fine but they typically gravitate towards two out of three. I structure the class so that we're learning the basic concepts two-thirds of the way in all three languages, and in the last third of the semester they select their own project. For the week-by-week deliverables they have to write them in all the different languages, and in the final third of the semester they can select one of those languages for the final project. I give them extra credit if they build it in two languages. Mostly they don't like it at first, but I do find that students rise to the water level that you expect of them. Hopefully it helps them learn new languages when they need to, without being afraid.

Allison Parrish

Teaching technology with the arts in mind kind of gives you a leg up on that problem automatically. If you consider my class as primarily a programming class—which it isn't, but if you look at it from that point of view—it's the conceptual part that levels the students to some extent because there are some students who, despite being beginning programmers, have amazingly strong artistic points of view and are aware of the history of procedural writing or are into conceptual writing in general. Even with the very rudimentary tools that I'm teaching at the beginning, they're able to make something that aesthetically stands up to whatever the advanced programmers are making off the bat. I often teach in Python, and Python used to be a language that not a lot of people knew, and so that was another equalizer for the class. That's been less true more recently in the last

couple of years as I get more programmers coming into my class who have a deeper understanding of Python. But then the subject area [of creative writing and computational poetry] helps with that problem. Not a lot of computer programmers know how to do that, so a little bit of every tutorial is going to be new to everyone regardless of what their preexisting programming skill is.

Encouraging a Point of View

How do you encourage meaning-making, criticality, perspective, and heart in otherwise technoformal education?

"More poetry, less demo." This is the motto of the School for Poetic Computation (SFPC) in New York City, an artist-run school co-directed by Taeyoon Choi, Zach Lieberman, and Lauren Gardner. The motto encapsulates an expanded ideal for the education of computational literacy: one that frames "learning to code" not as mere vocational training, but as central to cultivating a student's critical perspective and expressive voice. In this scheme, "creative coding," by analogy to creative writing, is an essential practice. Simultaneously, this motto also critiques a prevailing technophilic attitude: one characterized by technological solutionism, a seemingly apolitical preoccupation with "disruptive innovation," and the narrow objectification of programming education as an economic stimulant. The SFPC motto is also, in its own modest way, an aspirational rebuttal to older critiques of computer art as hollow, impersonal, and instrumental. In this section, we ask educators how they work to ensure their students' focus on making meaning, in spite of technoformalist tendencies in programming education.

Taeyoon Choi

That is a really good question because it's easy to retreat to this mode like, "We are going to help you become a coder; we're going to help you become an expert." But to me that sounds as thin as, "We are going to help you become good at Photoshop." I think the real question is about finding a desire within students to master the language of the technology. It's code and electronics and all of that, but it's really about expressive literacy. I want them to approach code and technology as an artistic medium, so they can not only overcome the psychological barrier of "I can't do this" or "this is not for me," but also be creative with the medium. One thing I like to do is give exercises that are as simple as possible. For example, one button, one output, like pressing a button that lights up an LED, and putting delays in between. I like to show that you can make a lot of meaning with very little technology.

Zach Lieberman

I try to bring in as many outside examples of things that I think are important, even if they are not necessarily made with code, but artworks or visual ideas or projects that inspire me....A lot of teaching is about the public articulation of values in a classroom, and that helps students understand your value system. Maybe they have their own value systems or interests, but seeing your curiosity, and what you think has heart, helps them bring that into their work.

Jer Thorp

I've been lucky to teach programming in environments where people want to find meaning in the work. I throw a lot of theory and a lot of reading and a lot of weird stuff

at the students. Often I assign a novel that they have to read during the class. In the past I've assigned Gary Shteyngart's *Super Sad True Love Story* and normally, the response is overwhelmingly "Oh, that was great! Give me more of that." Almost nobody says, "Please teach me more technical things." The response is almost always, "Let's get into the weird stuff more." I would encourage people to think about ways to do that, even in a basic programming class. Give small readings. There are some great Pynchon passages that are so good for this type of thing. Ask them to make something in response, to remind them that it's not all about the computer.

Lauren McCarthy

I like to show a lot of references and artworks that have nothing to do with code, especially when I'm giving assignments. I ask students, "What would this be like if we were doing it with the tools that we're using? How would this idea manifest?" I also put a really big emphasis on context, especially as we get closer to the final project. For example, they are required to come up with several examples of influences or other things that inspired their work beyond the "I learned how to make a for-loop" or "I went to office hours" type response. This is often really hard for some people at first and when I ask for their inspiration, their response is literally "office hours with the residents." So I always say: "Keep looking!"

The Web is also a really ideal social context for sharing and publishing work. We taught our intro class with the Web this semester and it was cool because people are already so familiar with that space...everything from websites, to news, to ads, to videos, to art pieces. I also try to bring in news and current

affairs, like, "Hey, this lawsuit is happening, or this new regulation got approved. What does that mean for us?"

Tatsuo Sugimoto

It's important to balance the technical and the conceptual, but developing conceptual thinking can be very hard, especially in Japan where the art and technology scene is very commercial. Japan is very different from the USA or Europe—of course there are some artists using technology, but most of the work is coming from designers and from commercial studios. My students know less about artists and art practices, but are very familiar with commercial work. I think art is an important space for being critical of society, but many Japanese young people don't often think this way. For example, in Japan, drones are popular in entertainment and live performance, but on the other hand they are also used for military purposes and for surveillance. People don't think enough about this. I don't have the answers, but I show a lot of examples of international art projects to try to draw my students into thinking about the politics of the tools they are using.

Daniel Shiffman

Early in the semester, I tell them, don't worry about making a *magnum opus,* you don't have to make a really important, meaningful thing: just play and explore. Let your work wander, and in that sense, have a free spirit while you're doing your assignments. It's okay to focus on, "I just want to try this thing with a for-loop, because that's what we're learning and I don't want to get lost in my own head about having to solve this climate change crisis; I just want to play around here with a for-loop." So it's OK to free yourself of the ideas at some point, and then—and this often happens at the end of the semester—flip it and free yourself of the technological requirements. I always offer to students, "You don't have to use code for your final project," but nobody ever really takes me up on this. I say, "If you have a project that came out of the ideas we're talking about and you're excited enough to make it without code, go for it and explain why." I'm sure that the process of a student explaining why they're not using code would show there's probably a good reason.

The other thing students get really lost in is, "But I think it's so simple, I feel like it needs more." It isn't bad if it's simple; that can be good. Worry about your idea or what you're trying to communicate at that point and forget about the technology.

Heather Dewey-Hagborg

In my Intro to BioArt course...I'm trying to teach technical skills but I'm also trying to teach something that students don't really know anything about, and trying to bring in critical and ethical questions along with that. The way that I structured the BioArt class is around four projects: three topical projects that each involved several sets of skills, and then one final project. Each project is a module, and then each module had a set of critical readings to frame the conversation for which the students had to write a page. Before we came into class they would discuss the readings and I had them all submit a very short essay the day before, just to make sure they actually read it and thought about it. Then in class I went through their writing and pulled out one thing from each student's writing and tried to bring that into the conversation. So before we actually started working hands-on with the materials and the methods of the technology, I tried to frame it with those critical

questions in mind. Then when they started on their final projects, I also tried to bring those questions from the readings they critiqued back into the discussion of the project. It was very natural this time because the students had already been thinking about these issues a lot and so as they started proposing projects or sharing their work, the questions naturally came into the critique from all directions and not just from me. I feel like I've grappled with this question for a long time when teaching programming and even during the last semester with the BioArt class. This was the first time I think I've ever come kind of close to getting it right.

Luke DuBois

I mostly have engineering students, and the hardest part of teaching engineers is to get them to know that they are allowed to ask questions too. That they are allowed to draw from their own lived experience and problematize a situation. These things are not normalized in their educations so they're flying blind when you ask them to do that. We have hybrid classes, such as one around developing assistive technologies. It's an undergraduate disabilities studies class that requires client-centered design and we do it in partnership with United Cerebral Palsy of New York. We put two undergraduate engineers on a client, so it could be computer science students, it could be civil engineering students, or others. And the first thing they have to do is make a documentary film about their client that helps teach empathy, and then they have to make a design intervention.

A problem with engineers is that they're trained to always go for the most general solution of a specific problem. But that doesn't really work in this context, so instead of saying,

"You're going to make an adaptive wheelchair thing and we are going to patent it and we are going to get it approved by the FDA," instead, it's more like: this is Steve. Steve has cerebral palsy, Steve has residual motion in two fingers on his right hand, Steve needs an umbrella. Now design that for Steve. That's an actual example of a real case, and they created this mechanized umbrella. In the Ability Lab, we often do "design for one."

With societal-scale problems, solutionism falls apart really fast and that's a really useful lesson for undergrads—to understand that you can't necessarily fix things by building a better widget. So we encourage "meaning-making" with our engineers by giving them problems that don't or can't have exclusively technological solutions. I'm not as good at this as my colleague Dana Karwas, who is really good at pushing them to reveal aspects of their lived experience and to riff on that. Dana does a lot of activities with her students to help them address things that have happened in their lives, often bad things, and it's a way of distilling art out of shit.

Winnie Soon

My course Aesthetic Programming is different from a typical coding course in that every week we have one or two conceptual texts the students have to read. For example, in the first week we teach shapes, like drawing rectangles or ellipses, so I usually give them something to read on representational politics, like that of emoticons, or something about the politics of geometry. So it's about shapes, but also how can we think about shapes differently, or how when we use emoticons, how colors matter. How we assume one emoji is rendered the same on every device, but this universality is not the case. I have them think through the problems that arise

because of this kind of technical infrastructure.

In terms of assignments, each week my students make a RUNME and a README. A RUNME is technical, like writing a program. At the same time they need to contextualize it through the README using the text they are given to read. This forces them to not only code, but also think with and through coding and the text. I provide a brief for both the RUNME and the README. For example, they may have to redesign a progress bar for the RUNME. I give guiding questions for the README like: what does a progress bar hide or show us? How does it link with the text, to help us think about temporality? The README is like a description of the program, but also a discussion on why you think you are making this. It forces them to think beyond, "I just want to make a game."

My course is not about making something that looks cool; it's about the process of understanding software systems as cultural phenomena. It is about using code to increase your sensitivity to tools like Facebook or other platforms. If you know how data capture works, then you can reflect on how you use Instagram or other tools.

Allison Parrish

I am personally very excited by systems and by rules and by the act of putting things together programmatically, sometimes like a poet but first and foremost like a computer programmer. When I'm teaching classes it's similar in that my courses are about making computer programs produce creative text towards an aesthetic end...I have to focus a lot on the technical aspects and say, "We're going to learn this thing that is applicable to all this conceptual stuff, but we're also going to learn how to make a dictionary or learn how to parse text into parts

of speech." ...Of course I would love to be able to teach a class where every single student in the class is completely devoted to exactly the same concepts as I am and is motivated by exactly the same things that I am, but that would actually probably be boring. I really try to keep it half my weird conceptual ideas and half programming tutorials. The conceptual stuff is what allows the programming stuff to be applied in a way that's not just a technical worksheet that demonstrates mastery.

Tega Brain: You also require your students to perform their work in public. Why do you do that?

That's for a couple of different reasons. The first is that text as a medium has all of these affordances...it can sit on a screen, it can be on a printed page, [or] it can be transmitted into language and read out loud. I think it would be a disservice in a class that's about language to only use the one affordance of text on the screen. People don't usually think about procedural text as something that you can read out loud, but when I have the students read their work out loud they learn new things about the text. It's like having another window into the language because when you read text out loud you find out the places where you have to breathe, what sequences of words sound really good, what sequences of words trip you up, how long it takes to read.

When you're reading out loud you also become hyper-aware of other people's reactions. You can literally see when people get bored with what you're saying and use that in the feedback loop to bring that back in and ask, "How am I going to compute a textual artifact that has a different curve when it comes to how people

are paying attention to it?"...I also find that it keeps students a little bit on task and focused because it means that students take a little more responsibility for their work. They know it's not just something that's gonna sit in a blog post until the end of time. They know that for two to five minutes of in-class time they're actually going to have to be there, in their body, allowing their body to speak this text out loud. I find that that makes the work a little bit more thoughtful and a little bit more interesting.

The First Day

What do you do on the first day of class?

It's the night before the semester begins and you can't sleep for worrying about tomorrow's class. The first day is often nerve-racking; it's a critical moment to set the tone for the semester and shape student expectations. In this section, our respondents discuss their different approaches to teaching that first class of the term.

Zach Lieberman

On the first day of the School for Poetic Computation we start with questions, and it is really fascinating. We teachers come in and explain a little bit about what we do and I ask students to take 20–30 minutes by themselves and write down every single question that they have. And this creates a really interesting and really strange moment. I want to know whatever has brought them into the classroom and what questions they had in mind. These questions become signposts or markers for what we talk about. So someone will say, "I want to learn about X, Y, Z," and someone else will put up a response saying, "Come talk to me." Some questions are unanswerable, like really deep and profound questions, and I love that some students will try and cross questions off the list as the class progresses. I think it's important grounding. A lot of times you come into the classroom and the professor gives you a syllabus and it's like: here's where you're going to go, here's the journey we are going to take, we're going to cover these things to get to that point. So it's nice to start on the first day and say: "What we are going to do here is really *driven by questions,* driven by a collective exploration of questioning."

Daniel Shiffman

On the first day, I always feel very anxious all morning before class. I wonder, "What am I going to do for two and a half hours? I mean, that's so much time!" And then I over-prepare and inevitably only get to like a tenth of what I meant to. It's different in different contexts, but one of the things that I do if possible is to not look at any code until the last five minutes of class, if at all. In the past I've done a conditional drawing exercise, where the students pair up and one writes instructions that the other has to draw.

Another thing that I also do is try to have a discussion about historical context, programming languages, and what it means to program. Like, why should you program? If I'm in a class of true beginners, I like to talk about what programming languages the students have heard of and what they think people do with them. I ground everybody in a larger landscape, which is a nice thing to do.

What I also find is useful is to show work people have made in previous years and to really focus on projects that do some social good, or projects that just have this totally nonsensical, playful quality with no practical value whatsoever. It's easy to imagine certain kinds of interactive exhibits or certain kinds of games, so I try to showcase projects that are a bit different. One thing that I have become much more conscious about recently is making sure that...I have a diverse set of people who've made the projects: from different communities, different genders.

Lauren McCarthy

I like to tell a lot of jokes that nobody gets, and if I keep it up, by Week 7 I might at least get a pity laugh. In the introductory class we do a lot of borrowed things, like "Conditional Design" drawing exercises, which is also something Casey Reas does. If I'm teaching JavaScript, we pull up an example online and I show them how to open the console and start messing with the JavaScript or CSS that's running to get to the idea that it is all hackable. I also try to ask who's feeling nervous or scared or unhappy or thinks they're going to be bad at this class. I think a lot of times everyone comes in thinking that they're the worst student in the class or that they're

the only one who is not going to get it, and sometimes I think that it is reassuring to see that everyone is terrified.

Our Social Hacking class [taught with Kyle McDonald] has special requirements. On the very first day, we have students sign a contract that says a few things. Firstly, that we are asking them to experiment but that they acknowledge that the experiments are theirs so we're not liable for their decisions. Also that they take into consideration that they are doing work that involves other people and that just because these may be art projects, that doesn't give license to not respect a person. Also that they acknowledge that we are asking them to take risks and they must be willing to do that or otherwise they should drop the class. Then lastly, that as everyone is taking risks, we need to respect that and not shut anyone down for doing so and rather we each need to respond to this. In this class everyone puts themselves out there, and so we all need to put ourselves out there by giving feedback about how other people's work makes us feel.

Winnie Soon
I usually explain the intention of why I choose to work with particular tools. We talk about how there are different coding languages and different coding editors and I will talk about why I chose GitLab to host my syllabus. Why did I choose to work with p5.js? What are the priorities of this software and how are values embedded in software? In a way, choosing a tool is a kind of politics and I want to set the scene that the course is not about picking something because it is efficient or good and then just using it. I want to ask why you are using it and what kind of values you are subscribing to. I think that is quite important.

The second thing is more about creating a space for them to speak. A lot of them have no programming experience and they usually come with a lot of fear and anxiety. I am very particular and I ask them to say something about their feelings about code. I want to focus on feelings and the emotions attached to coding, rather than on "why I want to learn C++" and so on. At the end of the course in the year before, I always ask the students for a sentence on a Post-It note on what they want to channel to the students in the coming year. How do you want them to prepare for this course? Usually there are comments like, "Coding can be queer." "Be open." "Coding can be something very fun and conceptual." "Don't expect code to always work." They see these Post-its with their peers' words and it's much more convincing than me saying these things. I usually stick them on the wall and ask them to come and take a look. I want to set the scene that this is a rigorous course, it's difficult, but you are not alone. If we work together, you can pass through this just like these students who are able to give you this advice.

The third thing I find very useful is to ask them to think about a reason to attend this course, beyond that it is mandatory. As coders and teachers, we know that this stuff is not easy. If they have zero coding experience, it's going to be difficult to sustain their motivation throughout the entire course. So I want them to think in the first class of why this is beneficial for them, e.g., I can get a better job, I can communicate between programmers and business leaders, or I can understand the black box of computing culture. Whatever it is. They need to have a reason. I then emphasize this in a lighthearted way. I tell them: remember what you have written down and keep this motivation. If you feel fear or anxiety about your work, get

these words out again and look at them and think about why you want to learn and why you were once motivated. This will be a helpful tool to pass through the difficult times.

I try very hard to prepare them psychologically for this challenging class and remind them that we will work together. This is the difference between an engineering class and a non-engineering class. For engineering and CS students, they have the motivation to learn coding; they want to be programmers. But for arts and humanities students, they are scared of this weird language. And you have to find a way to bridge that.

Heather Dewey-Hagborg

We talk about conceptual art and code as an instruction-based medium. Then I have one student stand at the board with a marker, and then the other students instruct them how to draw something...we go around the classroom and the students each give an instruction to the person. It's fun and it helps them think about how specific or not specific their instructions are.

Jer Thorp

I'm really aggressive on that first day and we do a lot of things. At that point, everyone's brains are so pliable because it's all foreign.... I've found that the longer I wait to get to the trickier stuff, the harder a time they have with it. Things start to calcify in their brains, and that flexibility they had on the first day disappears because they are building these constructs. If I wait until the fourth session to talk about what a class might look like or what an object is, by that time they are like, "Wait, wait, wait, no, this doesn't mesh with the construct that I've built in my brain around this." So if you put it in the first day, you don't have to teach it really heavily and they are like "Oh. Okay, that's how this works."

Golan Levin: What about the first day of an intermediate studio in information visualization? What does that look like for you?

My information visualization class is half theory and half practice, and there we take a pretty different tack. On the first day in the first half of the class, I write the word "data" up on the board and we talk about what that word means, which is actually an incredible little rabbit hole. Everyone thinks they know what it means, but nobody actually knows what it means. Then we really talk about "Where does data come from? What does that process mean? What is it? How does it manifest? What do we do with it?" What I'm trying to do is I'm trying to get them to define what I think of as the data pipeline. Data is the result of measurement, and we then parse that data using computers in some way, and then there's a representation step. I want them to make that map for me, to start identifying interesting places to intervene. For me, a data class is not about that representation piece; it's about the other pieces because I think they're so much more interesting.

In the second half of that first day, I try to get the students to create a dataset on the fly and think about what that means. A simple one is asking students to say what they think their level of programming skill is between 0 and 10. Then we take those 16 answers and do a very simple plot of them, and then we come back and say, "What would have happened if I would have asked this question differently? What would have happened if I would have given you a clearer way to bound [your answer]? What would have happened if I allowed you to share, if the first person read their answer aloud, and then the second person had to base their answer

on that person?" This gives the idea that these numbers already carry a fantastic amount of bias. Even in a really simple exercise like that, you can't really do it the "right way." We can talk all we want about how to represent that data, but actually there are a million things that have happened in producing it that have as much of an effect, if not more of an effect, on what end the reader will see.

Taeyoon Choi
I usually prepare a pretty long lecture. This gets the students who are into it excited, and also shows what the class is about to the ones who are not into it so that they can see my lecture and leave. I think this is a really good thing. Also, when I write the course description, it's usually like four months before the course actually starts and my idea of the class was completely different [then]. This then becomes a chance for me to realign what I want to do and what students think the class is. I rarely teach technical courses now, but when I do, it's usually contextualized, so it has some conceptual arc. I explain what I can teach and what students need to learn on their own. I try to make it clear that learning technique is really hard, and it's dependent on where you're coming from. I don't try to give them the expectation that they'll be good at technical stuff by the end of the course.

De Angela Duff
I try to demystify their fears, and let them know that it's not magical and that it takes what I call "butt-in-seat time." You just have to really spend the time to either watch Dan Shiffman's videos, or read out of the *Learning Processing* book. I cover more of the philosophy behind programming. I also sort of quiz them and ask them why are they here, beyond the class being

a requirement. I want to know their expectations, and I try to get a sense of what their programming background is. We don't talk about code or anything until probably the third class. The very first assignment I give is actually having the students create directions for something that they do in life, just written instructions....I make them do that before we even start talking about code to draw upon the point that the computer only does what you tell it to do....They then have another classmate execute those instructions, but they can't discuss it. Like the person writing the rules can't talk to the person executing them. The person who wrote the rules can observe and then modify the written rules to improve the outcome. I find that a very useful prompt for getting people used to the idea that if you're not very direct and literal in your language, then the program won't execute, and it's usually because you haven't broken it down in enough steps.

Tatsuo Sugimoto
Don't be a maniac. The beginning of a class is very important. The students' first touch and first experience with code makes a big impression. Although as a teacher you want to show your students that you have a deep knowledge of the material, it's more important to go slowly and casually, and stay open to where they are at.

Rune Madsen
I remind them that they are in the beginning of a semester course. They are basically safe from thinking too much because I'm going to take away, I'm going to put so many constraints on them in the assignments in the beginning that their creative freedom is very small. So the first assignment we do is at the end of the very first class. I tell them to design an ice cream cone

using a triangle, an ellipse, and a rectangle, in black and white only. If you're young and you're a student and you've never designed before, which many of my students haven't, the whole palette of everything that can be done is just way too big. So I try to impose core constraints and have them work on very specific things. Like, how to position three basic shapes. How do I make it say "ice cream cone"? How can I make it say "sad" or "happy"? So the first class is very much about, "You're here. Don't feel bad about not knowing things, because I will make the assignments so simple, that at least in the beginning there's nothing to worry about."

Allison Parrish
In my text processing classes, I take them straight into the UNIX command line tools. I do this because the people who take my classes usually have an OSX computer, so they have all these tools already built-in and the UNIX command line has this reputation of being super forbidding and difficult to get into, or for hackers only....Once they know how to open this imposing terminal window and then type something into it and make something happen, it instantly feels good to be able to add that to your repertoire. I focus on the command-line text processing tools, tools like *grep, head,* and *tail* and other commands that are for transforming text in addition to tools for searching. I relate that back to a conceptual presentation, where we talk about work from the Dada movement, conceptual writers, and poetry from *L=A=N=G=U=A=G=E* [an avant-garde poetry magazine, published between 1978 and 1981]—here's how you can either repeat these methodologies or their aesthetics using these tools that are already on your computer and that really are wonderful to use. Of course, I also

cover what the class is going to be about, but [learning about the UNIX command line] makes them feel powerful and like they have dug into something that's unique to this particular class.

Favorite Assignment

What's your favorite assignment for computational arts students?

Like the riddles of the Sphinx, or the labors of Hercules, good assignments have folkloric qualities. As in any oral tradition, the most memorable assignments are passed from teacher to student, often with small changes. They resist change, yet allow personalization. We asked our respondents to describe the assignments that are closest to their hearts, or that yield especially good classroom experiences.

Daniel Shiffman

Let me preface this by saying that sometimes I feel like assignments are my weakness. The tricky thing is to balance a feeling of open-endedness with constraints, so that students can feel creative and make their own thing, but the assignment is not impossible.

I have two assignments to share. One is from the Nature of Code course materials and it's for more of an advanced classroom, for people who've already taken a full semester of programming and who are now launching into learning about motion, simulation, nature, and physics. The assignment is to build your own ecosystem. It's really not a single assignment but a project you might do over a long period of time. It starts by learning to make this one little thing move around the screen, and then later figuring out how to make ten of those move around the screen, and then how to make those ten things see an obstacle in the environment, see each other, and bounce and interact with each other. So [students create] a whole ecosystem out of little miniature parts. I really enjoy seeing what kind of strange worlds people will create, that either mirror things in our real world or are fantastical inventions.

The other thing I really love doing in an intro class is anything that fosters collaboration. It's really hard to do and is a much easier thing to pull off in a physical computing class, although I don't actually teach that. But what I've observed is that when you're building something physical, seeing where the collaboration comes in is more obvious. When learning programming, students tend to think they have to work solo on code projects, when actually, large pieces of software are built by teams of people. One of the assignments I really like is to randomly partner students and have them exchange bits

of code and you get these kind of Frankenstein monsters, like, "I made the sun rise," and "I made a fish swimming," and now they have a fish swimming through a sunrise.

Golan Levin: That reminds me of an assignment that John Maeda gave a long time ago, which was to take someone else's assignment from last week and "improve" it or modify it.

Right. And where this can also work well with is when teaching object-oriented programming. I really like to say, "Make your class and then give it to somebody else to make objects from inside of their world." What I love about that is not just the collaboration and having to talk to somebody, but that it also teaches about open-source development and making libraries. Students can't just give somebody else their code—they also have to explain what all the functions do and invent their own documentation, whether that's just explaining it in an email or with good code comments.

Obviously if you were teaching a more advanced class, you might have the class use GitHub or whatever, and create a documentation page. I like trying to keep that spirit of collaboration, learning how to exchange code and also learning about object-oriented programming. All of that works well together.

Jer Thorp

One that works the best for me is the "drawing tool" assignment and I often give it on the first day. There's something really rewarding about making a drawing tool because you can quickly get at what makes computational assistance powerful, and students also get something that they can share very quickly. One of my big

strategies for teaching designers and artists how to code is to get them making as soon as possible, and associated with that is sharing as soon as possible. I want them to have something that they can post on their feeds at the end of three hours and because they are proud of it, they get that little buzz. They get to say, "Check out what I'm making," and their friends are like, "This is great! How did you do it?"

One of the other reasons I think that [this assignment] works so well at the beginning is that it gets people into this idea of the modularity of programming. I say to them, "Let's look at the command to draw a line and the command to draw a rectangle." Even though one command draws a line and the other draws a rectangle, they both take four numbers and so they're actually interchangeable. I can just drop the arguments for one into the other. In the beginning of my first two or three classes, the big focus is to get people to repeatedly ask, "Every time you see a number, what would happen if I put another number in there?" and "Every time you see a method, what would happen if I put another method in there?" Because that's where this stuff becomes exciting....I want to get them into that Lego method of programming as soon as possible, and to see programs not as things that are Krazy-Glued together, but as things that can be taken apart and reassembled.

Golan Levin: Let me tweak the question. What are some of your favorite prompts, specifically in the field of information visualization—and maybe prompts that are not necessarily for beginners, but that can be approached by anyone at different levels, including advanced or intermediate students?

In an information visualization context, the one that works the best is to take location-based data and ask students to do something with it that is not allowed to be on a map. I could build a whole course around this assignment. In my data class, students take a big data set of something that is primarily latitude and longitude but as they can't plot it on a map, they have to plot them in some other way. It's really nice because it kind of frees you from constraint. It's a different take on the exact same thing that we were talking about before: I want people to understand that there's no rule that says that you have to plot longitude as a line along a horizontal axis. In binding my student's arms a little and saying "You are not allowed to put this on a map," it forces them to see it in a different way.... More than any other assignment, it gets them thinking about our mental constructs that seem to force us towards making one type of thing with certain types of data.

Tatsuo Sugimoto
I am often teaching students who have never been involved in programming, so I focus on getting rid of their fear. In a recent class on data visualization, my first assignment used hand drawing based on personal data and took inspiration from a project called *Dear Data* by Giorgia Lupi and Stefanie Posavec. First of all, I had the students discuss what they wanted to record in their everyday lives; they chose to look at the dishes and cutlery they use for each meal. So for a week they recorded what items they used to eat with in a spreadsheet and then they had to convert this data to hand drawings. I think it's important to start without coding, but then afterwards I have them interpret their hand drawings in JavaScript.

Lauren McCarthy

In my introductory classes, one of my favorite assignments is for learning parameters and variables. The assignment is to create a sketch where there's a change of perspective as you move your mouse across the screen. The question is, how can you subvert the viewer's expectations when they move the mouse? I often show some examples of this from other areas of art, such a video performance work by Anya Liftig and Caitlin Berrigan called *Adoring Appetite*. In this piece, the two artists pushed strollers around NYC, snuggling and kissing their babies. At some point, the kissing turns to biting and eating, and they chew through the babies' heads, which turn out to be made of sugar and filled with red jelly. I ask my students, "What would it look like to create an experience this affecting with code?"

I also like the assignments for my more advanced Social Hacking course. My favorite one is where you have to create an API for an aspect of yourself or your life. Students have to pick something and make it controllable somehow by someone else. This is done either using a data feed or by opening up a question to the public; usually it's the second thing. Another one that can go anywhere is I instruct them to create something such as a browser extension, or app or whatever, but they have to make it for one specific person. Students then must start with the person rather than the idea, and I think this helps because it's a different design process. When you are just making something for yourself, it's easy to not be thinking really clearly about why you're making [certain] decisions, but if you are thinking about someone else, then you're forced to imagine the user experience a little more.

The last exercise I like to do is have students write down what they are going to do that week, usually the steps they'll take when working towards a final project. I ask them to write down exactly what tasks they are going to accomplish, and a time estimate for each one. Then throughout the week they are asked to time each task. We then have a debrief afterwards, and they're like: "Well, I thought I was just going to make a simple data viz connecting only one stream of information." And we find these buzzwords: if you use the word "just," multiply your estimate by two; if you say "simple," multiply by four. It's really common that people do not easily anticipate how long things take.

Phœnix Perry

I like to get people to think about the kinds of things they can do with gaming—and not just video games, but gaming more broadly. For example, maybe you want to use a sensor and you want to track someone's position. I'll show them the games I've made—for example, where you can knock things with your head, or when you scream and something happens. I try to expand the possibilities and get them to just dream up crazy games. If the sky's the limit, what are some things that you would like to try and do? Around the same time, I introduce the idea of pervasive gaming [games in which the play experience is extended into the physical world], and you can get them thinking about play outside of the computer. That really works well if you have a mix of artists and game designers, because they can synthesize their interests in a really fascinating way and make games that have nothing to do with the computer and that have very simple rules. I think that that's a really empowering experience that isn't tied to a prior skillset.

Rune Madsen

My midterm assignment is always to make a dynamic logo that never looks the same when you run the code. I think that's a very typical assignment for me. But for my "favorite," I think I'll go with another assignment, which is my week on computational typography. Before every semester I always consider cutting this week out entirely, because typography is such a handmade thing; with typefaces, you really need that finesse of tweaking everything. I go to the students and ask them to build a typeface (or just design a typeface for a specific word so they don't have to do the whole alphabet) that has to come from a core set of rules. That means it has to be better done in code than by hand. And that is as broad as it can be: Make a typeface that is better done in code than by hand. For example, each letter in the typeface can be defined as an object in an array. I need to be able to loop over it and use the same process in the for-loop to draw each letter.

This was inspired by John Maeda. [He] has this example in one of his early books, I think it's a pie typeface, two pie charts are kind of overlapping to make an alphabet. [*Note: Madsen is referring to "Type Me, Type Me Not" by Peter Cho, shown in our Modular Alphabet assignment.*] And my students just always surprise me, making crazy things like sine and cosine fonts. The creativity of the students always amazes me in that assignment.

Heather Dewey-Hagborg

In my BioArt class, the first assignment starts by looking at the future of synthetic biology, genetic engineering, and design futuring. I use a speculative design approach, and the assignment is to design a product or service that anticipates where genetic engineering or synthetic biology is going in, say, the next 100 years. The students then come up with a sketch of the product or service and also write a page on the future they have envisioned and how that product has an impact on society.

Tega Brain: So it is a critical project that they don't actually have to build in a working form? It can remain entirely speculative so long as it has a criticality to it?

Exactly. In that module we also perform genetic engineering experiments, so the students have some hands-on engagement with these processes and so they understand some of the limits of what's possible. But this assignment encourages them to think beyond what they are capable of actually doing. A semester is not enough time for them to really do anything significant with something like genetic engineering. This way, they get some experience in a lab where they learn what the processes look like, and then I'm asking them to think about where this work is going and what future we are building.

Zach Lieberman

The best assignment that I have is to study and recreate work from an artist from the past. A common example is where I ask students to take the work of James and John Whitney as a starting point and [have them] approach it in two ways. First is to make something inspired by their work—to take a look at their body of work and add a comment to it. [Next I have them] focus on replication and come up with a faithful copy. The ReCode Project by Matthew Epler does a great job at presenting both of these approaches side by side. This assignment can then also be used as a method to talk about

how people were working in the '50s, '60s, '70s and to talk about different computational approaches. I like that it allows you to talk about the past and history and not just the technology and code. Taking an in-depth look at the work of another artist, rather than responding to an open-ended prompt, pushes students to produce better results and to take the work they are doing more seriously.

Luke DuBois

If I'm teaching an audio class with Max/MSP, I'll have everybody build a flanger. A flanger plays two copies of the same sound simultaneously, but slightly offset in time.

Every audio effect on the planet can be demonstrated using the guitar solo from Jimi Hendrix's version of Bob Dylan's "All Along the Watchtower." Hendrix's secret weapon was this guy Roger Mayer, who built guitar pedals for him that nobody else had. He had the first wah-wah and the first pedal flanger. The flanger originally was a studio technique because the flange refers to manipulating the inner reel of the tape and so it had to be done in the studio. But Mayer figured out how to do it with a capacitor in his delays. The "All Along the Watchtower" solo has Hendrix switching pickups on his guitar, going from picks to fingering to slide, plus a distortion pedal, an echo pedal, a core, a flanger, and a wah-wah. In that moment in between the second and third verse, you can learn pretty much everything you need to know about audio signal processing....I usually start by playing that and then I show them how to make a delay line and add feedback. I give them the assignment of figuring out how to tweak all the values to make a flanger in Max or something similar, and then they have to bring in a record that uses a flanger and a recording of them copying it. Like bring

in a Siouxsie and the Banshees tune, or Kanye West. Kanye uses flangers all over the place. I have my students do this because it's a really simple Max patch to build.

De Angela Duff

I have the students draw something either by hand or in Adobe Illustrator using only basic shapes: triangles, squares, circles, and lines. Then I ask them to recreate that drawing using code. It's really important that it's something that they draw themselves instead of recreating a painting, because there are a lot of examples of that online from which they could just copy the code.

Tega Brain: I've always wanted to try to start the term with a figure drawing class, but using Processing—hire a nude model to sit for my first programming class and have students represent him or her in code.

Right! I think drawing is useful because some people aren't practiced in it. They think they can't draw and just to have them engaged with that creative exercise is really important, even if they are just drawing stick figures.

Winnie Soon

My favorite assignment for design students is about rule-based systems in relation to generativity, generative art, and emergence. In this assignment, I ask them to start with a paper and pen and write down two or three instructions. You can't have your outcome in mind first; you need to just start with rules and from there you start to program these rules and they unfold over time. I usually introduce this in week six or seven and it is fascinating for me because in the first six classes they are given

more direct tasks—like they have to make a flow bar, an icon, or an emoticon. They are able to visualise what they want to make before they code it. But then when you suddenly introduce a rule-based system they are like "WHAT!? WHAT are you talking about?" It's very difficult for them as designers to comprehend this concept. Like 10 PRINT or Game of Life, it's just a different way of thinking. It allows me to talk about things like chaos, noise, ordering, simulations, authorship—whether the machine is co-creating with you. It also lets me introduce conceptual art and conceptual thinking and focus on process rather than the end result. I'm really able to contemplate how things unfold over time, which I think is a really important perspective from which to think about programming.

When Things Go Wrong

What happens on your worst day?

Code is a brittle medium. There's a steep cliff of failure; a simple, easy-to-miss syntax error will often prevent a program from compiling altogether. All software educators will experience this publicly at some stage and find themselves sweating in front of a room full of impatient students while desperately debugging. Teaching media arts also demands that instructors constantly keep abreast of ever-changing development environments and new technologies, many of which are likely to be peripheral to their primary field of expertise. Meanwhile, operating systems update themselves, familiar tools abruptly become obsolete or incompatible, and cherished references unexpectedly disappear from the Internet. For these reasons the creative programming teacher is particularly prone to having to work through mistakes and errors live in the classroom, often while attempting to maintain the interest of skeptical and apprehensive pupils. Our respondents discuss the days when stuff breaks and nothing goes right.

Daniel Shiffman

I have moments where nothing is working and I can't figure it out, but apparently these moments are useful. People tell me this about the [*Coding Train*] videos all the time. Like, "My favorite part was when you couldn't figure it out and you got stuck for like ten minutes, because I like to see how that happens to everybody," or "I like to see the way you tried to fix it." Even so, these moments can be really bad and stressful. There've been times when I get completely tripped up in my own head, trying to explain something like a Markov chain and just feeling like, "That was the worst explanation ever; it made no sense! I should have practiced that."

Golan Levin: It's interesting how you do practice your explanations. It's very obvious in your case, because you live this out more publicly than the rest of us through your video channel. It's quite clear that all of your explanations are very patiently refined and revised through practice.

I've been doing the videos for a while, but recently they clicked for me as I was just more mentally focused on them. I used to do the videos to get ready for class, but now I use the class to practice for the videos. I'm like those comedians who go to comedy clubs to try material out before their TV specials.

Also, if I have the same class that meets two days in a row, I can never have them both go well. It's either that the first day is amazing, and then I try to force that to happen again the second day and it fails—or the first day kind of goes haywire, and it motivates me to fix it all the next day.

Winnie Soon

I just had one two weeks ago. The worst day is where nothing works. You think it works and then when everyone runs it you find all these different problems and you have to follow up and figure out if it's their system, version, or browser, and you even don't know why it's not working. And then you need to pretend it's OK and actually in your heart you're like ARRGH, *how come it's not working?* Maybe it's good to have this kind of disruption because it allows the students to see the imperfect aspect of programming, which is also the reality, but at the same time you need to be mentally strong to handle this situation. You also have to know how to turn it around and make up something on the fly so that you can still cover the content you have to cover.

Luke DuBois

I've had classes where things just fail. My first attempt at setting up a cloud-like Node server was the perfect storm clusterfuck. I wanted to show how to do a socket IO thing where we could all kick something up to a cloud and get a response. And that fucker just didn't want to work. I had some problem with my .ssh directory that wouldn't allow me to log into the thing and it took me 45 minutes to debug. Well, it felt like 45 minutes. It was probably only 15 minutes, but it was right in front of the students. Everything was a mess. It was bad.

On the music side I once taught a terrible, terrible class involving a Disklavier [digital piano]. Its default is that there's always a half-second delay on the song, and there's a safety switch that you flip off, and I could not for the life of me figure this out. They built this into the hardware to prevent feedback, to prevent you from hitting a key and then getting drilled down

and grinding the whole thing and breaking it. I had this beautiful piece of repertoire by Kaija Saariaho, who is the composer laureate of Finland and has a really great Disklavier piece. And I, Luke DuBois, with four years of piano and graduate studies, can actually play this piece, as it's not hard and it's part of an undergraduate pedagogy study she wrote in the '90s. But I couldn't get this fucking 500-millisecond thing off and I went ballistic on the piano. I went into this psychotic cursing fit, where there was no stopping me. I sounded like fucking Don Rickles at one of those comedy roasts in the '70s. I was like, "You lousy fucking half-assed goddamned piece of shit, I'm going to fly to Tokyo tonight and single-handedly beat the shit out of the entire drum, guitar, and motorcycle division of Yamaha for foisting this piece of garbage on us." That was my worst day of teaching.

De Angela Duff
This is not necessarily my worst day but more a realization of something that was not working. I used to go through a lot of code in class, like line by line, and I would dissect code and explain it. When you know how to code, it's clear as day, but it's like noise for the newbies. Many of them create this narrative in their head that they're not good with programming or with math. Then I'd say to somebody in the class, "Tell me what I just said," and they can't regurgitate it even one minute after I said it. I realized that actually explaining code line by line is such a waste of time. So I guess my worst days were those days when I thought I was teaching something but I wasn't—it was all just noise.

Allison Parrish
I think the worst days for me were the days when I was teaching a programming class in the English department. I had lost half the students, like half of the students were not really keeping up with the content of the class, but I still had this very strict schedule that I wanted to follow so that the class could reach its conclusion conceptually. So there were one or two days when I was just like gritting my teeth and doing the tutorial even though I knew that half the students weren't able to follow along.

Much of my teaching experience has been in grad school environments at schools like ITP, where the students are so internally motivated to keep up and wanting to extract value from the class no matter how poorly it's coming. Undergrads, on the other hand, will check out if you are not connecting with them. So having that experience in the English department and having students check out on you for the first time kind of sucked a lot. But I learned from that experience.

Lauren McCarthy
I think it is worth saying that as a teacher, you are there to motivate and encourage everyone, and sometimes that's hard. It's tiring, and it doesn't always feel OK to admit that. In other jobs somehow it feels easier to talk about how it's hard, and I guess we do that too sometimes with fellow teachers. But often it feels like there is a pressure to always be like: "Hurrah! Everything is great!" Maybe that's a buzzkill, but I think it's good to say sometimes.

Jer Thorp
I taught a programming class for a few years at Vancouver Film School. It was a required class, and that sucked, as half the students didn't want to be there. You're always able to recruit some of them, but some of them don't care. This is a school where most of the parents pay the tuition

and throw them in there because the kids don't know what they want to do. Being in a roomful of students who don't care is really hard, even though I think I'm pretty good at getting people who might not otherwise care to care.

Taeyoon Choi

I once brought resistors to class to make a flip-flop memory unit. It's made from just two transistors, two resistors, and one LED; it's a really simple component. Some of the resistors are colored brown, but they can look red when it's dark. I think I might be a little bit colorblind or maybe I was in a hurry, so I accidentally brought the brown one, which has a different value than the red resistor, and none of the examples worked in the classroom. I was going nuts because I tested it so many times. It was so frustrating and I was just sweating like crazy and I was so embarrassed. Not only did it make me look bad, but [I feel like a public mistake like that] discourages students from exploring electronics and technology.

At the start, students need to have immediate feedback, like, *the thing should work*. Luckily I figured it out at the end of the class and some students had resistors of the right value and we switched them and everything worked. But I was definitely underprepared and got totally lost, and was hating myself for not being prepared.

Most Memorable Response

What was the most memorable response to an assignment you've given?

There may be no better proof of an assignment's educational potential than a surprising student response. Here, we ask educators to reminisce about students who responded to assignments in ways that were subversive, or unexpected, or indicative of significant learning. These memories reveal how assignments are not only a fulcrum for student growth, but can lead to greater understanding for the instructor themselves.

Taeyoon Choi

The most heartwarming response I've had was when Andy Clymer from the first School for Poetic Computation class saw me two years after he finished the program and said, "I'm still working on your homework." He's a fantastic type designer who does generative fonts and I helped get him excited about electronics. He got really into synthesizers and robotics from some of the workshops that I did. It's funny because the workshop itself was not that successful; it was one of my first classes teaching technical things and I don't think I was really ready to be the teacher. Still, we tried to adopt a collaborative approach where the students took the lead at the end of the course and told us what they learned, and hearing that he continued from where we left off probably made this one of my best teaching experiences.

Winnie Soon

Well, this was a response to the whole semester and not just one assignment. One of the students wrote down in the course evaluation that she realized that coding is not just a gentleman's club. And just with that line I felt like I actually achieved something. I know that the NYC coding scene is much more focused on diversity, but in many parts of the world, gender is still very problematic.

Phœnix Perry

Don't be afraid to be a bitch. Don't be afraid to tear somebody down. Some of the most rewarding responses I've had have come from students to whom I gave very negative feedback early on about a bad idea. And they've taken my feedback as kind of fuel for the fire and they've either proven me totally wrong, or they've improved their concept significantly by the time

I see it again. For example, I had one student who wanted to make an Oculus Rift VR game and he told me his original idea, and I was like, "This is total shit. I don't like it at all. It's not interesting, it's not new, I don't want you to just make a space shooter. Why use the Oculus Rift to make a space shooter? What are you bringing to this?" So what he decided to do was make a rhythm-based space shooter and he used the diegesis of the cockpit to be the control system for the game. You had to look toward the rhythm of the beat, and the beat got stratified. So when the tom drum beat, one kind of object would shoot out, and you would have to go look at that location to stop it. If you heard a bass drum beat, you would have to look over at the other location. And doing this would destroy the object that was making the bass beat. It was really fun because then the act of turning your head, looking up and down and around, became satisfying because you were doing it on rhythm and at a pulse.

Another student project that really broke my brain, and I've never actually seen anyone do anything like this before, was by a kid named James Cameron. I gave a game assignment, and he wanted to make a horror game that connected through to the real world. He made this horror video game, and it's a really terrible scenario, like a murder has occurred, and all of a sudden you see a phone in the VR, and when you touch the phone your actual cell phone rings. Then the characters start calling you and leaving you messages during the day and they're prompting you to kind of play out this story. That was really amazing, even though his original idea was not spectacular. I was really hard on this kid in his exams—like he missed a semicolon on something and I drew a pirate and wrote, "Now walk the plank." I think sometimes teachers want to make students feel really good and sometimes

that's not the goal. Sometimes you want to make them question if something is worth their time and how they can bring something new to it.

Lauren McCarthy

For me, the things that are the most memorable are usually less about the output and more about the process. Like seeing that student who is really struggling in the first few weeks, and then every week, rather than just doing the assignment, she does five versions of the assignment. Then by the end she's a great programmer with a really strong concept in her final project. That's the sort of thing that really sticks with me. In terms of specific responses, one of my students did a project when she was just learning to code where she would go up and ask people for their Processing sketches, like the code itself. She would then try to draw by hand what the outcome would be and after would run the sketch to see how close she could get.

Tega Brain: That's novel, and courageous for a beginner.

Yeah. Let's see, there's another one that is not such a crazy concept itself, but I really liked where the two students were coming from. The project was called "Not Lost in Translation" and they basically made a chat app for themselves. They both spoke English but with a strong accent. And they felt like people didn't understand them a lot. They first just wanted to make something that would translate into the opposite language, but then when they hit some technical barriers, they changed their concept so that you would speak, and you could choose English, or Hindu, or Korean, or whatever language you are speaking. And then it would do a Google Translate of that, and then a Google image search. It would just show the other person a pictogram of what they had said, and then the person would respond by speaking and it would show another pictogram. So the result is totally nonsense, but it was nicely executed.

Then the last one I remember was my student Ben Kauffman's response to the API assignment, where you have to make some aspect of your life controllable. His project was super simple: if you messaged him with the hashtag *#brainstamp*, he would pull a postcard out of his pocket, mark down whatever he was thinking at that moment, and drop it in the next mailbox that he saw.

Zach Lieberman

My department head asked me to teach a class on artistic data visualization, and I'm a fan of *artistic* data work but I'm not a fan of much data visualization, and so I was conflicted the whole time I was teaching it, and I really brought that energy into the classroom. But in that class there were folks like Evan Roth and Christine Sugrue. They took these prompts and really created artworks out of them—things like Evan Roth's project *Explicit Content Only,* a record composed entirely of swear words extracted from a rap album. They took the prompts that I was giving them and created things that would stand in a gallery or would be written about in a blog. For me it's really exciting as a teacher when your students create work that is noteworthy, work that gets people writing or talking about it, because you start to see that feedback loop with culture, which is great. As a practitioner there is a feedback loop of making something, reaching an audience, and getting feedback from it. [Without that cycle,] it's otherwise really hard to understand the value of what you do. For me, the most exciting prompts are the ones that result in work that makes it out there in the world.

Luke DuBois

In my creative coding class, I do an assignment where I show the floor of the Alhambra Palace and explain how it's a Lindenmayer system, how it can be re-created with an L-system. I then give them a basic turtle graphic sketch in p5.js and give them a couple ideas for how to do Lindenmayer systems and a bunch of links, and tell them to figure it out. I had a student L-system his way toward a perfect replica of this mandala that's in some crazy third-century CE Hindustani temple in his hometown—Calcutta, if I remember. He remembered it, like he knew it visually, and he was like, "There's got to be a way I can make this thing." It's kind of like a space-filling curve, like a Koch curve, so it's not too hard to do. Most of the kids made these weird turtle graphics things—mazes or Sierpinski triangles or some of those bullshit fractal 101 things. But this kid showed a Google Earth photo of the temple, an image of its ceiling; he hit play on the sketch and walked away. What really stood out was the personal connection he had to the form, which clearly motivated his craft. All the other kids were just like, "*Fuuuuck.*"

Allison Parrish

It was by my student Susan Stock, and it's a program that produces a poem. It's based on a poem that she wrote about a friend of hers. She passed the poem through this procedure that randomly repeated small segments of the text, so that it feels like her record is skipping. It keeps on moving back into the text so that it has to kinda catch up to itself. It's called "Susan's Scratch." And she gave this reading of it in class and it was really affecting, because it was personal. I think that with procedural art in general it's harder, or seen as less desirable, to get at the lyrical, the emotional, or the personal.... It was clear that the procedure brought out something in the original text that wasn't there to begin with.

I think [this] was for my midterm assignment, which is to invent a new form of poetry and then write a computer program that attempts to write poems in that form. The thing that I remember is that once Susan presented this, it was like a switch flipped in my head. I realized I can teach my students how to make jokes with this, I can teach my students how to do data analysis with this stuff, I can teach my students how to be postmodern jerks with procedural text. "Susan's Scratch" just made me think: Oh, wait a second, the emotional range of this is way, way larger than I had originally conceived.

Tega Brain: And of course computers are rarely framed as emotional or for exploring emotion; they are not perceived as having enough ambiguity or unpredictability.

Absolutely. I think that's understandable considering the history of the medium. People in general don't think that systems can be expressive. They're not perceived as having intentionality. People often don't see the act of making rules as being the same thing as the act of writing a poem. And this is sort of what I am trying to attack in my teaching—to say that actually, the process of designing a computer program, designing a poetic form, or designing a game are all processes, and the system that creates these artifacts is itself a thing that can contain lyricism and emotion and a personal point of view. In fact, it *has* to have a personal point of view and we shouldn't ignore the personal aspect of that kind of making.

Advice for New Educators

What's your advice for educators teaching arts-programming for the first time?

In teaching media artists and computational designers, we need to cultivate multiple skills: a sharp eye, a critical perspective, technological craft, and passion for the field. And we must support the student's ability to connect these capabilities in practice. The following conversations navigate this terrain, outlining a range of tactics, tips, and lessons learned the hard way.

Jer Thorp

When teaching programming to non-programmers, and specifically to designers and artists, I think it's really important to say in the beginning, "My intent here is not to make you into a programmer. I think you should continue being a printmaker, or a typographer or whatever you are. My intent is to give you some computational tools that will help you." Also, get your students making things as soon as you can. For me that has to be ten minutes into the class. We write a really simple four-line Processing sketch that does something really easy and gets them there right away. Don't stop to talk about what the IDE is and what syntax looks like, or what a semicolon means. That stuff sucks. You need it but it sucks. Do the making first, then use that to go back and talk about it after.

Zach Lieberman

Every time I give out homework, I always say that every homework assignment is an opportunity for genius. The most important advice is to have that sort of optimism, to have that sort of energy for your students with every prompt and every time you ask them to do something or engage in something. Learning code can be frustrating and it requires a lot of time and a lot of failure. Time and failure and misunderstanding. To imbue a sense of optimism here is so important—to celebrate this as a new mode of working and to help students to realize that there's all these untapped ideas out there. Also, anything that can turn the classroom into a mini film festival is really great. I think it's important as a teacher to show what you're curious about, to show what inspires you, and to be able to talk elegantly or passionately about what moves you, as that helps students articulate what moves them. By showing these references and using them as a

context to talk about code, it can help students translate and articulate what they care about.

Lauren McCarthy

Something that I read that really stuck with me is that as soon as you figure out something that was confusing you, your brain immediately forgets what it feels like to be confused. Your synapses will fire in a way so that you're not confused anymore. So you learn to code and it clicks. You ride a bike, and then you can't remember how to not ride a bike and for that reason, it's sometimes really hard to remember that feeling of confusion. So...before office hours, I try to think about something that's really confusing, or I try to imagine myself back in the lab as a student. I really try to tap into that feeling of frustration, that confusion when things don't just click....By trying to take yourself back there as a teacher, particularly if there's a lot of students you need to help, it helps you connect with them more.

Tega Brain: That's fascinating. There have been times when teaching a class for the first time where I've received some unexpectedly good results and reviews, especially for material slightly outside my skill set. Then once I've taught it a few more times and I know the material really well, I think it gets harder to empathize. After those first couple of times I often feel like I'm actually getting worse at teaching it, which is really not intuitive. So as first-time educators your inexperience can actually be a positive thing, because you are more likely to relate to students and understand what they are going through.

Totally. I think the other thing is just modeling belief, as this can change a student's

world. I think probably everyone who has ever done something or been successful has had someone who believed in them and made that clear, and helped the student understand how to believe in themselves. I think about that a lot.

Rune Madsen

Don't be afraid that you don't know enough. I was so afraid that I would get questions I didn't know how to answer. And that's not really what makes you a good teacher. Some of the best teachers I know learned programming at ITP and started teaching programming just a few years after. Because they were so close to the material, they understood how to explain concepts—they remember how it felt not knowing. Something that comes with being afraid when you teach the first time is that you over-prepare, you rush through materials. You're afraid of not teaching enough, so you squeeze every last bit of information into this long lecture. And then you and all the students in the class say, "What the hell was that?" I would say, *take your time*. Breathe.

That, and maintaining a good balance between talking and doing. It's okay to switch activities a lot and be clear about, "OK, now I'm going to talk, so please put your laptops down. I'm going to explain things. You don't need to copy my code. You just need to look at it. I'll leave the code on the screen, and then in 15 minutes from now open your laptops and let's try to work together." So you have to be vocal about what you're doing in the classroom. And this mix of lecture and hands-on doing is a style that has worked really well for me.

Daniel Shiffman

Well, I continually make the same mistakes over and over again, and one piece of advice I have

is to do a lot less than you think you can do. As a long-time neurotic, I am a way over-preparer. For example, I was teaching a new class this semester and I ended up making 30 examples when there was only time to look at like two or three in class. One thing I've often done is to assume that because I made all this stuff, I have to get to it all. Then when there's only ten minutes left of class, I would try to rush through the rest of it. In my opinion, it's definitely much better to slow down and leave stuff out. You can always get to it later, or you can send out an email, or not do it at all.

Obviously, I've been doing a lot with videos [*The Coding Train* on YouTube] and that's part of an attempt to create an environment where there is some quality of self-paced learning. If you can do this or foster some collaborative learning where the students are working in smaller groups or individually in a kind of workshop setting, it's a really good thing. Much better than rushing through a lecture and showing 500 examples in 15 minutes.

Also, don't overlook teaching students how to ask for help. That's a huge part of the learning process. You can't just teach the programming; you've also got to teach how to get help, like: "How do you ask? What's the right question to ask? When do you write, how do you debug?" All of that type of stuff can easily be lost in the "here's the lesson"-type approach.

De Angela Duff

I would recommend that first-time educators check out Daniel Shiffman's videos. I love these videos. Some of my students don't like them because they don't think they're serious enough. They think somehow that they shouldn't be having fun learning, which sort of blows my mind. But I think it's seriously important for first-

time teachers to witness the enthusiasm that Dan Shiffman has about teaching programming.

I would also recommend doing something similar to what I tell my students to do, which is to look at multiple books to see which book they prefer. Look at as many syllabi as you can find. There's a lot on GitHub. I don't recommend following what someone has done before because I think that teaching should be a creative process; crafting your syllabus should also be a creative process, and you shouldn't just be following someone else's syllabus. However, it's a good way to get assignment ideas and to get to know how certain assignments are just sort of classics.

One thing I do with my students is called "ticket to leave." Towards the end of class, I give out sticky notes or pieces of paper (but it could be done online). And I tell students to write down three questions that they might have about any of the material that was covered and also to list three key points that they got from what we did in class that day. That way, I can find out what stuck and what the problems were. I think that's a really awesome tool, because then at the beginning of the next class I answer the questions and maybe see something that didn't stick overall. Then I'll go over it again.

Heather Dewey-Hagborg

I would tell first-time educators to try to teach what they are enthusiastic about, what they actually care about. If the technical aspects matter less than their enthusiasm for the subject, then they shouldn't feel like they have to get up there and lecture about code. It's possible to engage students in lots of different ways. The most important thing is to share what is exciting to you about the practice of programming.

When I started out as a freshman, I really didn't have any kind of interaction with technology whatsoever; in fact, I was probably pretty anti-technology. Then in my first year I took a conceptual art class that included a lot of references to media art, the beginnings of Dada and Fluxus and installation art, and that got me excited about learning some of the tools of new media, which led me into doing some work with sound and video. Then as I started working more with sound in particular, I felt very distant from the medium. Having come from a more materially engaged practice like sculpture and installation, I felt like when I was working with sound I was removed from the material. I was using a software interface but I felt distant from it, so I signed up for an introductory programming class, a Python class. In part, I signed up for it because of the title, which was Thinking with Objects. I liked that because I thought it sounded very physical and visual. Of course, I didn't know it just meant object-oriented code, but luckily the professor was really fascinating—a brilliant, brilliant man who, even in that intro class, started tying the code into ideas about neural networking and genetic algorithms.

Even though we were total beginners and we couldn't quite understand what he was saying, he provided these very visual explanations of neural networks and of organisms and I found that really exciting. Again, I probably would have never continued with it except that he specifically came to me and said, "You should consider taking the Artificial Intelligence class." If he hadn't gone out of his way to invite me to take this class, I would have thought I wasn't good enough to do it, but because he did I became curious about it, and then I took it and really loved it. This kind of

faith in students can make a huge difference. It's what launched me into this whole algorithmic direction.

Taeyoon Choi

Teaching a very small group of students, like maybe less than five people, can be really instructive...you get much higher-resolution feedback on how the material is being received. I also think drawing is really helpful. I draw a lot before the class and during the class and I sometimes draw the same thing over and over again. The idea is that I'm performing a drawing and it gives the students the time to think with me about how knowledge is processed. I encourage them to make drawings in their sketchbook as well and then they end up with their own textbook in a way—an explanatory text that they processed themselves.

It's also helpful to understand that not all students are going to appreciate what you teach. If I get twenty percent of the students excited about what I do, I call it a good day. Teaching is a really difficult thing to do.

Winnie Soon

I really want to emphasize this notion of *care*, care in a lot of different ways. Care in terms of whether you can create and sustain a motivated and positive space for learning and discussion and for just saying vulnerable stuff like something is not working. Also care for a diverse range of responses, because as a teacher you see some work that is technically strong and some [that shows] the students are struggling—like where they are just changing the values of the parameters. But still they need encouragement, they need appreciation. I think you need to be really sensitive to those students who are unmotivated and falling behind, who

have fear and stress. You need to think about how fast you speak, how much repetition you need to have in order to adjust the energy of the classroom.

Phœnix Perry

My advice would be to discourage students from collaborating with peers they know. Try and get people to work in groups where they might be exposed to new ideas or new kinds of things.

The other piece of advice I would give is to be really careful when you start seeing "bro" culture emerge—when you start seeing the classroom segregate and the women are fetching coffee and the guys are doing the code, or where the women are doing all the "art." Remain very cognizant that it can happen.

Luke DuBois

In our creative-coding curriculum [at NYU IDM], we have four sections that are all different. I teach one that focuses on music. Allison Parrish teaches one that focuses on text, Kevin Siwoff on graphics and 3D, and Katherine Bennett on physical computing. You choose one to be your home section, but you can float between the others as the classes don't happen simultaneously. You can get reinforcement by going to the other sections....In an ideal world, we would figure out a way to teach all four of those things in each section, and the instructors would rotate, but there's not enough time.

My advice is, don't just make it a graphics class....Teach that first to get it the fuck out of the way and then talk about text, sound, and hardware. Or the Web. Talk about Rest APIs or about all those pet peeves you have about the dot-com fetish of the day. Last year, I had this kid who had hacked his entire home in LA so his mom could hit the snooze button and it would

turn on the coffee maker and then when she picked up the coffee [pot], the shower would turn on. Really great stuff! Around that time we'd gotten a beta release of one of those stupid Nest things and I told him to hack it and figure out how to get it to do something useful. Originally, he was like, "I'm going to make a robotic arm for the equipment room," but by the end of it he had made this weird garden of little automatic bleepy bloopy things that look like bombs. He made this great little art installation out of hacking this piece of horrible commerce tech. That was cool.

Allison Parrish

I had the pleasure of taking several classes from Marina Zurkow at ITP and she was really mean on the first day of class. She was really strict and she just projected this persona of being very exacting. I found that super refreshing in the context of the rest of ITP, where teachers tend to be a tiny bit lackadaisical. I've tried to adopt Marina's approach at least for that first day: be strict up front and don't give any ground when it comes to the idea that you're the one teaching, and that the class that you've designed or the class that you're teaching is a serious thing that deserves the students' attention. Otherwise they might not apply themselves to the same degree. It's important they know that you really care and that you're not going to accept work or behavior that doesn't live up to a particular standard, even if you become a super softie as the class evolves. I found that to be successful.

Classroom Techniques

Managing the dynamics of any classroom can take practice. Computational arts courses present special challenges, requiring educators who can both oversee an art or design critique and debug a student's code—sometimes simultaneously. In this section we present a selection of tips and tricks to manage a healthy classroom community, organize feedback to and from students, and open up channels for communication.

Respect and Accommodation

Find out more. Distribute non-anonymous questionnaires on the first day of class to get information about each student's background, goals, interests, skill level, and concerns. This can be a way to learn each student's name and pronouns and identify any learning difficulties early on. It can also provide helpful context when working with students from diverse disciplines or socioeconomic backgrounds. Follow up by having one-on-one conversations with students who have concerns about the class.[2]

Use a specific code of conduct. Many schools now require educators to include a code of conduct in their syllabus. Typically, this prohibits harassment and other discriminatory, aggressive, oppressive, or suppressive behavior. Classrooms that cover technical concepts often have additional needs. The Hacker School provides key examples of social rules that address these particular issues: "No feigning surprise" (e.g., "What?! I can't believe you don't know what *the terminal* is!"), "no "well-actually's" (when a minor and often irrelevant correction is made in a conversation, as in "well, *actually...*"), and "no backseat driving" (when someone overhears people working through a problem and interjects without invitation). These rules are "designed to curtail specific behavior...found to be destructive to a supportive, productive, and fun learning environment."[3]

Consider your language. Try to not say phrases like "this is easy" when presenting technical concepts. Instead, say, "You can do this." This helps to not alienate students who might be struggling to learn introductory concepts.[5]

Debugging in the Classroom

We all have bugs. Don't be afraid to debug your code at the lectern. Ask your students for their eyes on the problem. Allowing your students to see you say "I don't know" can help diminish their own impostor syndrome.

Inclusivity is not just about the diversity of people but a habitat of learning that is inclusive and empowering for people.
—Taeyoon Choi[1]

It is imperative that we engineer robust participation of people from a broad set of communities, identity groups, value systems, and fields of knowledge in this emerging media landscape, in all roles and levels of power. This will help to mitigate the pitfalls of disruption and potentially usher in a change that has justice and equity as core values.
—Kamal Sinclair[4]

The only skill you need is to know (1) how to identify what you don't know / when you don't know something; and (2) how to look things up, how to read documentation, how to try & try & try and keep trying while things fail, until they work. That's literally the job of writing code.
—Jen Simmons[7]

Code isn't precious. Deliberately break your code in front of students. In repairing it, narrate your steps out loud.[6]

Program in pairs. When giving exercises in class, direct your students to collaborate in pairs on one computer. One student should do the typing while the other observes, comments, and makes suggestions. Have students switch roles for each exercise.

Teach how to ask for help. Don't assume that your students will know how to ask for help. Lauren McCarthy provides her students with example questions to ask when they are confused: "Will you repeat that last thing you said? Could you do another example? Could you go through that again, slower? Will you explain that a different way? Can you explain that word you said? Can you please speak a little slower?"[8]

No typing. When a student asks for help, resist the urge to repair their code directly; they need the firsthand experience of resolving the issue themselves. Francis Hunger advises: "Never touch the keyboard, mouse or trackpad of a student's computer. Just tell [them] what needs to be done—they own the keyboard, they own the problem."[9]

Adopt a "three before me" policy. Taking time to debug one student's problematic code can interrupt the classroom flow for the others. When a student encounters a bug in their code, require them to seek help from three of their peers before coming to the educator for assistance. The "three before me" classroom policy also helps instill an atmosphere of collaboration and comradery during studio time.

Use paper. Require students to bring a sketchbook to class. This can be an essential aid for rapid problem-solving, brainstorming, and paper prototyping.[10] It can also help support a laptop-free lecture environment—as research shows that writing things down improves student recall and understanding.[11]

Teaching Critique

Follow a structure for critique. Students often struggle to give each other meaningful feedback on creative work, lacking a vocabulary or template for doing so. A variety of educators, educational theorists, and critics have outlined steps to help students better engage with each other's work. A common pattern asks students to start with description ("What do you

see?"), followed by analysis ("How is it made? What does it make you think about or feel?"), interpretation ("What is it about? What is the main idea being explored?"), and finally, evaluation ("Is it successful? Does it explore the prompt in a compelling, interesting or unique way?")[12] This last step will typically require a conversation on what criteria are appropriate for judging the work.

Use collaborative notepads for critiques. Critiques in studio classrooms of 12–20 students can be impractical and awkward—both because of the total time required to discuss every student project, and because of the social dynamics of groups this size. For a more efficient critique, have each student briefly present their project at the lectern; meanwhile, during their presentation, direct the presenter's classmates to type comments into an online collaborative real-time text editor (such as a Google Doc or Etherpad). This has several advantages: peer feedback is instantly captured and organized; anonymous editing can encourage more honest contributions; shy students can offer feedback more easily; and the group is spared the repetition of statements like "I agree with what everyone else has already said." For laptop-free classrooms, students can instead provide feedback to their peers on sticky notes.

Promoting Research
Encourage weekly journaling. Help students become familiar with the field through regular online research. Golan, for example, requires his students to browse specific blogs and video-sharing sites and then write weekly "Looking Outwards" reports: lightweight essays about a specific artwork or other project they've discovered. In a Looking Outwards report, the student should explain what the project is and how it operates, explain what inspires them about it, research the project's chain of influences, and critique the project by discussing the possibilities it suggests or the opportunities it missed. Looking Outwards reports can be productively constrained in a variety of ways, such as by restricting them to projects that use certain media, or to work by specific artists.

Stage research sprints. Don't exclusively allocate studio time to technical content. To reinforce the principle that code always exists in a cultural context, arrange 15–20 minute "research sprints" in which groups of students are asked to quickly compile links to projects that exemplify a particular type of practice. Create an editable slide deck and have each group contribute one slide.[13]

Getting Feedback on Your Teaching

Allow time for questions. Allocate time throughout the term for students to ask questions on anything they are confused about, safely and without judgment. Many educators recommend asking students, "What questions do you have?" rather than, "Do you have any questions?" in order to elicit more responses.[14] Post the questions somewhere visible, and over the following sessions, address each one in a class discussion.

Request exit tickets. At the end of a class, ask students to submit one or two questions about the content of the day's lesson. This can be done via handwritten notes, an online messaging tool, or a structured electronic survey. Such "exit tickets" are a way of getting instant feedback on your teaching and can help you understand your students' comprehension.[15] They can also function as an attendance record.

Students will remember your kindness a lot longer than they'll remember any particular homework assignment.
—Holly Ordway[16]

Notes

1. Taeyoon Choi. "Worms, Butterflies, and Dandelions: Open Source Tools for the Arts." Medium.com, June 20, 2018, https://medium.com/@tchoi8/worms-butterflies-and-dandelions-open-source-tools-for-the-arts-9b4dcd76a1f2.

2. Rebecca Fiebrink (@RebeccaFiebrink), Twitter, August 8, 2019, 7:18 AM, https://twitter.com/RebeccaFiebrink/status/1159423540392812546.

3. "User's Manual," The Recurse Center, last modified July 26, 2019, https://www.recurse.com/manual.

4. Kamal Sinclair, "The High Stakes of Limited Inclusion," Making a New Reality, November 29, 2017, https://makinganewreality.org; quoted in Cara Mertes, "Now Is the Time for Social Justice Philanthropy to Invest in Emerging Media," *Equals Change Blog*, June 22, 2018, https://www.fordfoundation.org/ideas/equals-change-blog/posts/now-is-the-time-for-social-justice-philanthropy-to-invest-in-emerging-media.

5. Luca Damasco (@Lucapodular), Twitter, August 8, 2019, 8:14 AM, https://twitter.com/Lucapodular/status/1159437696663789569.

6. Douglas E. Stanley (@abstractmachine), "Break code, then try to find your way back, asking students for help," Twitter, August 8, 2019, 6:10 AM, https://twitter.com/abstractmachine/status/1159406642947121152.

7. Jen Simmons (@jensimmons), Twitter, July 26, 2018, 1:20 PM, https://twitter.com/jensimmons/status/1022532183733481472.

8. Lauren McCarthy, "Are You All In?" (lecture, Learning to Teach, Teaching to Learn II, Postlight, NY, January 2017), video, 1:12:35, https://www.youtube.com/watch?v=D7-m6NJ90RE.

9. Francis Hunger (@databaseculture), Twitter, August 7, 2019, 4:35 PM, https://twitter.com/databaseculture/status/1159201338112319491.

10. Rebecca Fiebrink (@RebeccaFiebrink), Twitter, August 8, 2019, 7:16 AM, https://twitter.com/RebeccaFiebrink/status/1159423246745382912.

11. Pam A. Mueller and Daniel M. Oppenheimer, "The Pen Is Mightier than the Keyboard: Advantages of Longhand over Laptop Note Taking," *Psychological Science* 25, no. 6 (April 23, 2014): 1159–1168, doi:10.1177/0956797614524581.

12. Terry Barrett, *CRITS: A Student Manual* (London: Bloomsbury Visual Arts, 2018), 69–154 and *Criticizing Art: Understanding the Contemporary* (Mountain View, CA: Mayfield Publishing Company, 1994).

13. Mitchell Whitelaw (@mtchl), Twitter, August 7, 2019, 5:23 PM, https://twitter.com/mtchl/status/1159213387458347009.

14. Cris Tovani, "Let's Switch Questioning Around," *Educational Leadership* 73, no. 1 (2015): 30–35.

15. Elizabeth F. Barkley, K. Patricia Cross, and Claire Howell Major, *Collaborative Learning Techniques: A Handbook for College Faculty* (San Francisco: Jossey-Bass, 2014), 35.

16. Holly Ordway (@HollyOrdway), Twitter, March 13, 2020, 5:47 PM, https://twitter.com/HollyOrdway/status/1238582577461702657 and thread at https://twitter.com/HollyOrdway/status/1238576343840968710.

Provenance

Like the Brothers Grimm, who compiled fairy tales from interviews with grandmothers, or Dushko Petrovich and Roger White, who collected accounts of memorable art assignments from artists and teachers alike, we have assembled favorite computational art and design prompts from friends, colleagues, mentors, and students, documenting the strategies and pedagogies of a community teaching creative visual production through code. Petrovich and White remind us that legendary assignments can stay with you for life, often resurfacing when one reenters the classroom as a teacher: "Most artists, when they begin to teach, will pass along—consciously or not—assignments they themselves were once given."[1] Assignments are fodder for adaptation and are continually shared, forked, recontextualized, subverted, and renewed, a process that often makes their authorship plural and ambiguous.

Public records documenting art and design pedagogy are scarce and poorly maintained, especially in contrast to notable works of art and design, which are discussed in critical texts and collected by museums. In their extraordinary compilation of graphic design assignments, *Taking a Line for a Walk: Assignments in Design Education,* Nina Paim, Emilia Bergmark, and Corinne Gisel lament that, in design education, "the layer of language that runs alongside this process is often neglected. Words fly out of a teacher's or a student's mouth and quickly disappear into thin air. Instructions and specifications, corrections and questions, fuse with practical work. And assignments, if written down at all, are rarely considered something worth saving."[2] In the realm of computational media arts and design, it has been more common for classroom syllabi and curricula to appear online; these materials, however, are subject to the uniquely digital vagaries of data preservation: link rot and bit rot. Web servers for old courses are rarely considered something worth maintaining; the "walled gardens" of many courseware systems restrict public access; and computer arts courses prior to 1994 precede the World Wide Web altogether, eluding search engines. The Internet is astonishingly fragile, and even within the few years we have spent writing this book, links to many noteworthy resources have gone dark, and projects have been quietly retired from creator portfolios—a process that is producing an undeniable amnesia throughout the field.

In this section, we lay out the sources from which we encountered or developed the assignments in this collection. We cannot and do not claim that the information here is definitive. To trace the origins, history, and provenance of these assignments would require extensive oral history research, and remains a worthy challenge for art and education historians of the future. In addition to the gaps in our knowledge due to the absence or loss of documentation, we also acknowledge that the information below contains oversights and blind spots owing to our lack of familiarity with non-English-speaking art and technology educational communities, and we fully acknowledge that our perspective is not representative of the rest of the world.

While many of the assignments in this book have been adapted from the syllabi of our teachers and peers, a few were primarily inspired by projects that we admire. In discussing the provenance of the assignments in their book, Paim, Bergmark, and Gisel call this process of back-formation "reconstruction," and we choose similar vocabulary here. In particular, our assignments Personal Prosthetic, Parametric Object, and Virtual Public Sculpture were inspired by the works that illustrate their respective modules, and are not otherwise discussed below.

In other cases, our assignments rely on technologies like speech recognition, 3D printing, augmented reality, or machine learning that have only recently become widely accessible. As educators and practitioners have only had a relatively brief time to experiment with these tools, methods for how to teach the creative use of these technologies within art and design contexts are still (quickly) emerging. In such cases, we have taken the liberty to devise the assignment briefs ourselves. This is the case for assignments including Voice Machine, Bot, Personal Prosthetic, Parametric Object, and Virtual Public Sculpture.

Finally, some of the educational approaches documented here spread from the community of John Maeda's Aesthetics + Computation Group at the MIT Media Laboratory, where one of the authors of this book (Golan Levin) was a graduate student alongside Casey Reas and Ben Fry (who co-founded the Processing initiative). With this context in mind, it is important to note that some of the assignments presented in this book have been drawn directly from personal experience and firsthand accounts from our peers, and some have been plucked from a buzzing zeitgeist—distilled from the research, educational materials, and social media posts of a highly interconnected community of artists, teachers, and students.

Iterative Pattern

The Iterative Pattern exercise extends from the earliest practices in plotter-based computer art—the first university courses for which arose in the early-to-mid 1970s. Writing in 1977, Grace C. Hertlein, a professor of computer science at California State University at Chico, details a list of notable "computer art systems" actively used in higher education at the time: "in Jerusalem, by Vladimir Bonacic; Reiner Schneeberger (University of Munich); Jean Bevis (Georgia State University); Grace C. Hertlein (California State University system); John Skelton (University of Denver); Katherine Nash and Richard Williams (University of Minnesota at Minneapolis)."[3]

An example of work by one of Reiner Schneeberger's students, Robert Stoiber, is shown below, a grid of nested squares.[4] In this picture, in which "the middle point of each square was obtained by chance," it is clear that students were directed to explore iterative loops and randomness. In a 1976 article, Schneeberger describes the context in which this work was produced, a summer course taught in collaboration with Professor Hans Daucher of the Department of Art: "This is a report of the first computer graphics course for students of art at the University of Munich. [...] A further objective to be realized was for every student to be able to generate aesthetically appealing computer graphics after only the first lecture period." Schneeberger mentions that the art students experienced greater than normal hardship, as all of the computer programming work had to be performed "locally at the Computer Center, some ten kilometers distant from the instructional site."[5]

Iterative patternmaking is now a standard exercise in texts on creative coding, especially where iteration techniques are introduced. Examples include Casey Reas and Chandler McWilliams's *Form+Code in Design, Art, and Architecture* (2010)[6] and Hartmut Bohnacker et al.'s *Generative Design: Visualize, Program, and Create with Processing* (2012).[7]

Figure 4 (BELOW) — SEE DESCRIPTION AT RIGHT.

COMPUTER GRAPHICS and ART for November, 1976

Face Generator

In his book *Design as Art* (1966), Bruno Munari presents the results of a challenge he gave himself: how many different ways could he draw the human face?[8] Mark Wilson later transposed this assignment to the realm of computer arts education in *Drawing with Computers* (1985). Wilson describes a hypothetical face-generation software program called METAFACE, analogous to Donald Knuth's METAFONT (1977), that his reader is encouraged to develop:

> The human face could be schematically rendered with a sparse set of lines and circles similar to the minimal description of the alphabet. It would be possible to write a program—let's call it METAFACE—that would emulate some of the extraordinary variations of the face. The parameters for the various visual descriptions of the face would be given to the program: the size of the eyes, the location of the eyes, and so forth. Depending on the ambitiousness of the programmer, the program could become exceedingly complex.[9]

Wilson also illustrated the variety of faces such a program might produce:

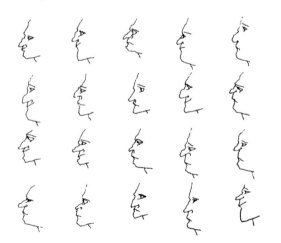

Lorenzo Bravi, an educator at the design department of IUAV of Venice and later at the ISIA of Urbino, gave an influential generative face assignment called "Parametric Mask" in 2010. Computational face designs by Bravi's students were used to create *Bla Bla Bla*, a sound-reactive application for iPhone and iPad.[10] In a 2011 brief, Casey Reas, acknowledging both Munari and Bravi, invited his students at UCLA to make microphone-reactive faces.[11] Face generator exercises have since become commonplace in introductory creative technology courses; dozens of examples can be found at OpenProcessing.org, written by educators such as Julia Pierre, Steffen Klaue, Rich Pell, Isaac Muro, and Anna Mª del Corral.

Clock

"The Clock" is an evergreen creative coding assignment, and was the original inspiration for this book. An August 2019 survey of 847 classrooms on OpenProcessing.org revealed scores of clock projects—assigned by a bevy of international educators including Amy Cartwright, Sheng-Fen Nik Chien, Tomi Dufva, Scott Fitzgerald, June-Hao Hou, Cedric Kiefer, Michael Kontopoulos, Brian Lucid, Monica Monin, Matti Niinimäki, Ben Norskov, Paolo Pedercini, Rich Pell, Julia Pierre, Rusty Robison, Lynn Tomaszewski, Andreas Wanner, Mitsuya Watanabe, and Michael Zöllner. The particular text of the clock assignment presented in this volume is most closely adapted from Golan's version, "Abstract Clock: A diurnally-cyclic dynamic display," which he assigned in his Fall 2004 Interactive Image course at Carnegie Mellon.[12]

The graphic representation of time has long figured into both analog and digital design education. An assignment to devise a graphic system that displays and contrasts the rhythms of sixteen different calendars (including Aztec, Chinese, Gregorian, etc.) was given at the Yale School of Art in 1982 by Greer Allen, Alvin Eisenman, and Jane Greenfield.[13] The first *computational* clock assignment that we know of was assigned by John Maeda in his Fall 1999 Organic Form course at the MIT Media Lab. This course—whose students included Golan as well as future

computational media educators like Elise Co, Ben Fry, Aisling Kelliher, Axel Kilian, Casey Reas, and Tom White — examined "the nature of symbolic descriptions that are creatively coerced into representations that react to both internal changes in state and external changes in environment." In his clock assignment, shown below, Maeda asked students to use the DBN programming environment to "create a display of time that does not necessarily depict the exact progress of time, but rather the abstract concept of time."[14]

Maeda's assignment extended from his own artistic exploration of time displays in his 1996 *12 O'Clocks* project. Introducing a simplified clock project in his 1999 book, *Design by Numbers*, Maeda writes that "time is the most relevant subject to depict by means of a dynamically changing form.[...] Given the ability to computationally observe the progress of time, a form that can reflect the time is easily constructed."[15]

The computational clock assignment spread quickly to other universities in the early 2000s. The Computer-Related Design graduate course at Royal College of Art, London, was an early such center for creative coding education.[16] Citing Maeda's clocks as an inspiration, RCA instructors Rory Hamilton and Dominic Robson asked graduate students to design a "timepiece" in an interaction design course in February 2002. Hamilton and Robson's conceptually oriented "pressure project" is agnostic as to medium:

> This simple brief is to look at the nature of clocks and other time measuring devices. How do we use them? Why do we use them? What is their meaning? Restyling of clocks are numerous: but we ask you not to restyle but to rethink. Not to reskin existing clocks but to come up with a completely new way of looking at time. Your design should be beautiful, engaging, and work. Whatever medium you choose we should all be able to understand and use your system.[17]

A 2005 article by a group of Georgia Tech faculty highlights the clock as a key assignment in Computing as an Expressive Medium, a core graduate level course taught by Michael Mateas. For Mateas, who asks students to "display the progress of time in a non-traditional way," the clock is not an exercise in utilitarian design, but an "expressive project" whose "goal is to start students thinking about the procedural generation of imagery as well as responsiveness to input, in this case both the system clock, and potentially, mouse input."[18]

In his Fall 2008 Comparative Media Studies workshop at MIT, Nick Montfort asked students to develop clocks ("a computer program that visually indicates the current hour, minute, and second").[19] Casey Reas introduced the clock assignment to UCLA in Spring 2011. Reas's version leaves open the question of whether the students' clock should be literal or abstract, and instead places a primary emphasis on an iterative design process of sketching and ideation. Asking students to "create a 'time visualization,' aka a clock," Reas requires students to

bring "at least five different ideas, each with six drawings to show how the clock changes in time."[20]

In September 2017, NYU ITP educator Dan Shiffman canonized the clock assignment for a wide audience in his popular *Coding Train* video channel on YouTube. Citing Maeda's *12 O'Clocks* and Golan Levin's Fall 2016 course materials, Shiffman's "Coding Challenge #74: Clock with p5.js" video has accumulated (as of May 2020) more than 350,000 views.[21]

Generative Landscape

As a 2006 survey by George Kelly and Hugh McCabe shows, the challenge of procedurally generating landscapes and terrains has been a fixture in game design and computer graphics literature since the mid-1980s.[22] Whereas most early computer graphics research was concerned with achieving realism, the introduction of software development environments into art schools in the early 2000s created a context in which the problem could be imaginatively addressed by students steeped in the traditions of conceptual art, performance, film, and art history. The language of the Generative Landscape assignment presented here (populated with "body parts, hairs, seaweed, space junk, [or] zombies") is adapted from a prompt given by Golan in his Fall 2005 Interactive Image course.[23]

Nick Montfort's Comparative Media Studies workshop in 2008 also featured a "Generated Landscape" assignment. Navigability is a key requirement of Montfort's assignment, which stipulates that a user be able to "move around a large virtual space, seeing one window of this space at a time."[24] This assignment is included and discussed in Montfort's 2016 book, *Exploratory Programming for the Arts and Humanities*, which provides sample code for readers to "create a virtual, navigable space."[25] A more tightly constrained "Noisy Landscapes" assignment also appears in Bohnacker et al., *Generative Design*.[26]

Virtual Creature

John Maeda asked students to create a virtual creature in his Fall 1999 course, Fundamentals of Computational Media Design (MAS.110) at MIT. "Inspired by a diagram of a cell in *The Biology Coloring Book*, I asked my class to re-interpret the canonical drawing of an amoeba in a medium of their choice."[27] Influenced by this prompt, Golan initiated the Singlecell.org project in January 2001, inviting creators like Lia, Marius Watz, Casey Reas, and Martin Wattenberg to create interactive creatures for an "online bestiary of online life-forms reared by a diverse group of computational artists and designers."[28] An even more open-ended virtual creature assignment was presented by Lukas Vojir's influential *Processing Monsters* project in 2008, which collected Processing-based code sketches from scores of contributors around the world:[29]

I'm trying to get as much people as possible, to create simple b/w [black and white] monster in Processing, [...] while the bottom line is to encourage other people to learn Processing by showing the source code. So if you feel like you can make one too and be part of it, the rules are simple: Strictly black and white + mouse reactive.[30]

"Creature" assignments in courses taught by Chandler McWilliams and John Houck at UCLA between 2007 and 2009 made explicit mention of Vojir's *Processing Monsters*, as well as animistic simulation models like Valentino Braitenberg's vehicles. The UCLA assignments emphasized the use of Java classes and object-oriented programming to develop virtual creatures with parameterized appearances and behaviors.[31] More recently, OpenProcessing.org has come to host creature assignments by educators including Tifanie Bouchara, Margaretha Haughwout, Caroline Kassimo-Zahnd, Cedric Kiefer, Rose Marshack, Matt Richard, Matt Robinett, and Kevin Siwoff. Some of these assignments invite students to use flocking behaviors explained by Craig Reynolds in his influential 1999 "Steering Behaviors For Autonomous Characters"[32] and popularized in Dan Shiffman's *Nature of Code* book and associated videos.[33]

Custom Pixel
The concept of custom picture elements in computer arts extends from experiments in the 1960s by Leon Harmon and Ken Knowlton at Bell Labs; Danny Rozin's renowned *Wooden Mirror* (1999) and other interactive mirror sculptures; and photomosaic work by Joseph Francis and Rob Silvers, among others. The ability of Processing and other creative coding toolkits to provide straightforward access to image pixel data means that a "custom pixel" assignment can be a productive way to support instruction in introductory image processing. Exercises of this sort appear in Casey Reas and Ben Fry's *Processing: A Programming Handbook for Visual Designers and Artists* (2007);[34] in Ira Greenberg's *Processing: Creative Coding and Computational Art* (2007);[35] in Dan Shiffman's *Learning Processing* (2008);[36] in Andrew Glassner's

Processing for Visual Artists: How to Create Expressive Images and Interactive Art (2010);[37] in Reas and McWilliams's *Form+Code* (2010);[38] and in Bohnacker et al.'s *Generative Design* (2012)[39].

The assignment as presented here derives from Golan's Fall 2004 Interactive Image course. He asked students to "create a 'custom picture element' with which to render your image. At no time should the original image be seen directly."[40]

Drawing Machine
Our Drawing Machine assignment extends from a tradition of experimental interactive paint programs developed by artists during the late 1980s and 1990s, such as Paul Haeberli's *DynaDraw*, Scott Snibbe's *Motion Sketch* and *Bubble Harp*, Toshio Iwai's *Music Insects*, and John Maeda's conceptually oriented drawing tools, *Radial Paint*, *Time Paint*, and *A-Paint* (or *Alive-Paint*).[41] By 1999, Maeda had formalized this type of inquiry as an educational assignment. In his book *Design by Numbers*, he presents an exercise involving the construction of an ultra-minimal paint program: a loop that continually sets a canvas pixel to black, at the location of the cursor. In a section entitled "Special Brushes," Maeda writes: "Perhaps the most entertaining exercise in studying digital paint is the process of designing your own special paintbrush. There really is no limit to the kind of brush you can create, ranging from the most straightforward to the completely nonsensical. How you approach this creative endeavor is up to you."[42] Maeda offers some potential responses to this assignment, including a pen whose ink changes color over time; a calligraphy brush with a diagonal tip; and a vector drawing tool for polylines. Exemplary student responses to this prompt were published by JT Nimoy in 2001 (then an undergraduate intern in Maeda's group at MIT) as a collection of twenty interactive "Scribble Variations,"[43] and by Zach Lieberman in his 2002 master's thesis at Parsons School of Design, "Gesture Machines." Lieberman's interactive thesis projects were published at the now-defunct Remedi Project online gallery[44] and were revived for a lecture presentation recorded at the 2015 Eyeo Festival.[45]

Variants of the drawing tool assignment proliferated in the early 2000s. In a Fall 2003 course at UCLA, Casey Reas asked students to develop a "mouse-based drawing machine."[46] In a Spring 2004 course, he asked students to

> Have a concrete idea about the type of images your machine will construct and be prepared to explain this idea during the critique. Build your project to have a large range in the quality of drawings generated and to have a large range of formal contrasts. It's very difficult to program representational images, so it's advised to focus on constructing abstract drawings. Do not use any random values, but instead rely on other sources of data [...] as the generators of form and motion.[47]

Golan's 2000 master's thesis, "Painterly Interfaces for Audiovisual Performance," developed under John Maeda's supervision at MIT, presented a collection of five interactive software programs for the gestural creation and performance of dynamic imagery and sound. Based on insights from this work, Golan assigned a "custom drawing program" in his Fall 2004 course at CMU, Introduction to Interactive Graphics.[48] In Spring 2005, he refined this drawing program to one in which "the user's drawings come to life" by making "a drawing program which augments the user's gesture in an engaging manner."[49]

In a 2005 article, Michael Mateas describes a "drawing tool" assignment given in his graduate-level course at Georgia Tech, Computing as an Expressive Medium. Mateas asks students to

> Create your own drawing tool, emphasizing algorithmic generation / modification / manipulation. [...] The goal of this project is to explore the notion of a tool. Tools are not neutral, but rather bear the marks of the historical process of their creation, literally encoding the biases, dreams, and political realities of its creators, offering

affordances for some interactions while making other interactions difficult or impossible to perform or even conceive.[50]

In his Winter 2007 and Spring 2008 Interactivity courses at UCLA, Chandler McWilliams gave assignments that explored the nuanced differences between a mouse-based "drawing machine" and a "drawing tool."[51] Since that time, a panoply of drawing tool assignments have been published online at OpenProcessing.org, in online classrooms taught by Antonio Belluscio, Tifanie Bouchara, Tomi Dufva, Briag Dupont, Rachel Florman, Erik Harloff, Cedric Kiefer, Steffen Klaue, Andreas Koller, Brian Lucid, Yasushi Noguchi, Paolo Pedercini, Julia Pierre, Ben Schulz, Devon Scott-Tunkin, and Bridget Sitkoff, among others. The assignment has also featured in books on introductory creative coding, such as Bohnacker et al.'s *Generative Design* (2012).[52]

Modular Alphabet

The design principles of parameterization and modularity are foundational considerations in traditional typography education, quite apart from the use of code and digital techniques. A 1982 pencil-and-paper assignment by Hans-Rudolf Lutz at Ohio State University, for example, asked students to render an alphabet with five stages of transitions between consecutive letters.[53] An assignment by Laura Meseguer, given in 2013 at the Escuela Universitaria de Diseño e Ingeniería de Barcelona, asked students to design a modular typeface from a small set of hand-drawn graphical elements. According to Meseguer, "working with this modular method will help you to understand the architecture of letterforms and modularity, coherence, and harmony inherent to type design."[54]

As a creative coding assignment, our Modular Alphabet project descends most directly from prompts and student work developed in John Maeda's 1997 Digital Typography course at the MIT Media Lab, which focused on the "algorithmic manipulation of type as word, symbol, and form."[55] Maeda assigned "Pliant Type" and "Unstable

Type" projects that asked students (working in Java) to "design a vector-based typeface that transforms well" and to "design a parameterized typeface with inherently unstable properties."[56] Peter Cho's project *Type Me, Type Me Not* emerged from Maeda's prompts, and established the template for the assignment as reconstructed here.[57] Cho's writeup for the course gallery page explains that "at some point in the class I became fixated with the idea of constructing letters from only circular pie pieces, using the fillArc method of the Java graphics class. [...] Since each letter is devised from two filled arcs, it is easy to make transitions between letters in a smooth way."[58] The text of the assignment in the present volume is adapted from Golan's "Intermorphable Alphabet: A custom graphic alphabet," which he assigned in his 2004 Interactive Image course.[59]

Computational "parametric type" assignments, extending from the logic of Knuth's METAFONT (1977), focus on the use of parameters to control continuous properties of a typeface. An assignment that illustrates this is "Varying the Font Outline (P 3.2.2)" in *Generative Design*,[60] in which the reader is prompted to explore how a code variable may govern a property such as the typeface's overall slant, or something more unconventional, like wiggliness.

Data Self-Portrait
During the first decade of the 2000s, Judith Donath and her graduate students in the MIT Media Lab's Sociable Media Group created "data portraits," formulating principles for producing and understanding media objects that depict their subjects' accumulated data rather than their faces. Donath argued that "calling these representations 'portraits' rather than 'visualizations' shifts the way we think about them."[61] Concurrently, Nick Felton's diaristic, assignment-like "Annual Report" information visualizations, which he published from 2005 through 2014 and are now part of MoMA's permanent collection, were highly influential in establishing a precedent for computationally designed, data-driven self-portraiture.

By the early 2010s, the use of personal fitness trackers and smartphone selfies had become widespread, pushing an evolution in how data self-portraiture was both implemented and described. The wording of the assignment in this book is adapted from an exercise in Golan's Spring 2014 Interactive Art & Computational Design course at CMU, which asked students to "develop a visualization which offers insights into some data you care about. This project will probably take the form of a "Quantified Selfie": a computational self-portrait developed from any (one or more) of the data-streams you produce."[62]

Augmented Projection
Our assignment is inspired by installation works by artists including Michael Naimark, Krystof Wodiczo, Christopher Baker, Andreas Gysin + Sidi Vanetti, HeHe (Helen Evans and Heiko Hansen), Jillian Mayer, Joreg Djerzinski, and Pablo Valbuena. Valbuena's computationally generative *Augmented Sculpture* artwork, presented at the 2007 Ars Electronica Festival and widely viewed online,[63] was also particularly influential to creative technologists, and spurred the development of commercial projection mapping software like MadMapper and Millumin. With the help of these tools, projection mapping has become a staple in progressive theater scenography, and is taught in many graduate programs in video and media design.

Golan gave a version of this assignment ("a poetic gesture projected on a wall") in fall 2013. Students were asked to write code in Processing, using the Box2D physics library, in order to generate real-time animated graphics that related both visually and conceptually to wall features like power outlets and doorknobs.[64]

One-Button Game

The first public competition to create "a strictly one-button game"—that we know of—was held in April 2005 by Retro Remakes, an online community of independent game developers.[65] Soon after, in a Gamasutra article that would be widely cited in subsequent game design syllabi, Berbank Green discussed in-depth design issues in the low-level mechanics of one-button games.[66]

In December of 2009, the experimental game design collective Kokoromi announced the GAMMA IV competition for one-button games, whose winners were presented to a large audience at the March 2010 Game Developers Conference. Responding to an efflorescence of "high-tech" game controllers that had just been released to the market, with interfaces like "gestural controls, multi-touch surfaces, musical instruments, voice recognition—even brain control," Kokoromi proposed "that game developers can still find beauty in absolute simplicity."[67] In August of 2009, the wildly popular one-button game *Canabalt* was released online.[68] For his Winter 2009 Interactivity course at UCLA, Chandler McWilliams introduced the one-button game as a classroom exercise:

> Develop a simple one-button game, meaning the interface is a single button. Focus your ideas on expressing a theme while making an interesting experience. Do not be overly concerned with how the game behaves technically, great games can be made very simply. Instead consider how common video and board games operate and what features of these artifacts you can reinterpret in interesting ways. The game need not involve scores or levels; it can be a playful experience. Remember that conceptual and visual development is as important as technical achievement.[69]

Paolo Pedercini also mentions one-button games (and "no-button games") in a CMU Experimental Game Design syllabus from Fall 2010.[70]

One-button games are now a popular and well-established genre. As of August 2019, the indie game distribution website Itch.io, for example, reported hosting over 2800 unique one-button games.

Experimental Chat

Our assignment is influenced by mid-1990s telematic media artworks, such as Paul Sermon's *Telematic Dreaming* (1992), Scott Snibbe's *Motion Phone* (1995), and Rafael Lozano-Hemmer's *The Trace* (1995). This assignment also has roots in the "Shared Paper" exercise that John Maeda discusses in *Design by Numbers*. (1999).[71] Maeda describes a publicly accessible web server that stores 1000 numbers, whose values could be read and modified by user code. Building on this ultra-simple platform, Maeda presents a "Collaborative Drawing" project, in which mouse coordinates are shared from one person to another,[72] and "Primitive Chat," in which a single letter is sent at a time.[73]

Maeda elaborates on this assignment in *Creative Code* (2004):

> The standard final assignment I used to set my class [in 1997] was to transmute a stream of data communication. The communication stream in question was the server, which used to pass messages from any connected client to all connected clients simultaneously in the way that Internet-based chat systems work. I stopped setting this assignment because of the technical difficulties of keeping the server running reliably.[74]

Browser Extension

A precursor to the Browser Extension assignment was Alex Galloway's *Carnivore* project (2000–2001), in which he invited 15 artists to contribute custom software clients that visualized network traffic captured by a packet sniffer. Each "Carnivore Client" provided a different lens on internet communication. In 2008–2009, Google and Mozilla introduced add-on ecosystems for their Chrome and Firefox web browsers,

kicking off a wave of shareable experimentation. The creation of commercial browser extensions as a mode of art practice arose at that time, boosted by the popular success of Steve Lambert's *Add Art*, a browser plugin that automatically replaces online advertisements with artworks. Lambert's project informs our assignment, and we took additional inspiration from artworks by Allison Burtch, Julian Oliver, Lauren McCarthy, and others.

Creative Cryptography

The 2013 Snowden revelations catalyzed artistic engagement with issues surrounding digital privacy, security, surveillance, anonymity, and cryptographic technologies.[75] Keeping in mind certain cultural practices and artworks that problematized these themes, Tega developed this prompt for Social Software, a 2015 class at Purchase College. It draws on research and projects by practitioners like Addie Wagenecht, Julian Oliver, Adam Harvey, David Huerta and many others.

A variety of mathematics educators have also written about the pedagogic value of cryptography for engaging students from non-technical backgrounds, including Brian Winkel, Neal Koblitz, Manmohan Kaur, and Lorelei Koss.[76] These authors discuss cryptography in the context of both mathematics education and general education, and although they aim to cultivate mathematical competencies, rather than designerly or artistic skill sets, they each observe that the study of cryptography brings together the political, social and technical dimensions of math and computation.

Voice Machine

Speech-based human-computer interaction in real time became a practical reality for creative experimentation in the late 2010s, as we were writing this book. In 2017, Google's Creative Lab division, seeking to encourage developers to adopt their Google Home platform and Dialogflow speech-to-text toolkit, sponsored exploratory investigations into "what's possible when you bring open-ended, natural conversation into games, music, storytelling, and more."[77] Among those supported by this "Voice Experiments" initiative

was programmer and artist Nicole He, who created projects like *Mystery Animal*, a game in which the computer pretends to be an animal and users have to guess what it is by asking spoken questions. In Fall 2018, He taught a course at NYU ITP entitled Hello, Computer: Unconventional Uses of Voice Technology. The course objective was to

> give students the technical ability to imagine and build more creative uses of voice technology. Students will be encouraged to examine and play with the ways in which this emerging field is still broken and strange. We will develop interactions, performances, artworks or apps exploring the unique experience of human-computer conversation.[78]

Our Voice Machine assignment draws inspiration from He's syllabus and projects by her students;[79] from Google's Voice Experiments program; and from pioneering early works of speech-based interactive media art, such as David Rokeby's *The Giver of Names* (1990).

Measuring Device

Data collection is a starting point for education in a wide range of fields, whether in engineering, the natural sciences, social sciences, communication design (e.g., in information visualization), or contemporary art (in critical cultural practices). Several of our peers have given assignments that ask creative coding students to collect data using an API (Jer Thorp at NYU ITP)[80] or that ask them to develop "scrapers" for computationally harvesting information from the Internet (Sam Lavigne at NYU ITP and the School for Poetic Computation).[81] The assignment we present here, however, specifically requires students to develop custom hardware to collect measurements from some dynamic system in the physical world.

The premise of data-collection-as-art comes from approaches used by many artists, including Hans Haacke, Mark Lombardi, On Kawara, Natalie Jeremijenko, Beatriz da Costa, Brooke Singer, Catherine D'Ignazio, Eric Paulos, Amy Balkin, and

Kate Rich. It also draws on citizen science projects like Safecast, the Air Quality Egg, Smart Citizen Platform, Pachube, and the many instructables and online tutorials for DIY data collection tools. Our assignment was adapted from an assignment in Golan's Electronic Media Studio 2 syllabus, given to art students at CMU in 2013.[82]

Extrapolated Body

The Extrapolated Body assignment is inspired by interactive artworks like Myron Krueger's *Videoplace* (~1974–1989) and the long history of expressive uses of offline motion capture in Hollywood computer graphics. Casey Reas's UCLA syllabi from the mid-2000s are some of the earliest extant records of assignments for the computational, real-time augmentation of bodies captured with cameras and computer vision; an exercise from Winter 2004, for example, asks students to use "the unencumbered body as the interface to interacting with a piece of software. Develop and implement an idea for the interaction between two people via a projection, camera, and computer. Remember that through processing the camera data, it is possible to track the body, track colors, determine the direction of motion, read gestures, etc."[83] A related assignment from Winter 2006 asks students to "Develop a concept for a video mirror which utilizes techniques of computer vision."[84]

From Lauren McCarthy's "Mask" assignment, we have borrowed the premise of asking students to not only develop body-responsive software, but simultaneously craft a performance that uses that software. For her Winter 2019 Interactivity course at UCLA, McCarthy writes:

> Write or select a short text (one paragraph or less) that you will read/perform for the class. Based on the text, design and build a virtual mask that you will use to perform the text. Using the provided code template, make your mask react to audio, changing as the volume of your voice changes. This project will be evaluated based on how the face relates to the text, the variation of the mask (how

much it changes), the design of the mask, and your performance of it.[85]

Synesthetic Instrument

The Synesthetic Instrument assignment asks students to develop a tool for the simultaneous performance of sound and image. Our formulation extends from Golan's master's thesis work at the MIT Media Lab (1998–2000), which itself took inspiration from 1990s audiovisual performance instruments by Toshio Iwai especially. In April 2002, in his Audiovisual Systems and Machines ("Avsys") graduate course at the Parsons School of Design, Golan translated this research problem into an assignment in "Simultaneous real-time graphics and sound":

> Your assignment is to develop a system which responds to some kind of input (for example, the mouse, the keyboard, some kind of real-time data-stream, etc.) through the real-time generation of synthetic sound and graphics. [...] Your system must not use canned (pre-prepared) audio fragments or samples. Therefore it will be necessary for you to code your own digital synthesizer, from scratch. To create a relationship between the image and sound, it is presumed that you will also need to appropriately map the data which describes your visual simulation, to the inputs of your sound synthesizer. When creating your system, consider some of the following possible issues, to which there are no 'correct' answers: are the sound and image commensurately plastic, or is one more malleable than the other? Are the sound and image tightly related, or indirectly linked? What is the quality of your use of negative space, in the sound as well as the image? Are rhythms evident in either image or sound, or both?[86]

Notes

1. Dushko Petrovich and Roger White, eds., *Draw It with Your Eyes Closed: The Art of the Art Assignment* (Paper Monument, 2012), 122.

2. Nina Paim, Emilia Bergmark, and Corinne Gisel, eds., *Taking a Line for a Walk: Assignments in Design Education* (Leipzig, Germany: Spector Books, 2016), 3.

3. Grace C. Hertlein, "Design Techniques and Art Materials in Computer Art," *Computer Graphics and Art* 2, no. 3 (August 1977): 27, http://dada.compart-bremen.de/docUploads/COMPUTER_GRAPHICS_AND_ART_Aug1977.pdf.

4. Reiner Schneeberger, "Computer Graphics at the University of Munich (West Germany)," *Computer Graphics and Art* 1, no. 4 (November 1976): 28, http://dada.compart-bremen.de/docUploads/COMPUTER_GRAPHICS_AND_ART_Nov1976.pdf.

5. Schneeberger, "Computer Graphics," 28.

6. Casey Reas and Chandler McWilliams, *Form+Code in Design, Art, and Architecture* (New York: Princeton Architectural Press, 2010), 64. See the exercise "Code Examples: Embedded Iteration."

7. Hartmut Bohnacker, Benedikt Groß, and Julia Laub, *Generative Design: Visualize, Program, and Create with Processing*, ed. Claudius Lazzeroni (Hudson, NY: Princeton Architectural Press, 2012), 214–217. See the exercise "Complex Modules in a Grid."

8. Bruno Munari, "Variations on the Theme of the Human Face," in *Design as Art*, trans. Patrick Creagh (London: Pelican Books, 1971), n.p. Originally published in Italian as *Arte come mestiere* (Editori Laterza, 1966).

9. Mark Wilson, *Drawing with Computers* (New York: Perigee Books, 1985), 18, http://mgwilson.com/Drawing%20with%20Computers.pdf.

10. Filip Visnjic, "Bla Bla Bla," Creative Applications Network, April 26, 2011, https://www.creativeapplications.net/processing/bla-bla-bla-iphone-of-processing-sound/.

11. Casey Reas, syllabus for Interactivity (UCLA, Spring 2011 and Fall 2011), http://classes.design.ucla.edu/Spring11/28/exercises.html and http://classes.design.ucla.edu/Fall11/28/projects.html.

12. https://web.archive.org/web/20060519010135/http://artscool.cfa.cmu.edu/~levin/courses/dmc/iig_04f/ejercicio.php.

13. Paim, Bergmark, and Gisel, *Taking a Line for a Walk*, 135.

14. John Maeda, syllabus for MAS.961: Organic Form (MIT Media Lab, Fall 1999), https://web.archive.org/web/20000901042632/http://acg.media.mit.edu/courses/organic/, accessed January 18, 2000.

15. John Maeda, *Design by Numbers* (New York: Rizzoli, 1999), 208.

16. Gillian Crampton-Smith, "Computer-Related Design at the Royal College of Art," *Interactions* 4, no. 6 (November 1997): 27–33, https://doi.org/10.1145/267505.267511.

17. https://joelgethinlewis.com/oldrcasite/clock.html.

18. Ian Bogost, Michael Mateas, Janet Murray, and Michael Nitsche, "Asking What Is Possible: The Georgia Tech Approach to Game Research and Education," *iDMAa Journal* 2, no. 1 (Spring 2005): 59–68.

19. Nick Montfort, syllabus for CMS.950: Comparative Media Studies Workshop 1 (MIT, Fall 2008), http://nickm.com/classes/cms_workshop_i/2008_fall/.

20. http://classes.design.ucla.edu/Spring11/28/exercises.html.

21. https://www.youtube.com/watch?v=E4RyStef-gY.

22. George Kelly and Hugh McCabe, "A Survey of Procedural Techniques for City Generation," *The ITB Journal* 7, no. 2 (January 2006), doi:10.21427/D76M9P. Available at: https://arrow.dit.ie/itbj/vol7/iss2/5.

23. https://web.archive.org/web/20060617092315/http://artscool.cfa.cmu.edu/~levin/courses/dmc/iig_05f/ejercicio.php.

24. http://nickm.com/classes/cms_workshop_i/2008_fall/.

25. Nick Montfort, *Exploratory Programming for the Arts and Humanities* (Cambridge, MA: MIT Press, 2016), 260.

26. Bohnacker, Groß, and Laub, *Generative Design*, 330.

27. John Maeda, *Creative Code: Aesthetics + Computation* (London: Thames & Hudson, 2004), 53.

28. Golan Levin (editor), http://singlecell.org/singlecell.html, 2001.

29. https://web.archive.org/web/20090304170310/http://rmx.cz/monsters/.

30. Marc De Vinck, "Processing Monsters by Lukas Vojir," *Make:magazine* (blog), November 11, 2008, https://makezine.com/2008/11/11/processing-monsters-by-lu/, accessed August 9, 2019.

31. Chandler McWilliams, syllabus for Interactivity (UCLA, Winter 2007 and Spring 2008), http://classes.dma.ucla.edu/Winter07/28/ and http://classes.dma.ucla.edu/Spring08/28/; John Houck, syllabus for Interactivity (UCLA, Spring 2009), http://classes.dma.ucla.edu/Spring09/28/exercises/.

32. Craig W. Reynolds, "Steering Behaviors For Autonomous Characters," *Proceedings of Game Developers Conference 1999, San Jose, California* (San Francisco, CA: Miller Freeman Game Group, 1999), 763–782.

33. Daniel Shiffman, *The Nature of Code* (2012); *The Coding Train* (YouTube channel).

34. Casey Reas and Ben Fry, "Image as Data," in *Processing: A Programming Handbook* (Cambridge, MA: MIT Press, 2007), 364. Examples include "Convert pixel values into a

circle's diameter" and "Convert the red values of pixels to line lengths."

35. Ira Greenberg, *Processing: Creative Coding and Computational Art* (New York: Friends of Ed Publishing, 2007), 441–451. See the "Pixilate" and "Pixel Array Mask" examples.

36. Dan Shiffman, *Learning Processing: A Beginner's Guide to Programming Images, Animation, and Interaction* (Burlington, MA: Morgan Kaufmann Publishers, Inc., 2008), 324–327. See exercises like Example 15-4, "Pointillism" and Example 16-10, "The Scribbler Mirror."

37. Andrew Glassner, *Processing for Visual Artists: How to Create Expressive Images and Interactive Art* (Boca Raton, FL: A K Peters/CRC Press, 2010), 468–470.

38. Reas and McWilliams, *Form+Code in Design, Art, and Architecture* (New York: Princeton Architectural Press, 2010), 90. See the exercise "Transcoded Landscape."

39. Bohnacker, Groß, and Laub, *Generative Design*, 302–317. See exercises like "Graphic from pixel values," "Type from pixel values," and "Real-time pixel values."

40. https://web.archive.org/web/20060519010135/http://artscool.cfa.cmu.edu/~levin/courses/dmc/iig_04f/ejercicio.php.

41. John Maeda, *Maeda@Media* (New York: Rizzoli, 2000), 94–99.

42. Maeda, *Design by Numbers*, 166–169.

43. https://github.com/jtnimoy/scribble-variations.

44. http://www.theremediproject.com/projects/issue12/systemisgesture/.

45. Zach Lieberman, "From Point A to Point B" (lecture, Eyeo Festival, Minneapolis, MN, June 2015), https://vimeo.com/135073747.

46. Casey Reas, syllabus for Design for Interactive Media (UCLA, Fall 2003),

http://classes.dma.ucla.edu/Fall03/157A/exercises.html.

47. Casey Reas, syllabus for Programming Media (UCLA, Spring 2004) http://classes.design.ucla.edu/Spring04/160-2/exercises.html.

48. https://web.archive.org/web/20060519010135/http://artscool.cfa.cmu.edu/~levin/courses/dmc/iig_04f/ejercicio.php.

49. Golan Levin, syllabus for The Interactive Image (CMU, Spring 2005), https://web.archive.org/web/20060518224636/http://artscool.cfa.cmu.edu/~levin/courses/dmc/iig_05s/ejercicio.php.

50. Ian Bogost et al., "Asking What Is Possible," 59–68.

51. http://classes.dma.ucla.edu/Winter07/28/; http://classes.dma.ucla.edu/Spring08/28/.

52. Bohnacker, Groß, and Laub, Generative Design, 236–245. See exercises including "Drawing with Animated Brushes" and "Drawing with Dynamic Brushes."

53. Paim, Bergmark, and Gisel, Taking a Line for a Walk, 51.

54. Paim, Bergmark, and Gisel, Taking a Line for a Walk, 41.

55. John Maeda, course description for MAS.962: Digital Typography (MIT Media Lab, Fall 1997), https://ocw.mit.edu/courses/media-arts-and-sciences/mas-962-digital-typography-fall-1997/.

56. Maeda, Maeda@Media. See also https://web.archive.org/web/20010124052200/https://acg.media.mit.edu/courses/mas962/.

57. Cho's project appears in print in Maeda, Maeda@Media, 436.

58. The MAS.962 course gallery page is no longer available. See also Peter Cho, "Computational Models for Expressive

Dimensional Typography" (master's thesis, MIT, 1999), 34, https://acg.media.mit.edu/people/pcho/thesis/pchothesis.pdf.

59. https://web.archive.org/web/20060519010135/http://artscool.cfa.cmu.edu/~levin/courses/dmc/iig_04f/ejercicio.php.

60. Bohnacker, Groß, and Laub, Generative Design, 276–285.

61. Judith Donath et al., "Data Portraits" (lecture, SIGGRAPH '10, Los Angeles, CA, July 2010), https://smg.media.mit.edu/papers/Donath/DataPortraits.Siggraph.final.graphics.pdf.

62. http://golancourses.net/2014/assignments/project-3/.

63. http://www.pablovalbuena.com/augmented/.

64. Golan Levin, syllabus for 60-210: Electronic Media Studio 2 (CMU, Fall 2013), http://cmuems.com/2013/a/assignments/assignment-07/.

65. Barrie Ellis, "Physical Barriers in Video Games," OneSwitch.org.uk, March 20, 2006, http://www.oneswitch.org.uk/OS-REPOSITORY/ARTICLES/Physical_Barriers.doc, accessed September 28, 2010.

66. Berbank Green, "One Button Games," Gamasutra.com, June 2, 2005, https://web.archive.org/web/20050822041906/http://www.gamasutra.com/features/20050602/green_01.shtml.

67. http://web.archive.org/web/20091204142734/http://www.kokoromi.org/gamma4.

68. http://adamatomic.com/canabalt/.

69. http://classes.dma.ucla.edu/Winter09/28/exercises/.

70. http://gamedesign.molleindustria.org/2010/.

71. Maeda, Design by Numbers, 204.

72. Maeda, Design by Numbers, 207.

73. Maeda, Design by Numbers, 213.

74. Maeda, Creative Code, 106.

75. See events like the Prism Breakup conference and exhibition at New York's Eyebeam Center in 2013 (https://www.eyebeam.org/events/prism-break-up/) as well as numerous cryptoparties (https://www.cryptoparty.in/) and Art Hack Days (http://arthackday.net/) that brought together artists and technologists.

76. See Brian Winkel, "Lessons Learned from a Mathematical Cryptology Course," Cryptologia 32, no. 1 (January 2008): 45–55; Neal Koblitz "Cryptography as a Teaching Tool," Cryptologia 21, no. 4 (June 1997): 317–326; Manmohan Kaur, "Cryptography as a Pedagogical Tool," Primus 18, no. 2 (March 2008): 198–206; Lorelei Koss, "Writing and Information Literacy in a Cryptology First-Year Seminar," Cryptologia 38, no. 3 (June 2014): 223–231.

77. https://experiments.withgoogle.com/collection/voice.

78. https://nicolehe.github.io/schedule, last modified October 23, 2018.

79. https://medium.com/@nicolehe/fifteen-unconventional-uses-of-voice-technology-fa1b749c14bf.

80. Jer Thorp, syllabus for Data Art (NYU ITP, Spring 2016), https://github.com/blprnt/dataart2017a.

81. Sam Lavigne, syllabus for Scrapism (NYU ITP, Fall 2018), https://github.com/antiboredom/sfpc-scrapism.

82. Golan Levin, syllabus for Electronic Media Studio 2 (CMU, Fall 2013), http://cmuems.com/2013/a/assignments/assignment-08/, last modified December 2013.

83. Casey Reas, syllabus for Interactive Environments (UCLA, Winter 2004), http://classes.design.ucla.edu/Winter04/256/exercises.html#B.

84. Casey Reas, syllabus for Interactive Environments (UCLA, Winter 2006), http://classes.design.ucla.edu/Winter06/256/exercises.html#A.

85. Lauren McCarthy, syllabus for Interactivity (UCLA, Winter 2019), http://classes.dma.ucla.edu/Winter19/28/#projects.

86. Golan Levin, syllabus for Audiovisual Systems and Machines (Parsons School of Design MFADT Program, Spring 2002, https://web.archive.org/web/20020802181442/http://a.parsons.edu/~avsys/homework7/index.html.

Appendices

Authors and Contributors

Tega Brain

Golan Levin

Tega Brain is an Australian-born artist, environmental engineer, and educator. Her work examines issues of ecology, data systems, and infrastructure. Her work has been shown in the Vienna Biennale for Change, the Guangzhou Triennial, and in institutions like the Haus der Kulturen der Welt and the New Museum, among others. She is Assistant Professor of Integrated Digital Media at New York University (NYU) and works with the Processing Foundation on the Learning to Teach conference series and p5.js project.

Golan Levin is Professor of Electronic Art at Carnegie Mellon University, where he also holds courtesy appointments in the School of Computer Science, the School of Design, the School of Architecture, and the Entertainment Technology Center. As an educator, Golan's pedagogy is concerned with reclaiming computation as a medium of personal expression. He teaches "studio art courses in computer science," on themes like interactive art, generative form, and information visualization. Since 2009, Golan has also served as Director of CMU's Frank-Ratchye STUDIO for Creative Inquiry, a laboratory for atypical and anti-disciplinary research across the arts, science, technology, and culture.

Taeyoon Choi

Heather Dewey-Hagborg

R. Luke DuBois

De Angela L. Duff

Taeyoon Choi is an artist and educator based in New York City and Seoul. He is the co-founder of the School for Poetic Computation and is a faculty researcher at NYU's Interactive Telecommunications Program (ITP). Choi has extensive experience teaching art and technology to youth and communities through his Making Lab and Poetic Science Fair initiatives. He has held artist residencies at Eyebeam Art and Technology Center, Lower Manhattan Cultural Council, the Frank-Ratchye STUDIO for Creative Inquiry at CMU, and the Art + Technology Lab at the Los Angeles County Museum of Art. His collaboration with Christine Sun Kim was presented at the Whitney Museum of American Art.

Heather Dewey-Hagborg is a transdisciplinary artist and educator who is interested in art as research and critical practice. She has shown work internationally at events and venues including the World Economic Forum, Shenzhen Urbanism and Architecture Biennale, the New Museum, and MoMA PS1. Her work has been widely discussed in the media, from the *New York Times* and the BBC to TED and *WIRED*. She is Visiting Assistant Professor of Interactive Media at NYU Abu Dhabi and is co-founder of REFRESH, an inclusive and politically engaged collaborative platform at the intersection of art, science, and technology.

R. Luke DuBois is a composer, artist, and performer who explores the temporal, verbal, and visual structures of cultural and personal ephemera. He holds a doctorate in music composition from Columbia University, and has lectured and taught worldwide on interactive sound and video performance. An active visual and musical collaborator, DuBois is the co-author of Jitter, a software suite for the real-time manipulation of matrix data developed by San Francisco-based software company Cycling'74. DuBois is the director of the Brooklyn Experimental Media Center at the NYU Tandon School of Engineering, and is on the Board of Directors of the ISSUE Project Room.

De Angela L. Duff is Industry Professor at NYU Tandon School of Engineering and an Associate Vice Provost at NYU. Teaching in higher education since 1999, she is passionate about educating students at the intersection of design, art, and technology. She was acknowledged for this passion by being awarded the NYU Tandon School's 2018 Distinguished Teaching Award. Duff holds an MFA in Studio Art (Photography) from MiCA, a BFA in Graphic Design from Georgia State University, and a BS in Textiles from Georgia Tech.

Minsun Eo

Minsun Eo is a professor of graphic design at the Maryland Institute College of Art (MICA), where he is a recipient of the Trustees Award for Excellence in Teaching; previously, Eo was adjunct professor at the City University of New York (CUNY) Queens College. His New York-based design-research studio focuses on practices that create integrated knowledge, systems, and experiences for the art, technology, architecture, fashion, and education sectors. Eo holds an MFA in Graphic Design from Rhode Island School of Design and a BFA in Visual Communication Design from Kookmin University, Seoul. Eo has worked at 2x4 New York under the guidance of Michael Rock (2013–15) and is a member of the Korean Society of Typography (KST).

Zachary Lieberman

Zachary Lieberman is an artist, researcher, educator, and hacker with a simple goal: he wants you surprised. He creates performances and installations that take human gesture as input and amplify it in different ways—making drawings come to life, imagining what the voice would look like, transforming silhouettes into music. He's been listed as one of Fast Company's Most Creative People, and his work has been awarded the Golden Nica from Ars Electronica and the Interactive Design of the Year award from Design Museum London. He creates artwork through writing software and is a co-creator of openFrameworks, an open-source C++ toolkit for creative coding. Lieberman is co-founder of the School for Poetic Computation, a school examining the lyrical possibilities of code, and is also Adjunct Associate Professor of Media Arts and Sciences at the MIT Media Laboratory, where he directs the Future Sketches research group.

Rune Madsen

Rune Madsen is a designer, artist, and educator who explores code as a design material. As a co-founder of Design Systems International, a design studio that explores systems in graphic design and digital media, he specializes in non-trivial interfaces, brand systems, and custom design tools. He is the author of *Programming Design Systems*, a free online book that teaches a practical introduction to the new foundations of graphic design. Rune has previously worked for the *New York Times*, O'Reilly Media, and as an Assistant Arts Professor at New York University Shanghai. Rune holds a BA from the University of Copenhagen and a master's degree from NYU ITP.

Lauren Lee McCarthy

Lauren Lee McCarthy is an Los Angeles-based artist examining social relationships in the midst of surveillance, automation, and algorithmic living. She is the creator of p5.js and Co-Director of the Processing Foundation. Lauren's work has been exhibited internationally, at places such as The Barbican Centre, Ars Electronica, Fotomuseum Winterthur, Haus der elektronischen Künste, SIGGRAPH, Onassis Cultural Center, IDFA DocLab, and Seoul Museum of Art. She has received numerous honors including a Creative Capital Award, a Sundance Fellowship, an Eyebeam Residency, and grants from the Knight Foundation, Mozilla Foundation, Google, and Rhizome. Lauren is Associate Professor at UCLA Design | Media Arts.

Allison Parrish

Phœnix Perry

Casey Reas

Daniel Shiffman

Allison Parrish is a computer programmer, poet, educator, and game designer whose teaching and practice address the unusual phenomena that blossom when language and computers meet, with a focus on artificial intelligence and computational creativity. She is Assistant Arts Professor at NYU ITP, where she earned her master's degree in 2008. Named "Best Maker of Poetry Bots" by *The Village Voice* in 2016, she is also the author of *@Everyword: The Book* (Instar, 2015), which collects the output of her popular long-term automated writing project that tweeted every word in the English language—attracting over 100,000 followers along the way. Her first full-length book of computer-generated poetry, *Articulations*, was published by Counterpath in 2018.

Phœnix Perry creates embodied games and installations. Her work brings people together to explore their impact on each other and the environment. As an advocate for women in game development, she founded the Code Liberation Foundation. Presently, she leads an MSc in Creative Computing at University of the Arts London's Creative Coding Institute. Since 1996, she has exhibited in a range of cultural venues and game events including Somerset House, Wellcome Collection, Lincoln Center, GDC, A Maze, and Indiecade. She owned Devotion Gallery in Brooklyn, NY from 2009–2014. Devotion generated dialogue between art, technology, and scientific research.

Casey Reas is a professor of Design Media Arts at the University of California, Los Angeles, where he is co-founder of the UCLA Arts Conditional Studio. Reas' creative work builds upon concrete art, conceptual art, experimental animation, and drawing; his projects range from generative prints to urban-scale installations, solo projects in studio to collaborations with architects and musicians. With Ben Fry, Reas is renowned for his development of Processing, an open-source, flexible software sketchbook and language for learning how to code within the context of the visual arts. Reas is also co-author of *Form+Code in Design, Art, and Architecture* (Princeton Architectural Press, 2010), a non-technical introduction to the history and practice of software in the visual arts, and *Processing: A Programming Handbook for Visual Designers and Artists* (MIT Press, 2007/2014).

Daniel Shiffman is Associate Arts Professor at NYU ITP. In his YouTube channel, *The Coding Train*, he publishes tutorials with subjects ranging from the basics of programming languages to generative algorithms like physics simulation, computer vision, and data visualization. Shiffman is a director of the Processing Foundation and the author of *Learning Processing: A Beginner's Guide to Programming Images, Animation, and Interaction* and *The Nature of Code: Simulating Natural Systems with Processing*, an open-source book about simulating natural phenomenon with code.

Kyuha (Q) Shim

Winnie Soon

Tatsuo Sugimoto

Jer Thorp

Kyuha (Q) Shim is a computational designer and researcher based in Pittsburgh and Seoul. He is Assistant Professor in the School of Design at Carnegie Mellon University, where he is also the director of Type Lab. Prior to CMU, he had worked as a researcher at Jan van Eyck Academie and MIT's SENSEable City Laboratory, and had been awarded residencies and fellowships at Frans Masereel Centrum and Facebook Analog Research Lab. His work has been exhibited internationally, at the Cooper Hewitt, Smithsonian Design Museum; Museu Nacional da República; National Museum of Modern and Contemporary Art, Korea; and ggg Gallery, Tokyo. He has also been featured in design festivals such as AGI Open, Beijing Design Week, and London Design Festival. Q is the editor of *GRAPHIC #37: Introduction to Computation* (Propaganda, 2016) and is working on a forthcoming book entitled *Computational Making in Graphic Design*.

Denmark-based, Hong Kong-born artist-researcher Winnie Soon is interested in the cultural implications of technologies, specifically concerning internet censorship, data politics, real-time processing/liveness, invisible infrastructure, and the culture of code practice. Her current research focuses on critical technical and feminist practice, and she is working on two forthcoming books entitled *Aesthetic Programming: A Handbook of Software Studies* (with Geoff Cox) and *Fix My Code* (with Cornelia Sollfrank). She is Assistant Professor at Aarhus University.

Tatsuo Sugimoto works across multiple fields, including information design, media art, and media studies. A member of the faculty in the Graduate School of Systems Design at Tokyo Metropolitan University, Sugimoto has participated in exhibitions such as Picture Book Museum and the Sapporo International Art Festival, and has won awards from the Japan Media Arts Festival and the Exploratory IT Human Resources Project. He is co-author of the textbook History of Media Technology and a co-translator of the Japanese editions of *Processing: A Programming Handbook for Visual Designers and Artists* and *Generative Design: Visualize, Program, and Create with Processing*.

Jer Thorp is an artist, writer, and educator from Vancouver, Canada, currently living in New York. Coming from a background in genetics, his digital art practice explores the many-folded boundaries between science, data, art, and culture. He is Adjunct Professor at NYU ITP and is the co-founder of The Office for Creative Research. Jer was the *New York Times*'s first Data Artist-in-Residence, and in 2017 and 2018 served as the Innovator in Residence at the Library of Congress. He is a National Geographic Explorer and a Rockefeller Foundation Fellow. In 2015, *Canadian Geographic* named Jer one of Canada's Greatest Explorers.

Authors and Contributors

Notes on Computational Book Design

Kyuha Shim

Computation is a primary medium in my design practice, so when Golan and Tega invited me to design their book computationally, I was thrilled by both my role in what would be the first publication of its kind by MIT Press and the prospect of demonstrating computational book design in the larger context of graphic design. In my studio, I write programs to design dynamic visual formations, generate variable end results informed by data, and discover new creative opportunities in graphic design. I also teach in the School of Design at Carnegie Mellon University, where I have developed courses that introduce computation as a creative medium. This project was as refreshing as it was challenging, because it required new ways of working—both in my design process and in my collaboration with the authors.

For the design of the book, the functions handling data were built by Golan and Tega, and I made the graphic design decisions with the help of Minsun Eo, who specializes in typography. In addition to designing visual systems, my main role was writing code in Basil.js that intertwined the data and form. Basil.js enables designers to go back and forth between designing and programming, providing "a bridge between generating through code and adjusting by mouse."[1] Thinking about how CSS provides the stylistic specifications in website design, I used InDesign files to save and load the typographic styles (i.e., character and paragraph styles) and then used Basil.js code to conditionally apply them. This enabled me to work systematically by adjusting generated outcomes through character and paragraph styles. In building this workflow, I needed to work with the rawer computational medium, which enabled me to overcome technical obstacles and boundaries set by software.

While Golan and Tega worked on their content, sharing it as markdown files and parsers on GitHub, I was able to simultaneously build the algorithms generating the book with data pulled from the online repository. We were all able to see and reflect on the designs rendered with the most up-to-date content and work side by side in real time, which would be unthinkable in a typical publication process—usually book designers only begin work once the authors have handed over the finalized content. What I realized during this project is that the programming aspect of my practice is about generating not only a creative end result, but also a bespoke process. While this book was predominantly designed with code, there were certain tasks that I completed by hand—such as handling orphans and widows—since my intent in using computation was to make my design process more intelligent rather than to solve programming problems.

When thinking about the larger implications of using computation in this project, I recall a conversation I had with graphic design educator and theorist Ellen Lupton. She speculated that making templates will be one of graphic designers' primary roles in the future.[2] But what if more designers use code to write their own systems? Instead of a scenario in which designers' roles are diminished, the computational medium would extend and enhance their roles. As computation shifts emphasis from crafting an individual form to building the method from which forms emerge, programming is more than ever relevant to design innovation.

Notes

1. Ludwig Zeller, Benedikt Groß, and Ted Davis, "basil.js – Bridging Mouse and Code Based Design Strategies," in *Proceedings of the Third International Conference, DUXU 2014*, ed. Aaron Marcus (Cham, Switzerland: Springer, 2014): 686–696.

2. Ellen Lupton, "Conversation: Ellen Lupton," *GRAPHIC* 37 (2016): 158–167.

Acknowledgments

It's humbling to think we began this project eight years ago, intending to self-publish it as a short 'zine or guidebook. As we compiled assignments, references, and exercises, it grew into what you hold in your hands. Like most endeavors, it has been made possible by the generous efforts of so many people—more than we can name here. Many of our colleagues and peers have made direct contributions, and many more have lit our path with their work in the field.

We are indebted to Casey Reas for writing the Foreword. His unparalleled perspective on the field emerges from his tremendously important work creating Processing with Ben Fry, as well as from his teaching and art making. We also wish to acknowledge Casey, Ben, and Golan's mentor John Maeda, whose foundational work and influential guidance still shape the field today. Along with John, we are grateful to Christiane Paul, Ellen Lupton, and Chris Coleman, whose panoptic understandings of new media arts and design gives such gravity to their kind endorsements.

Thank you to our book production team: our copy editor and savior Shannon Fry, whose wizardry is woven through so many of the publications on our shelves, and our designers Kyuha (Q) Shim and Minsun Eo, who have pulled off a unique and remarkable achievement in using computational techniques to design this book. These are gorgeous pages. At MIT Press, we are grateful to editors Doug Sery, Noah Springer, and Gita Manaktala, and to designers Yasuyo Iguchi and Emily Gutheinz, and production coordinator Jay McNair, for their stewardship and accommodation of this unusual project.

Thank you to all of our interviewees—Taeyoon Choi, Heather Dewey-Hagborg, Luke DuBois, De Angela Duff, Zach Lieberman, Rune Madsen, Lauren McCarthy, Allison Parrish, Phœnix Perry, Dan Shiffman, Winnie Soon, Tatsuo Sugimoto, and Jer Thorp—for generously sharing their time, perspectives, and energies. Thanks also to our colleagues who provided material and gave feedback and advice on our manuscript: Daniel Cardoso-Llach, Matt Deslauriers, Benedikt Groß, Jon Ippolito, Sam Lavigne, Joel Gethin Lewis, Ramsey Nasser, Allison Parrish, Paolo Pedercini, Caroline Record, Tom White, and our anonymous reviewers. We sincerely appreciate the many artists, designers, researchers, and former students who graciously gave their permissions for us to share their works in these pages.

So many of the projects featured in this book were nurtured and made possible by creative coding communities and the open-source toolkits they develop. We express deep gratitude to the Processing Foundation, the Processing community, and the p5.js community. Lauren McCarthy, Dorothy Santos, and Johanna Hedva, your commitment to diversity, access, and community building has set the standard for us all. Thanks also to Zach Lieberman, Theo Watson, Arturo Castro, Kyle McDonald, the members of the openFrameworks community, and to the many other open-source contributors who spend late nights tending to bugs, issues, and the maintenance of the creative coding toolkits that make this field possible. Thanks also to our many teaching role models in these communities: Dan Shiffman, for his profound public contributions as a new media arts educator; Taeyoon Choi and the School for Poetic Computation, for sharing a practice of institution building in its most compassionate form; and Chris Coleman of the

University of Denver, whose new Clinic for Open Source Arts holds great promise for the continued support of our field.

This book was conceived at the 2013 Eyeo Festival Code+Education Summit. We wish to thank the directors of the Eyeo Festival—Jer Thorp, Dave Schroeder, Wes Grubbs, and Caitlin Rae Hargarten—for creating the conditions for this exchange and for gathering, galvanizing, and supporting our creative community. Similarly, we thank Filip Visnjic, former curator of the Resonate Festival and co-curator, with Greg J. Smith, of the CreativeApplications.net blog, which has provided such a tremendously valuable platform to bring the efforts of our community to a broader public.

This project was funded in part by ArtWorks grant #1855045-34-19 from the Media Arts Program of the National Endowment for the Arts. We thank the NEA and its reviewers, and especially Media Arts Director Jax Deluca for her leadership in sharing these precious public funds. This book was also supported by a grant from the Frank-Ratchye Fund for Art at the Frontier, administered by the Frank-Ratchye STUDIO for Creative Inquiry at Carnegie Mellon University; we express our deep gratitude to Edward H. Frank and Sarah Ratchye for their generosity. Additional support for this book was provided through graduate assistantships from the Integrative Digital Media program at the Tandon School of Engineering, New York University.

This book was realized through the logistical and administrative support of many dedicated staff at CMU's Frank-Ratchye STUDIO for Creative Inquiry: Thomas Hughes, Linda Hager, Carol Hernandez, and Bill Rodgers. We are also indebted to the staff of the CMU College of Fine Arts Sponsored Projects Office, Jenn Joy Wilson and January Johnson, for their assistance in bureaucratic wayfinding. We thank our student research assistants both at CMU and NYU: Sarah Keeling, who tirelessly compiled thousands of assignments from around the Web, and Najma Dawood-McCarthy, Chloé Desaulles, Cassidy Haney, Andrew Lau, Tatyana Mustakos, Cassie Scheirer, Xinyi (Joyce) Wang, and T. James Yurek, who helped us with many critical tasks including preparing and porting code samples, formatting citations, and securing image permissions.

We acknowledge that we are following in the footsteps of our peers, the fellow educators who have written excellent books on computer art and design education. These include John Maeda; Casey Reas and Ben Fry; Daniel Shiffman; Lauren McCarthy; Andrew Blauvelt and Koert van Mensvoort; Greg Borenstein; Andrew Glassner; Nikolaus Gradwohl; Ira Greenberg; Benedikt Groß, Hartmut Bohnacker, Julia Laub, and Claudius Lazzeroni; Carl Lostritto; Rune Madsen; Nick Montfort; Joshua Noble; Kostas Terzidis; Jan Vantomme; Mitchell Whitelaw; Mark Wilson; and Chandler McWilliams. Many of the exercises in this book were adapted from projects posted to the p5.js Web Editor and public online classrooms on the OpenProcessing.org repository, and so we are especially grateful to Cassie Tarakajian and Sinan Ascioglu, respectively, for creating and maintaining these critical community resources.

Thanks also to the many educators, students, and friends—a wider set of peers—who, knowingly or otherwise, contributed their creative energies to our volume, including: Alba G. Corral, Andreas Koller, Art Simon, Arthur Violy, Barton Poulson, Bea Alvarez, Ben Chun, Ben Norskov, Brian Lucid, Caitlin Morris, Caroline KZ, Cedric Kiefer, Charlotte Stiles, Chris Sugrue, Chris G. Todd, Christophe Lemaitre, Christopher Warnow, Claire Hentschker, Clement Valla, Connie Ye, Felix Worseck, Florian Jenett, Francisco Zamorano, Gabriel Dunne, Gene Kogan, Herbert Spencer, Hyeoncheol Kim, Isaac Muro, Joan Roca Gipuzkoa, Jeremy Rotsztain, Jim Roberts, Joey K. Lee, John Simon, Juan Patino, Juseung Stephen Lee, Kasper Kamperman, Kate Hollenbach, Kenneth Roraback, Lali Barriere, Lingdong Huang, Luiz Ernesto Merkle, Manolo Gamboa Naon, Marius Watz, Marty Altman, Matt Richard, Michael Kontopoulos, Monica Monin, Nick Fox-Gieg, Nick Senske, Nidhi Malhotra, Ozge Samanci, Paul Ruvolo, Pinar Yoldas, Rose Marshack, Ryan D'Orazi, Seb Lee-Delisle, Sheng-Fen Nik Chien, Stanislav Roudavski, Steffen Fiedler, Steffen Klaue, Tami Evnin, Thomas O. Fredericks, and Winterstein / Riekoff.

Finally, we thank our families, partners, and close friends, especially Andrea Boykowycz and Sam Lavigne, who have supported us with their feedback, encouragement, and unwavering patience throughout this seemingly never-ending project.

Bibliographies

Related Resources

This book is a handbook for teaching and learning computational art and design and there are many related texts that complement the topics we cover. This list includes some that we have found to be particularly helpful.

Compendia of Art Assignments

Bayerdörfer, Mirjam, and Rosalie Schweiker, eds. *Teaching for People Who Prefer Not to Teach.* London: AND Publishing, 2018.

Blauvelt, Andrew, and Koert van Mensvoort. *Conditional Design: Workbook.* Amsterdam: Valiz, 2013.

Cardoso Llach, Daniel. *Exploring Algorithmic Tectonics: A Course on Creative Computing in Architecture and Design.* State College, PA: The Design Ecologies Laboratory at the Stuckeman Center for Design Computing, The Pennsylvania State University College of Arts and Architecture, 2015.

Fulford, Jason, and Gregory Halpern, eds. *The Photographer's Playbook: 307 Assignments and Ideas.* New York: Aperture, 2014.

Garfinkel, Harold, Daniel Birnbaum, Hans Ulrich Obrist, and Lee Lozano et al. *Do It.* St. Louis, MO: Turtleback, 2005.

Heijnen, Emiel, and Melissa Bremmer, eds. *Wicked Arts Assignments: Practising Creativity in Contemporary Arts Education.* Amsterdam: Valiz, 2020.

Johnson, Jason S., and Joshua Vermillion, eds. *Digital Design Exercises for Architecture Students.* London: Routledge, 2016.

Ono, Yoko. *Grapefruit.* London: Simon & Schuster, 2000.

Paim, Nina, Emilia Bergmark, and Corinne Gisel. *Taking a Line for a Walk: Assignments in Design Education.* Leipzig, Germany: Spector, 2016.

Petrovich, Dushko, and Roger White. *Draw It with Your Eyes Closed: The Art of the Art Assignment.* Paper Monument, 2012.

Smith, Keri. *How to Be an Explorer of the World: Portable Life Museum.* New York: Penguin Books, 2008.

Computational Art and Design History

Allahyari, Morehshin, and Daniel Rourke. *The 3D Additivist Cookbook.* Amsterdam: The Institute of Network Cultures, 2017. Accessed July 20, 2020. https://additivism.org/cookbook.

Armstrong, Helen, ed. *Digital Design Theory: Readings from the Field.* New York: Princeton Architectural Press, 2016.

Cornell, Lauren, and Ed Halter, eds. *Mass Effect: Art and the Internet in the Twenty-First Century.* Vol. 1. Cambridge, MA: MIT Press, 2015.

Freyer, Conny, Sebastien Noel, and Eva Rucki. *Digital by Design: Crafting Technology for Products and Environments.* London: Thames & Hudson, 2008.

Hoy, Meredith. *From Point to Pixel: A Genealogy of Digital Aesthetics.* Hanover, NH: Dartmouth College Press, 2017.

Klanten, Robert, Sven Ehmann, and Lukas Feireiss, eds. *A Touch of Code: Interactive Installations and Experiences.* New York: Die Gestalten Verlag, 2011.

Kwastek, Katja. *Aesthetics of Interaction in Digital Art.* Cambridge, MA: MIT Press, 2013.

Montfort, Nick, Patsy Baudoin, John Bell, Ian Bogost, Jeremy Douglass, Mark C. Marino, Michael Mateas, Casey Reas, Mark Sample, and Noah Vawter. *10 PRINT CHR $(205.5+ RND (1));: GOTO 10.* Cambridge, MA: MIT Press, 2012.

Paul, Christiane. *A Companion to Digital Art.* Hoboken, NJ: John Wiley & Sons, 2016.

Paul, Christiane. *Digital Art (World of Art).* London: Thames & Hudson, 2015.

Plant, Sadie. *Zeros and Ones: Digital Women and the New Technoculture.* London: Fourth Estate, 1998.

Reas, Casey, and Chandler McWilliams. *Form+Code in Design, Art, and Architecture.* New York: Princeton Architectural Press, 2011.

Rosner, Daniela K. *Critical Fabulations: Reworking the Methods and Margins of Design.* Cambridge, MA: MIT Press, 2018.

Shanken, Edward A. *Art and Electronic Media.* London: Phaidon Press, 2009.

Taylor, Grant D. *When the Machine Made Art: The Troubled History of Computer Art.* New York: Bloomsbury Academic, 2014.

Tribe, Mark, Reena Jana, and Uta Grosenick. *New Media Art.* Los Angeles: Taschen, 2006.

Whitelaw, Mitchell. *Metacreation: Art and Artificial Life.* Cambridge, MA: MIT Press, 2004.

Art and Design Pedagogy

Barry, Lynda. *Syllabus: Notes from an Accidental Professor.* Montreal: Drawn & Quarterly, 2014.

Davis, Meredith. *Teaching Design: A Guide to Curriculum and Pedagogy for College Design Faculty and Teachers Who Use Design in Their Classrooms.* New York: Simon and Schuster, 2017.

Itten, Johannes. *Design and Form: The Basic Course at the Bauhaus and Later.* New York: Van Nostrand Reinhold Company, 1975.

Jaffe, Nick, Becca Barniskis, and Barbara Hackett Cox. *Teaching Artist Handbook, Volume One: Tools, Techniques, and Ideas to Help Any Artist Teach.* Chicago: University of Chicago Press, 2015.

Klee, Paul, and Sibyl Moholy-Nagy. *Pedagogical Sketchbook.* London: Faber & Faber, 1953.

Lostritto, Carl. *Computational Drawing: From Foundational Exercises to Theories of Representation.* San Francisco: ORO Editions / Applied Research + Design, 2019.

Lupton, Ellen. *The ABC's of Triangle, Circle, Square: The Bauhaus and Design Theory.* New York: Princeton Architectural Press, 2019.

Schlemmer, Oskar. *Man: Teaching Notes from the Bauhaus.* Cambridge, MA: MIT Press, 1971.

Tufte, Edward R. *The Visual Display of Quantitative Information.* Cheshire, CT: Graphics Press, 2001.

Wong, Wucius. *Principles of Two-Dimensional Design.* New York: John Wiley & Sons, 1972.

Handbooks for Computational Art and Design

Bohnacker, Hartmut, Benedikt Groß, and Julia Laub. *Generative Design: Visualize, Program, and Create with JavaScript in p5.js.* Ed. Claudius Lazzeroni. New York: Princeton Architectural Press, 2018.

De Byl, Penny. *Creating Procedural Artworks with Processing: A Holistic Guide.* CreateSpace Independent, 2017.

Fry, Ben. *Visualizing Data: Exploring and Explaining Data with the Processing Environment.* Sebastopol, CA: O'Reilly Media, Inc., 2008.

Gonzalez-Vivo, Patricio, and Jennifer Lowe. *The Book of Shaders.* Last modified 2015. https://thebookofshaders.com/.

Greenberg, Ira. *Processing: Creative Coding and Computational Art.* New York: Apress, 2007.

Igoe, Tom. *Making Things Talk: Practical Methods for Connecting Physical Objects.* Cambridge, MA: O'Reilly Media, Inc., 2007.

Madsen, Rune. *Programming Design Systems.* Accessed July 20, 2020. https://programmingdesignsystems.com/.

Maeda, John. *Design by Numbers.* Cambridge, MA: MIT Press, 2001.

McCarthy, Lauren, Casey Reas, and Ben Fry. *Getting Started with P5.js: Making Interactive Graphics in JavaScript and Processing.* San Francisco: Maker Media, Inc., 2015.

Montfort, Nick. *Exploratory Programming for the Arts and Humanities.* Cambridge, MA: MIT Press, 2016.

Murray, Scott. *Creative Coding and Data Visualization with p5.js: Drawing on the Web with JavaScript.* Sebastopol, CA: O'Reilly Media, Inc., 2017.

Parrish, Allison, Ben Fry, and Casey Reas. *Getting Started with Processing.py: Making Interactive Graphics with Processing's Python Mode.* San Francisco: Maker Media, Inc., 2016.

Petzold, Charles. *Code: The Hidden Language of Computer Hardware and Software.* Redmond, WA: Microsoft Press, 2000.

Reas, Casey, and Ben Fry. *Processing: A Programming Handbook for Visual Designers and Artists.* Cambridge, MA: MIT Press, 2014.

Shiffman, Daniel. *Learning Processing: A Beginner's Guide to Programming Images, Animation, and Interaction.* San Francisco: Morgan Kaufmann, 2009.

Shiffman, Daniel. *The Nature of Code: Simulating Natural Systems with Processing.* 2012.

Wilson, Mark. *Drawing with Computers.* New York: Perigee Books, 1985.

Commentary on Computational Culture

Baudrillard, Jean. *Simulacra and Simulation.* Ann Arbor: University of Michigan Press, 1994.

Benjamin, Ruha. *Race after Technology: Abolitionist Tools for the New Jim Code.* New York: Wiley, 2019.

Bridle, James. *New Dark Age: Technology and the End of the Future.* London: Verso, 2018.

Browne, Simone. *Dark Matters: On the Surveillance of Blackness.* Durham, NC: Duke University Press, 2015.

Cox, Geoff, and Alex McLean. *Speaking Code: Coding as Aesthetic and Political Expression.* Cambridge, MA: MIT Press, 2013.

D'Ignazio, Catherine, and Lauren F. Klein. *Data Feminism.* Cambridge, MA: MIT Press, 2020.

Haraway, Donna J. *Simians, Cyborgs and Women: The Reinvention of Nature.* New York: Routledge, 1991: 149–181.

Hayles, N. Katherine. *How We Became Posthuman: Virtual Bodies in Cybernetics, Literature, and Informatics.* Chicago: University of Chicago Press, 1999.

Kane, Carolyn L. *Chromatic Algorithms: Synthetic Color, Computer Art, and Aesthetics after Code.* Chicago: University of Chicago Press, 2014.

McNeil, Joanne. *Lurking: How a Person Became a User.* New York: Macmillan, 2020.

Odell, Jenny. *How to Do Nothing: Resisting the Attention Economy.* London: Melville House, 2019.

Quaranta, Domenico. *In Your Computer.* LINK Editions, 2011.

Steyerl, Hito. *Duty Free Art: Art in the Age of Planetary Civil War.* London: Verso, 2017.

Illustration Credits

Unless otherwise noted,
all images are courtesy of the artist(s).

Iterative Pattern

1. Todo. *Spamghetto*. 2010. Wall coverings with computer-generated patterns. https://flickr.com/photos/todotoit/albums/72157616412434905.

2. Pólya, Georg. "Über die Analogie der Kristallsymmetrie in der Ebene." *Zeitschrift für Kristallographie* 60 (1924): 278–282.

3. Alexander, Ian. "Ceramic Tile Tessellations in Marrakech." 2001. Ceramic tile. https://en.wikipedia.org/wiki/Tessellation#/media/File:Ceramic_Tile_Tessellations_in_Marrakech.jpg.

4. Reas, Casey. *One Non-Narcotic Pill A Day*. 2013. Print, 27 x 48". https://paddle8.com/work/casey-reas/27050-one-non-narcotic-pill-a-day.

5. Gondek, Alison. *Wallpaper*. 2015. Generative wallpaper design. http://cmuems.com/2015c/deliverables/deliverables-03/project-03-staff-picks/.

6. Molnár, Vera. *Untitled*. 1974. Computer drawing, 51.5 x 36 cm. Courtesy of the Mayor Gallery, London. https://www.mayorgallery.com/artists/190-vera-molnar/works/10579. Courtesy of The Mayor Gallery, London.

7. Buechley, Leah. *Curtain (Computational Design)*. 2017. Lasercut wool felt. https://handandmachine.cs.unm.edu/index.php/2019/12/02/computational-design/.

Face Generator

8. Dörfelt, Matthias. *Weird Faces*. 2012. Archival digital print on paper. http://www.mokafolio.de/works/Weird-Faces.

9. Dewey-Hagborg, Heather. *Stranger Visions*. 2012. 3D-printed full-color portraits. http://deweyhagborg.com/projects/stranger-visions.

10. Chernoff, Herman. "The Use of Faces to Represent Points in K-Dimensional Space Graphically." *Journal of the American Statistical Association* 68, no. 342 (June 1973): 361–368. http://doi.org/b42z6k.

11. Compton, Kate. *Evolving Faces with User Input*. 2009. Interactive software. https://vimeo.com/111667058.

12. Pelletier, Mike. *Parametric Expression*. 2013. Video loops. http://mikepelletier.nl/Parametric-Expression.

13. Sobecka, Karolina. *All the Universe Is Full of the Lives of Perfect Creatures*. 2012. Interactive mirror. http://cargocollective.com/karolinasobecka/All-The-Universe-is-Full-of-The-Lives-of-Perfect-Creatures.

14. National Safety Council, Energy BBDO, MssngPeces, Tucker Walsh, Hyphen-Labs, RMI, and Rodrigo Aguirre. *Prescribed to Death*. 2018. Installation wall with machine-carved pills. http://www.hyphen-labs.com/nsc.html. Courtesy of National Safety Council and U.S. Justice Department.

Clock

15. Byron, Lee. *Center Clock*. 2007. Abstract generative clock. http://leebyron.com/centerclock.

16. Ängeslevä, Jussi, and Ross Cooper. *Last Clock*. 2002. Interactive slit-scan clock. https://lastclock.net.

17. Levin, Golan. *Banded Clock*. 1999. Abstract clock. http://www.flong.com/projects/clock.

18. Puckey, Jonathan, and Studio Moniker. *All the Minutes*. 2014. Twitter bot. https://twitter.com/alltheminutes.

19. Formanek, Mark. *Standard Time*. 2003. Video, 24:00:00. http://www.standard-time.com/index_en.php.

20. Diaz, Oscar. *Ink Calendar*. 2009. Paper and ink bottle, 420 x 595 mm. http://www.oscar-diaz.net/project/inkcalendar.

Generative Landscape

21. Brown, Daniel. *Dantilon: The Brutal Deluxe*, from the series *Travelling by Numbers*.

Generative Architecture. 2016. Collection of digital renderings. http://flic.kr/s/aHskyNR2Tz.

22. Solie, Kristyn Janae. *Lonely Planets*. 2013. Stylized 3D terrain. https://www.instagram.com/kyttenjanae.

23. Mandelbrot, Benoît B. *The Fractal Geometry of Nature*. San Francisco: W. H. Freeman, 1982. Image courtesy of Richard F. Voss.

24. Pipkin, Everest. *Mirror Lake*. 2015. Virtual landscape generator. https://everestpipkin.itch.io/mirrorlake.

25. Tarbell, Jared. *Substrate*. 2003. Virtual landscape generator. http://www.complexification.net/gallery/machines/substrate.

Virtual Creature

26. Watanabe, Brent. *San Andreas Streaming Deer Cam*. 2015–2016. Live video stream of modified game software. http://bwatanabe.com/GTA_V_WanderingDeer.html.

27. Design IO. *Connected Worlds*. 2015. Large-scale interactive projection installation. New York: Great Hall of Science. http://design-io.com/projects/ConnectedWorlds.

28. Walter, William Grey. *Machina Speculatrix*. 1948–1949. Context-responsive wheeled robots. http://cyberneticzoo.com/cyberneticanimals/w-grey-walter-and-his-tortoises.

29. Sims, Karl. *Evolved Virtual Creatures*. 1994. Animated simulated evolution of block creatures. https://archive.org/details/sims_evolved_virtual_creatures_1994.

Custom Pixel

30. Bartholl, Aram. *0,16*. 2009. Light installation, 530 x 280 x 35 cm. https://arambartholl.com/016.

31. Albers, Anni. *South of The Border*. 1958. Cotton and wool weaving, 4 1/8 x 15

1/4". Baltimore Museum of Art. https://albersfoundation.org/art/anni-albers/weavings/#slide15. Image courtesy of Albers Foundation.

32. Harmon, Leon, and Ken Knowlton. *Studies in Perception #1*. 1966. Print. https://www.albrightknox.org/artworks/p20142-computer-nude-studies-perception-i. Image used with permission of Nokia Corporation and AT&T Archives.

33. Odell, Jenny. *Garbage Selfie*. 2014. Collage. http://www.jennyodell.com/garbage.html.

34. Gaines, Charles. *Numbers and Trees: Central Park Series II: Tree #8, Amelia*. 2016. Black and white photograph, acrylic on plexiglass, 95 x 127 x 6". https://vielmetter.com/exhibitions/2016-10-charles-gaines-numbers-and-trees-central-park-series-ii. Image courtesy of the artist and Hauser & Wirth.

35. Koblin, Aaron, and Takashi Kawashima. *10,000 Cents*. 2008. Crowdsourced digital artwork. http://www.aaronkoblin.com/project/10000-cents.

36. Rozin, Daniel. *Peg Mirror*. 2007. Interactive sculpture with wood dowels, motors, video camera, and control electronics. https://www.smoothware.com/danny/pegmirror.html. Image courtesy of bitforms gallery, New York.

37. Blake, Scott. *Self-Portrait Made with Lucas Tiles*. 2012. Digital collage. http://freechuckcloseart.com.

Drawing Machine

38. Wagenknecht, Addie. *Alone Together*. 2017–. Mechanically assisted paintings. http://www.placesiveneverbeen.com/details/alonetogether.

39. Chung, Sougwen. *Drawing Operations*. 2015–. Robot-assisted drawings. https://sougwen.com/project/drawing-operations.

40. Knowles, Tim. *Tree Drawings*. 2005. Tree-assisted drawings. http://www.cabinetmagazine.org/issues/28/knowles.php.

41. Front Design. *Sketch Furniture*. 2007. Hand-sketched 3D-printed furniture. http://www.frontdesign.se/sketch-furniture-performance-design-project.

42. Graffiti Research Lab (Evan Roth, James Powderly, Theo Watson et al.). *L.A.S.E.R. Tag*. 2007. System for projecting "graffiti." http://www.theowatson.com/site_docs/work.php?id=40.

43. Warren, Jonah. *Sloppy Forgeries*. 2018. Painting game. https://playfulsystems.com/sloppy-forgeries.

44. Maire, Julien. *Digit*. 2006. Performance, writing printed text with fingers. https://www.youtube.com/watch?v=IzDtVR0-0Es.

45. Haeberli, Paul. *DynaDraw*. 1989. Computational drawing environment. http://www.graficaobscura.com/dyna.

Modular Alphabet

46. Pashenkov, Nikita. *Alphabot*. 2000. Interactive typographic system. https://tokyotypedirectorsclub.org/en/award/2001_interactive.

47. Huang, Mary. *Typeface: A Typographic Photobooth*. 2010. Interactive type system that translates facial dimensions into type design. https://mary-huang.com/projects/typeface/typeface.html.

48. Lu, David. *Letter 3*. 2002. Interactive typographic system.

49. Cho, Peter. *Type Me, Type Me Not*. 1997. Interactive typographic system. https://acg.media.mit.edu/people/pcho/typemenot/info.html.

50. Katsumoto, Yuichiro. *Mojigen & Sujigen*. 2016. Robotic typographic system. http://www.katsumotoy.com/mojisuji.

51. Munari, Bruno. *ABC with Imagination*. 1960. Game with plastic letter-composing elements. Corraini Edizioni. https://www.corraini.com/en/catalogo/scheda_libro/336/Abc-con-fantasia. Courtesy of The Museum

of Modern Art, New York. Digital Image © The Museum of Modern Art/Licensed by SCALA / Art Resource, NY.

52. Soennecken, Friedrich. *Schriftsystem*. 1887. Modular type system. http://luc.devroye.org/fonts-49000.html.

53. Devroye, Luc. *Fregio Mecano*. 1920s. Modular font. http://luc.devroye.org/fonts-58232.html.

54. Popp, Julius. *bit.fall*. 2001–2016. Physical typographic installation. https://www.youtube.com/watch?v=AICq53U3dl8. Photograph: Rosa Menkman.

Data Self-Portrait

55. Huang, Shan. *Favicon Diary*. 2014. Browser extension. http://golancourses.net/2014/shan/03/06/project-3-shan-browser-history-visualization.

56. Lupi, Giorgia, and Stephanie Posavec. *Dear Data*. 2016. Analog data drawing project. http://dear-data.com.

57. Viégas, Fernanda. *Themail* (2006). Email visualization software. https://web.archive.org/web/20111112164734/http://www.fernandaviegas.com/themail/.

58. Emin, Tracey. *Everyone I Have Ever Slept With 1963–1995*. 1995. Appliquéd tent, mattress, and light, 122 x 245 x 214 cm. https://en.wikipedia.org/wiki/Everyone_I_Have_Ever_Slept_With_1963%E2%80%931995. Image courtesy of Artists Rights Society, NY.

59. Rapoport, Sonya. *Biorhythm*. 1981. Interactive computer-mediated participation performance. http://www.sonyarapoport.org/portfolio/biorhythm. Image courtesy of the Estate of Sonya Rapoport.

60. Elahi, Hasan. *Stay*. 2011. C-print, 30 x 40". https://elahi.gmu.edu/elahi_stay.php.

Augmented Projection

61. Wodiczko, Krzysztof. *Warsaw Projection*. 2005. Public video projection. Zachęta National Gallery of Art, Warsaw. http://www.art21.org/artists/krzysztof-wodiczko. © Krzysztof Wodiczko. Photograph: Sebastian Madejski, Zachęta National Gallery of Art. Image courtesy of Galerie Lelong & Co., New York.

62. Naimark, Michael. *Displacements*. 1980. Rotating projector in exhibition space. Art Center College of Design, Pasadena, CA. http://http://www.naimark.net/projects/displacements.html.

63. McKay, Joe. *Sunset Solitaire*. 2007. Custom software. http://www.joemckaystudio.com/sunset.php.

64. HeHe. *Nuage Vert*. 2008. Laser projection on vapor cloud. Salmisaari power plant, Helsinki. https://vimeo.com/17350218.

65. Mayer, Jillian. *Scenic Jogging*. 2010. Video. The Solomon R. Guggenheim Museum, New York City. https://youtu.be/uMq9Th3NgGk. Image courtesy of David Castillo Gallery.

66. Obermaier, Klaus, and Ars Electronica Futurelab. *Apparition*. 2004. http://www.exile.at/apparition.

67. Peyton, Miles Hiroo. *Keyfleas*. 2013. Interactive augmented projection. Carnegie Mellon University, Pittsburgh. https://vimeo.com/151334392.

68. Valbuena, Pablo. *Augmented Sculpture*. 2007. Virtual projection on physical base. Medialab Prado, Madrid. http://www.pablovalbuena.com/augmented. Courtesy of Ars Electronica.

69. Sugrue, Christine. *Delicate Boundaries*. 2006. Interactive projection. Medialab Prado, Madrid. http://csugrue.com/delicateboundaries. Courtesy of the Science Gallery Dublin.

70. Sobecka, Karolina. *Wildlife*. 2006. Public projection from car. ZeroOne ISEA2006, San Jose, CA. http://cargocollective.com/karolinasobecka/filter/interactive-installation/Wildlife.

One-Button Game

71. Nguyen, Dong. *Flappy Bird*. 2013. Mobile game. https://flappybird.io.

72. Rozendaal, Rafaël, and Dirk van Oosterbosch. *Finger Battle*. 2011. Mobile game. https://www.newrafael.com/new-iphone-app-finger-battle.

73. Hummel, Benedikt, and Marius Winter (Major Bueno). *Moon Waltz*. 2016. Video game. http://www.majorbueno.com/moon-waltz.

74. Rubock, Jonathan. *Nipple Golf*. 2016. Online game. https://jrap.itch.io/obng.

75. Abe, Kaho. *Hit Me!* 2011. Two-player physical game. http://kahoabe.net/portfolio/hit-me. Photograph: Shalin Scupham.

76. Bieg, Kurt, and Ramsey Nasser. *Sword Fight*. 2012. Two-player physical game. https://swordfightgame.tumblr.com.

Bot

77. Thompson, Jeff. *Art Assignment Bot*. 2013. Twitter bot. https://twitter.com/artassignbot.

78. Parrish, Allison. *Ephemerides*. 2015. Twitter bot. https://twitter.com/the_ephemerides.

79. Pipkin, Everest, and Loren Schmidt. *Moth Generator*. 2015. Twitter bot. http://everest-pipkin.com/#projects/bots.html.

80. Kazemi, Darius. *Reverse OCR*. 2014. Tumblr bot. http://reverseocr.tumblr.com.

81. !Mediengruppe Bitnik. *Random Darknet Shopper*. 2014. Bot. https://bitnik.org/r.

82. Lavigne, Sam. *CSPAN 5*. 2015. YouTube bot. https://twitter.com/CSPANFive.

Collective Memory

83. McDonald, Kyle. *Exhausting a Crowd*. 2015. Video with crowdsourced annotations. https://www.exhaustingacrowd.com.

84. Klajban, Michal. *Rock Cairn at Cairn Sasunnaich, Scotland*. 2019. Photograph. https://commons.wikimedia.org/wiki/File:Rock_cairn_at_Cairn_Sasunnaich,_Scotland.jpg.

85. Goldberg, Ken, and Santarromana, Joseph. *Telegarden*. 1995. Collaborative garden with industrial robot arm. Ars Electronica Museum, Linz, Austria. http://ieor.berkeley.edu/~goldberg/garden/Ars.

86. Vasudevan, Roopa. *Sluts across America*. 2012. Digital map with user input. http://www.slutsacrossamerica.org.

87. Bartholl, Aram. *Dead Drops*. 2010. http://deaddrops.com/.

88. Studio Moniker. *Do Not Touch*. 2013. Interactive crowdsourced music video. https://studiomoniker.com/projects/do-not-touch.

89. Davis, Kevan. *Typophile: The Smaller Picture*. 2002. Collaborative pixel art gallery. https://kevan.org/smaller.cgi.

90. Reddit. */r/place*. 2017. Crowdsourced pixel art. https://reddit.com/r/place.

91. Asega, Salome, and Ayodamola Okunseinde. *Iyapo Repository*. 2015. http://www.salome.zone/iyapo-repository.

Experimental Chat

92. Galloway, Kit, and Sherrie Rabinowitz. *Hole in Space*. 1980. Public communication sculpture. http://y2u.be/SyIJJr6Ldg8. Courtesy of the 18th St Arts Center.

93. Lozano-Hemmer, Rafael. *The Trace*. 1995. Telepresence installation. http://www.lozano-hemmer.com/the_trace.php.

94. Horvitz, David. *The Space Between Us*. 2015. App. https://rhizome.org/editorial/2015/dec/09/space-between-us.

95. Snibbe, Scott. *Motion Phone*. 1995. Interactive software for abstract visual communication. https://www.snibbe.com/projects/interactive/motionphone.

96. Varner, Maddy. *Poop Chat Pro*. 2016. Chatroom. https://cargocollective.com/maddyv/POOPCHAT-PRO. Photograph: Thomas Dunlap.

97. Fong-Adwent, Jen, and Soledad Penadés. *Meatspace*. 2013. Ephemeral chatroom with animated GIFs. https://chat.meatspac.es/.

98. Pedercini, Paolo. *Online Museum of Multiplayer Art*. 2020. Collection of chatrooms with interaction constraints. https://likelike2.glitch.me/?room=firstFloor.

99. Artist, American. *Sandy Speaks*. 2017. Chat platform based on video archive. https://americanartist.us/works/sandy-speaks.

Browser Extension

100. Hoff, Melanie. *Decodelia*. 2016. Browser extension. https://melaniehoff.github.io/DECODELIA/.

101. Lund, Jonas. *We See in Every Direction*. 2013. Web browser. Mac OS X 10.7.5 or later. http://ineverydirection.net/

102. Lambert, Steve. *Add Art*. 2008. Browser extension. http://add-art.org/

103. Oliver, Julian, and Daniil (Danja) Vasiliev. *Newstweek*. 2011. Custom internet router. https://julianoliver.com/output/newstweek.

104. McCarthy, Lauren, and Kyle McDonald. *Us+*. 2013. Google Hangout video chat app. http://lauren-mccarthy.com/us.

Creative Cryptography

105. Wu, Amy Suo. *Thunderclap*. 2017. Steganographic zine. http://amysuowu.net/content/thunderclap.

106. Sherman, William H. "How to Make Anything Signify Anything: William F. Friedman and the Birth of Modern Cryptanalysis." *Cabinet* 40 (Winter 2010–2011): n.p. http://www.cabinetmagazine.org/issues/40/sherman.php. Courtesy of New York Public Library.

107. Varner, Maddy. *KARDASHIAN KRYPT*. 2014. Browser extension. https://cargocollective.com/maddyv/KARDASHIAN-KRYPT.

108. Dörfelt, Matthias. *Block Bills*. 2017. Digital print on paper, 5.9 x 3.3". https://www.mokafolio.de/works/BlockBills.

109. Plummer-Fernández, Matthew. *Disarming Corruptor*. 2013. Encryption software. https://www.plummerfernandez.com/works/disarming-corruptor.

110. Tremmel, Georg, and Shiho Fukuhara. *Biopresence*. 2005. Trees transcoded with human DNA. https://bcl.io/project/biopresence.

111. Katchadourian, Nina. *Talking Popcorn*. 2001. Sound sculpture. http://www.ninakatchadourian.com/languagetranslation/talkingpopcorn.php. Courtesy of the artist, Catharine Clark Gallery, and Pace Gallery.

112. Kenyon, Matt, and Douglas Easterly. *Notepad*. 2007. Microprinted ink on paper. http://www.swamp.nu/projects/notepad.

Voice Machine

113. Leeson, Lynn Hershman. *DiNA, Artificial Intelligent Agent Installation*. 2002–2004. Interactive network-based multimedia installation. Civic Radar, ZKM Museum of Contemporary Art, Karlsruhe. https://www.lynnhershman.com/project/artificial-intelligence. Programming: Lynn Hershman Leeson and Colin Klingman. Courtesy of Yerba Buena Center for the Arts. Photograph: Charlie Villyard.

114. Dinkins, Stephanie. *Conversations with Bina48*. 2014–. Ongoing effort to establish a social relationship with a robot built by Terasem Movement Foundation. https://www.stephaniedinkins.com/conversations-with-bina48.html.

115. Everybody House Games. *Hey Robot*. 2019. A party game involving smart speakers. https://everybodyhousegames.com/heyrobot.html.

116. Rokeby, David. *The Giver of Names*. 1990–. Computer system for naming objects. Kiasma Museum of Contemporary Art, Helsinki. http://www.davidrokeby.com/gon.html. Photograph: Tiffany Lam.

117. Lev, Roi. *When Things Talk Back. An AR Experience*. 2018. Mobile augmented reality artificial intelligence app. http://www.roilev.com/when-things-talk-back-an-ar-experience.

118. Lublin, David. *Game of Phones*. 2012–. Social game of telephone transcription. http://www.davidlubl.in/game-of-phones.

119. Thapen, Neil. *Pink Trombone*. 2017. Interactive articulatory speech synthesizer. https://experiments.withgoogle.com/pink-trombone.

120. Dobson, Kelly. *Blendie*. 2003–2004. Interactive voice-controlled blender. https://web.media.mit.edu/~monster/blendie.

121. He, Nicole. *ENHANCE.COMPUTER*. 2018. Interactive speech-driven browser game. https://www.enhance.computer.

Measuring Device

122. Jeremijenko, Natalie, and Kate Rich (Bureau of Inverse Technology). *Suicide Box*. 1996. Camera, video, and custom software. http://www.bureauit.org/sbox.

123. Oliver, Julian, Bengt Sjölen, and Danja Vasiliev (Critical Engineering Working Group). *The Deep Sweep*. 2016. Weather balloon, embedded computer, and RF equipment. https://criticalengineering.org/projects/deep-sweep.

124. Varner, Maddy. *This or That*. 2013. Interactive poster. https://www.youtube.com/watch?v=HDWxq1v6A2k.

125. Ma, Michelle. *Revolving Games*. 2014. Location-based game and public intervention. https://vimeo.com/83068752.

126. D'Ignazio, Catherine. *Babbling Brook*. 2014. Water sensor with voice interface. http://www.kanarinka.com/project/the-babbling-brook/.

127. Sobecka, Karolina, and Christopher Baker. *Picture Sky*. 2018. Participatory photography event. http://cargocollective.com/karolinasobecka/Picture-Sky-Zagreb.

128. Onuoha, Mimi. *Library of Missing Datasets*. 2016. Mixed media installation. http://mimionuoha.com/the-library-of-missing-datasets. Photograph: Brandon Schulman Photography.

Personal Prosthetic

129. Clark, Lygia. *Dialogue Goggles*. 1968. Wearable device. http://www.laboralcentrodearte.org/en/recursos/obras/dialogue-goggles-dialogo-oculos-1968. Image courtesy Associação Cultural O Mundo de Lygia Clark.

130. Sputniko!. *Menstruation Machine – Takashi's Take*. 2010. Installation with video and wearable device. Scai the Bathhouse, Tokyo. https://sputniko.com/Menstruation-Machine.

131. Dobson, Kelly. *ScreamBody*. 1998–2004. Wearable device. MIT Media Lab, Cambridge. http://web.media.mit.edu/~monster/screambody. Photograph: Toshihiro Komatsu.

132. Ross, Sarah. *Archisuits*. 2005–2006. Wearable soft sculpture. Los Angeles. https://www.insecurespaces.net/archisuits.html.

133. Woebken, Chris, and Kenichi Okada. *Animal Superpowers*. 2008–2015. Series of wearable devices. https://chriswoebken.com/Animal-Superpowers. Photograph: Haeyoon Yoo.

134. Hendren, Sara, and Caitrin Lynch. *Engineering at Home*. 2016. Documentation and discussion of adapted household implements. Olin College of Engineering, Needham, MA. http://engineeringathome.org.

135. Montinar, Steven. 2019. *Entry Holes and Exit Wounds*. Performance with wearable electronics. Carnegie Mellon University, Pittsburgh. https://www.youtube.com/watch?v=KBsTpQgyvhk.

136. McDermott, Kathleen. *Urban Armor #7: The Social Escape Dress*. 2016. Bio-responsive electromechanical garment. http://www.kthartic.com/index.php?/class/urban-armor-7.

137. Okunseinde, Ayodamola. *The Rift: An Afronaut's Journey*. 2015. Afronaut suit. http://www.ayo.io/rift.html.

Parametric Object

138. Desbiens Design Research. *Fahz*. 2015. System for rendering profiles as 3D-printed vases. http://www.fahzface.com/. Photograph: Nicholas Desbiens.

139. Nervous System. *Kinematic Dress*. 2014. System for 3D-printing custom one-piece dresses. https://n-e-r-v-o-u-s.com/projects/sets/kinematics-dress. Photograph: Steve Marsel Studio.

140. Eisenmann, Jonathan A. *Interactive Evolutionary Design with Region-of-Interest Selection for Spatiotemporal Ideation & Generation*. 2014. Ph.D. defense slides, Ohio State University. https://slides.com/jeisenma/defense# and https://etd.ohiolink.edu/pg_10?0::NO:10:P10_ACCESSION_NUM:osu1405610355.

141. Epler, Matthew. *Grand Old Party*. 2013. Political polling data visualized as silicone butt plugs. https://mepler.com/Grand-Old-Party.

142. Lia. *Filament Sculptures*. 2014. Computational and organically formed filament sculptures. https://www.liaworks.com/theprojects/filament-sculptures.

143. Csuri, Charles A. *Numeric Milling*. 1968. Computational wood sculpture created with punch cards, an IBM 7094, and a 3-axis milling machine. https://csuriproject.osu.edu/index.php/Detail/objects/769.

144. Ijeoma, Ekene. *Wage Islands*. 2015. Interactive installation and data visualization. New York. https://studioijeoma.com/Wage-Islands.

145. Segal, Adrien. *Wildfire Progression Series*, 2017. Data-driven sculpture. https://www.adriensegal.com/wildfire-progression.

146. Ghassaei, Amanda. *3D Printed Record*. 2012. System for rendering audio files as 3D-printed 33RPM records. https://www.instructables.com/id/3D-Printed-Record.

147. Binx, Rachel, and Sha Huang. *Meshu*. 2012. System for rendering geodata as 3D-printed accessories. http://www.meshu.io/about.

148. Chung, Lisa Kori, and Kyle McDonald. *Open Fit Lab*. 2013. Performance producing custom-tailored pants for audience members. http://openfitlab.com.

149. Allahyari, Morehshin. *Material Speculation: ISIS; King Uthal*. 2015–2016. 3D-printed resin and electronic components. 12 x 4 x 3.5" (30.5 x 10.2 x 8.9 cm). http://www.morehshin.com/material-speculation-isis/.

Virtual Public Sculpture

150. Matsuda, Keiichi. *HYPER-REALITY*. 2016. Augmented reality futuristic cityscape. http://km.cx/projects/hyper-reality.

151. Shaw, Jeffrey. *Golden Calf*. 1994. Augmented reality idol with custom hardware. https://www.jeffreyshawcompendium.com/portfolio/golden-calf. Image: Ars Electronica '94, Design Center Linz, Linz, Austria, 1994.

152. Bailey, Jeremy. *Nail Art Museum*. 2014. Augmented reality miniature museum. https://www.jeremybailey.net/products/nail-art-museum.

153. Y&R New York. *The Whole Story*. 2017. Augmented reality public statuary. https://play.google.com/store/apps/details?id=ca.currentstudios.thewholestory.

154. Skwarek, Mark, and Joseph Hocking. *The Leak In Your Hometown*. 2010. Augmented reality protest app triggered by BP's logo. https://theleakinyourhometown.wordpress.com.

155. Shafer, Nathan, and the Institute for Speculative Media. *The Exit Glacier Augmented Reality Terminus Project*. 2012. Augmented reality climate data visualization app. Kenai Fjords National Park. http://nshafer.com/exitglacier.

156. Raupach, Anna Madeleine. *Augmented Nature*. 2019. Augmented reality project series using natural objects with data visualization. http://www.annamadeleine.com/augmented-nature.

Extrapolated Body

157. Jones, Bill T., and Google Creative Lab. *Body, Movement, Language*. 2019. Pose model experiments. https://experiments.withgoogle.com/billtjonesai. Image courtesy of Google Creative Lab.

158. Akten, Memo, and Davide Quayola. *Forms*. 2012. Digital renderings. https://vimeo.com/38017188. This project was commissioned by the National Media Museum, with the support of imove, part of the Cultural Olympiad programme. Produced by Nexus Interactive Arts.

159. Universal Everything. *Walking City*. 2014. Video sculpture. https://vimeo.com/85596568.

160. Groupierre, Karleen, Adrien Mazaud, and Sophie Daste. *Miroir*. 2011. Interactive augmented reality installation. http://vimeo.com/20891308.

161. YesYesNo. *Más Que la Cara*. 2016. Interactive installation. https://www.instagram.com/p/BDxsVZ0JNpm/. Discussed in Lieberman, Zach. "Más Que la Cara Overview." Medium, posted April 3, 2017. https://medium.com/@zachlieberman/m%C3%A1s-que-la-cara-overview-48331a0202c0.

Synesthetic Instrument

162. Pereira, Luisa, Yotam Mann, and Kevin Siwoff. *In C*. 2015. Evolving web-based interactive audiovisual score and performance. http://www.luisapereira.net/projects/project/in-c.

163. Pitaru, Amit. *Sonic Wire Sculptor*. 2003. Audiovisual composition and performance instrument. https://www.youtube.com/watch?v=ji4VHWTk8TQ.

164. Van Gelder, Pia. *Psychic Synth*. 2014. Interactive audiovisual installation powered by brain waves. https://piavangelder.com/psychicsynth.

165. Brandel, Jono, and Lullatone. *Patatap*. 2012. Audiovisual composition and performance instrument. https://works.jonobr1.com/Patatap.

166. Clayton, Jace. *Sufi Plug Ins*. 2012. Suite of music-making apps with poetic interface. http://www.beyond-digital.org/sufiplugins.

167. Hundred Rabbits (Rekka Bellum and Devine Lu Linvega). *ORCA*. 2018–2020.

Exercises

(p. 152) Aliyu, Zainab. *p5.js Self-Portrait*. Student project from 15-104: Computation for Creative Practices, Carnegie Mellon University, 2015. http://cmuems.com/2015c/.

(p. 178) Blankensmith, Isaac. *ANTI-FACE-TOUCHING MACHINE*. Interactive software presented on Twitter, March 2, 2020. https://twitter.com/Blankensmith/status/1234603129443962880.

(p. 179) MSCHF (Gabriel Whaley et al.). *MSCHF Drop #12: This Foot Does Not Exist*. Software and text message service. 2020. https://thisfootdoesnotexist.com/.

(p. 179) Pietsch, Christopher. *UMAP Plot of the OpenMoji Emoji Collection*. Presented on Twitter, April 15, 2020. https://twitter.com/chrispiecom/status/1250404420644454406/

Provenance

(p. 239) Stoiber, Robert. Student artwork. In Schneeberger, Reiner. "Computer Graphics at the University of Munich (West Germany)," *Computer Graphics and Art* 1, no. 4 (November 1976): 28, http://dada.compart-bremen.de/docUploads/COMPUTER_GRAPHICS_AND_ART_Nov1976.pdf.

(p. 240) Wilson, Mark. "METAFACE". Generated face designs. In *Drawing with Computers* (New York: Perigee Books, 1985), 18. http://mgwilson.com/Drawing%20with%20Computers.pdf.

(p. 241) Maeda, John. "Problem 2A — Time Display". Assignment from *MAS.961: Organic Form* (MIT Media Lab, fall 1999). https://web.archive.org/web/20000901042632/http://acg.media.mit.edu/courses/organic/, accessed January 18, 2000. Screenshot courtesy Casey Reas.

(p. 242) Vojir, Lukas. *Processing Monsters*. 2008. Website with contributed interactive sketches. https://web.archive.org/web/20090304170310/http://rmx.cz/monsters/.

Indexes

Name Index

Subject Index

O gracious reader, wash your hands and touch the book only when you have coerced those who represent you to dismantle the police and decarbonize our societies, else there will be no future for computational art and design, nor life on Earth as we know it.

The attractive parts of this book were designed by Kyuha (Q) Shim and Minsun Eo. Any unattractive parts are wholly the result of interference and questionable decisions by Golan Levin and Tega Brain. The majority of this book's layout was computationally generated using Basil.js.

The artworks on the front and back covers of this book were generated in Processing by Manolo Gamboa Naon and are excerpted from *Vitamina* (2019) and *Fils* (2020), respectively. The illustrations in the Exercises section were designed using Processing and p5.js.

The book was set in Atlas Grotesk and Atlas Typewriter, designed in 2012 by Susana Carvalho, Kai Bernau, Christian Schwartz, and Ilya Ruderman.

A repository of code for this book, including sample solutions for Exercises, is located at: https://github.com/CodeAsCreativeMedium.